mediated boyhoods

mediated
youth

Sharon R. Mazzarella
General Editor

Vol. 8

Mediated Youth series is part of the Peter Lang Media list.
Every volume is peer reviewed and meets
the highest quality standards for content and production.

PETER LANG
New York • Washington, D.C./Baltimore • Bern
Frankfurt • Berlin • Brussels • Vienna • Oxford

mediated boyhoods

BOYS, TEENS, AND YOUNG MEN IN POPULAR MEDIA AND CULTURE

EDITED BY ANNETTE WANNAMAKER

PETER LANG
New York • Washington, D.C./Baltimore • Bern
Frankfurt • Berlin • Brussels • Vienna • Oxford

Library of Congress Cataloging-in-Publication Data

Mediated boyhoods: boys, teens, and young men in popular media and culture /
edited by Annette Wannamaker.
p. cm. — (Mediated youth; vol. 8)
Includes bibliographical references and index.
1. Boys. 2. Teenage boys. 3. Young men.
4. Teenagers in mass media. 5. Sex role. 6. Masculinity.
7. Gender identity. 8. Men—Identity. I. Wannamaker, Annette.
HQ775.M425 302.23083—dc22 2010032382
ISBN 978-1-4331-0541-8 (hardcover)
ISBN 978-1-4331-0540-1 (paperback)
ISSN 1555-1814

Bibliographic information published by **Die Deutsche Nationalbibliothek.**
Die Deutsche Nationalbibliothek lists this publication in the "Deutsche
Nationalbibliografie"; detailed bibliographic data is available
on the Internet at http://dnb.d-nb.de/.

FSC
Mixed Sources
Product group from well-managed
forests, controlled sources and
recycled wood or fiber

Cert no. SCS-COC-002464
www.fsc.org
©1996 Forest Stewardship Council

Cover photo by Rodrigo Favera

The paper in this book meets the guidelines for permanence and durability
of the Committee on Production Guidelines for Book Longevity
of the Council of Library Resources.

© 2011 Peter Lang Publishing, Inc., New York
29 Broadway, 18th floor, New York, NY 10006
www.peterlang.com

Printed in the United States of America

To Will

Contents

Acknowledgments

I am grateful to Eastern Michigan University for providing research time for this project, especially Rebecca Sipe, Chair of the Department of English Language and Literature. I am also indebted to my colleagues, friends, and family who have always been so generous and supportive, especially Ian Wojcik-Andrews, Joe Csicsila, Gina Boldman, Cathy Fleischer, Rachel Dewees, Steven D. Krause, and Mom and Dad.

Members of the Children's Literature Association contributed to this project in numerous ways by suggesting contributors and topics, by providing moral support, and by sharing research and ideas. This collection would not have come together without help from Kenneth Kidd, Michelle Ann Abate and June Cummins.

I am grateful, as well, to my editors at Peter Lang. Sharon Mazzarella is a dream to work with, and I so appreciate her time, attention and astute advice. Finally, the contributors to this project also made editing this collection a pleasure, and I feel I have learned so much from reading their work.

Media about Boys, for Boys and by Boys

Annette Wannamaker

J udith Butler (1990, 1993) explores the paradox that gender is at once socially constructed and a foundation of identity: "What are we to make of constructions without which we would not be able to think, to live, to make sense at all, those which have acquired for us a kind of necessity?" ("Bodies" v). Gender is foundational because it is not merely one aspect of identity we can separate out from a true self; we are not capable of fully imagining what it would mean to be a human without a gender. Gender is integral to our understanding of ourselves, our place in the world and the relationships we have with one another. We inhabit bodies that are gendered, and people around us react to us and interact with us in particular ways based on our gender. When a child is born—or these days, months before a child is born—the first question we ask is, "is it a boy or a girl?" and the answer to this question shapes the ways in which that child will be allowed to navigate through the world. As Judy L. Isaksen writes in her contribution to this collection, "gender reigns as one of the most potent features to not only organize our lives but also to determine our individual and collective identity" (147).

Because gender is so foundational to our sense of self and to many of the minute, ordinary events and interactions we experience every day, it is easy to think of gender identity as natural, as something that just is, which is fixed and permanent. Over the past 150 years though, feminist scholars have worked to denaturalize gender by making visible those aspects of femininity that are socially

constructed and, therefore, alterable by individuals and society. As a result, our individual and cultural assumptions about girls and women have broadened so that many people now believe, for example, that girls are not naturally bad at math and science, do not always yearn to become wives and mothers, can excel in athletics, and can grow up to be political leaders, C.E.O.s, doctors or astronauts.

Those things we believe our children can or cannot achieve—whether true or false, whether we are conscious of these beliefs or not—directly affect our everyday interactions with children and teenagers, the school curriculums we design for them, the limits we impose upon them, the books and other media texts we create for them, and the gendered ways we depict children and teens in these various texts. However, the media texts young people consume, read, create, or use as background noise for their lives are so ubiquitous, and yet so fleeting, that they often escape careful analysis: "It's *just* a kids' movie. Why are we reading so much into it?" These everyday media texts and our interactions with them—even ones that at first glance might seem trivial; *especially* ones that at first glance might seem trivial—are worthy of careful study because they help to shape the sort of gendered adult a child will eventually become. "So much of Subject formation occurs in minutia, in an accretion of details that build upon one another through repetition—innumerable insignificant moments join together to create the seamless-seeming narratives that shape our sense of self" (Wannamaker 227). In other words, the little bits and pieces of popular culture—that children's film watched over and over again on the VCR in the living room, that beer commercial with high-fiving men and bikini-clad women aired during sports programming, or that YouTube video we forward on to all of our friends—all work together as part of a complex and expansive media matrix that both reflects and shapes our collective and individual attitudes about gender.

While much research has been conducted analyzing the ways girls and young women are depicted in the media, we have not yet focused the same intense and far-reaching critical attention on boys and young men in the media. As Suzanne M. Enck-Wanzer and Scott A. Murray point out in their contribution to this collection, "there has been a bevy of research on constructions of femininities across popular media; however, emphases on the construction of masculinities have, most often, been an afterthought or implied by default" (59). We have not conducted enough research on media created about boys, for boys and by boys, and, as a result, we have not asked most boys and young men to think critically about the ways they are portrayed, the ways in which these portrayals might reflect or influence their lives, or about the ways in which various masculine roles are socially constructed and, therefore, as alterable as feminine roles. The cliché "boys will be boys," for instance, implies there is something natural and simple about traditional masculinity that we should not work to alter, and that does not need to be interrogated. Also, while there are, increasingly, a number of scholars

who study and teach masculinity, men's studies, and boyhood studies (e.g., Kimmel and Messner, 1990; Messner and Sabo, 1994; Mac an Ghaill, 1994; Connell, 1995; Harris, 1995; Beneke, 1997; Faludi, 2000; Nodelman, 2002; Stephens, 2002; Bilz, 2004; Kidd, 2004; Kimmel, 2008) most "gender studies" programs at colleges and universities still focus almost exclusively on femininity and women's studies. This is understandable because "gender studies" grew out of larger political movements meant to challenge deeply entrenched policies and attitudes that severely limited (and continue to limit) the social and familial roles women play, the political and economic power women wield, and the rights and privileges they enjoy in their everyday lives. This work is unfinished and needs to continue both as an academic study and as a social and political movement.

However, as several of the men's studies scholars listed above have noted, since gender is seen as a binary (masculine/feminine, man/woman, boy/girl) a focus solely on women and girls is incomplete and, ultimately, unproductive. Masculinity and femininity, as is the case with any binary, exist only in relation to one another: We cannot fully understand one without fully understanding the other; we cannot change one without changing the other; and we certainly cannot work to break down and challenge binaries without developing a deeper understanding of the ways one half of the binary is inextricably linked to and works to define the other half.

One might assume that boys and boyhood are receiving a great deal of serious scholarly attention because, over the past few decades, boys have been the focus of much attention from mainstream media pundits and authors of pop-psychology books on parenting, psychology and education (e.g., Gurian, 1996; Biddulph, 1998; Pollack, 1998; Garbarino, 1999; Kindlon and Thompson, 1999; Gurian and Trueman, 2000; Sommers, 2000; Brozo, 2002; Marano, 2008; Strausbaugh, 2008). Much of the recent attention boys have received in the mainstream media, however, has been less an attempt to understand masculinity, and more an attempt to pathologize boys and then to prescribe various remedies to cure them of an ailing masculinity. At their worst, some of these texts kindle and then capitalize on parental and societal fears about boys and teens, worries about boys being violent or illiterate or delinquent or gay being the most common of these adult anxieties. In the public debates played out in mass-marketed books and on television talk shows, traditional versions of masculinity are either valorized or pilloried. For instance, some argue that traditional cultural assumptions about masculinity harm boys and young men by brutalizing them and by severely limiting the emotional and social roles allowed to boys and young men (Kindlon and Thompson, 1999). Others argue that feminist demands are harming boys and men and making them feel guilty about being male, and that we should just let boys be boys instead of asking them to embrace more feminine roles (Gurian, 1996). Many of these mainstream discussions about boys often play to an adult

nostalgia about a mythic time when "boys could be boys" or they use boys as a symbol or a scapegoat for societal ills (Sommers, 2000; Strausbaugh, 2008). These public debates about the failings of contemporary boyhood are so pervasive that they have led to policy changes in schools such as gender-segregated classrooms or subjects, and have created a niche industry of advice manuals for the parents and teachers of boys. They have also directly and indirectly influenced our culture's current attitudes about boys.

In their article critiquing four of these pop-psychology books, Kristin J. Anderson and Christina Accomando (2002), discuss the ways that these books often ignore the differences among boys, and instead focus mostly on a universalized, straight, white, middle-class boy. They end their study by calling for research that would "complicate notions of gender and critically inspect false universalities. Such analysis also could examine the ways in which boys and men both benefit from and are constrained by gender polarization and male privilege" (511). This is one goal of this collection, to complicate some of our commonly held notions about a universalized boyhood by studying a broad variety of boys and young men from various cultures and subcultures.

Another goal is to complicate commonly held notions about the media and its influences upon boys. When I tell people I am editing a collection of essays about boys and the media, responses are enthusiastic and concerned, but also vague: "Oh . . . boys and the media . . . That's a problem, isn't it?" This response—that there is some sort of "problem" involving boys and the media—is not surprising given the negative tone of many recent books and articles that raise alarms about boys in crisis, gloomy and often over-exaggerated reports of illiterate and alliterate boys, and various news stories that imply a direct connection between violent video games or music lyrics and violent behavior. The vagueness of the response also is not surprising, given the contradictory information available about boys, young men and the media:

- One assumption is that violent video games, slasher films, rap music, sports programming, and an overdose of on-line role playing games are turning our boys and young men into violent delinquents (e.g., Garbarino, 1999; Ravitch and Viteretti, 2003)

- Then, conversely, there are the experts who claim that all this media consumption is turning our boys into obese and alliterate couch potatoes. (Kaiser Family Foundation, 2004)

- Or, according to a different set of experts, the media has turned the current generation of boys and young men into "wimps" and "sissies," who need to be taught how to be the vibrant (violent?), outdoorsy, and appro-

priately manly boys their fathers and grandfathers most certainly must have been (e.g., Gurian, 1996; Sommers, 2000; Marano, 2008; Strausbaugh, 2008).

- And then there are those who argue the exact opposite: stereotypical depictions of gender in the media work to reinforce narrow and oppressive gender roles that objectify girls and women, and that restrict options for those boys (most boys) who do not easily fulfill traditional, rigid expectations of masculinity (e.g., Pollack, 1998; Kindlon and Thompson, 1999; Faludi, 2000; Stephens, 2002; Way and Chu, 2004; Kimmel, 2008).

- And, finally, there are those who question whether media is harming boys at all, or whether some adults are overreacting. Generations of adults have, after all, fretted over every new media platform to come along, proclaiming that each new development—from moving pictures to comic books to rock-and-roll to rap to video games to the internet—will most certainly create marauding bands of juvenile delinquents. Some scholars, therefore, argue that we need to temper our alarm with a bit of historical perspective, and that, perhaps, we need to have more faith in the critical thinking abilities and moral compasses of our boys and young men (e.g., Jenkins, 1992, 1998; Newkirk, 2002; Osgerby, 2004; Gee, 2007; Wannamaker, 2008).

Perhaps, given these contradictory opinions, the relationship between boys and young men and the media is far more complicated and ambiguous than it might initially seem.

What is worth considering, then, is not whether we can find commonalities among all boys or all media created for boys, or whether we are able to succinctly define contemporary boyhood, but, instead, whether the generalizations we make about boys in our public discourse have an effect on the lives of boys, on the ways we socialize them, on the policies we make regarding them, on the media we create for them, on the ways we portray them in the media, and on the ways they view themselves. What is at stake in the assumptions we make? What is the picture of the contemporary boy created by the popular media? Is this mediated boy a reflection of or an influence on the lives of actual boys? How thoughtfully are boys and young men able to respond to and interact with the media texts they consume or create? While various pundits, authors, educators, and psychologists seem to reach very different conclusions about the current state of boyhood, one thing too many of these mainstream theories have in common is the notion that something negative is being "done to" our boys by contemporary popular culture and media. Missing from many of these arguments are the points of view of the

boys themselves, which, as will be illustrated in some of the chapters that follow, often surprise us and transcend our assumptions through their abilities to understand, to resist, to remake, and to critically think about the media in their lives.

All of the essays in this collection work to challenge and complicate our assumptions about masculinity, boys, young men and the media. They ask us to question and to re-think the supposed naturalness of such dominant masculine traits as heterosexuality, emotional toughness, sexual aggressiveness or violent impulses. They also ask us to expand our beliefs about the ways boys and young men use the media or are affected by it. They do so from a variety of perspectives and critical lenses, but all assume that a) there is no monolithic, universal "boy" or experience of boyhood, that there are numerous varieties of boyhoods influenced by such factors as race, sexual orientation, socio-economic class or national identity; and that b) there is much we can learn from media portrayals of boys and boyhood, which sometimes are at odds with the actual lives of boys at the same time as they reflect cultural attitudes about boys.

This collection features chapters examining the ways boys and young men use, interact with and create film, literature, fashion, YouTube videos, bedroom culture, video games, wrestling shows, hip hop, social networking sites and queer culture. There are also chapters examining the ways boys and young men are depicted in documentary films, news shows, music videos, magazines, young adult novels, and children's films. The contributors to this collection are all working to understand boys and young men, and their depictions in and relation to the media, in complex ways that do not assume we can make easy generalizations about all boys, and that do not assume that all media aimed at boys or created by boys is inherently negative. Additionally, by listening to boys, by studying various media texts and the contexts in which these are used, and by paying close attention to some of the media texts that boys themselves are creating, this collection hopes to illuminate the thoughtful and interactive relationship many boys and young men have with the media.

The Chapters: Approaching Interdisciplinary Approaches

This collection brings together work from scholars approaching boys and the media using a variety of research methodologies and critical lenses, which can be a challenge for readers unused to navigating among different sorts of disciplinary discourse, but which also can work to highlight the complex web of relationships among boys and young men, identity, community, culture, ideology and the media. Contributors to this volume come from the fields of literary studies, media studies, film studies, sociology, folklore, cultural studies, rhetoric and gender studies. While some of the scholars contributing to this collection look at the ways boys and young men are depicted in the media, others look at the ways boys

use and understand the media, and some others look at the ways that boys and young men are creating their own media texts.

Different research methodologies ask different sets of questions and focus on different aspects of media environment (e.g. text, author, reader, context, community, genre, media platform, and various modes of production, distribution and consumption). So, for instance, a careful close reading of a work of literature or a film text can help us to think more critically about the ideologies about gender that might be underlying that work, while interviews with boys and young men can map their viewing habits or reading strategies. Observations of boys and young men using media in their living rooms, bedrooms or on internet chat rooms and social networking sites can shed light on the active roles they take when using the media, while cultural, gender or rhetorical theories can provide lenses through which to analyze what all these texts and interactions might mean. Taken together, then, this collection of essays employing a wide range of disciplinary approaches allows us to come at the complex relationships among boys, the media and culture from various angles, and to look at similar questions using different points of view and different sets of data. For example, while a close reading of a television program might reveal certain themes or patterns of discourse, a study of the way young people view the program might reveal that they are surfing the internet while watching and not paying full attention to the program or that their parents and younger siblings are watching with them in ways that influence their viewing experience. Interviews with these same young people might demonstrate that they interpret the program in ways adults might not predict or that they create sophisticated video mash-ups that are meant to be parodies of the program. An analysis of the advertisements running during the program or of the corporate sponsorship of the program could create an even more complex picture of the larger, increasingly global, media environment contemporary boys and young men inhabit.

All of the contributors to this volume have worked to retain the complexity of their arguments while also making their ideas accessible to a general audience. As editor, I have worked to organize the chapters in an order that highlights the relationships among them and that works to create a multi-faceted look at masculinity and the media that, ideally, challenges and complicates many of the assumptions we make about boys, young men and the media. For this reason, the collection begins with a chapter that asks us to reconsider the very notion of boyhood as a biological category: Michelle Ann Abate's "When Girls Will Be Bois: Female Masculinity, Genderqueer Identity and Millennial LGBTQ Culture." Abate researches the lesbian sub-culture of "bois," young women who take on the role of teenaged boys, and convincingly argues that "this phenomenon suggests that the study of masculinity and femininity in the twenty-first century cannot simply

exist side-by-side as two separate, though parallel, discursive disciplines. Instead, they must be viewed as mutually constructive and constitutive" (32).

Abate's chapter is followed by another that challenges us to re-think the naturalness of masculinity as a category. In "Who is the Victim Again?: Female Abuse of Adolescent Boys in Contemporary Culture," Matthew B. Prickett turns a critical eye on young adult novels, films and television shows and news stories that feature adult women in relationships with teenaged boys in ways that assume the boys want to be sexually molested and benefit from being seduced by an adult woman. He documents a double standard that constructs all women as victims and all males—even underaged ones—as sexual predators. This double standard perpetuates a culture in which boys and young men are discouraged from seeing themselves or other males as victims of sexual abuse, and is an example of the ways in which our attitudes about "natural" masculine sexual desire work to harm boys and young men.

The chapter "'How to Hook a Hottie': Teenage Boys, Hegemonic Masculinity, and *CosmoGirl!* Magazine" by Scott A. Murray and Suzanne Enck-Wanzer, continues this discussion by looking at different media texts targeted at a different audience, magazines written for an audience of teenaged girls, which also work to naturalize male sexuality as aggressive and predatory. They study advice columns and articles in these magazines that depict teenaged boys as sexually forceful and emotionally stunted, and that encourage girl readers to expect and enable such behaviors. They write that "if we can identify the messages being directed at girls, we can, by extension, realize how girls are being trained to (re)act toward boys" (58). If our identities, attitudes toward others and communities are shaped by the ways other people react to us, then these magazines, ironically, may be encouraging girls to perpetuate some of the more negative aspects of traditional masculinity that are harmful to both boys and girls. These magazines, then, are part of a larger matrix of media texts working together to maintain our collective cultural constructions of boyhood.

The next two chapters continue this dialogue by carefully examining the ways boys and young men are depicted in popular children's and young adults films. Both argue that in order to appeal to a broad audience, movies often depict boys and teens in ways that universalize them or that place them into "types." In his chapter, "From 'Booger Breath' to 'The Guy': Juni Cortez Grows Up in Robert Rodriguez's *Spy Kids* Trilogy," Phillip Serrato analyzes the development of the main male character over the course of the three *Spy Kids* films. Serrato convincingly argues that director Robert Rodriguez "departicularizes Juni to offer a text that can speak to a broader audience of boys" (93), but in so doing, he loses an opportunity to create a specific, complex and multi-faceted boy, and Juni—a potentially ground-breaking character, who could have performed specific aspects of Latino masculinity—simply reverts to being a generic "type." Kent Baxter looks at

similar issues in his chapter, "Adolescence Vérité: Shocking Glimpses of the Teen in Contemporary American Film," which focuses attention, primarily, on two recent and controversial films about teens that blur the lines between fiction and documentary: *Kids* and *American Teen*. These films, he argues, reflect an American obsession with trying to uncover and represent the "real" teenager: by conflating documentary and fiction these films work to reinforce gender role stereotypes and continue to perpetuate the idea that there is a universalized experience of boyhood.

The next several chapters also challenge our constructions of a universalized boyhood, but do so by examining very specific cultures and subcultures of boys and young men, both in the United States and overseas. Bayard E. Lyons, in his chapter, "Beyond the Gloss of Youth: Turkish Cypriot Television's Mediation of Young Men in the Public Sphere," looks at the ways masculinity, and, by extension, femininity, are portrayed on television and constructed in public spaces and in public discourse in Turkish Cyprus. His chapter looks at a broad range of factors—nationality, economics, traditional cultural values, attitudes about youth, allocation of public space and public speech, and the role of the news media—that all work together to construct gender expectations and norms for young people living in a specific culture. This careful study works to destabilize notions of a natural and universal boy or young man by looking very carefully at the complex and specific factors at work in depicting, reflecting, and creating one culture's attitudes about boyhood.

Jes Battis also destabilizes universalizing notions of masculinity, which often assume a heterosexual boy or young man, in his analysis of two highly acclaimed young adult novels featuring idealized gay characters and communities. In his chapter, "Almost Paradise: Queer Utopias in Abeyance in David Levithan's *Wide Awake* and *Boy Meets Boy*," Battis considers the queer communities and gay male characters depicted in these novels, and the questions raised by these depictions: What might a queer utopia look like? What would it take to achieve? Most significantly, what factors keep both our culture and these novels from fully realizing the political and social changes necessary to achieve such equality among people of various sexual orientations and gendered identities?

The next several essays look at various other subcultures in the United States in order to explore the specific ways that African and African-American masculinity are portrayed and constructed—sometimes in dialogue with, and sometimes in opposition to one another. In her chapter, "'Word Up': Hip Hoppers' Smart Pose Outwits Masculine Scripts," Judy Isaksen explores the rhetoric of hip hop as it is read by and re-appropriated by teens and young men in on-line communities. These musical and digital discursive spaces, she argues, allow boys and young men to perform resistant, playful gendered identities, which "brilliantly use rhetorical techniques as defense mechanisms to survive and re-articulate masculinity" (161).

Isaksen demonstrates, through examples of on-line discussions among boys, the ways in which we need to rethink our assumptions about hip-hop culture, internet culture, and masculine identities.

While Isaksen focuses on young African-American men finding ways to re-define their identity through the media, Rebecca B. Watts looks at a group of young men from Africa whose American identity is being constructed for them through mass media coverage. Her chapter, "The Lost Boys of Sudan: Race, Ethnicity, and Perpetual Boyhood in Documentary Film and Television News," focuses on the ways adult male refugees of the Sudanese Civil War are depicted as perpetual "boys." The essay that follows Watts's looks at another group of immigrants from Africa living in the United States, and the ways in which they are working to re-define their masculine identities by combining African and American cultural rituals. Sandra Grady's essay, "Consuming the WWE: Professional Wrestling as a Surrogate Initiation Ritual among Somali Bantu Teenagers," examines the ways boys and young men from Somalia incorporate American media into their cultural identity, their coming of age rituals, and their efforts to adjust to life in the United States. In order to understand the viewing habits and attitudes of Somali Bantu teenagers living in the U.S., Grady spent time in their living rooms interviewing groups of boys and young men as she watched wrestling programs with them.

Stacey J. T. Hust used similar methods to study the ways 13– to 15-year-old boys use various media platforms and texts in their homes in her chapter, "The Shrines to What They Love: Exploring Boys' Uses and Gratifications of Media in their Personal Spaces." Hust's study complicates commonly held assumptions about the ways boys consume media: her research, part of a larger study on teens and the media, suggests we may be underestimating the access teen boys have to various sorts of media in their homes, we need to better understand the ways differences in socio-economic class shape the ways in which and the spaces in which boys consume media, and we need to do more to carefully study and understand the ways boys often multi-task by consuming a variety of texts at once.

Finally, this collection concludes with two chapters focused on the creative and analytical work of young men. "Love Song: Queer Video Use of One Pop Tune by Homosocial Boys and Young Men" by Keith Dorwick is a case study of one song, "What is Love?" by Haddaway, which has become the backdrop for numerous YouTube video appropriations, parodies, and mash-ups, many of which were created by boys and young men. Dorwick looks specifically at the ways that some of these on-line performances create playful spaces where boys and young men can safely, yet publicly, celebrate their relationships with other boys and young men. Finally, Margaret Mackey's contribution to this collection, "Growing Up Multimodal: Young Men Talk Media," includes transcripts of her interviews with young men, who are comparing and analyzing their readings of literary,

video game and film texts. While a number of experts raise alarms about boys and young men being negatively influenced by media texts like films and video games, Mackey asks young males to speak for themselves on the subject. Working from the assumptions that "young male gamers are as varied and perceptive as the rest of humanity" and that, "some of the most interesting observations about contemporary boyhood might come from those who have most recently left it behind" (240) Mackey conducted in-depth interviews with a group of young men. The transcripts and analysis of these interviews work to counter our assumptions that video game playing can contribute to illiteracy, short attention spans, or a lack of critical reading and thinking abilities. Indeed, the young men interviewed by Mackey speak eloquently and thoughtfully about the pleasures of reading a variety of media texts, both print and digital.

Sources Cited

Anderson, Kristin J. and Christina Accomando. "'Real' Boys?: Manufacturing Masculinity and Erasing Privilege in Popular Books on Raising Boys." *Feminism and Psychology.* 12.4 (2002): 491–516. Sage. Web. 28 May 2010.

Beneke, Timothy. *Proving Manhood: Reflections on Men and Sexism.* Berkeley, CA: University of California Press, 1997.

Biddulph, Steve. *Raising Boys: Why Boys Are Different—And How to Help Them Become Happy and Well-Balanced Men.* Berkeley, CA: Celestial Arts, 1998.

Bilz, Rachelle Lasky. *Life is Tough: Guys, Growing Up, and Young Adult Literature.* Lanham, MD: Scarecrow, 2004.

Brozo, William G. *To Be a Boy, To Be a Reader: Engaging Teen and Preteen Boys in Active Literacy.* Knoxville, TN: University of Tennessee Press, 2002.

Butler, Judith. *Gender Trouble: Feminism and the Subversion of Identity.* New York: Routledge, 1990.

———. *Bodies That Matter: On the Discursive Limits of 'Sex'.* New York: Routledge, 1993.

Connell, R. W. *Masculinities.* Berkeley, CA: University of California Press, 1995.

Faludi, Susan. *Stiffed: The Betrayal of the American Man.* New York: Harper Perennial, 2000.

Garbarino, James. *Lost Boys: Why Our Sons Turn Violent and How We Can Save Them.* New York: Free Press, 1999.

Gee, James Paul. *What Video Games Have to Teach Us About Learning and Literacy.* New York: Palgrave Macmillan, 2007.

Gurian, Michael. *The Wonder of Boys: What Parents, Mentors, and Educators Can Do To Shape Boys into Exceptional Men.* New York: Penguin Putnam, 1996.

Gurian, Michael and Terry Trueman. *What Stories Does My Son Need?: A Guide to Books and Movies that Build Character in Boys.* New York: Penguin Putnam, 2000.

Harris, Ian M. *Messages Men Hear: Constructing Masculinities*. Bristol, PA: Taylor & Francis, 1995.

Jenkins, Henry. *Textual Poachers: Television Fans & Participatory Culture*. New York: Routledge, 1992.

Jenkins, Henry, Ed. *The Children's Culture Reader*. New York: New York University Press, 1998.

Kaiser Family Foundation. "The Role of Media in Childhood Obesity." Kaiser Family Foundation Website. February 2004.

Kidd, Kenneth B. *Making American Boys: Boyology and the Feral Tale*. Minneapolis, MN: University of Minnesota Press, 2004.

Kimmel, Michael S. *Guyland: The Perilous World Where Boys Become Men*. New York: HarperCollins, 2008.

Kimmel, Michael S. and Michael A. Messner, Eds. *Men's Lives*. New York: Macmillan, 1990.

Kindlon, Dan and Michael Thompson. *Raising Cain: Protecting the Emotional Life of Boys*. New York: Ballantine, 1999.

Mac an Ghaill, Máirtín. *The Making of Men: Masculinities, Sexuality and School*. Philadelphia, PA: Open University Press, 1994.

Marano, Hara Estroff. *A Nation of Wimps: The High Cost of Invasive Parenting*. New York: Broadway, 2008.

Messner, Michael and Donald Sabo. *Sex, Violence and Power in Sports: Rethinking Masculinity*. Freedom, CA: Crossing, 1994.

Newkirk, Thomas. *Misreading Masculinity: Boys, Literacy, and Popular Culture*. Portsmouth, NH: Heinemann, 2002.

Nodelman, Perry. "Making Boys Appear: The Masculinity of Children's Fiction." In *Ways of Being Male: Representing Masculinities in Children's Literature and Film*, John Stephens, Ed. New York: Routledge, 2002. 1–14.

Osgerby, Bill. *Youth Media*. New York and London: Routledge, 2004.

Pollack, William. *Real Boys: Rescuing Our Sons from the Myths of Boyhood*. New York: Random House, 1998.

Ravitch, Diane and Joseph P. Viteretti, Eds. *Kid Stuff: Marketing Sex and Violence to America's Children*. Baltimore, MD: John Hopkins University Press, 2003.

Sommers, Christina Hoff. *The War Against Boys: How Misguided Feminism is Harming Our Young Men*. New York: Simon & Schuster, 2000.

Stephens, John, Ed. *Ways of Being Male: Representing Masculinities in Children's Literature and Film*. New York: Routledge, 2002.

Strausbaugh, John. *Sissy Nation: How America Became a Culture of Wimps and Stoopits*. New York: St. Martin's, 2008.

Wannamaker, Annette. *Boys in Children's Literature and Popular Culture: Masculinity, Abjection, and the Fictional Child*. New York: Routledge, 2008.

Way, Niobe and Judy Y. Chu, Eds. *Adolescent Boys: Exploring Diverse Cultures of Boyhood*. New York: New York University Press: 2004.

Constructing Masculinities

When Girls Will Be Bois: Female Masculinity, Genderqueer Identity and Millennial LGBTQ Culture

Michelle Ann Abate

"Gender is like a lens through which we've not yet learned to see. Or, more accurately, like glasses worn from childhood, it's like a lens through which we've always seen and can't remember how the world looked before. And this lens is strictly bifocal."
— Riki Wilchins, 2002, in "A Continuous Nonverbal Communication," from *Genderqueer: Voices from Beyond the Sexual Binary*

At least since the second half of the twentieth century in the United States, scholars working in the fields of psychology, sociology, education and literary criticism have recognized the importance of gender as a marker of identity. From the rise of women's studies during the 1970s to the advent of men's studies in the 1990s, the issues of masculinity and femininity have become ones by which individuals routinely examine, and evaluate, human experience.

However, as Riki Wilchins suggests in a comment that forms the epigraph to this chapter, gender is commonly considered a binary system that always only consists of two classifications: masculine and feminine, men and women, boys and girls. These two categories co-exist but are also mutually exclusive: a person must belong—either by choice or by force—to one category or the other, not both. In examples ranging from the signs found on restroom doors and the organization of professional athletics to the clothing departments at retail stores and the first question that is still commonly asked at the news of a new birth, Western society typically sees gender as a dyad, not triad, quad or quintet. As a result,

in the words of Wilchins, while individuals today recognize the importance of considering the subject of gender, the lens through which they view this issue is "strictly bifocal" ("Continuous" 13).

This chapter will challenge the historical bifurcation of gender into the rigid and mutually exclusive categories of masculine and feminine by spotlighting an identity that blurs, blends and combines the two. In the pages that follow, I explore the social concept of boyhood and the gender construction of boys in the United States by examining a queer variation on it: the lesbian "boi." A category of identity that emerged among young queer women in the opening years of the twenty-first century, bois are usually twenty-something figures who traffic not in adult masculinity but in post-pubescent boyhood. Possessing what is commonly referred to as an "andro" look, bois have short hair, masculine-styled clothing, and a flat or even bound chest. In addition, many bois use masculine pronouns and situate themselves in sharp personal and psychological contradistinction from more feminine lesbians. In so doing, bois merge notions about lesbian sexual style, hipster fashion sense, and transgender or, at least, genderqueer personal identity. They embody a complex negotiation between new, emerging and often transgressive constructions of female identity in the LGBTQ community and mainstream, hegemonic notions of boys and boyhood. Indeed, lesbian bois both participate in and can be seen as products of the widespread cultural obsession with adolescent boys and post-pubescent boyhood that emerged during the late twentieth and early twenty-first centuries. Evidenced in everything from the proliferation of boy bands like 'N Sync and the Backstreet Boys to the popularity of boyish-looking actors such as Tobey Maguire and Jake Gyllenhaal, American culture is engaged in a largely postmodern process whereby individuals are questioning, challenging and even reimaging formerly sacrosanct notions of masculinity as stable, received and monolithic.

The pages that follow locate lesbian bois in the process by charting their presence in millennial-era literature, film and especially urban bar culture. I will examine the way in which the concept of the boi both builds on and breaks from previous conceptions of lesbian butchness, as well as the role that bois' strong interest in sexual autonomy, their grounding in youth culture, and their interest in postmodern camp play in this construction. My discussion will make visible the ways in which lesbian bois embody a distinctly queer as well as deeply postmodern take on notions about adolescent masculinity along with American conceptions of boys and boyhood. Indeed, tracing the linguistic history and unpacking the various cultural meanings of the term "boi" reveals that the concept is not just limited to female masculinity, lesbian gender performance and emerging concepts of genderqueer; it impacts the very concept of boyhood itself. Lesbian bois embody a form of masculinity that is not predicated on, or located within, the male body. Accordingly, my larger purpose will be to demonstrate how bois

engage in the more radical and far-reaching project of uncoupling the whole notion of boyhood from the presence or existence of biological boys.

Boi Meets World: Postmodern Linguistic Play and Uncoupling Adolescent Masculinity from Biological Boys

Although the term *boi* is now used among young, urban lesbians, it did not originate within this community. On the contrary, the first incarnation of the term "boy" reimagined as "boi" occurred in the realm of mainstream, even hegemonic, masculinity: via the music industry in general and hip-hop culture—which often promotes a macho form of male gender expression—in particular. In the early 1990s, a young, Georgia-based musician named Antoine Patton adopted the performance name "Big Boi" ("Outkast," 2006, 357). According to *The Encyclopedia of Popular Music*, Patton first adopted this moniker while he was a student at Atlanta's Tri-City High School ("Outkast," 2006, 357). The variant spelling signaled a countercultural component and even street vibe, akin to the word "Boyz" from John Singleton's film *Boyz in the Hood*, which had been released in 1991 and whose popularity had inspired a veritable explosion of homophonic re-offerings of everyday words.

Although Patton may have re-imagined the term "boy" as "boi," in the early 1990s his usage did not announce a different manifestation of masculinity—either in an adult or adolescent form. On the contrary, with the performer's dress, clothes and mannerisms readily identifiable as masculine, Big Boi's personal appearance and gender identity were largely conventional. His reconfiguration of the word "boy," therefore, was more likely a play off the racially charged meaning that has long been associated with the term, given the long history of whites, especially in the South where Patton hailed, calling adult black men by the diminutive term "boy." Akin to the process of other marginalized groups throughout the 1990s reclaiming formerly pejorative terms—such as "queer" in the LGBTQ community—Patton's use of the word both recalled this history and rewrote it. Patton's addition of the adjective "Big," which embeds connotations not simply of chronological age and physical size, but also, of course, sexual prowess, extends this critique one step further. One of the reasons that adult black men were infantilized by their white Southern counterparts as "boys" was because of the threat posed by their allegedly superior sexual skills and accompanying erotic endowments.

As the 1990s progressed, the term "boi" did not simply persist, it morphed into new socio-cultural forms—and ones that did not embody a mere homophonic respelling of the word "boy" but signaled a new form of masculine gender expression. Young men involved in both the skate and rave scenes, for instance, adopted the moniker "boi" to denote their rejection—either in part or in full—of

hegemonic forms of masculinity and their subscription to a softer, more sensitive identity.[1] As R. W. Connell documented in his groundbreaking book *Masculinities*, young men realized that the way in which they expressed themselves need not be so limited and monolithic. Moreover, amidst the era's increasing awareness about issues like bullying, school shootings and substance abuse, many adolescent boys and young men also realized the high personal costs and damaging psychological toll that maintaining a tough, macho stance can take (see Connell, 2005, 120–39). By the first years of the new millennium, the term skater boi—further reconfigured as "Sk8er Boi"—entered the mainstream lexicon when it appeared as the title of a song by pop singer Avril Lavigne (2002).

Over time, young male fans of the new musical genre known as "emo"—short for "emotional hardcore" and characterized by songs with emotionally expressive and often sensitive lyrics (see "emo, 2009" and "emo-core, 2009" in *OED*)—adopted the boi identity as one of their hallmarks. As an article in *Incendiary* magazine remarked: "There was something about the music that kids could relate to. Kids who felt isolated and alienated, the kids who kept diaries and liked to cry, the kids who. . . got picked on in gym class because they were too skinny" (Rolter, 2003, par 2). Indeed, in stark contrast to traditional gender codes for men, emo bois often wore nail polish, flat-ironed their hair, and emphasized their skinny, non-muscular look (Greenwald, 2003, 2–15).

This less macho and more sensitive usage of the concept of "boi" among the rave, skate and emo scene caused the term to migrate to yet another community: the gay male one.[2] Many gay bois were often not simply boyish-looking but chronologically young: perhaps in their late teens or early twenties. Those who were older could "pass" for such ages by having a slim physique, scant body hair, and a build that was trim and fit but not overly muscular (see Belifus, 36; Marech, 2004, A1; Ellwood, 2005, 52). The new concept of queer bois permeated nearly all facets of the gay male community, but it became especially prevalent among the community's sado-mascochistic, bondage-and-discipline (SMBD) subculture. Here, the term came to refer to the submissive partner or "bottom" in anal sex. The former Daddy/Boy dynamic came to be known instead as "Daddy/Boi."[3]

Although the cultural associations for the term *boi* varied widely in its uses by SM dyad Daddy/Bois, sensitive emo bois, or hip-hop performer Big Boi, the concept remained firmly linked to a biological male body. That is, it denoted different ways of embodying, performing or expressing masculinity for men by other men. This chapter discusses what happens when that link is broken—and the concept of boys and boyhood, along with the portrayal of especially youth-inflected forms of masculinity, begins to be deployed by women.

The tipping over point for this phenomenon may have first occurred in skateboarding culture. Amidst the growth of other alternative sports like rock climbing and the rising general interest in extreme sports via venues like the X-Games,

this formerly countercultural activity entered the mainstream. Professional skate-boarders like Tony Hawk became household names, skating fashion such as Vans sneakers became the popular look, and terminology including "air," "half-pipe" and "grind" became part of the new vernacular.

Skateboarding had existed as a largely male-dominated activity prior to the 1990s when it intersected with the era's powerful "Girl Power" movement. As I have written elsewhere, "Serving as the title for Hilary Carlip's popular 1995 book as well as the catch phrase for the popular British musical group the Spice Girls," the concept celebrated female empowerment, daring and autonomy (Abate, 2008, 222). Girl Power—along with its edgier counterpart, the Riot Grrl Move-ment—was perhaps most popularly evidenced on t-shirts with phrases like "Girls Rule" emblazoned across the chest which, as Natalie G. Adams has observed, could be seen adorning hip teenagers in New York City and, later, ten year olds at suburban malls by the middle of the decade (102–103). But it was also power-fully present in the realm of sports. This first generation of girls who were raised under Title IX participated in athletics in record numbers (Abate, 2008, 222). Even more importantly, they were no longer "merely relegated to the feminine activities of cheerleading, swimming or gymnastics" (222). Instead, adolescent girls and young women "were involved in ones that were more iconoclastic. From forming female rugby and lacrosse teams to winning the legal right to compete in formerly all-male sports like college football and baseball, women in athletics had a new and more powerful presence" during the 1990s (222).

In the same way women were competing in long-established sports like base-ball and rugby, so too were they entering the realm of new and emerging realms of athletics, like skateboarding. Echoing the already extant connotation of the term "skater boi" with a less-than-fully-masculine male, it was soon expanded to en-compass a more masculine-styled female, or a girl who skated. Indeed, a full four out of the seven entries for "skater boi, 2009" in the online version of the *Urban Dictionary* discuss female skaters. The alternative spelling of the word "boy" in these instances denotes that the young woman engages in the stereotypically mas-culine world of skateboarding, but is not biologically male. In this context, the term "skater boi" was generally one of respect, a way to signal that a female skater was "one of the boys" while acknowledging that she was, in fact, a girl.

While some of these new female skateboarders identified as heterosexual, akin to the demographic composition of many other girls who engage in tomboyish activities, a significant portion were lesbian. As a result, "skater boi" morphed one final time. In the words of the online *Urban Dictionary*, the term came to specifi-cally denote "A young lesbian who is into skateboards."

Although the term "boi" may have first entered lesbian culture via the skate-boarding scene, it would not remain fixed there. During the dawn of the new mil-lennium, the word would detach itself from skateboarding altogether and assume

a linguistic life and cultural existence all its own. In bars in cities like San Francisco and New York—as well as in the transgender and transsexual community in regions throughout the United States—it would come to signal a new queer female personal style, sexual identity and gender performance.

In many ways, the concept of "boi" as a new female—and not male—identity was ripe for emergence at the turn of the new millennium. Throughout the 1990s, the work of queer theorists like Eve Kosofsky Sedgwick and especially Judith Butler were making a case for the artificial, imitative and even performative nature of gender. In what has become an oft-quoted passage from the final chapter of Butler's landmark 1990 book *Gender Trouble*, she argued: ". . . external acts, gestures, and enactments of gender are *performative* in the sense that the essence or identity that they otherwise purport to express are *fabrications* manufactured and sustained through corporeal signs" (136). Butler asserted that all forms of gender display—from clothing choices and gestures to hair style and body posture—are not the inevitable products of a fixed and stable system in which gender follows naturally from sex. On the contrary, they are the result of a lifelong process by which an individual self-consciously and deliberately decides to conform to a prescribed set of behaviors deemed acceptable for men or women. This phenomenon, as Butler (1991) would go on to note in an essay titled "Imitation and Gender Insubordination," "implies that all gendering is a kind of impersonation and approximation" (21). Men do not naturally act or even necessarily feel innately masculine; rather, from an early age, they learn to restrict their actions and appearance to this limited range of socially acceptable traits. The same is true for women and their display of femininity. Such gender conformity, Butler notes, "is a *compulsory* performance in the sense that acting out of line. . . brings with it ostracism, punishment, and violence" (Butler, 1991, "Imitation" 24; italics in original). As Sheila Koenig (2003) has commented on the implications of this dynamic, "Such policing ensures that the performance will be repeated, and will gain more power in its claim to originality through repetition" (148).

The high social stakes associated with successfully acting "like a man" or "like a woman" require individuals to engage in a lifelong process of constantly monitoring, checking and even policing their behavior. As a result, their public gender display may not accurately reflect how they personally experience or privately see their inner and unadulterated identity. In the words of Butler once again: "the performance of the gendered body in such daily activities as dress, mannerisms and behavior has no ontological relationship with what may constitute its inner reality" (*Gender* 136). Meanwhile, Eve Kosofsky Sedgwick (1990), in an oft-quoted passage from *Epistemology of the Closet*, would describe this phenomenon as the process "by which chromosomal sex is turned into, processed as, cultural gender" (28).

In this way, Sedgwick and Butler argued, all gender is a mere public performance, self-fashioned personal presentation, and constant social imitation. It is not a factual human reality, but an artificial, fictitious or, at least, abstract ideal that is manufactured and maintained by a specific culture, at a specific time, for specific societal purposes. When a man attempts to "be" masculine or a woman feminine, they are, to quote another one of Butler's oft-referenced passages, "mere copies of a copy" (*Gender* 31). Their gender presentation is not a manifestation of "true" masculinity or "authentic" femininity, for no such ideal exists. As Butler has argued, "there is no original or primary gender. . . but *gender is a kind of imitation for which there is no original*; in fact, the very notion of the original is an *effect* and consequence of the imitation itself" ("Imitation" 21; italics in original).

Butler's argument gave rise to the notion, which gained widespread critical and cultural traction as the 1990s progressed, that masculinity and femininity were not stable, fixed and biologically based systems, but rather fluid, malleable and socially constructed signs. If, as she argued, men were simply performing masculinity, and women were likewise imitating a purely imagined notion of femininity, then the next logical step was that men—if they so chose—could elect to perform femininity, while women could similarly decide to traffic in masculinity. Indeed, Riki Wilchins commented on this exact implication of, or ramification for, Butler's argument: "For although it looks like something we *are*, gender is always a *doing* rather than a being. In this sense, all gender is drag" (Wilchins, 2002, "Continuous" 12; italics in original). Because *Gender Trouble* and *Epistemology of the Closet* demonstrated that gender did not follow from sex, masculinity could be uncoupled from being male, and femininity could be similarly unlinked from being female.

Seven years after the publication of Butler's landmark work, Judith Halberstam (1998) released the first full-length study that explored this exact topic; the book bore the simple yet telling title *Female Masculinity*. As Halberstam accurately observed in the preface, "remarkably little is written about masculinity in women" (xii). By spotlighting specific figures like Radclyffe Hall, Gertrude Stein and k. d. lang, as well as profiling more general forms of masculine female identity such as stone butches, drag kings and female-to-male transsexuals (FTMs), Halberstam asserted: "This book, I hope, will eventually form just one part of a cultural onslaught on the privileged reservation of masculinity for men" (xii).

The emergence of *boi* as a new queer female identity during the first years of the new millennium constituted part of this phenomenon. Although making its debut after Halberstam's text was written and released, it constituted "part of a cultural onslaught on the privileged reservation of masculinity for men" that she urged and even predicted. In its most basic definition, bois are lesbians who see themselves as being more boyish than girlish, and adopt a gender self-presentation that is accordingly modeled not after adult men, but post-pubescent boys or, at

least, young men. Possessing what is commonly referred to as an "andro" look—a term that simultaneously evokes the Greek prefix for male, a slang term for testosterone-based steroids, and the term "androgyny"—bois cut their hair short, wear masculine clothes and also often adopt boyish names or nicknames. Some bois take their performance of post-pubescent masculinity one step further by binding their chests and preferring the use of male pronouns. In so doing, bois place themselves on the intersection of not simply the lesbian and queer communities but the transgendered and transsexual ones. Indeed, while all bois challenge the boundaries separating masculine from feminine, some also defy the seemingly intractable line dividing male from female. These bois are part of the FTM community and occupy various stages in the process of transitioning—either in part or in full—from female to male: some have had double mastectomies—commonly known as "top surgery"—to remove their breasts, while others take testosterone (or "T") to deepen their voice, increase their muscle mass, and allow them to grow facial hair. In so doing, Sarah Trimble has written, "Bois emerge into the paradoxical position of subverting the ontological 'reality' of normative masculinity even as they negotiate its imperatives in an effort to remain/become legible as masculine subjects" (75). That is, bois attempt to present or, sometimes, even to "pass" as boys, while all the while retaining a link—however loose and tenuous—to their female identity.

Not surprisingly, given this ideological project, one of the first arenas in which boi-like lesbian figures could be found was in the realm of drag king shows and camp culture. Echoing the way in which bois engage "in complex negotiations with hegemonic masculinity" by simultaneously being "in dialogue with queer communities as well as with mainstream constructions of boyishness" (Trimble 75), many drag king performers began impersonations of the post-pubescent pin-up boys who populated the incredibly popular and seemingly endlessly prolific boy bands during the late 1990s. Comprised of young male figures—like the baby-faced Justin Timberlake or chubby-cheeked Nick Carter—who possessed what Gayle Wald (2002) has called "a girlish masculinity" (32), groups like the Backstreet Boys, 98 Degrees and 'N Sync were the seemingly perfect raw material for the drag king's experimentation with a boyish femininity. Accordingly, Halberstam has written about a NYC-based group who call themselves the "Backdoor Boys" (see "What's That Smell," 2006, 19–22). Meanwhile, Thomas Piontek has documented another drag troupe—based in Columbus, Ohio and performing under the campy name "H. I. S. Kings"—who routinely enact a queer female variation on the Backstreet Boys. Piontek notes that the performance relocates the boy band "from an object of teenage girl crushes or gay male fantasies to an object of lesbian adoration and approval; it appropriates the Backstreet Boys—a boy band and an icon of straight girl (and gay male) culture—as a phenomenon in lesbian culture" (130). Even more importantly for the purposes of this article,

Piontek continues about the socio-sexual implications of drag king performance: "in this case, the female fan's relationship to the pop icon is not limited to the fantasy of *having* the Boy(s)—the crush or the sexual fantasy—but also entails the added dimension of *being* the Boy" (130).

Boi Oh Boi!:
Genderqueer Identity and the New Subculture of Lesbian Boihood

As the final decade of the twentieth century tipped over into the opening years of the new millennium, this boyish drag identity was no longer merely camp fantasy, but became authentic reality. In the words of Piontek once again, "Kinging. . . puts an entirely new spin on another crossdresser's famous maxim: 'Don't dream it, be it'" (Piontek, 2003, 130). The drag king boy became a boi when he moved from being merely enacted on the drag king stage to embodied on the streets of the LGBTQ community. As Sarah Trimble has said about bois in a comment that could also apply to kings, "What is consistent about these social/sexual positions is a particular aesthetic, a performance of masculinity that resignifies and redeploys an otherwise 'female' body" (75).

One of the first as well as most extensive critical examinations of this new lesbian boi appeared in *New York Magazine*, in an article written by Ariel Levy and published in 2004. Levy begins her essay by making the following important distinction between the respelling of the word "boi" in the opening years of the new millennium and variations on the words "woman" and "women" that permeated the latter half of the twentieth century. While these two phenomena can be placed on a rhetorical continuum, they do not possess cultural continuity. "In a different lesbian era, you pronounced womyn 'woman.' Throwing a *y* in *woman* was a linguistic attempt, however goofy, to overthrow the patriarchy, to identify the female gender as something independent, self-sustaining, and reformed" (Levy, 2004, par 5; italics in original). In a crucial semantic as well as social distinction, she goes on to note: "Being a boi is not about that. Boihood has nothing to do with earth mothers or sisterhood or herbal tea, and everything to do with being young, hip, 'sex positive,' a little masculine, and ready to rock" (Levy, 2004, par 5).

Levy sees the rise of queer female bois as the product of a larger sea change among the new generation of LGBTQ individuals with regard to how they view existing terms for, or established forms of, gender and sexual identity. As Ritch C. Savin-Williams (2005) has detailed in *The New Gay Teenager*, young people today who possess same-sex attraction are far less likely to use words "gay" or "lesbian" to describe themselves. For them, these terms are too limited and constricting. Possessing a strong postmodern awareness about the inherently problematic, insufficient and unsatisfactory nature of any identity label or sexual category, queer teenagers, in the words of Savin-Williams once again, assert that "[t]heir sexu-

ality is not something that can be easily described, categorized, or understood apart from being part of their life in general" (1). Indeed, Riki Wilchins perhaps best summarized the sentiment fueling this stance when she wrote: "What do we mean by *identity*? No one is perfectly gay, completely straight, totally womanly, or wholly transgendered" ("Changing the Subject," 2002, 47; italics in original).

For these reasons, as Mark Ellwood has observed, "Terms such as gay, straight and lesbian are slowly vanishing in the US; while new niche identities, intended to reflect a less binary view of sexuality, appear in their place" (52). As one queer nineteen-year-old man who was interviewed for an article in *The San Francisco Chronicle* said of this growing phenomenon, "People are feeling like, what's the point of labeling? If I must label, let me create my own" (Marech, 2004, A1). Indeed, as Judith Frank, a professor at Amherst College and author of the book *Crybaby Butch*, asserted about the generational elements that are fueling the proliferation of these new identities: "It's queer youth trying to self-define in their own terms, not have those terms handed down" (qtd in Ellwood, 2005, 52).

The result of such changes in attitude has been a veritable explosion of queer-inflected neologisms to describe almost every conceivable sexual preference and gender expression. As figures like Ritch Savin-Williams, Tristan Taormino, and Riki Wilchins have documented, these terms include "heteroflexible" (generally straight people who have some queer tendencies) and "hasbian" (women who previously identified as lesbians but who are now dating men) to "polysexual," "multisexual" and "pan-sexual" (individuals who are not only attracted to all genders but engage in a wide array of sexual practices). Indeed, as one journalist aptly remarked about the social implications associated with this proliferation of queer-related terms and categories: "First, there was the term 'homosexual,' then 'gay' and 'lesbian,' then the once taboo 'dyke' and 'queer.' Now, all bets are off" (Marech, 2004, A1).

Neologisms like "heteroflexible" and "pan-sexual" are often collectively grouped under the umbrella category of "genderqueer." In a recent article, Rona Marech provided a useful working definition of the term: "Someone who is 'genderqueer' . . . views the gender options as more than just male and female or doesn't fit into the binary male-female system" (A1). For these individuals, genderqueer is as much a personal identity as it is political statement, for the term signals an interest—in the words of Wilchins—in "transcending narrow, outdated, 20th-century gender norms" ("It's Your Gender Stupid," 2002, 24).

At the same time, and in an equally important implication, Sarah Trimble has noted that the "combination of theory and activism" underpinning these new and emerging gender and sexual identities can also be seen as "carrying on the work of depathologizing gender 'dysphoria'" (75), or the medico-scientific belief that individuals who are biologically female but see themselves as being more innately male are suffering from a psychological disorder. Genderqueer rejects the patholo-

gization of such nontraditional, unconventional and experimental identities. Far from seeing such figures as psychologically confused or mentally ill, they see them as being truthful and authentic. As Wilchins aptly summarized the candid honesty and unguarded self-discovery—rather than fearful self-policing and blind conformity—required of those who participate in the genderqueer movement: "[we] will need to begin thinking out loud about the political tools to recover that small inner voice that once said, 'This is who I am, this is how I see myself, this is how I want you to see me'" ("Continuous" 15).

The lesbian boi is firmly located within this phenomenon. As Ariel Levy writes, in "the back-and-forth migratory ladies' pipeline that runs between San Francisco and New York, the word 'lesbian' is an almost empty term, and 'identifying' requires a great deal more specificity and reduction, like: 'I'm a high femme,' or 'I'm a butch top,' or, most recently and frequently, 'I'm a boi'" (par 4). Indeed, not only can the term "boi" be placed on the spectrum of genderqueer, but it itself has given rise to many subcategories. An article profiling queer culture in the twenty-first century enumerates just some of these permutations: "A 'boi' describes a boyish gay guy or a biological female with a male presentation. . . other terms—which have hotly-contested definitions—include boydyke, trannyboy, trannyfag, multigendered, polygendered, queerboi, transboi, transguy, transman, half-dyke, bi-dyke, stud, stem, trisexual, omnisexual, and multisexual" ("Identity Parade" A30). Given the sheer number of these neologisms as well as their variety and complexity, the discussion bears the apt title "Identity Parade" (2004).

Regardless of the prefix or suffix attached to the term boi, it has a firm grounding in youth and youth culture. Indeed, as Levy notes, "It's no coincidence that the word is boi and not some version of man. Men have to deal with responsibilities, money, wives, career, car insurance. Boys just get to have fun and, if they're lucky, sex" (par 6). This "sense of play," Levy continues, and its connection to the carefree nature stereotypically associated with adolescence and even young adulthood, is what distinguishes the twenty-first century boi from its twentieth-century antecedent in many ways: the queer female butch. As Lissa Doty, one boi interviewed in Levy's article, observed, "To me, butch is like adult. If you're a butch, you're a grown-up: You're the man of the house'" (Levy, 2004, par 6). Indeed, in a comment that belies the way in which postmodern bois view postwar butches as merely blindly imitating—rather than thoughtfully modifying, ironically altering and campily reimagining—masculinity in her views about butch identity: "A lot of butch women just think, *I'm big, I'm butch.* They feel like because they're some big hunk of meat with abs, that's all it takes" (Levy, par 9). Finally, the same interviewee goes one to point out the socio-economic differences that separate largely working-class butches and more middle-class bois, "I just find other bois to be more open-minded and a little more educated and artsier [sic]" (Levy, 2004, par 9).

Such comments notwithstanding, Trimble has aptly observed that the relationship between bois and butches is far much more culturally complex and socio-sexually complicated. "Insofar as the boi is understood to be in conversation with 'female masculinities,' his relationship to the butch is not and cannot be one of straightforward refusal. As the abjected 'relic,' butch identity is always already one of the boi's definitional terms" (Trimble, 2005, 78). Bois may repudiate the butch identity, but—akin to the oft-used Hollywood formula whereby the leading lady claims to dislike the leading man because she is secretly attracted to him—they are more closely affiliated. As Trimble asserts, "in defining themselves against butches, bois invoke a complex history of female masculinities and erotic subjectivities that become part of their self-definition; the butch becomes one of the Others, a definitional reference without whom descriptions of 'boi' flounder" (77). In this way, the postmodern boi could not have emerged without the post-war butch: as an antecedent, an antithetical, and even an inspiration.

While twenty-first century bois may share more traits with twentieth-century butches than they care to admit, one difference is certain: bois are firmly rooted in the seemingly pleasure-seeking existence, relaxed nature and responsibility-free lifestyle associated with youth and youth culture. Indeed, one boi quoted in Ariel Levy's article wisely notes, "you'd never see a boi cop" (Levy, 2004, par 11), and Sarah Trimble offers the following apt interpretation: "Where cop stands in for various permutations of 'Man' (adult, male, metonym for the state, 'Establishment,' cultural Father, etc.), the boi's radical potential lies in his refusal to embody these regulatory schemes" (79). Echoing this observation, Lissa Doty remarked about her attraction to, and participation in, the boi identity: "I never really wanted to grow up, which is what a lot of the boi identity is about" (qtd in Levy, 2004, par 6). Although Doty is 37 years old, Levy remarks that she "looks more like 24. She wears a baggy T-shirt and jeans and she has gelled her bleached hair into a stiff fin, like the raised spike of a Komodo dragon" (par 6). Even more telling, when asked what interests her most right now, Doty says: "I want to go out and have a good time! I want to be able to go out to the bar at night and go to parties and go to the amusement park and play" (qtd in Levy, 2004, par 6).

Leisure-time fun is an important element in the construction of a boi identity, but an equally vital aspect is sexual play. Once again, this facet of boihood emerged in direct response to earlier forms of lesbian identity. As one of Levy's interviewees noted about social and sexual norms among queer women during the 1970s and 1980s: "'If you flirted with somebody, you better be getting her number and buying that house and getting those dogs. Otherwise, lesbian community is coming *down* on you. Now it's more. . . playful'" (Levy, 2004, par 7; italics in original). Echoing the sexual (double) standard in the heterosexual world that allows young men to be sexually free and even promiscuous, lesbian bois are

able to be more erotically adventurous. Indeed, Levy begins her article about the boi phenomenon with the following revealing anecdote:

> A girl in a newsboy cap and a white t-shirt with rolled-up sleeves is leaning against the back wall at Meow Mix [a lesbian bar in Manhattan] and telling her friend, 'Some femme. . . just some femme. I met her at a party three weeks ago, but now she's like *e-mailing* me and I'm just like, chill *out*, bitch!' (Levy, 2004, par 1; italics in original)
> 'Some of these chicks, it's like you top them once and then they're all up in your face. It's like, did I get you off? Yes. Am I your new best friend? No. You know what I'm saying, bro?'
> 'Bois like us,' she says, 'we've got to stick together.' (Levy, 2004, par 1–2)

While some find this element freeing—a chance for women to enjoy the sexual freedoms commonly reserved for men—others are alarmed and even disturbed by its almost cartoonish replication of boyish sexual bravado and even machismo. Akin to the debates that raged during the twentieth century about whether the butch/femme dynamic merely aped heterosexual gender and sexual roles—including their imbalances of power—or reconfigured them within an all-female environment, many wonder with which project the lesbian boi is engaged. On one hand, this figure does, as Joan Nestle (1987) famously asserted about butch/femme identity, make "a radical, sexual political statement" (102). Yet, at the same time, as Sarah Trimble has noted, the boi figure "objectifies femmes and grrls [sic] in an effort to secure and shore up the boundaries of 'her' masculinity" (76). Indeed, Levy profiles "a particular camp of bois who date femmes exclusively and follow a locker-room code of ethics referenced by the phrase 'bros before hos' or 'bros before bitches'" (par 16). A young woman who is in a relationship with this type of boi comments on the objectifying and often even demeaning way her partner views women: "This all ties into their kind of approach to women in general—they are so very predatory about it. It makes me kind of uncomfortable. Clara won't just touch on it, like: *That girl's hot*. She will talk and talk and talk about how she wants to get them home and fuck them" (Levy, par 27; italics in original). In a comment that forms the ominous closing remark of Levy's article, the young woman continues: "I'm nervous to see her now because I'm not dressed up. . . . and then, all of a sudden, it's like I've come full circle. It's like I'm trying to please a guy" (Levy, 2004, par 27).

Echoing the work of Suzanne Pharr (1988) in *Homophobia: A Weapon of Sexism* about the strong links between negative attitudes about women and those about gays and lesbians, other bois ironically and even paradoxically express homophobic attitudes. Levy relays a conversation with one boi, whom she characterizes as embodying "a sculpture of toughness," concerning the subject of sexual preference: 'I don't understand the appeal or the sense of two faggot dykes riding

each other,' she says, and cracks up. 'Femme-on-femme is stupid to me, too. It's air. It's air on air' (Levy, 2004, par 19).

Such attitudes, however, certainly do not reflect the views of all bois, nor is there even one universal or accepted definition of boihood. On the contrary, echoing the socio-sexual project of genderqueer itself, the term is fluid, malleable, shifting, changing and varied. Indeed, while providing an overview of the various extant definitions of the concept "boi," Levy unwittingly rehearses much of the origins, history and evolution of the term in American popular, print and material culture. "Being a boi means different things to different people—it's a fluid identity, and that's the whole point. Some women who call themselves bois are playing off 'boy' in the gay-male S/M sense of the term, as in Daddy/Boy: The boy or boi who is the submissive and, in the case of lesbians, has sex with dominant butches (tops)" (Levy, 2004, par 8). This meaning co-exists with a second, and slightly different, incarnation: "Some of the people who identify as bois are female-to-male transsexuals in various stages of the transition process, ranging from having had top surgery and taking testosterone ('T') to simply adopting the pronoun *he*" (Levy, 2004, par 8; italics in original). Within this category, a few sub-categories have emerged. For instance, Levy notes that some bois date only other bois and thus "think of themselves as 'fags'" (Levy, 2004, par 8). A final definition or understanding of bois and boihood also exists; this one is by far most broad or general. In the words of Levy: "others simply think being a boi means that they are young and cool and probably promiscuous" (par 8).

Going Boi Crazy:
Lesbian Bois Beyond Urban Bar Culture

While the emergence of lesbian bois first received mainstream attention in the urban bar cultures of New York and San Francisco, these figures can be found in various cultural sites and societal sources throughout the United States. The short documentary *A Boi's Life* (2009), by Amaris Blackmore and Heidi Petty, examines the concept of boihood within the transgendered and FTM transsexual communities. In an early segment of the film, one of the interviewees, Brody Elton, offers the following definition of boihood which highlights the "both/and"—as opposed to "either/or"—nature of genderqueer: "'B-o-i,' I would say that b-o-i is a way of still acknowledging your feminine upbringing, but not necessarily your future." Later, another profiled figure, aspiring photographer Amos Mac, comments on the queer sexual identity that accompanies his genderqueer one: "I feel comfortable being a queer person even if I seem [. . .] as if I'm heterosexual on the street when I'm with a girl. Y'know, that's not how I feel. I definitely don't feel straight." He continues: "I usually date queer women and they don't expect me to act like, um, anything other than, like, the big queer faggot that I act like in general." Both

Mac and subsequent interviewee Shirï Gornicki have had top surgeries to remove their breasts. Gornicki says of the procedure, "it was probably the best thing I ever did. And I feel a lot better now that I have removed certain parts of me that didn't feel like who I needed to be." Likewise, Mac reflects on his self-image post-operation: "I feel, like, very happy with my body right now. Like, really I love it. For the first time ever, I'm really comfortable in it." In so doing, Gornicki and Mac offer embodied examples of Bobby Noble's theoretical observation about this new genderqueer concept: "'Boi' is a term emerging in genderqueer and trans cultures to mark spaces of embodiment outside of the binarized duality of the sexed body as either male or female. The incoherent boi body, replete with flat chest, facial hair, deepened voice, hormonally and sometimes surgically altered but not necessarily anatomically correct genitals, emerges as a new way of embodying gender outside of the rigid binaries of sexual difference" (Noble 148).

While Blackmore and Petty's documentary, as well as Ariel Levy's article, focuses on a subset of bois who encompass a wide range of gender and sexual identities—from lesbians and boifags to transgender individuals and FTMs—they represent a narrow range of racial and ethnic ones. Indeed, the genderqueer figures featured in these segments are overwhelmingly white. Echoing the origins of the term "boi" with Antoine "Big Boi" Patton in the realm of hip-hop music, the concept transcends cultural boundaries. The short digital documentary *Boi Hair* (2005), for instance, profiles queer women of color and their experiences with having close-cropped coifs, from the personal, psychological and sexual reasons that inspired their particular hairstyle to the reactions that they have received from family, friends, and even hairdressers to it. Over the course of the film's twenty minutes, director Alma Lopez profiles three women, each from a different racial or ethnic minority group: Alice Y. Hom is Chinese-American and works as a community activist; Lizette Sanchez hails from a Puerto Rico family but was born and is currently living in California; and Claudia Rodriguez is Chicana and resides in the Compton area of Los Angeles. As the director Alma Lopez says about the documentary—which is her first film—on its homepage:

> It was conceived in collaboration with friends while having dinner in Little Tokyo after attending Fusion, a queer people of color film festival. I love and admire butch women, and this project is an attempt to understand them as well as creating a space for them to speak about their hair, and for audiences to understand butch hair issues. (Alma Lopez, 2009)

Lopez began filming the segments for her documentary as a roundtable discussion with her three participants in February 2004 by offering one simple but loaded opening question: "When did you cut your hair?" (Alma Lopez, 2009). The conversation that followed lasted for more than an hour, and raised such follow-up

questions as "Is there a short haircut language?," "How does your mom feel about your hair?," and "Have you ever been sir'ed?" (Alma Lopez, 2009). In addressing these and other issues, the participants touch on subjects like the sexual attraction and/or personal camaraderie that they feel towards other women who have similarly short hair. Subsequent segments of the film accompany each of the three participants on a regular visit to their hairdressers, fold in commentaries by their parents, siblings and friends about their short hairstyles, and address questions that were raised by audience members when previews of the documentary were screened (Alma Lopez, 2009).[4]

In recent years, some of these new and emerging gender and sexual identities have moved from the relative periphery of the queer community to mainstream American print and visual media. An episode of *The Tyra Banks Show* which aired on April 19, 2006 was dedicated to the topic of "Women Who Love Gay Men." About mid-point through the show, Tyra welcomed two guests whom she introduced only as Bianca and Sarah and who offered a decidedly genderqueer twist on this phenomenon. The host began the segment by saying—in an almost cautionary tone—"We've all heard of men who say they are women trapped in a man's body, or women who say they are men trapped in a woman's body, but Bianca and Sarah say they are women—now, listen up—they are women who believe that they are gay men who are trapped inside of a woman's body" (*Tyra Banks*, 2006). During the interview and discussion segment, Bianca and Sarah go on to articulate this new and decidedly queer identity—how it encompasses more than simply an erotic attraction to gay men, but identifying as a gay man themselves. During this process, Bianca asserts that she is participating in the subculture of "bois." Interestingly, as she wrote on her blog, the other terms by which she commonly identifies herself—as a "girlfag" who is engaging in a more radical and in-your-face form of genderqueer known as "genderfuck"—she was not permitted to actually utter on the show (James, 2006).

Given the strong connection between bois and the new generation of LGBTQ young people, it is perhaps not surprising that they have begun appearing in the realm of young adult fiction. Julie Anne Peters, in her 2007 collection of short stories *grl2grl*, includes a narrative that she explicitly calls "Boi." The story follows the experiences of a transgendered FTM teen who identifies with the boi phenomenon and goes by the name Vince. Meanwhile, Myra Lazara Dole's YA novel, *Down to the Bone* (2008), explores the presence of bois and boihood in the Cuban-American community in Miami. After the central character, Laura Amores, is expelled from her Catholic school and then thrown out of her home in the wake of being outed as a *tortillera*, or lesbian, she encounters various bois who usher her into Miami's queer scene, including one who becomes her romantic partner. The relationship that the two share contributes to making Dole's novel

what one reviewer at *Publishers Weekly* called an "honest, intense and at times moving romance" ("*Down to the Bone*," 2008, 44).

Today, the term "boi"—in reference to masculine-presenting lesbians, FTMs, gay male SM bottoms, and/or genderqueer women—can be found not only in the print, visual and cultural media of the United States, but also in that of other countries around the globe. Indeed, articles about the phenomenon have appeared in such mainstream print media as *The Globe and Mail* in Canada, the *Independent* in England, and the *Gold Coast Bulletin* in Australia.[5] The appearance of "bois" in these Western nations and English-speaking cultures expands the socio-cultural reach of this transgender and transsexual concept into one more realm: the transnational.

A New Boi in Town: Female Bois, Hegemonic Boyhood, and the Millennial Movement for Gender Civil Rights

Annette Wannamaker–the editor of this collection—rightly notes in her book *Boys in Children's Literature and Popular Culture* (2008) that the bulk of scholarship addressing the issue of gender in both children's literature and youth culture focuses on girls:

> While the study of women and girls as readers and as characters is necessary and important work, a continued focus solely on women and girls as the primary subjects of the study of gender in children's literature [and media] runs the risk of further naturalizing masculinity; of perpetuating the assumption that girls are gendered, while boys are just naturally boys . . . When girls are gendered and boys just are, then boyhood takes on a universal quality—boyhood is the norm against which (abnormal) girlhood is measured. As long as masculinity is invisible, natural, and universal (boys will be boys), it remains rigidly defined and works to maintain, by naturalizing them, definitive borders that narrowly define dominant, acceptable versions of the masculine subject. (Wannamaker, 2008, 25)

As a result, she calls for scholars working in fields ranging from sociology, psychology and literary criticism to education, science and history to make masculinity a topic of intellectual inquiry once again. Wannamaker argues that moving the study of male gender roles from the margins to the mainstream is crucial because "changing the ways our culture perceives of dominant masculinity, and the hierarchal systems constructed in relation to it, must first begin with marking masculinity as a gender, making visible the ways it is both socially constructed and evolving, and creating spaces for child readers to see themselves as agents of change" (148). For these reasons, Wannamaker calls for the interdisciplinary study of men and masculinity to exist beside that of women and femininity. The

two disciplines do not simply complement each other, they complete one another. As Wannamaker aptly points out, any discussion about the social construction of gender that does not address the roles assigned to both men and women is presenting only part of the full picture.

The rise of the lesbian boi pushes Wannamaker's argument one step further. This phenomenon suggests that the study of masculinity and femininity in the twenty-first century cannot simply exist side-by-side as two separate, though parallel, discursive disciplines. Instead, they must be viewed as mutually constructive and constitutive. Indeed, as Trimble has written, "Not only do bois rupture the supposedly synonymous relationship between 'anatomy, identity, and authority' (Noble x), but in so doing, they (re)construct masculinity as prosthetic: it is something to be 'put on' through various combinations of accessories, acts and other signifying practices" (77). As she continues, bois "lay bare its essence *as* representation (thus open to disruptive re-articulation) as opposed to an ontologically fixed category" (Trimble, 2005, 77). As Trimble's comments suggest, in the wake of lesbian boihood, adolescent masculinity will never be the same again. Freed from its former predication on a biologically male body, it can migrate to new social sites and cultural sources.

Transsexual activist Dana Rivers once observed, "I was too young for women's rights and gay rights. Gender is the civil rights movement of my time" (qtd in Wilchins, "Continuous," 2002, 13). As the twenty-first century and its attendant interest in genderqueer progresses, the accuracy of this comment will only increase. The phenomenon of the lesbian boi forms just one example of the new, radical and often recombinant forms of sexual identity and gender expression that have emerged in the first decade of the new millennium. Especially when viewed in concert with neologisms like pansexual, polygendered and heteroflexible, they suggest a time when the boundaries separating masculine from feminine, male from female, and heterosexual from homosexual will blend, blur and perhaps even be banished altogether. In so doing, the phenomenon of genderqueer and the gender civil rights movement with which it is affiliated poses a challenge to the arguments in recent books like Hara Estroff Marano's *A Nation of Wimps* (2008), Peg Tyre's *The Trouble with Boys* (2008) and John Strausbaugh's *Sissy Nation* (2008). Contrary to the assertions by these authors that boyhood in the United States is withering, weakening and contracting, the lesbian boi reveals that it can more accurately be seen as transforming, metamorphosing, and—ultimately—expanding.

Notes

1. In a powerful demonstration of the way in which skater bois rejected or at least reimagined traditional forms of masculinity, they were often met with

negative and even openly homophobic reactions by more macho male skaters. The first entry for the term in the *Urban Dictionary,* for instance, defines "skater boi" as a "Wannabe male skater." Meanwhile, a subsequent definition is even more blunt: "A skater boi who sais [sic] he can skate but can't really at all. OR a guy who dresses in skater fashion and listens to gay-as-ass Avril Lavigne and/or emo/pop-punk" ("skater boi, 2009" *Urban*). The entry goes on to conclude that a "skater boi" is "not to be confused with "skaters or skatepunks," who are presumably the "real" form of these male figures ("skater boi" *Urban*).

2. Indeed, young men who subscribed to emo music, fashion or subculture were routinely seen by their more macho male counterparts as effeminate, sissies, and also, presumably, homosexuals. A drawing depicting "The Anatomy of the Emo"—which has circulated around the web but can be found on a blog hosted by the appropriately named "The Spokesman Review, 2009"—forms a telling example. In a preview of the blunt homophobia permeating the image, the drawing is subtitled "AKA: The Shallowanusofemotionalgaynus." Pointing to the tight jeans on the cartoon-like male emo figure, the chart assumes the role of the gender police by flatly labeling them "Girl's Jeans." Offering its view of the emo's reason or rationale for this slim-fitting garment, it explains: "This way they can be gayer and gayer without sucking penis. . . all of the time. . . ." Similarly, the chart points to the long, floppy bangs on the male emo figure and labels them "The Faggotry [sic] Emo Hair."

3. Discussions of the "Daddy/Boi" dynamic appear in an array of sites and sources, from Ryan Field's personal essay "The Blogger Boi" (2007) and Ty Dehner's hardcore SM book *Skin Boi* (2007) to the biweekly serial publication *Boi Chicago* (2000–2003) which was later renamed simply *Boi Magazine* (2004–present).

4. *Boi Hair* was completed in February 2005, and the final version of the documentary has been shown at numerous venues and film festivals in the United States and Mexico, including the Teatro Santa Ana at the Biblioteca San Miguel de Allende, Mexico; Outfest, The 23rd Los Angeles Gay & Lesbian Film Festival in Hollywood; the Latino Queer Youth Conference at UCLA, and the Women of Color Film & Video Festival, University of California, Santa Cruz.

5. See, for example, the article "Identity Parade" in the February 12, 2004 issue of the *The Globe and Mail,* Mark Ellwood's essay "Life, Etc.: New Boi in Town" in the March 27, 2005 issue of *Independent on Sunday,* and the profile "Gender-Bending Times" in the October 8, 2005 issue of the *Gold Coast Review.*

Works Cited

Abate, Michelle Ann. *Tomboys: A Literary and Cultural History*. Philadelphia, PA: Temple University Press, 2008.

Adams, Natalie G. "Fighters and Cheerleaders: Disrupting the Discourse of the 'Girl Power' in the New Millennium." *Geographies of Girlhood: Identities In-Between*. Eds. Pamela J. Bettis and Natalie G. Adams. Mahwah, NJ: Lawrence Erlbaum Associates, 2005. 101 – 13.

Alma Lopez Webpage. Section: Video. *Boi Hair*. By Alma Lopez. Web. 25 March 2009.

"The Anatomy of the Emo." *The Spokesman Review*. Web. 13 March 2009.

Belifuss, Joel. "A Politically Correct Lexicon: Your 'How-to' Guide to Offending Anyone." *In These Times*. (February 2007): 36.

Boi Hair. Dir. Alma Lopez. Perf. Alice Y. Hom, Claudia Rodriguez, and Lizette Sanchez. Alma Lopez, 2005. Web. 20 March 2009.

Boi Magazine. Biweekly Serial Periodical. Chicago, IL: D. C. Tyler, 2004–present.

A Boi's Life. Dirs. Amaris Blackmore and Heidi Petty. San Francisco. Both 24/Current TV, 2009. Aired on Current TV in the US and UK on 5 February 2009. Web. 20 March 2009.

Boyz in the Hood. Dir. John Singleton. Perf. Laurence Fishburn, Angela Bassett, Cuba Gooding, Jr. and Ice Cube. Columbia Pictures, 1991.

Butler, Judith. *Gender Trouble: Feminism and the Subversion of Identity*. New York: Routledge, 1990.

———. "Imitation and Gender Insubordination." *Inside/Out: Lesbian Theories, Gay Theories*. Ed. Diana Fuss. New York: Routledge, 1991. 13–31.

Chicago Boi. Biweekly Serial Periodical. Chicago, IL: D. C. Tyler, 2000–2003.

Connell, R. W. *Masculinities*. 1995. 2nd ed. Berkeley, CA: University of California Press, 2005.

Dehner, Ty. *Skin Boi*. Las Vegas, NV: The Nazca Plains, 2007.

Dole, Mayra Lazara. *Down to the Bone*. New York: HarperTeen, 2008.

"*Down to the Bone*—Review." *Publishers Weekly*. 3 March 2008: 44.

Ellwood, Mark. "Life, Etc.: New Boi in Town." *Independent on Sunday* (London). 27 March 2005: 52+.

"emo." *Oxford English Dictionary*. Draft Entry. June 2005. Accessed via Hollins University. Web. 20 March 2009.

"emo-core." *Oxford English Dictionary*. Draft Entry. June 2005. Accessed via Hollins University. Web. 20 March 2009.

Field, Ryan. "The Blogger Boi." *Best Date Ever: True Stories that Celebrate Gay Relationships*. Ed. Lawrence Schimel. New York: Alison, 2007. 31–42.

Greenwald, Andy. *Nothing Feels Good: Punk Rock, Teenagers and EMO*. New York: St. Martin's, 2003.

Halberstam, Judith. *Female Masculinity*. Durham, NC: Duke University Press, 1998.

———. "What's That Smell?: Queer Temporalities and Subcultural Lives." *Queering the Popular Pitch*. Ed. Sheila Whiteley and Kennifer Rycenga. New York: Routledge, 2006. 3–26.

"Identity Parade." *The Globe and Mail* (Canada). 12 February 2004: A30.

James, Bianca. "Bianca's Appearance on the Tyra Banks Show." Blog: Junk In My Trunk. *School for Scandal: Confessions of a Lady Vagabond, Chicago Style*. 20 April 2006. Web. 25 March 2009.

Koenig, Sheila. "Walk Like a Man: Enactments and Embodiments of Masculinity and the Potential for Multiple Genders." *The Drag King Anthology*. Eds. Donna Troka, Kathleen LeBesco, and Jean Bobby Noble. Philadelphia, PA: Haworth/Taylor & Francis, 2003. 145–159.

Lavinge, Avril. "Sk8er Boi." *Let Go*. Arista, 2002.

Levy, Ariel. "Where the Bois Are." *New York Magazine*. Web. 5 January 2004.

Marano, Hara Estroff. *A Nation of Wimps: The High Cost of Invasive Parenting*. New York: Broadway, 2008.

Marech, Rona. "'Homosexual' is Passé in a 'Boi's' Life." *The San Francisco Chronicle*. 8 Feburary 2004: A1.

Nestle, Joan. *A Restricted Country*. New York: Firebrand, 1987.

Noble, Bobby. "Queer as Box: Boi Spectators and Boy Culture on Showtime's *Queer as Folk*." *Third Wave Feminism and Television: Jane Puts it in a Box*. Ed. Merri Lisa Johnson. London: Palgrave, 2007. 147–65.

"Outkast." *The Encyclopedia of Popular Music*. Vol. 6. 4th ed. Ed. Colin Larkin. New York: Oxford University Press, 2006. 357–358.

Peters, Julie Anne. "Boi." *grl2grl*. New York: Little Brown, 2007. 87–107.

Pharr, Suzanne. *Homophobia: A Weapon of Sexism*. Inverness, CA: Chardon, 1988. 1997.

Piontek, Thomas. "Kinging in the Heartland; or, the Power of Marginality." *The Drag King Anthology*. Eds. Donna Troka, Kathleen LeBesco, and Jean Bobby Noble. PA: Haworth/Taylor & Francis, 2003. 125–143.

Rolter, G. "EMO: What Is It?" *Incendiary Magazine*. Web. 1 February 2003.

Savin-Williams, Ritch C. *The New Gay Teenager*. Cambridge, MA: Harvard University Press, 2005.

Sedgwick, Eve. *Epistemology of the Closet*. Berkeley, CA: University of California Press, 1990.

"skater boi." *Urban Dictionary*. Web. 14 March 2009.

Strausbaugh, John. *Sissy Nation: How America Became a Culture of Wimps and Stoopits*. New York: St. Martin's, 2008.

Taormino, Tristan. "Agenda: Gender." *The Village Voice*. 12 June 2001: 160.

Trimble, Sarah. "Playing Peter Pan: Conceptualizing 'Bois' in Contemporary Queer Theory." *Canadian Women's Studies*. (Winter/Spring 2005): 75–79.

The Tyra Banks Show. "Women Who Love Gay Men." CBS. Season 1, Episode 10. Web. 19 April 2006.

Wald, Gayle. "I Want it That Way: Teenybopper Music and the Girling of Boy Bands." *Genders*. 35 (2002): 1–39.

Wannamaker, Annette. *Boys in Children's Literature and Popular Culture: Masculinity, Abjection and the Fictional Child*. New York: Routledge, 2008.

Wilchins, Riki. "Changing the Subject." *Genderqueer: Voices from Beyond the Sexual Binary*. Eds. Joan Nestle, Clare Howell, and Riki Wilchins. Los Angeles, CA: Alyson, 2002. 47–54.

———. "A Continuous Nonverbal Communication." *Genderqueer: Voices from Beyond the Sexual Binary*. Eds. Joan Nestle, Clare Howell, and Riki Wilchins. Los Angeles, CA: Alyson, 2002. 11–17.

———. "It's Your Gender, Stupid!" *Genderqueer: Voices from Beyond the Sexual Binary*. Eds. Joan Nestle, Clare Howell, and Riki Wilchins. Los Angeles, CA: Alyson, 2002. 23–32.

Who is the Victim Again?: Female Abuse of Adolescent Boys in Contemporary Culture

Matthew B. Prickett

On February 3, 1998, a Washington State police officer discovered 35-year-old Mary Kay Letourneau and her 15-year-old lover sitting in a parked car. Three months prior, Letourneau pled guilty to raping the young man and vowed to never be in contact with him again. The court believed her, she was sentenced to 26 months in prison, and subsequently released early on good behavior. What was thought to be an open and shut case quickly turned into a media storm the night the police discovered the car, the lovers, and a new hot topic for public consumption.

In the car the police discovered $6,500 in cash, baby clothes, and passports. Clearly, the two were planning to flee the country together despite promises to the court that neither would attempt to see the other. What followed was a media frenzy. The public followed the case with fascination, and the news media were happy to report on every movement of Letourneau. Some saw the case as an example of a teacher abusing her power, while others used Letourneau's relaxed sentence of 26 months, and subsequent early release, as a platform to expose the inconsistencies of a court system toward female sex offenders. Regardless of the politics of the reactions, one thing was consistent: women were, and are, capable of sexually abusing boys.

Before Letourneau, the idea that a teenage boy of sexual maturity could be abused by a woman was laughable and unthinkable. Part of this attitude may stem from the notion that we are socialized to believe that young men should want sex

regardless of the situation. In *Betrayed As Boys*, Richard Gartner (2001) writes, "If boys have premature sexual experiences, especially with girls and women, they are thought to be 'sexually initiated,' not molested" (42). This initiation is often seen as an important part of conforming to hegemonic masculinity. In regards to male sexualities, Ken Plummer (2005) has pointed out that male sexuality, as it is constructed within hegemonic masculinity, "is powerful, natural, driven; it is uncontrollable; it is penis centered; it seeks to achieve orgasm whenever it can" (178). As scholars in the fields of feminism and masculinity studies have pointed out, male sexuality is often seen as aggressive and necessary. Men, and to some degree teenage boys, are supposed to want sex, seek sex, and appreciate sex. If a teenage boy has sex with an adult woman, he should think of himself as fortunate, not as victimized. About masculinity and "initiation," French feminist Elizabeth Badinter (1995) writes, "The objective of all initiation rites is to change the status and identity of the boy so that he may be reborn as a man" (69). While this view may appear to be outdated to some, much of what our contemporary culture tells us is that only women are capable of being victims, not men. While the field of masculinity studies has made many strides over the years, it still appears to be difficult to discuss men as victims. To some degree, this inability stems from outdated feminist ideals that men are always the oppressor, and women always the oppressed.

In the introduction to their 2005 book, *Handbook of Studies on Men & Masculinities,* R. W. Connell, Michael Kimmel, and Jeff Hearn write, "The field of gender research has mainly addressed questions about women and has mainly been developed by women. The impulse to develop gender studies has come mainly from contemporary feminism, and women have therefore mainly been the ones to make gender visible in contemporary scholarship and in public forms" (1). What the three editors attempt to do in their handbook is establish the important issues specifically pertaining to masculinity as a field of study. They acknowledge that the field is fairly new (about 20 years old), and that most theories of masculinity derive from a feminist foundation. In certain instances, however, feminist theory and masculinity studies collide, and even contradict one another.

A prime example of this collision is our willingness or unwillingness to think of men or teenage boys as victims or of women as victimizers. If some feminist theories rely on the belief that men are always in control, how can a teenage boy ever be sexually abused by an adult woman? In a situation of sexual abuse, isn't the male in control simply because he is able to achieve an erection, a sign of want, desire, and aggression? Many, including myself, don't agree. As Connell, Kimmel, and Hearn acknowledge in their book, feminist thought has shaped much of our current scholarship on masculinity. Without feminism, there would be no dialogue about boys or men. Without feminism, victims of sexual abuse would not be recognized and girls and boys would continue to be stifled by rigid

social standards of gender. Both men and the study of masculinity owe a lot to feminism. Feminism has shaped our current understandings of rape, abuse, and victimization, and for this it is impossible not to acknowledge its influence on the ways we perceive of the victimization of boys.[1] However, as I will argue later, feminism may also be unknowingly preventing boys from seeing themselves as victims, even when, by all accounts, they are victims.

Teenage boys and adult women engaging in sexual activities is not a new topic. What is new is the idea that these boys could be damaged by a relationship that is otherwise culturally viewed as "natural." It's easy for our culture to see perversion in a man desiring a teenage boy, or that same man desiring a teenage girl; but for a woman to have sexual feelings toward an underage male, and act upon them, is often a source of laughter. Many teen comedies and shows contain plots where a young, maybe slightly nerdy, teenage boy has fantasies about a female teacher, stranger, or parent of a friend. Even when the desire is reversed and the teacher, stranger, or parent desires the teen, the situation is handled with humor. Oftentimes, the teenager is rewarded for his "conquest," either sexually or socially.

One such example can be found in the popular teen sex comedy *American Pie*. In the film, a group of friends agree to lose their virginities before the end of their senior year. All the characters succeed, but Paul Finch, the nerdy one of the group, manages to lose his virginity to an older woman, who is also the mother of the school's bully, Steve Stifler. The scene between Paul and Stifler's mom is played as coy flirtation, and the dialogue is performed in a humorous way. The two sit in the basement rec room of Stifler's house. They drink and talk about life. When Paul comments on the quality of the scotch Stifler's mom is drinking, she seductively replies, "Aged Eighteen Years" (*American Pie*, 1999). After a few more glances and innuendos, the two can be heard from outside the door having sex. Eventually, Stifler walks in on his mother and Paul having sex on the pool table, and he faints. The scene is meant to e licit laughs. While Paul is only eighteen, the scene still implies that he should be grateful for his sexual conquest with an older woman, and that sex between a teenage boy and an older woman is funny.

Would it be possible to handle such a scene with humor if the gender roles were reversed? What if, instead of Stifler's mom, Stifler's dad leaned in and said, "are you trying to seduce me?" to a high school girl or boy (*American Pie*, 1999)? In contemporary culture, this scene would not be humorous. Because, as a culture, we have been made aware of rape and sexual abuse, we would find a scene depicting an older man seducing a young woman to be disturbing and an abuse of power. Though, for some reason, it is difficult to see this same abuse between a teenage boy and an adult woman. Rarely are these relationships seen as disturbing. If anything we see them as a rite-of-passage or as an "initiation" for teenage boys.

Male Victims in the News

In 1993, Ronald W. Price was convicted on three counts of engaging in sexual acts with three of his female high school students in Anne Arundel County, Maryland. The media attention surrounding the case was a result of Price's television appearances begging forgiveness and explaining that he believed himself to be mentally unstable. A counselor, Lawrence Raifman, who worked with Price throughout the trial, admitted that he believed Price to have "a capacity for exploitation of others . . . a tendency toward promiscuity . . . and a narcissistic personality disorder" that was a direct result of Price's early abuse from his father (Shen, 1993, A1). During the months leading up to the conviction, the defense tried desperately to show that Price needed psychological treatment, not a prison sentence. Fred Berlin, psychiatrist and assistant professor at Johns Hopkins University, did not believe that Price was aware his actions were criminal. About Price, he states, "He's like a blind man who doesn't see, not a malicious person who doesn't care at all" (Shen, 1993, A1). However, the judge did not see Price as a victim in need of help. Instead, he sentenced Price to 26 years in prison. In his closing statement, the judge said to Price, "You have blamed the victims, you have blamed the Board of Education . . . blamed parents—everybody but yourself" (Shen, 1993, A1).

On October 14, 1993, *The Washington Post* ran a front-page article about Price's conviction with the headline, "Arundel Teacher Gets 26 Years on Sex Charges." The very next day, *The Washington Post* ran an article about a Northern Virginia woman convicted of sexually abusing a former student for three years. The headline read: "Woman Gets 30 Days for Having Sex with Student." The convicted abuser, Jean-Michelle Whitiak, a popular swimming teacher in Fairfax County, Virginia, was originally sentenced to 2 years in prison; however the judge suspended all but 30 days of the sentence and ordered Whitiak to continue receiving psychotherapy. While the abuse in Price and Whitiak's cases are slightly different, their defenses were strikingly similar. Like Price's defense, Whitiak's lawyers wanted to show the accused as a woman in need of help, not incarceration. Unlike Price's defense, they succeeded. Letters of support poured into the courtroom explaining that Whitiak was an outstanding person who must be troubled. Even the victim stood up for Whitiak and explained that he "did not believe it was fair for Whitiak to get in trouble when he was a participant. In addition to being the boy's swimming instructor, Whitiak was a family friend" (Davis, 1993, B1). The prosecutor for the case, Steven D. Briglia, explained that the case against Whitiak was in no way similar to Price's. He said, "That guy is a predator. . . . This is more than just a swim coach. They were friends" (Davis, 1993, B1). For those involved in the Whitiak case, the relationship between abuser and victim was seen as a kind of affair. The judge even referred to the relationship as an "aberration" (Davis, 1993, B1).

What is not mentioned often in the news reports of the case is that Whitiak slept with several of the teenager's friends in order to make him jealous. When does an "aberration" become an obsession, and when does that obsession become dangerous? And when does a grown woman evolve from being psychologically damaged to being a predator? Whitiak could have slept with adult men to make the teen jealous, but she chose other teenagers. This helped her defense prove that she was incapable of distinguishing between right and wrong behavior. On the other hand, when it came to light that Price also slept with several underage girls, the judge in his case saw him as a threat. The young women in Price's case were consistently viewed as victims, whereas Whitiak's young men were viewed as mere lovers.

Even Mary Kay Letourneau's 1997 sentence of 26 months in prison was reduced to six months in a county jail and a mandatory three-year stint in a sex offender treatment program. Letourneau was eventually released early for good behavior. But, anyone following the news during the time of Letourneau's release knows what happened next. On February 3, 1998, Letourneau and her former student were discovered, by a police officer, having sex in the back seat of a car. Letourneau's original sentence of 26 months was reinstated and she wasn't released until 2004.[2]

According to a 2009 article by Kristin Rodine in *The Idaho Statesman*, the state of Idaho is seeing an increase in sex scandals involving female predators. She writes, "In the past year, a dozen women have been in Valley courtrooms on charges of sexually abusing minors. They range in age from 20 to 40; their victims from 12 to 17" (Rodine, 2009). Idaho's punishment for these women varies depending on the age of the victim. Lax sentences were given to women who engaged in sexual activities with young men between the ages of 14 and 17. It appears that the older the male victim, the more likely the court system is to view the relationship as consensual and non-threatening. When we do find such relationships appalling, it is often because the woman involved holds some sort of tangible power over the victimized boy. Mary Kay Letourneau's 1996 trial was not necessarily about the horrors of a woman sexually abusing a boy, but about a teacher abusing her power.[3] The same is true for other female-male abusers that have made headlines, such as Debra Lafave, Pamela Rogers Turner, and Pamela Smart. These stories ignited a media frenzy that is almost unseen with male-female or male-male abuse.

Why is it that our society seems to relish hearing about these stories of teenage boys and older women, yet there is little discourse characterizing the boys as victims? In part, this may be due to our culture's inability to get past the concept of male sexual "initiation" typically associated with such relationships. Another reason is that we cannot move past an old-fashioned feminist notion that women are oppressed—all of them—and that any male, even a young one, capable of

engaging in sexual intercourse is oppressive. Despite having sex with multiple teenage boys, Whitiak was viewed by the court and society as being a damaged, helpless woman in need of guidance. Even when it came to light that Price was sexually abused in his own childhood, the court saw him only as a monster.

Male Victims in Contemporary Young Adult Literature

Since the 1970s, Young Adult novels have, to some degree, served a biblio-thera-peutic purpose. Many YA authors build characters around plots that concern seri-ous social or political issues. These "problem novels" are often seen as a means to help expose teenagers to a pressing issue or to help teens through tough decisions. Here I will discuss two such novels for Young Adults, Lurlene McDaniel's *Prey*, published by Delacorte in 2008, and Barry Lyga's *Boy Toy*, published in 2007 by Houghton Mifflin. My intention is not to prove how accurately or inaccurately these novels portray the female-male abuse depicted in them, nor how these re-lationships reflect real psychological and sociological effects on victims. Instead, I will focus my attention on how these novels construct their victims in terms of gender and on the ways both novels focus on the boys being victimized.

Before looking specifically at victimization, an understanding as to how each book presents masculinity is important. *Prey's* Ryan lives in an upper-middle-class suburb of Atlanta. He's an average student, athletic, yet not an athlete, who is sex crazed and uncontrollable. Within the first chapter of the book, the reader is led to believe that Ryan is not only vain, but also over-sexed. In the world of *Prey*, it seems this is what all teenage boys are: It's only natural. The novel is told in first-person among three alternating characters (Ryan, our sex-crazed teen male, Honey, his "best gal-pal," and Lori Settles, the teacher/predator). The plot of the novel is simple: Mrs. Settles is a new, young history teacher whom all the boys have a crush on and Ryan, like his classmates, is fascinated by Mrs. Settles. The two begin a relationship, which turns sexual. As the novel closes, the relationship is revealed and Mrs. Settles is sent to prison. Within this plot, Honey's chapters seem out of place. When Honey gets a chance to voice her opinions about Ryan's attraction to their new history teacher she says, "He thinks Settles is smoking hot. Of course. He's a red-blooded male" (20). McDaniel, an author primarily known for her "inspirational novels about teenagers facing life-altering situations," goes no further in working to construct masculinity in more complex or non-hege-monic ways.[4] Teen boys are horny, and because they are horny, they will make stupid decisions. For McDaniel's purpose there is no need to go further than this stereotype.[5]

Lyga, in his novel *Boy Toy*, is more complex in his depiction of masculinity. The novel is about Josh, a high school senior struggling with his past abuse. While much of the novel takes place during Josh's senior year, a large bulk recounts the

abuse from Josh's history teacher, Eve, five years prior. At the end of the novel, Eve is released and Josh confronts her about the abuse. While Josh, like Ryan in *Prey*, is concerned with sex, it's not all that defines him, or his friends, as male. They are intelligent, reflective, and caring. Josh's obsession with both baseball and mathematics often converge. At one point in the novel, Josh talks about missing the bus because he's "calculating a better radioactive batting average" (132). Josh is more than hormones. Along with his friends, he's extremely smart, cares deeply about his family, and shows compassion toward others. Josh's sexual abuse comes to light after he rips a girl's underwear off during a game of spin the bottle when he's thirteen. For the community within the novel, Josh is just a horny teenage boy, until all the details are revealed about his relationship with Eve, his history teacher. As the abusive relationship is told, the novel moves between an examination of masculinity and the other characters' expectations of teenage boys.

Both of these novels present different views of masculinity, but both also use the teen protagonist's supposedly innate sexual desire to dismiss any discussion of power. Much research has shown that sexual abuse is more an issue of power and control than sexual desire. But in these novels, as in our popular culture, discussions of power are diminished by depictions of sexualized teenage boys and adult women unable to control their desire. Both predators, Lori in *Prey* and Eve in *Boy Toy*, are highly sexual. When Lori discusses her love for teaching, she sounds more like a soft-core porn star than a professional teacher. For example, when she talks about her feelings toward the students, she says, "I envy them. And I'm drawn to them. I covet their innocence, and their youth" (14). When she teaches, she runs her hands down the surface of the desk, feeling every smooth spot. Upon first seeing Ryan she thinks, "I stare at him and the room seems to recede. A halo of light encircles him and suddenly, I know . . . he'll be the One" (15). Lori doesn't want to have power over Ryan; she desires him sexually. She is drawn to his young body and boyishness. The same is true for Eve. While not as lecherous as Lori, Eve just wants Josh for sex. Like Lori, Eve is sexually aroused by Josh's youth. There are moments in the novel when Eve appears to be aroused by talking to Josh. In a scene late in their sexual relationship, Eve shows Josh a pornographic film depicting a threesome. As they watch the film, Josh remarks, "I want to do that" (207). Eve sits up and asks Josh if he's sure about that. As they talk, Josh reveals that he's never had sex with a woman before. Eve begins to cry, cradles Josh, kissing him "deep and long," and remarks "That's OK [. . .] I'll teach you" (208). This is not the first or the last time in the novel that Eve appears to be aroused by the thought of "teaching" Josh. She likes his naivety and her sexuality is strongest when she can guide Josh.

What these two novels do with their depictions of power and sexuality is interesting and troubling. Josh and Ryan are not weakened by their abuse. Instead, they are strengthened. After Lori is released from prison, Ryan sets up a place

and time to meet her so the two can be together. Whereas before, he was slightly weak and impaired by his hormones, now he is stronger, boasting about having had sex with many girls, and finally coming to the conclusion that it is no longer obvious which one, Lori or Ryan, is the predator and which one is the prey. While McDaniel explains in her note at the end of the book that she wanted to show how young boys are damaged by sexual abuse from women, her actual novel contradicts the claim. Ryan isn't damaged in the way McDaniel hopes. Instead of creating a victim who needs help and guidance, the author has created another predator in Ryan.

A similar pattern is seen in *Boy Toy*. Josh is not strengthened sexually, like Ryan. In that regard, he is damaged. Since his abuse surfaced, Josh is unable to engage in any sexual activity with a girl without feeling he is being abusive. But Josh doesn't care about sex. The novel gives very little evidence that his hormones control him before the abuse or after. What happens to Josh after his abuse is much more powerful than just sex. Josh becomes a stronger student and athlete, both traits that will help him get into a good college. During the abuse with Eve, Josh begins to get what he calls "flickers." They are not memories or flashbacks. Instead, they are tiny moments that help him with his baseball swing and his calculus. The novel tries desperately to show Josh as damaged, which to some degree he is, but it largely fails in doing so by connecting his two strongest character traits with his abuse. Both his athleticism and his intelligence are strengthened by Eve. He is more confident, even boasting at one point that Eve taught him "how to please a woman" (1).

While both *Boy Toy* and *Prey* are, to some degree, "problem novels" that set out to discuss a taboo topic and show teenage readers the dangers of female predators and the effects abuse can have on boys, there is an almost inverse idea being portrayed to the reader. In his book *Erotic Innocence: The Culture of Child Molesting*, James Kincaid (2001) writes:

> Few stories in our culture right now are as popular as those of child molesting, and I wonder why this should be so. We are likely to say that the reality of sexual child abuse compels us to speak, to break the silence; but I would like to poke at the compulsions and at the connections between 'the reality of sexual child abuse' and the stories we tell about it. (3)

Kincaid discusses how our culture is obsessed with stories of pedophilia and child molestation. But what concerns him the most is that we use these stories to deny any perversion on our own part. For Kincaid, society needs to abandon a Victorian ideal of the child and admit that erotic feelings are natural and can be controlled. Interestingly, *Prey* and *Boy Toy* appear to encourage the reader to gaze upon the relationships of the novels as sexually charged and titillating, while not

intentionally meaning to. As discussed earlier, *Prey* sometimes reads more like a soft-core romance novel than a tale of victimization. The chapter describing Ryan and Lori's first sexual encounter is filled with words typical of erotic romances. During a rather awkward conversation in the car while "rain [pelts] the windows, sluicing in long noisy rivers along the glass," Ryan narrates:

> "Oh, my dear, precious Ryan." [Lori] leans forward, lifts my face and kisses me gently on the mouth.
>
> I take her shoulders and *kiss her back. Hard*, I kiss her, and *long*. Her tongue slides between my teeth, *igniting a fire I can't control*. Outside, the rain drums on the glass, giving *a rhythm to some primitive force in me* I don't want to control.
>
> Her hand slips onto my crotch, *cups the bulge* pushing against my jeans and makes me groan. She rubs me and I think *I'm going to burst.* "Do you like that?" she asks.
>
> "Yes." I kiss her again, driving my tongue into her *wet, hot mouth.*
>
> We're both *breathing heavily* and all I want is *her body against mine.* (76, italics mine)

And a little while later Lori and Ryan leave the car and enter Lori's apartment. Ryan continues:

> Somehow, I don't remember how, we're in her bedroom and *our clothes have come off.* We're in her *soft bed*, and just before I think *I'm going to explode*, she hands me a foil packet from her bedside table and says, "*Put this on.*"
>
> My *hands are shaking so hard* I can't open the wrapper, so she helps. And then *the world goes away* and there's Lori, only Lori, *filling my universe.* (77, italics mine)

The words and images throughout this section, and almost the entire book, do not portray Ryan as being in any danger. In fact, Ryan (again, the narrator, and active participant, of this chapter) appears to be enjoying himself. He is portrayed as the young, virile sex object needing teaching from the more experienced older woman. She even needs to help him unwrap the condom. Clearly, the diction throughout this scene in no way depicts Ryan as being abused. Even though he is a boy, he is depicted as the virile, yet sensitive male found in many erotic romances.

The idea of how the audience must read McDaniel's novel also brings up the question of gender. Lurlene (note the predator's first name is Lori) McDaniel's novels are extremely popular among teenage girls. She often writes about young love that is stopped short by death. Essentially, they are melodramatic and cliché ridden. McDaniel's typical style does not lend itself to such a serious issue as sexual abuse. So, perhaps to appeal to her teen female readership, McDaniel seems to feel the need to use high, romantic language when describing sex, not

the type of diction one associates with victimization. In a scene later in the novel, Ryan and Lori are in a car, making love. The windows are foggy and, before nearly getting caught by the police, Lori reaches up and leaves a single handprint on the window. Interestingly, this same scene and image can be found in the movie *Titanic*, a high-romance film from 1998 that was popular among the teen girl demographic, and in Lifetime's made-for-TV movie *All-American Girl: The Mary Kay Letourneau Story* (2000), a movie that should not be in the high-romance genre given the subject matter, but walks a fine line. In the end, McDaniel has completely overshadowed any notion of victimization by telling her story of abuse using erotic and romantic language.

Boy Toy isn't as romantic as *Prey*, but it does ask the reader to look at the relationship between Josh and Eve as highly erotic, almost in ways that are pornographic. Lyga's novel is sexually graphic. As the relationship progresses, the narrative doesn't shy away from detailing every move, touch and sound. The novel is primarily set when Josh is 18 years old, but the majority of the first half is Josh recounting his relationship with Eve when he was 12 years old. The novel presents these chapters as Josh's own words. According to the novel, this is how the constructed victim chooses to narrate his abuse:

> I knocked on Eve's door. *She opened the door in her slinky robe, her hair falling around her face and down her shoulders.*
>
> She pulled me into the apartment and slammed the door. Pressing herself against me, slippery and soft in the robe. *She nibbled my ear, breathing into it,* gasping out her words: '*Oh, baby, I missed you.* I missed you so much. *I need you so bad.*' (204; italics mine)

And then:

> *She dropped to her knees and unbuckled my belt,* then skinned down my pants and underpants. I was ready for her already, *and she dived down, darting her head like a starving bird.* I hissed out my breath and clenched my fists and leaned my back against the door.
>
> She stopped. '*Watch me,*' she groaned. 'Watch.' And she took my hands and put them on her head. *I gripped her hair and looked down.* She looked up at me, *our eyes locked as she descended again.* (204; italics mine)

Like Ryan, Josh does not appear to be in any danger. In fact, this scene, like many others in the novel reads like bad soft-core pornography. It's a classic set-up: Attractive woman answers the door for a desiring younger man, little dialogue is exchanged, and the two immediately begin having sex.

If *Prey* is using romantic language to appeal to a female audience, then *Boy Toy* is using very blunt, pornographic language to appeal to teenage males. This only reinforces the idea that masculinity is affirmed through a young man's hetero-

sexual desire and arousal. Unlike *Prey*, the novel is never melodramatic: it's terse, honest, and harsh. The novel also juxtaposes these sex scenes with video games and sports. Often Josh must put down the Xbox controller before he can kiss Eve. In a scene early in the novel, Josh sits down to play a video game in Eve's apartment but finds pornography in the player instead of a game. Perhaps the reason that Josh doesn't see himself as a victim is because he's never shown as one. The sex isn't dangerous; it's instead a clichéd pornographic fantasy heterosexual teenage males are supposed to enjoy.

The assumption that neither of these novels was meant to arouse the reader is valid. Both Lyga and McDaniel fill their narratives with didactic messages about power, abuse, and victimization, but these brief moments pale in comparison to the language and images that are used to describe the "abusive scenes." Both novels *tell* the reader that he or she should be disgusted and upset, yet they *show* the reader that a relationship between a young boy and an adult woman can, at times, be arousing and lead to strength. Ryan becomes more aggressive and oppressive in the end, and Josh grows closer to the girl of his dreams, Rachel, because of his willingness to open up about his past abuse.

Sensationalizing Abuse: Teacher-Student Abuse on Television

In February 2009, both CW's *Gossip Girl* and FX's *Nip/Tuck* aired episodes that used teacher-student sex as a primary plot element. Both these shows are known for their sensational plotlines and high melodrama. The fact that both aired episodes with similar plots is not just a coincidence, it's a sign that these narratives are current, and we still find something fascinating about an older woman engaging in a sexual relationship with a teenage male.

On February 2, 2009, CW aired an episode of their hit show *Gossip Girl* titled "Carnal Knowledge." The show centers on the lives of several Upper-East-Side New York teens. Despite the fancy location, much of the show is typical teenage fare: romance, rumors, break-ups, and the occasional parental intervention. Earlier in the season the elite, suave teenagers of the show were introduced to Rachel Carr, the new, attractive young teacher at school. The show's queen-bee, Blair Waldorf, was sentenced to detention after she played a prank on the new teacher. As retaliation for the punishment she received, Blair decides to start a rumor that Mrs. Carr is having sex with a student, Dan Humphrey. While *Gossip Girl* is a show for teenagers, its focus is sensationalism. (Along with Blair's revenge plot, the current episode also details another character's entrance into a private sex club.) But Blair's revenge is the prominent plotline for this episode. In order to get the rumor started, Blair sends a text message to Gossip Girl, the school's mysterious gossip blogger. Soon, everyone in the school thinks Mrs. Carr is having sex

with a student. Instead of consoling him, however, the other boys in the school stop Dan in the halls to congratulate him.

Shortly after being expelled from school for slander, Blair tells her father that what she posted to Gossip Girl was not a rumor, but the truth. When her father says, "The real issue here is not about teenagers gossiping online," Blair responds, "It's not?" ("Carnal Knowledge," 2009). Blair doesn't seem to understand that these relationships are criminal, and they involve victims. She only sees the narrative of a female teacher having sex with a student as a scandal that will titillate the other students and parents and punish her enemy. When ethics are discussed in the episode, the characters talk about them as if they have to in order to instill a didactic message, but the narrative quickly moves back to shock and gossip. The plotline shows how we view these relationships between female teachers and male students: They are scandals, not crimes.

FX's *Nip/Tuck* concerns the lives of two plastic surgeons. Each week, the audience is provided a new, scintillating subplot involving a surgery. On February 3, 2009, Ricky Wells entered the show as a guest character. Ricky is 18 years old and recently married his middle-school sweetheart, Carrie Ann, his seventh grade teacher. Ricky needs plastic surgery so that he can look older. He's about to be a father, and doesn't want people to think that his future son is his brother. Ricky and Carrie Ann recount their past to the doctors. They first met when Carrie Ann was teaching second grade, and Ricky was her student. There were slight sparks, but nothing major. It wasn't until they met again when Carrie Ann was teaching seventh grade that the two began a sexual, and presumably emotional, relationship. As Ricky details why he wants to look older, Carrie Ann jumps in and informs the doctors that she likes Ricky "Just the way he is" ("Ricky Wells," 2009). Carrie Ann makes several other statements, and a few sly gestures that imply she's more interested in Ricky's youth than his personality.[6]

While *Nip/Tuck* has never been known for its strong moral guidance, the show does offer something interesting in this episode. There is no question that Carrie Ann is a predator. When Ricky returns home after the surgery, he finds Carrie Ann in bed with his underage brother. The look on Carrie Ann's face shows an understanding that she is a criminal and a danger. The episode does a decent job showcasing Carrie Ann as a threat to teenage boys, but there is still no focus on Ricky as a victim. He's heartbroken, yes. But, according to the show, he'll be fine. He's not a boy, but a grown man (with the facial hair transplants to prove it) who has been jilted by his wife. This is just the breakup of a long-term relationship. He'll get over it and move on. This time, looking older and wiser. Like other media representations of abused boys, Ricky appears to have gained maturity from his experiences with Carrie Ann.

The *Nip/Tuck* episode shows our culture's perverse interest in these types of stories. The audience is asked to partake in this scandal and wait anxiously as the

show progresses to its shocking end. Once introduced to Ricky and Carrie Ann, it's only a matter of time before something sexy, dirty, and surprising happens. This is, of course, cable television. When Ricky's new face is revealed, the audience can see that Carrie Ann is not happy. But we have to wait until the end of the show before we know what's really going on. Finally, Ricky catches Carrie Ann and his younger brother having sex: she's a monster, a predator that preys on young boys for sexual pleasure. To a degree, we are relieved. Our assumptions were right, yet we have forgotten about Ricky, who was the monster's prey several years before.

Female Predators: A Feminist Dilemma

These examples depict an often-ignored aspect of male victimization: the role of feminist discourse in constructing women as victims and men as predators. Since the second-wave feminist movement first brought much needed attention to the topics of rape, sexual abuse, and pedophilia, we have learned a great deal about the damages done to girls abused by adult men. But to some degree, the feminist movement, along with hegemonic masculinity, has made it difficult to view women as predators and young boys as victims. Our culture seems resistant to acknowledging women's capability for abuse, and, more importantly, the ways boys can be damaged by such abuse. When we sensationalize these relationships we are overlooking their seriousness.

Without feminism, many laws would not be in place protecting victims and punishing abusers. The study of victimization is also indebted to feminism for the now commonly accepted theory that rape and abuse have nothing whatsoever to do with sex, but are more manifestations of power and obsession. Despite these remarkable strides, however, some feminist discourse has also made it difficult for our society to accept that women can be sexual predators or that young post-pubescent boys can be victims. In her 1993 article, "Women Abusers—A Feminist View," Val Young discusses the issue of female sexual predators and feminism. For Young, the difficulty with discussing women abusers is not in the research, but in the fact that feminism will not allow women to appear as monsters, capable of horrible acts. She writes, "It seems we are willing to go only so far in acknowledging the negative characteristics of women and always putting them into the context of patriarchal oppression. Merely stating what female sexual abuse is and why it exists, however, offers no hope of any positive solutions" (100). Young goes on to examine the ways in which feminism has hurt victims of female sexual abuse. Because some strands of feminism allot agency to men, it is therefore implied that women are victims. To put it another way, a woman cannot abuse simply because she is a woman and can hold no sexual power over a man who is capable of achieving an erection.

Not surprisingly, this idea is prominent in McDaniel's *Prey*. Lori is portrayed as naive and incapable of understanding that her actions are wrong. Right before the police arrive at Lori's door she is threatening to kill herself. Ryan has come over to her apartment to warn her and confront her about her past (evidently, Ryan is not the first teenage male she has slept with). Lori tells Ryan about the last teen she slept with. According to Lori, this young man needed her help. She says to Ryan, "He needed me, but I need you" (174). At this moment the novel moves Lori from abuser to victim. The reader learns that Lori was sexually abused as a child and has a history of mental instability. Later in the novel, she is diagnosed as bipolar. Just as the police are ready to break down Lori's door she uses a large chopping knife to cut her wrists. Ryan jumps in and holds a towel to Lori's wrists and screams, "You can't die! Not like this. Not the way my mother did it" (175). Freudian issues aside, the end of *Prey* leaves the reader with a sense of sympathy for Lori. She is clearly troubled and needs help.

In the novel's final chapter, Lori and Ryan meet up several years later to begin their relationship again. Ryan walks through the botanical gardens waiting for Lori. The fog is thick, and Ryan recounts his sexual history *before* Lori. He mentions having slept with several girls before Lori. This is surprising, given how inexperienced Ryan made himself appear during his first sexual experience with Lori. Even more unsettling is when Ryan says, "Thinking back, I set out to be seduced by Lori. From the first time I saw her, I wanted to get something going between us" (191). According to recent research conducted by Gene Abel and Nora Harlow, "Being abused as a boy appears to increase the risk that the abused child will himself eventually molest a child" (qtd. in *The Abel and Harlow Child Molestation Prevention Study* 2). While this statement does reflect findings from therapists and psychologists, there is no evidence in the final chapter of *Prey* that Ryan is a victim. As he talks, there is no sense that he is suffering from his abuse, only that he has been hiding his own predatory nature even before meeting Lori. When he finally finds Lori, she is sitting on a bench. Her presence shows that she has not changed, but there is an underlying notion that Ryan has been taking advantage of Lori all along. In the final line of the novel, Ryan says, "Watching [Lori] through the mist, I can't help wondering—which one of us is the predator and which the prey?" (194). Given McDaniel's explicit intentions stated in both author notes at the beginning and end of the novel, the purpose of this chapter is unclear and its presence in the book only undermines any sense of victimization that McDaniel is working toward in the character of Ryan. Instead, Lori is left as the victim. She is the weak female, sitting alone at night with her head down. Her earlier predatory characteristics are gone.

But this is not just an issue in fiction. Looking back at the two court cases mentioned earlier, Price and Whitiak, we can see that it is easier to think of a woman as a victim than a man even if that woman is just as criminal in her ac-

tions. Whitiak's sentence was less severe than Price's. To the courts and the media, she was a victim, a woman misguided and in need of help. The judge didn't take her sexual relationship with several teenage boys as a threat. This issue should be alarming for all of us, because some teenage boys are not recognizing their own victimization. In his book *Abused Boys: The Neglected Victims of Sexual Abuse*, Mic Hunter (1990) remarks, "One reason why men frequently have difficulty thinking of themselves as victims is that in recalling the abuse they mentally picture themselves as men rather than as boys" (94). This is a very poignant statement. Hunter also addresses the issue that many male victims never come to terms with their abuse. They keep it held inside and don't seek any help. This may be because, within constructs of hegemonic masculinity, men must withhold feelings, must see themselves as strong and in control, and must desire sexual advances. By never thinking of themselves as children, young men are unable to see themselves as weak enough to be taken advantage of, especially by a woman. This only reinforces the idea that any male capable of sexual arousal is dominant, and therefore the female must be the one who is submissive. When we combine our culture's ideal standard of masculinity with an out-dated approach to feminism, we are left with a dangerous situation that is stifling victims and allowing abusers to get away with criminal acts.

The Need to Re-define Masculinity and Victimization in the Media

In 1995, director Gus Van Sant released *To Die For*, a big-screen retelling of Pamela Smart's story. Critics applauded star Nicole Kidman's brave performance as a desperate woman who seduces a 15-year-old and convinces him to kill her husband so the two can run away together. For many, the film launched Kidman into more serious roles and showed her ability to portray complex characters. While the other actors in the film—including Joaquin Phoenix, who plays the seduced young man—are praised for their work, the movie was about Kidman, and was the abuser's vehicle.

Similarly, Richard Eyre's 2006 thriller *Notes on a Scandal* also puts its focus on the female abuser. Eyre's film, based on Zoë Heller's 2003 novel of the same name, involves the friendship between two London schoolteachers, Barbara and Sheba. Barbara is older and unmarried, while Sheba is younger, pretty, and happily married with children. When the school and community discover that Sheba has been having a sexual relationship with one of her underage students, Barbara is the only compassionate friend. But the film suddenly changes direction. Whereas the focus of the first act is on the relationship between Sheba and her student, the second act concerns Barbara's dangerous obsession with Sheba. Suddenly, Sheba is in danger. The film decides that a pseudo-lesbian, *Fatal Attraction*-esque plot is much more important, and believable, then an adult woman abusing a teenage boy.

These narratives—whether fact or fiction—are not going away because we revel in them. Eagerly, we followed Mary Kay Letourneau as she made one bad move after another. We discussed how horrible it was when she was found having sex in her car with a student (just like a teenager!). We searched the Internet for those scandalous, *Playboy*-esque photos of Debra Lafave, another teacher convicted of molesting a male student, which suddenly appeared on the Internet shortly after her trial began. We were even appalled, and somewhat excited, to learn that Lafave may have been taken advantage of during her arrest.[7] When it was announced that Pamela Rogers Turner sent her 13-year-old student sex videos, again we searched the Internet. When not watching the news, we sit down to sensational television programs that involve an 18-year-old desperately wanting to look older so as not to draw attention to the age difference between himself and his wife, who is also his former teacher.

What about the victims? Do young men internalize these messages so that they don't see themselves as victims, or have we established a culture that still will not allow boys to either be victims or to be characterized as victims? It's easy to ignore the victims in real life cases. They are, of course, underage and should be protected; but even in fictional accounts of such relationships, the teenage male is rarely presented as a victim. Is James Kincaid right in saying that we need these stories to dismiss our own erotic feelings? Certainly, these stories do ignite a reaction that is perplexing, and at the same time scintillating. But perhaps there is a larger issue that needs to be addressed—what does it mean to be both male and a victim?

If feminism is right (and I believe it is) and victimization needs to be acknowledged, then our culture also needs to be able to abandon our old views about maleness and victimization. In "To Be a Man, or Not to Be a Man—That is the Feminist Question," Harry Brod (1998) writes, "For profeminist men to sustain ourselves, we need to see our stake in feminist future" (199). Brod is right in recognizing that anyone interested in masculinity must also be critical of the future of feminism. When masculinity and victimization intersect we cannot ignore the complexities or the subject. We cannot avert our gaze away from the male victim to something more understandable such as patriarchal oppression against women. If the current status of masculinity studies provides anything, it is the beginning of a dialogue about the complexities of boyhood and the hope that boys, like the female victims generations before, will no longer be ignored, misguided, or misrepresented.

Notes

1. For a great example of feminism's influence on the representation of female victims I highly recommend Cynthia Voight's (1994) *When She Hollers*. The

protagonist, Tish, confronts her step-father and demands that he stop abusing her. She keeps a knife handy to protect herself. The novel's first line, "She put the survival knife on the table. It pointed across at him" clearly shows that Tish is taking control of her life and no longer going to be a victim of her step-father's sexual abuse (1). The survival knife becomes a symbol of Tish's strength. At the end of the book Tish is described as holding her ideas "like a knife" (177). This progression from a symbolic strength to a more mental and emotional one is the focus of most treatments of victims.

2. Upon her release, Letourneau's former student asked the courts to lift a non-contact order. The courts agreed, allowing Letourneau and her former student (at this point he was of legal age) to continue seeing each other. The two already had two children together from previous sexual encounters (all while the student was underage). On May 20, 2005, they were married. In a 2006 interview with *Dateline NBC* Letourneau said, "I'm thinking about teaching English as a second language. . .or math. Turns out I have a serious passion for mathematics" (Letourneau). Given the media mad-house surrounding her case, it's hard to imagine why Letourneau would ever want to return to teaching.

3. In all the news articles I read about the Letourneau case, very few referred to her former student as "victim." Rhetorically, this poses a problem. Even with a case as famous as this, the media cannot see a young post-pubescent male as a victim. In keeping with this rhetoric, I will refer to the young man as the media did: her former student. Also, I don't feel comfortable using the names of any of the victims in these real cases. While Letourneau's former student is of legal age currently, at the time of the trial he was a minor, and for the purpose of this article will be treated as such. Also, I pulled much of the basic information, including dates and incidents during the trial and before Letourneau's release from Greg Olsen's (1999) *If Loving You Is Wrong: The Shocking True Story of Mary Kay Letourneau.*

4. This quote can be found in the author's bio in the back of every Lurlene McDaniel novel and on her website, http://www.randomhouse.com/features/lurlene/.

5. McDaniel's novel includes a "Note From the Author" at the beginning and end of the novel. In her notes, she explains her purpose for writing the novel, and recounts some of her findings in doing research. While I do not always think it is fair to assume an author's intent, for McDaniel that intent is clearly stated. This authorial intent overrides any organic plot, characterization, or theme. For this reason, I feel it's only fair to address the novel as McDaniel's words and not those solely of the text.

6. The plotline about Ricky and Carrie Ann is no doubt influenced by the Mary Kay Letourneau story. Like Mary Kay, Carrie Ann (notice the names) is caught and sentenced to several years in prison. Due to good behavior, she is released after six months. Shortly thereafter she is found, by the police, hav-

ing sex with Ricky in her car. Her original sentence is reinstated. When she is finally released, and Ricky is of legal age, they marry.

7. The detectives who arrested Lafave allegedly took graphic photos of the young teacher while she was in stirrups for an examination (McGinty, 2005). Also, Owen Lafave and Bill Simon's (2006) *Gorgeous Disaster: The Tragic Story of Debra Lafave* proved helpful in explaining all the sex scandals with sex scandals.

Works Cited

Abel, Gene G and Nora Harlow. "The Abel and Harlow Child Molestation Prevention Study." The Child Molestation Research and Prevention Institute, 2002. Web. 14 March 2010.

All-American Girl: The Mary Kay Letourneau Story. Dir. Loyd Kramer. Perf. Penelope Ann Miller, Omar Anguiano, and Mercedes Ruehl. Grosso-Jacobson, 2000.

American Pie. Dir. Paul and Chris Weitz. Perf. Jason Biggs, Chris Kline, Eddie Kaye Thomas, and Thomas Ian Nelson. Universal, 1999.

Badinter, Elizabeth. *XY: On Masculine Identity.* Trans. Lydia Davis. New York: Columbia University Press, 1995.

Brod, Harry. "To Be a Man, or Not to Be a Man—That is the Feminist Question." *Men Doing Feminism.* Ed. Tom Digby. New York: Routledge, 1998. 197–212.

"Carnal Knowledge." *Gossip Girl.* CW, Richmond. 2 Febuary 2009.

Connell, R. W., Michael Kimmel and Jeff Hearn, Eds. Introduction. *Handbook on Studies on Men & Masculinities.* Thousand Oaks, CA: Sage, 2005.

Davis, Patricia. "Woman Gets 30 Days For Having Sex With Student." *The Washington Post.* 16 October 1993, final ed.: B1.

Gartner, Richard B. *Betrayed as Boys: Psychodynamic Treatment of Sexually Abused Men.* New York: Guilford, 2001.

Hunter, Mic. *Abused Boys: The Neglected Victims of Sexual Abuse.* New York: Fawcett Columbine, 1990.

Kincaid, James. *Erotic Innocence: The Culture of Child Molesting.* New York: Duke University Press, 2001.

Lafave, Owen and Bill Simon. *Gorgeous Disaster: The Tragic Story of Debra Lafave.* Beverly Hills, CA: Phoenix, 2006.

Letourneau, Mary Kay. "Letourneau and Faulaau, One Year Later." Interview. *Dateline NBC.* By Josh Mankiewicz. 2 June 2006. Excerpt of Transcript. *MS-NBC.com.* Web. 4 March 2009.

Lyga, Barry. *Boy Toy.* Boston, MA: Houghton Mifflin, 2007.

McDaniel, Lurlene. *Prey.* New York: Delacorte, 2008.

McGinty, Bill. "Detective Investigating Debra Lafave Has Also Been Arrested." *Tampa Bay's 10 News.* Web. 19 September 2005.

Notes on a Scandal. Dir. Richard Eyre. Perf. Judi Dench, Cate Blanchett, and Tom Georgeson. Fox Searchlight, 2006.

Olsen, Gregg. *If Loving You Is Wrong: The Shocking True Story of Mary Kay Letourneau.* New York: St. Martin's, 1999.

Plummer, Ken. "Male Sexualities." *Handbook of Studies on Men & Masculinities.* Eds. R.W Connell, Michael Kimmel, and Jeff Hearn. Thousand Oaks, CA: Sage, 2005. 178–195.

"Ricky Wells." *Nip/Tuck.* FX, Richmond. 3 February 2009.

Rodine, Kristin. "SW Idaho Seeing More Women Charged With Sex Abuse." *Idaho Statesman.* Web. 18 April 2009.

Shen, Fern. "Arundel Teacher Gets 26 Years on Sex Charges." *The Washington Post.* 15 October 1993, final ed.: A1.

To Die For. Dir. Gus Van Sant. Perf. Nicole Kidman, Matt Dillon, and Joaquin Phoenix. Columbia, 1995.

Voight, Cynthia. *When She Hollers.* New York: Scholastic, 1994.

Young, Val. "Women Abusers—A Feminist View." *Female Sexual Abuse of Children.* Ed. Michele Elliot. New York: Guilford, 1993. 100–112.

"How to Hook a Hottie": Teenage Boys, Hegemonic Masculinity, and *CosmoGirl!* Magazine

Suzanne M. Enck-Wanzer and Scott A. Murray

"Hooking Up Dos and Don'ts"
 (*CosmoGirl!*, September 2007 cover)

"4 Dates Guys Love"
 (*CosmoGirl!*, April 2008 cover)

"What He Tells His Friends After You Hook Up"
 (*CosmoGirl!*, November 2007 cover)

"387 Ways to Make Him Fall For You"
 (*CosmoGirl!*, February 2008 cover)

To say that the world of teenage dating is complicated by our media-saturated world is quite an understatement. With mixed messages, gendered double binds, and sex stereotypes emanating from nearly every medium of U.S. popular culture, it should be little surprise that teenage boys and girls alike experience more anxiety than ever in respect to dating. Messages reminding budding women to maximize their femininity and let "boys be boys" saturate girls' magazines throughout the market. Since their conception in the 1940s, teen magazines have become staples of pop culture throughout the developed world. Typically intended for girls and young women, magazines such as *CosmoGirl!*, *Teen*, *Seventeen*, *J-14*, and *Teen Vogue* cover a wide array of topics, including school, beauty, fashion, celebrities, music, and—most importantly—teenage boys. Advising girls

how to catch the elusive boy species, columns, testimonials, and images combine in these magazines to construct an image of the prototypical teenage boy—one who is sexually assertive, emotionally evasive, and naturally prone to aggression.

There is a growing body of research dating back to the 1970s investigating girls' and women's magazines with an eye toward how these texts reproduce and reinforce gender roles.[1] Recognizing the power of mass-mediated artifacts to socialize women and girls into cultural norms and mores, most research confirms that female lifestyle magazines are guided by a singular focus on beauty and (heterosexual) romantic relationships. As Garner et al. suggest, magazines aimed at women and girls "fill in the contours and colors of what it means to be a woman and how women should relate to men (59). On the flipside of this spectrum, as Diane T. Prusank (2007) observes, "little work has been done to understand the portrayals of the males who appear in these magazines" (160). Though there is some growing interest in researching constructions of masculinity in men's lifestyle magazines, Mia Consalvo (2003) rightly insists that this focus on adult men "fail[s] to interrogate constructions of young or adolescent boys" (28). The importance of studying discursive constructions of younger males is especially important, Consalvo continues, because such research "may show gender as a process being worked out—rehearsed, refined, and modified" (28). Indeed, it is the premise of this chapter that a critical examination of how masculinity is prescribed (and proscribed) in teenage girls' magazines can help us better question our cultural investment in a very narrow range of acceptable attitudes and behaviors for adolescent boys.

Given the dearth of research on how boyhood masculinities are created, circulated, and reinforced through mediated portrayals aimed at girls, this essay seeks to provide one antidote. Specifically, this critical analysis of *CosmoGirl!* magazine interrogates several prevalent frameworks of meaning that reinforce what Robert Connell (1995, 1996) calls hegemonic masculinity.[2] If we can identify the messages being directed at girls, we can, by extension, realize how girls are being trained to (re)act toward boys. Such a revelation is important because hegemonic masculinity relies upon the willingness of those dominated to sustain the very system of their oppression. As such, in this essay we argue that *CosmoGirl!*'s positioning of teenage boys vis-à-vis teenage girls masks its support of hegemonic masculinity within a discursive scaffolding of girlhood empowerment. Buttressing other studies of popular magazine portrayals of gender differences, this current study pays particular attention to the constructions of boyhood masculinities and argues that *CosmoGirl!* reinforces hegemonic masculinity by portraying 1) males as sexual initiators; 2) males as emotionally distant; and 3) males as inherently more aggressive. After explaining the theoretical underpinnings of hegemonic masculinity, we provide a brief background on *CosmoGirl!* magazine and teen girl magazines as a genre, and, finally, delve into the text itself to offer evidence for

the presence of the three characteristics mentioned above. Ultimately, as Consalvo contends, "Until masculinity and its different constructions are better explored, . . . we as news audiences and citizens will be blind to how these masculinities are linked—falsely and not—to damaging traits and behaviors" (41).

Hegemonic Masculinity

As indicated above, there has been a bevy of research on constructions of femininities across popular media; however, emphases on the construction of masculinities have, most often, been an afterthought or implied by default. Depicting boys and men as if they were genderless has helped to reinforce the privileged position of invisibility when it comes to patriarchal dominance.[3] To claim that masculinity is privileged and invisible is not to say that men and boys have no gender. Rather, the gender of men and boys seems unimportant; gender is a topic that more frequently guides discussions of women and girls, thus making the gender of females (hyper)visible. This concealed gendering of boys and men is pivotal to allowing for central aspects of males to seem naturalized and preferred in U.S. public culture (Hirdman, 2007, 159). In response to the invisibility of masculinity, Richard Dyer (2002) makes the following analogy: "One would think that writing about images of male sexuality would be as easy as anything. We live in a world saturated with images, drenched in sexuality. But this is one of the reasons why it is in fact difficult to write about. Male sexuality is a bit like air—you breathe it in all the time, but you aren't aware of it much" (89). This sense of being everywhere and yet nowhere is what renders masculine privilege (generally speaking) so powerful in Western culture. This privileging of masculinity, we should note, is most seamless when it is accompanied by other privileged social identities (e.g., heterosexuality, whiteness, U.S. citizenship, middle/upper class status); to be sure, as bell hooks (2000) reminds us, not all masculinities enjoy the same sense of social power. It is this general privileging of masculinity (as opposed to femininity) that informs what is known as "hegemonic masculinity."

Connell's research on masculinities has been highly influential in enabling critical explorations of the gendering process. Drawing together the two ideas of masculinity and hegemony, hegemonic masculinity is Connell's term for "[t]he form of masculinity that is culturally dominant in a given setting" (1996, 209). Embedded in social institutions ranging from schools and governing bodies to families and the media, hegemony is never totalizing and is, at its core, not obvious. As articulated in critical/cultural theories assembled by Antonio Gramsci (1971), hegemonic powers and privileges maintain their dominance through broad-based ideological support and the appearance of being "common sense." Hegemony is supported both by those who most benefit from its sustenance, but also by those who are positioned subserviently; because it is naturalized, it

also goes unquestioned. Steve Craig (1992) helps to round out this definition of hegemonic masculinity by noting, "In modern American culture, part of [our] expectation is that men will participate in and support patriarchy, and the traditional characteristics of masculinity are made to seem so correct and natural that men find the domination and exploitation of women and other men to be not only expected, but actually demanded" (3). Contrasted with femininity (which emphasizes nurturance, submission, and empathy) and less culturally powerful masculine identities such as homosexuality, the idea of hegemonic masculinity provides a theoretical lens for conceptualizing the myriad ways that men collectively have privilege over women (Connell, 1996, 209). Notably, as Antony Easthope (1990) argues, once constructions of masculinity can be highlighted and exposed, the power of its hegemonic privilege can be challenged and "called into question" (168). This is the goal of our critical exploration of *CosmoGirl!*—to call into question hegemonic masculine privilege by detailing not only its effects on girls (which have been studied elsewhere), but to think more thoroughly about its deleterious effects on boys.

Mediating Meaning

Before offering an analysis of *CosmoGirl!* as it relates to hegemonic masculinity, it is important to recognize the significance of such discourses. Douglas Kellner (2001) offers the now-familiar suggestion that life in today's media culture "dramatize[s] social conflicts, celebrate[s] dominant values, and project[s] our deepest hopes and fears" (38). Challenging expectations that news representations of various stripes (ranging from national newscasts to fashion updates) are transparent and *true*, there is a wide range of scholars who remind us of the ideological potency of media portrayals to uphold hegemonic power structures.[4] From a critical/cultural perspective, it is not necessarily a question of "accuracy," but of the constitutive function of a discourse; in other words, how do characterizations found in mediated discourses help us form knowledge about the world(s) in which we live? Creating not just *what* we think about, but *how* we think, mediated representations exert great power.

Typically, research into these questions tends to critique more "mainstream" sources of news; however, as Ana Garner et al. (1998) argue, magazines are, for teenage girls especially, an important source of gender information and thus, a valuable area of study due to their accessibility, affordability, and availability (60). As Garner et al. continue, "Magazines constitute part of the media stories that shape both society's sense of culture and our sense of self in culture" (59). In line with this research, Debbie Treise and Alyse Gotthoffer (2002) found that teenage girls use magazines as a source of information about sexuality, ranking the value of such discourses on par with information provided by their parents and peers.[5]

Furthermore, for some readers, the content of girls' magazines is actually thought to be more convincing than personal experiences and first-hand knowledge (Currie 1999). Ultimately, as Stephanie R. Medley-Rath (2007) concludes, "Readers actively use [teen girl] magazines by looking for relevance with their own lives and to sort contradictory messages and gain sexual knowledge" (25).[6]

Aimed at girls ages 12–17, *CosmoGirl!*'s print magazine was launched in June of 1999, published monthly until December of 2008, and currently enjoys a vibrant online presence at CosmoGirl!.com. Distributed by the media corporation Hearst Magazines, *CosmoGirl!* boasted a circulation of 1.4 million by the end of 2008, making it one of the largest selling teen magazines in the U.S. market. Similar to other teen magazines in form and function, the sampling of *CosmoGirl!* pieces analyzed in this chapter provides a glimpse into broader constructions of the sexual scripts and ideologies prescribed to teenage girls and implicitly assumed of teenage boys. This study investigates *CosmoGirl!* as a rhetorical artifact, paying particular attention to the advice columns, articles about dating and romance, and editorial responses to readers' letters.[7] The archive of *CosmoGirl!* surveyed for this essay spans five years (2004–2009). In all, 32 articles that met our search standards were analyzed. Specifically, articles were selected if they included the keyword "dating" in the Lexis-Nexis database, offered explicit advice to girls about dating, and featured prominent gender paradigms.

The findings of our analysis are quite consistent with analyses of gender role constructions found in other studies of teenage girls' magazines. The argument forwarded by this essay is not that *CosmoGirl!* is fundamentally different from other teen magazines. Indeed, it is quite representative of the genre of magazines targeted toward teenage girls. It is the "normalcy" of the messages conveyed in this magazine that reinforces the power of the ideologies conveyed. As Hirdman (2007) confirms, "[S]exualized representations of femininity can . . . be understood as expressions of some of the paradoxes and contradictions connected to masculinity . . . " (162). Thus, where this study deviates from other analyses of teen girls' magazines is in its focus on how the discourse helps reinforce cultural investments in hegemonic masculinity. Importantly, in line with other invocations of Gramsci's notion of hegemony, *CosmoGirl!* and other magazines of its ilk hail girls and women into the subject position of willing participant of their own domination. In the end, such mediated discourses buttress a social system wherein girls and women are rhetorically conditioned to maintain the very structures that work to oppress them.

Rules of Engagement

To begin, *CosmoGirl!* reinforces elements of hegemonic masculinity through its portrayal of teenage boys as the primary initiators in relationships. In line with

traditional expectations of hegemonic masculinity, Nicola Gavey and Kathryn McPhillips (1999) suggest that "[d]iscourses of conventional heterosexuality constitute the male as the active, leading partner and the female as the passive, responding partner" (365). David Wyatt Seal and Anke A. Ehrhardt (2003) echo this expectation of masculinity with their study of urban male sexual scripts. Specifically, they observe:

> As with courtship, traditional heterosexual script theory portrays men as the initiators of sexual intercourse and women as the boundary setters[8]. . . Men are expected to actively initiate and pursue all sexual opportunities, whereas women are expected to delay sexual activity until emotional intimacy has been established. (296)

This is not to suggest that all males are *naturally* more likely to initiate intimate relationships; rather, social conditioning (scripts) promotes such an expectation for "appropriate" masculine action. Seal and Ehrhardt remark further that "many men learn by a very young age that part of being a man is to compete and to conquer. . . '[r]eal' men initiate and control heterosexual interactions, and 'real' sex is defined by penetration—a behaviour characterized by active 'doing' to another person" (315).

While usually not explicitly sexual in content and advice, the articles featured in *CosmoGirl!* reproduce and reinforce the hegemonic masculine construction of males as the initiating, active gender. First, the magazine advises teenage girls to let boys take the lead in advancing the relationship. In "The New Dating Rules," young women are told to "never text, call, e-mail, or [instant message] him first" (Khidekel, 2007a, 96). The reason for such prescribed hesitation, according to the columnist, is that "[i]t's basic guy nature to want to feel like he worked hard to get you. They like to call first, so let them" (96). A similar article, "How to Make Love Last," details how Lauren, 17, succeeded in building a strong relationship with Kyle in part because she let him say "I love you" first (Khidekel, 2008a, 100). "Lauren waited for Kyle to say it first, which is a good idea," the column observes; "[a]t this age, boys have a lot of the social power. . . so they may not know how to deal if you say it first" (100). Yet another article, "Do You Scare Guys Away?" strongly dissuades teen girls from taking the initiative in a relationship, lecturing that "[b]eing strong-willed can be hot, but when it's too obvious you're into him—and you create ways to be with him rather than let them happen—you could weird him out. You may also look desperate" (Khidekel, 2005a, 44). Such advice mirrors Amy K. Kiefer and Diana T. Sanchez's (2007) characterization of masculinity as active, concluding that "traditional gender-based sexual roles dictate sexual passivity for women but sexual agency for men" (269).

Paralleling this expectation of males as the initiators of romantic relationships, *CosmoGirl!* accedes to hegemonic masculinity by advising young women to adopt a passive or supporting role in romantic relationships. In "5 Things a Guy Wants in a Girlfriend," teen girls are told that "[a] great girlfriend doesn't let her pride stand in the way of letting her guy walk away from a silly argument at least *thinking* he got his point across (even if you still secretly disagree with him)" (Seidell, 2007, 87). The article also states that girls should avoid "little disagreements" and "pick [their] battles" (87). "The Guys' Code of Romance," a column written from the "voice" of teen boys, subordinates females as passive and elevates males as active by instructing girls to submerge themselves in their boyfriends' interests out of romantic obligation:

> My friend Jennifer tells me her boyfriend always asks her to go with him to basketball games—but sitting in a loud, brightly lit gym is so not romantic to her. My advice to her, and to all of you: Go to the game. When a guy asks a girl to join him in doing stuff he'd normally only do with his guy friends—go to the batting cage, play *Madden*—it may not seem romantic. But by inviting you along to do "guy things," it's as if he's saying, "I feel so close to you, I want to share all of my life with you." So hit those bleachers and cheer on his team. To a guy, it doesn't get any mushier than that! (Gilderman, 2006, 112)

Reinforcing these expectations that girls should "stand by their man" and play the submissive supportive role of nurturer and cheerleader, "5 Things" advises girls thusly:

> Stupid as it may seem, guys get worked up about things like video games and sports. The best girlfriends realize that these things really mean something to guys and affect us on an emotional level. . . . And it's nice to have a girl who'll cheer right along with us, whether or not she really cares what just happened. (Seidell, 2007, 87)

None of the dating columns taken from *CosmoGirl!* featured advice on how to get teen boyfriends more interested and involved in the girls' activities. In accordance with hegemonic masculinity, the hobbies and commitments of young women are presented as inconsequential to the relationship, whereas the interests of boys take center stage. Girls are asked to collaborate in their own subordination by viewing the interests of their (heterosexual) partners as being more important than their own individual investments.

A third, less overt way that boys are represented as the sexual initiators (and instigators) in relationships is through teenage girls' articulation of anxieties about young male libidos. "Under Pressure" most candidly explores this concern, chronicling several girls' encounters with sexually insistent boys. Marcy, the featured girl in the column, leads the discussion:

Whenever my guy and I are alone, he starts kissing me and trying to get me to undress even though I keep telling him I'm not ready to have sex with him. He says just kissing is fine, but then he gets tired of that and starts taking off his clothes. Sometimes I take off my shirt to make him happy. Lately all he wants to do is have sex and I'm afraid he'll leave me after I give in to him. I really like him and don't want that to happen. (Lawrence, 2006a)

"Under Pressure" highlights the experience of three other girls who struggled to negotiate male sexual initiative—Kelly, Heidi, and Leila. Kelly, a 21-year-old from Connecticut, writes that "[i]n high school I dated a guy who pressured me. I was infatuated with him but I listened to my gut and didn't sleep with him. Thank goodness—it turned out he was hooking up with tons of girls and lying to me!" (Lawrence, 2006a). Heidi and Leila, both 17, each were dumped by their boyfriends after refusing their sexual advances.

"Prom Q&A" (2009), a compilation of prom-related advice, also discusses the issue of handling male sexual initiative. One anonymous teen girl asks, "Where are fun places to go after the prom to avoid being in a sex situation with my guy? What if he brings it up?" Another inquires, "I know most guys think of prom night as a guarantee that they're going to score. How can I tell beforehand if my date is one of those guys?" (1). Anxieties about boyfriends who are uninterested in sex, or advice on engaging in pleasurable sex practices initiated by the girl, remain silent in the discourse of *CosmoGirl!*. These findings are consistent with other studies that view female sexual agency as being fraught with anxieties about contracting disease or pursuing bodily pleasure.[9] Broadly read, the representations of young males in *CosmoGirl!* reinforce what Jackson (2005b) and others observe to be a crucial feature of hegemonic masculinity: "the social construction of femininity and masculinity. . . through its positioning of women as passive recipients and men as active instigators" socially, romantically, and sexually (283). Once again, girls are encouraged to see it as being in their best interest to abstain from initiating sexual pleasure, to resist the advances of the elevated male libido, and to deny their own curiosities about sexuality. Such positioning simultaneously encourages girls to expect boys to act accordingly, thus reinforcing rigid codes for teenage boys to be sexual initiators.

Don't Stand Too Close to Me

In addition to casting males as the principal initiators and sexual instigators in relationships, *CosmoGirl!* paradoxically presents teenage boys as emotionally distant and romantically inept. Though there exists research suggesting correlation between gender and emotion that has demonstrated differences in the ways men and women experience and express feelings,[10] Walton, Adrian, and Evanthia (2004) argue that perceived differences in emotional behaviors are "socially con-

stituted"—or created—through performance, discourse, and social scripts (402). Matt Englar-Carlson and David S. Shepard (2005) support this finding in their research on couples counseling, finding that males often struggled in therapy sessions because men are socialized to "appear invulnerable by emphasizing emotional stoicism, physical toughness, and not asking for assistance" (384–385).[11] Y. Joel Wong and Aaron B. Rochlen (2005), summarizing recent research on men and emotional behavior, conclude that men's perceived inability to be emotionally expressive comes from a host of socially scripted causes including a "lack of awareness of emotion, inability to identify feelings, negative evaluations of one's emotions, and perceived lack of social opportunity to express feelings" (69). This research all supports broader conceptions of hegemonic masculinity by reinforcing an invisibility of masculine gender performances and expectation that men be sexually and physically active while requiring women to perform the labor of emotional support and expression.

The dating columns featured in *Cosmo Girl!* participate in the socialization of young men into these harmful emotional attitudes. "Who Loves Ya, Baby?" is one of the most explicit articles "uncensoring" male emotional dysfunction—in this case, non-committal behavior—and opens with the tagline: "he told you he loved you, then he told us the *truth*" (Benson, 2006, 88). In this exposé, six males confess to dishonestly saying "I love you" in order to maintain an intimate relationship. C.J., 19, writes that he used "the L word" to persuade a friend to have sex with him:

> For some stupid *guy reason* I wanted to hook up with my best girl friend, so one night at a party I said "I love you" to her face—we'd said it over the phone before, but it was kind of half serious. We did hook up that night, but it backfired when I realized she wanted a relationship. I have feelings for her, but not those feelings. (88, emphasis added)

Other boys in the article blame emotional inarticulateness or uncertainty for their false declarations of love. Chris, a teen from Murfreesboro, admits "My girlfriend told me 'I love you' after three weeks, so I said it back. But really, I still love my ex, who I talk to on the phone every night. Lying makes me feel like crap, but I know hearing me say it makes her happy" (88). Mirroring other tales of boys who falsely declared their love after a girl had initiated talk of love "too early" in the relationship, the articles of *CosmoGirl!* reinforce hegemonic masculinity by presuming that masculinity means initiating all romantic progression (especially sexual advancement), but without any of the work necessary for nurturing a mutual, emotionally mature relationship.

CosmoGirl! also articulates a number of generalized concerns about male lack of empathy and intimacy. "5 Things" reinforces the mixed messages being sent to

teenage girls. In one sentence, girls are told not to initiate intimacy, in the next, they are told: "don't leave [boys] guessing" because "truth is, guys aren't great at reading subtle hints. . . just tell your guy what you want—it will make your life easier, and he will be a lot less confused" (Seidell, 2007, 87). Similarly, "Do You Tell Him Too Much Too Soon?" warns girls against "over-sharing" emotions and feelings with new boyfriends, and "Just How to Be Friends" states "Guys don't discuss the minute details of their romantic relationships with each other like girls do, so they don't expect platonic girl friends to either. If you do, he'll get confused" (Graham, 2004; Khidekel, 2006, 150). *CosmoGirl!'s* reinforcement of hegemonic masculinity's construction of males as emotionally isolated is consistent with Kirsten B. Firminger's (2006) research on teen girl magazines, in that young female readers are "invited to explore boys as shallow, highly sexual, emotionally inexpressive, and insecure" (306).

Self-disclosure and the "emotional work and maintenance" of relationships, according to hegemonic masculinity, are the provenance of women and girls; through its representation of teenage boys *CosmoGirl!* does not include allowances for boys to become agents of this so-called "feminine" work (305). Qualities associated with femininity are, once again, swiftly cast off as something not *natural* to young men and, by extension, not desirable. Once again, while this characterization is more obviously disadvantaging toward teen girls, it is arguably just as harmful to boys. By reinforcing social codes that would preclude boys and men from exploring their emotions, such discourses function to close men off to important aspects of individual and collective development.

Boys Will Be Boys

Finally, *CosmoGirl!* normalizes (though does not condone) male aggression through a recurrent articulation of female anxiety about physical and emotional abuse. Hegemonic masculinity and relationship aggression are intimately linked, for as Amy Cohn and Amos Zeichner (2006) observe, "men are socialized to appear dominant and powerful," and "may, therefore, learn to use physical force or domineering approaches to resolve conflicts and cope with confrontational situations" (187). Marcia K. Fitzpatrick et al. (2004) offer support for this claim, finding in a psychological survey that increased levels of masculine "gender role ideology" in males correlated positively with both perpetration and acceptance of physical and emotional violence (97–98).[12] Other researchers, such as Theresa C. Kelly and Chris D. Erickson (2007), have criticized earlier studies on the relationship between masculinity and sexual coercion as problematic, but nonetheless concede that both gendered constructions of masculinity and femininity play an important role in fostering relationship aggression (242–243).

A number of articles in *CosmoGirl!* focus on male aggression and abuse, offering advice to teen girls who may find themselves in unhealthy relationships. One article, "Tainted Love," opens with the tagline "are you in love—or are you in *danger*," and recounts the murder of a high school junior, Elizabeth Butler, by her abusive boyfriend, Ariel. The piece then highlights three other high school girls formerly in abusive relationships, each offering their own experience as a cautionary tale to their peers. Katie, for example, "a preppy B+ freshman in high school," became involved with a boy four years her senior who refused to meet her parents and, mistaking a friend's car in her driveway for another boy's, left phone messages saying "who's with you bitch—I'll kill him!" and "I never loved you—I only used you. I hope you die" (Welch, 2005, 136). Carrie, a close friend of Katie, tells of her own abusive relationship, where her boyfriend Jake insisted she have sex with him every day and "instituted a point system, punishing Carrie with points if she did something he didn't like." After incurring over 200 points for offenses such as writing him only one note in school per day or "standing too close to another guy" in the hall, Jake demanded that she redeem herself by "[having] sex with an older guy he knew while he watched" (136).

Another article, "Possessive Boyfriend," follows a similar format. Seeking advice from *CosmoGirl!*'s "Love Doctor"—pop psychologist Cooper Lawrence—16-year-old Laura writes

> I've been with my guy eight months and I love him, but recently he's been controlling and possessive to the point where I've found myself so limited-even as far as just going out with my friends. And I feel brainwashed, thinking I shouldn't even hang out at the movies because it will make him mad. He gets so angry with me that I cry-it sucks! (Lawrence, 2006b, 134)

"The First Time I Realized My Self-Worth" (Miller, 2008), "Love Lessons: Romance Red Flags" (2008), and "I Was Topless on MySpace" (2007) touch on similar themes. In "First Time," high school cheerleader Mitzi Miller recounts her relationship with varsity basketball co-captain and All-State point guard Dexter Riviera, who frequently turned conversations into "CIA-worthy interrogations about [her] alleged flirtatious behavior" and become controlling and derisive (142). "Love Lessons" warns teenage girls about troublesome boy behavior—"he constantly criticizes you," "he doesn't respect your limits," "he tries to control you"—and "Topless" details how Michelle's ex-boyfriend hacked her MySpace account and posted private mobile phone images of her baring her breasts in revenge for ending the relationship (132).

While *CosmoGirl!* certainly does not endorse abusive behavior on the part of teenage boys, its coverage of male psychological and physical aggression nonetheless reinforces traditional gender identities by representing to teenage girls an

image of males consistent with the characteristics of hegemonic masculinity. As Garner et al. (1998) summarize, young women are socialized to perceive hostility and antisocial behavior as an ordinary element of masculinity—"[b]ecause guys are 'inconsiderate,' 'manipulative,' and 'possessive,' girls can expect to be treated like 'dirt'" (70). This representation, as Garner et al. would insist, circulates throughout the culture and functions as a social script on "how women should relate to men" in their romantic lives, which underlines the importance of Jackson's (2005b) suggestion that these constructions reinforce teenage masculinity as being both irresponsible and being driven almost solely by quests for sexual pleasure, power, and control (59).

As with the other themes explored in this essay, the teen readers of *CosmoGirl!* are not invited to question these elements of hegemonic masculinity and investigate the social conditions that encourage aggression and emotional reticence to flourish, but rather are advised on how to adapt to or avoid them ("dump the disrespectful jerk," "break it off, *pronto*," "cut the guy loose"). Such a framework of teaching girls to simply avoid naturalized male aggression is common in U.S. public culture (Hall 2004). Returning once again to Connell's notion of hegemonic masculinity, this tendency follows precisely the power of hegemony, or "the process by which a social order remains stable by *generating consent to its parameters* through the production and distribution of *ideological texts that define social reality for the majority of the people*" (Jasinski, 2001, 283, emphasis added).[13] By using popular mediated discourses to counsel teenage girls only to evade or acclimate themselves to a "social reality" fraught with problematic masculine attitudes and behaviors, *CosmoGirl!* perpetuates hegemonic masculinity by accepting its construction of young males and failing to articulate a "counter-hegemony" that would "challenge the values and practices of the dominant culture" (Jasinski 2001, 283, 285). This failure has strong implications for how teenage girls perceive and (re)act toward teenage boys in our culture, thus influencing how young males come to perceive and (re)act toward themselves and their peers.

Hegemonic Masculinity Reconsidered

Michael Moller (2007) observes, "[I]f masculinities are socially constructed, then there must be conditions under which masculinities can change" (264). This potential for social change and the amelioration of gendered conflict stands at the heart of this chapter. Though the constructions of boys in *CosmoGirl!* reinforce many of the dominating aspects of hegemonic masculinity, Raymond Williams (1977) and other writers commenting on the nature of hegemony emphasize that it is never absolute and never complete. Hegemony is constantly in a state of change; it is always a process of becoming, doing, and undoing. It makes sense, then, to seek out and challenge those elements of hegemonic masculinity that

can be subject to scrutiny and change—an important place to start if we are to begin wrenching apart the myriad systems of dominance and subordination that oppress all who are involved.

Throughout this essay, we have argued that part of how hegemonic masculinity is supported and reinforced is through the public construction of masculinity as *naturally* more active, emotionally withdrawn, and aggressive. However, these representations are never permanent and always dependent on time and place, as the process of gendering is one wherein expectations and foundations are constantly being formed and reformed in response to or anticipation of cultural and historical changes. As Moller (2007) argues, "[I]f masculinities are malleable, at least to some extent, then it becomes less necessary to live with those articulations of masculinity that are damaging. [Our job] then, is to mount and sustain arguments for change" (264). We intend to offer such arguments by exploring some of the implications this study has for how we as scholars and citizens (re)imagine teenage masculinities.

We might begin by drawing an analogy to the study of race. Following the lead of Stuart Hall (1992), Gilbert B. Rodman (2006) discusses problems of representing race in the following way: "[R]acism, as it currently lives and breathes in the United States, depends at least as much on the gaps in contemporary public discourse on race as it does on flawed media representations of people of color" (96–97). This observation can easily be extended to include representations of gender in U.S. public culture, which function in much the same way as race, or age, or class, and so on. The question that we and other critics (should) ask is not one of how accurately the images found in *CosmoGirl!* and other teen magazines represent what *really* goes on in teenage relationships, but rather one of how what is and *is not* represented tells teens how to act and (re)act toward one another. By responding to both the presence and absence of discourses found in this magazine, we aim to elaborate on their significance to a broader critique of hegemonic masculinity and its relationship to the mass media.

First, it should be uncontroversial that our analysis revealed that the information presented in *CosmoGirl!* assumes a primarily heterosexual readership. Such a finding is in line with other analyses of teenage girls' magazines.[14] As Jackson (2005a) points out, this pattern of heterosexual presumptions is "readily understood in the context of a society in which heterosexuality is both normative and compulsory" (291).[15] In our sampling of articles and columns, there were in fact two articles that referred to "alternative" sexualities (LGBT individuals and androgynous sexualities), and while it might seem progressive for other sexual orientations/options to be discussed at all, it is exactly because of its presence that heteronormativity is reinforced. By marking non-hetero sexualities and identities as Other, *CosmoGirl!* bolsters most mainstream discourses that presume heterosexuality as the natural and preferred position to occupy, especially for teenagers

whose sexual identities are always already considered troublesome. This hetero-normatizing affects not only teens who do not identify as straight; the heterosex-ist paradigm in its entirety offers all young men a very narrow range of options for how, when, and with whom they express their intimate, romantic, and sexual interests. Boys in our culture are told time and again that they not only must be interested in girls, but also that they must perform a heterosexual role that denies them the opportunity for intimacy with other boys. Men in this positioning are expected to deny their vulnerability and intimacy in all relationships.

Significantly, the constructions of masculinity found throughout our analysis disallow masculinity as a site for emotional exploration and growth. As Hirdman (2007) notes,

> [S]exual representations show how responsibility for emotional and sexual needs are transferred to women, as is the responsibility to satisfy these needs. In this sense, representations of femininity do not just stand for "the Other" but also for emotional and sexual aspects that masculinity has to place outside itself in order to remain and be regarded as "one substance." (168)

The "one substance" of masculinity is one that rests firmly on one side of the classic mind/body split, thus denying boys and men access to their own emotionality and the benefits associated with the sharing of intimacy with other individuals. The social policing of boys and their intimate relationships promotes a climate wherein teenage boys are all too often stripped of meaningful relationships with individuals of both sexes. This proscription also provides traction for hegemonic expectations that boys will act aggressively toward others rather than with nurturance and compassion.

As noted previously, much of the scholarship that exists regarding girls' or women's magazines focuses on masculinity only, if at all, as a by-product of how these texts construct femininity—masculinity is merely seen as the antithesis to femininity. What most scholarship fails to attend to is how constructions of hegemonic masculinity harm *boys* as well as girls. Though we would acknowledge that patriarchal privilege disadvantages girls and women in ways that are disproportionate to its effects on most boys and men, we cannot overlook how expectations of masculinity unfairly narrow the options available to males and harm their potential to live more fully. The pressures placed on boys who might fall outside of the expectations of hegemonic masculinity are tremendous, especially as it relates to dating and sexual expression. If what is portrayed as *reality* to girls is that boys are naturally emotionally inept, naturally more active, and naturally more aggressive, boys are in turn interpolated into these positions in ways that strip them of agency and determination as individuals and diversity as a group. While it is rather widely acknowledged that boys police the gendered behaviors of other boys

(e.g., through bullying), what this study illustrates is that girls too are conditioned to scrutinize the gendering of boys. Though not as apparently dominating, this type of gendered containment perpetuates damaging cycles of power and control.

Finally, we would be remiss not to comment on how *CosmoGirl!* reinforces hegemonic complicity toward the aggression of boys. On this front, *CosmoGirl!*'s advice to teenage girls might seem somewhat empowering at face value—the magazine acknowledges that girls are thinking about and perhaps engaging in sexual activity and urges girls to end violent or coercive relationships. This surely demonstrates an advancement beyond texts that assume that sex and sexuality are of little relevance to girls; however, once again, the discussions found in *Cosmo-Girl!* implicitly naturalize masculinity as more actively aggressive—the advice to girls is at once contradictory and problematic. *CosmoGirl!* echoes other cultural texts by telling girls to stand unwaveringly by their boys as they play video games and basketball, to avoid "head games" by letting boys affirm their desires first, but to leave a boy who becomes *too* disrespectful. This pattern of supporting and deferring to boys up until they go "too far" does little to challenge the system of hegemonic masculinity that expects boys to push for "too much" and be emotionally absent. This framework also leaves the hegemonic norms intact by responding to a wide-ranging pattern of masculine aggression on a case-by-case basis, rather than at the level of mainstream culture.

In the final analysis, our study of *CosmoGirl!* reinforces research conducted by others on the topic of teenage girls' magazines in a number of ways. Boys are represented in the advice columns and dating articles as more active, emotionally distant, and naturally aggressive. Girls are expected to embrace the opposite characteristics that are associated with being feminine: support boys and their interests, let them take the lead, don't pressure them into intimacy or intimidate them with self-disclosure, and expect—but don't tolerate—abusive or aggressive behavior. What this analysis fundamentally reveals is how such characterizations reinforce an underlying current of hegemonic masculinity that harms girls and boys alike in ways that we ought to challenge. In the end, it is not just the health and well-being of teenagers that is at stake, but also the ability to build a social world that denies the reach and influence of a deeply rooted cultural ideology founded on messages of gender inequality, distrust, and conflict.

Notes

1. See, for example, Durham (1996, 1998); Ferguson (1983); Garner, et al. (1998); Jackson (2005a, 2005b); McCracken (1993); McRobbie (1996, 2000); Peirce (1990); Steiner (1995); Walkerdine (1984); Walsh-Childers et al. (2002); and Winship (1991).
2. See also Whitehead (1999).

3. See, for example, Katz (1995).
4. Following in the scholarly tradition of Antonio Gramsci (1971), to suggest that U.S. culture is guided by hegemonic power is to argue that our dominant ideologies are viewed popularly as "common sense" and accepted generally as beneficial not only to the ruling classes, but to those who are dominated as well.
5. See also Walsh-Childers et al. (2002).
6. See also Brown et al. (1993); Jackson (1999); and Milkie (1999).
7. Though letters are likely crafted by *CosmoGirl!!* writers to represent reader concerns, questions of their validity are unimportant in this context; the printed letters work in tandem with other articles and images presented in the magazine to render a particular construction of what teenage sexuality *does*, and by extension *ought to*, look like (see, for example, Jackson, 2005a).
8. See also Brooks (1995); Tiefer (1995); and Byers (1996).
9. See also Fine (1988); Jackson (2005a); and Vance (1992).
10. See, for example, Averill (1983); Brody (1993); Fischer and Manstead (2000); and Jansz (2000).
11. See also Bruch (2002).
12. See also Aromäki et al. (2002).
13. See also Cloud (1996).
14. See, for example, Carpenter (1998); Jackson (2005a, 2005b); and Medley-Rath (2007).
15. See also Rich (1980).

Works Cited

Aromäki, Anu S., Kim Haebich, and Ralf E. Lindman. "Age as a Modifier of Sexually Aggressive Attitudes in Men." *Scandinavian Journal of Psychology.* 43 (2002): 419–423. *EBSCO.* Web. 10 Mar. 2009.

Averill, James R. "Studies on Anger and Aggression: Implications for Theories of Emotion." *American Psychologist.* 38 (1983): 1145–1160. *EBSCO.* Web. 10 Mar. 2009.

Benson, Elisa. "Who Loves Ya, Baby?" *Cosmo Girl!* 1 Oct. 2006: 88. *Lexis-Nexis.* Web. 26 Feb. 2009.

Brody, Leslie R. "On Understanding Gender Differences in the Expression of Emotions." *Human Feelings: Explorations in Affect Development and Meaning.* Eds. Steven L. Ablon, Daniel Brown, John E. Mack, and Edward Khantazian. Hillsdale, NJ: Analytic, 1993. 87–121.

Brooks, Gary R. *The Centerfold Syndrome: How Men Can Overcome Objectification and Achieve Intimacy with Women.* San Francisco, CA: Jossey-Bass, 1995.

Brown, Jane D., Bradley S. Greenberg, and Nancy L. Buerkel-Rothfuss. "Mass Media, Sex, and Sexuality." *Adolescent Medicine: State of the Art Reviews.* 4 (1993): 511–525. *ERIC.* Web. 15 Mar. 2009.

Bruch, Monroe A. "Shyness and Toughness: Unique and Moderated Relations with Men's Emotional Inexpression." *Journal of Counseling Psychology.* 49.1 (2002): 28–34. *EBSCO.* Web. 10 Mar. 2009.

Byers, E. Sandra. "How Well Does the Traditional Sexual Script Explain Coercion? Review of a Program of Research." *Journal of Psychology and Human Sexuality.* 8 (1996): 7–25.

Carpenter, Laura M. "From Girls into Women: Scripts for Sexuality and Romance in *Seventeen* Magazine, 1974–1994." *The Journal of Sex Research.* 35 (1998): 158–168. *EBSCO.* Web. 10 Mar. 2009.

Cloud, Dana L. "Hegemony or Concordance? The Rhetoric of Tokenism in 'Oprah' Winfrey's Rags-to-Riches Biography." *Critical Studies in Mass Communication.* 13 (1996): 115–137. *EBSCO.* Web. 26 May 2010.

Cohn, Amy and Amos Zeichner. "Effects of Masculine Identity and Gender Role Stress on Aggression in Men." *Psychology of Men & Masculinity.* 7.4 (2006): 179–190. *EBSCO.* Web. 26 May 2010.

Connell, Robert W. *Masculinities.* Cambridge: Polity, 1995.

———. "Teaching the Boys: New Research on Masculinity and Gender Strategies for Schools." *Teachers College Record.* 98.2 (1996): 206–234. *EBSCO.* Web. 10 Mar. 2009.

Consalvo, Mia. "The Monsters Next Door: Media Constructions of Boys and Masculinity." *Feminist Media Studies.* 3.1 (2003): 27–45. *EBSCO.* Web. 26 May 2010.

Craig, Steve. "Considering Men in the Media." *Men, Masculinity, and the Media.* Ed. Steve Craig. Newbury Park, CA: Sage, 1992. 1–7.

Currie, Dawn H. *Girl Talk: Adolescent Magazines and Their Readers.* Toronto: University of Toronto Press, 1999.

Durham, Gigi. "The Taming of the Shrew: Women's Magazines and the Regulation of Desire." *Journal of Communication Inquiry.* 20 (1996): 18–31. *EBSCO.* Web. 10 Mar. 2009.

Durham, Meenakshi Gigi. "Dilemmas of Desire: Representations of Adolescent Sexuality in Two Teen Magazines. *Youth & Society.* 29 (1998): 369–389. *EBSCO.* Web. 10 Mar. 2009.

Dyer, Richard. *Only Entertainment.* London & New York: Routledge, 2002.

Easthope, Antony. *What a Man's Gotta Do?: The Masculine Myth in Popular Culture.* Boston, MA: Unwin Hyman, 1990.

Englar-Carlson, Matt and David S. Shepard. "Engaging Men in Couples Counseling: Strategies for Overcoming Ambivalence and Inexpressiveness." *The Family Journal: Counseling and Therapy for Couples and Families.* 13.4 (2005): 383–391. *EBSCO.* Web. 10 Mar. 2009.

Ferguson, Marjorie. *Forever Feminine: Women's Magazines and the Cult of Femininity.* London: Heinemann, 1983.

Fine, Michelle. "Sexuality, Schooling, and Adolescent Females: The Missing Discourse of Desire." *Harvard Educational Review.* 58 (1988): 29–53. *EBSCO.* Web. 10 Mar. 2009.

Firminger, Kirsten B. "Is He Boyfriend Material?: Representation of Males in Teenage Girls' Magazines." *Men and Masculinities.* 8.3 (2006): 298–308. *EBSCO.* Web. 10 Mar. 2009.

Fischer, Agneta H. and Antony S.R. Manstead. "The Relation between Gender and Emotion in Different Cultures." *Gender and Emotion: Social Psychological Perspectives.* Ed. Agneta Fischer. Cambridge: Cambridge University Press, 2000. 71–94.

Fiske, John, *Media Matters: Everyday Culture and Political Change.* Minneapolis, MN: University of Minnesota Press, 1994.

Fitzpatrick, Marcia K., Dawn M. Salgado, Michael K. Suvak, Lynda A. King, and Daniel W. King. "Associations of Gender and Gender-Role Ideology with Behavioral and Attitudinal Features of Intimate Partner Aggression." *Psychology of Men & Masculinity.* 5.2 (2004): 91–102. *EBSCO.* Web. 10 Mar. 2009.

Gamson, William A. "On a Sociology of the Media." *Political Communication.* 21 (2004): 305–307. *EBSCO.* Web. 10 Mar. 2009.

Gans, Herbert J. *Deciding What's News.* New York: Vintage, 1979.

Garner, Ana, Helen M. Sterk, and Shawn Adams. "Narrative Analysis of Sexual Etiquette in Teenage Magazines." *Journal of Communication.* 48.4 (1998): 59–79. *EBSCO.* Web. 10 Mar. 2009.

Gavey, Nicola and Kathryn McPhillips. "Subject to Romance: Heterosexual Passivity as an Obstacle to Women Initiating Condom Use." *Psychology of Women Quarterly.* 23 (1999): 349–367. *EBSCO.* Web. 10 Mar. 2009.

Gilderman, Gregory. "The Guys' Code of Romance." *Cosmo Girl!* 1 Apr. 2006: 112. *Lexis-Nexis.* Web. 26 Feb. 2009.

Gitlin, Todd. *The Whole World is Watching: Mass Media in the Making and Unmaking of the New Left.* Berkeley, CA: University of California Press, 1980.

Graham, Jennifer. "Do You Tell Him Too Much Too Soon?" *Cosmo Girl!* 1 Dec. 2004. *Lexis-Nexis.* Web. 26 Feb. 2009.

Gramsci, Antonio. *Selections from the Prison Notebooks.* New York: International, 1971.

Hall, Rachel. "'It Can Happen to You:' Rape Prevention in the Age of Risk Management." *Hypatia.* 19.3 (2004): 1–19. *EBSCO.* Web. 26 May 2010.

Hall, Stuart. "Race, Culture, and Communications: Looking Backward and Forward at Cultural Studies." *Rethinking Marxism.* 5.1 (1992): 10–18. *Informaworld.* Web. 15 Mar. 2009.

Hall, Stuart (Ed). "The Work of Representation." *Representation: Cultural Representations and Signifying Practices.* London: Sage, 1997. 13–74.

Hartley, John. *Understanding News.* London: Methuen, 1982.

Hirdman, Anja. "(In)Visibility and the Display of Gendered Desire: Masculinity in Mainstream Soft- and Hardcore Pornography." *NORA—Nordic Journal of Women's Studies.* 15.2–3 (2007): 158–171. *EBSCO.* Web. 15 Mar. 2009.

hooks, bell. *Feminist Theory: From Margin to Center.* Boston, MA: South End, 2000.

"I Was Topless on MySpace." *Cosmo Girl!* 1 Sep. 2007: 132. *Lexis-Nexis.* Web. 26 Feb. 2009.

Jackson, Stevi. *Heterosexuality in Question.* Thousand Oaks, CA: Sage, 1999.

Jackson, Sue. "'Dear Girlfriend. . . ': Constructions of Sexual Health Problems and Sexual Identities in Letters to a Teenage Magazine." *Sexualities.* 8 (2005a): 282–305. *EBSCO.* Web. 10 Mar. 2009.

———. "'I'm 15 and Desperate for Sex': 'Doing' and 'Undoing' Desire in Letters to a Teenage Magazine." *Feminism & Psychology.* 15 (2005b): 295–313. *EBSCO.* Web. 10 Mar. 2009.

Jansz, Jeroen. "Masculine Identity and Restrictive Emotionality." *Gender and Emotion: Social Psychological Perspectives.* Ed. Agneta H. Fischer. Cambridge: Cambridge University Press, 2000. 166–186.

Jasinski, James. "Hegemony." *Sourcebook on Rhetoric: Key Concepts in Contemporary Rhetorical Studies.* Ed. James Jasinski. Thousand Oaks, CA: Sage, 2001. 308–312.

Katz, Jackson. "Advertising and the Construction of Violent White Masculinity." *Gender, Race, and Class in Media: A Text Reader.* Eds. Gail Dines and Jean M. Humez. Thousand Oaks, CA: Sage, 1995.

Kellner, Douglas. "The Sports Spectacle, Michael Jordan, and Nike: An Unholy Alliance?" *Michael Jordan, Inc.: Corporate Sport, Media Culture, and Late Modern America.* Ed. David Andrews. New York: SUNY Press, 2001. 37–64.

Kelly, Theresa C. and Chris D. Erickson. "An Examination of Gender Role Identity, Sexual Self-Esteem, Sexual Coercion and Sexual Victimization in a University Sample." *Journal of Sexual Aggression.* 13.3 (2007): 235–245. *EBSCO.* Web. 10 Mar. 2009.

Khidekel, Marina. "Do You Scare Guys Away?" *CosmoGirl!* 1 Oct. 2005a: 44. *Lexis-Nexis.* Web. 26 Feb. 2009.

Khidekel, Marina. "Thanks, Guys!" *CosmoGirl!* 1 Feb. 2005b: 56. *Lexis-Nexis.* Web. 26 Feb. 2009.

———. "Just How to Be Friends with a Guy." *CosmoGirl!* 1 Apr. 2006: 150. *Lexis-Nexis.* Web. 26 Feb. 2009.

———. "The New Dating Rules." *CosmoGirl!* 1 Feb. 2007a: 96. *Lexis-Nexis.* Web. 26 Feb. 2009.

———. "The Rise of the Playerette." *CosmoGirl!* 1 Nov. 2007b: 100. *Lexis-Nexis.* Web. 26 Feb. 2009.

———. "How to Make Love Last." *CosmoGirl!* 1 Feb. 2008a: 100. *Lexis-Nexis.* Web. 26 Feb. 2009.

———. "The Gray Area Guy." *CosmoGirl!* 1 May 2008b. *Lexis-Nexis.* Web. 26 Feb. 2009.

Kiefer, Amy K. and Diana T. Sanchez. "Scripting Sexual Passivity: A Gender Role Perspective." *Journal of Social and Personal Relationships.* 14 (2007): 269–290. *EBSCO.* Web. 10 Mar. 2009.

Lawrence, Cooper. "Under Pressure." *CosmoGirl!* 1 Sep. 2006a. *Lexis-Nexis.* Web. 26 Feb. 2009.

————. "Possessive Boyfriend?" *CosmoGirl!* 1 Mar. 2006b: 134. *Lexis-Nexis.* Web. 26 Feb. 2009.

"Love Lessons: Romance Red Flags." *Cosmo Girl!* 1 Mar. 2008. *Lexis-Nexis.* Web. 26 Feb. 2009.

McCracken, Ellen. *Decoding Women's Magazines: From Mademoiselle to Ms.* Houndmills, UK: Macmillan, 1993.

McRobbie, Angela. "More! New Sexualities in Girls' and Women's Magazines." *Cultural Studies and Communication.* Eds. David Morley, James Curran, and Valerie Walkerdine. London: Edward Arnold, 1996. 172–195.

————. *Feminism and Youth Culture.* New York: Routledge, 2000.

Medley-Rath, Stephanie R. "'Am I Still a Virgin?': What Counts as Sex in 20 Years of *Seventeen.*" *Sexuality and Culture.* 11 (2007): 24–38. *Informaworld.* Web. 15 Mar. 2009.

Milkie, Melissa A. "Social Comparisons, Reflected Appraisals, and Mass Media: The Impact of Pervasive Beauty Images on Black and White Girls' Self-Concepts." *Social Psychology Quarterly.* 62 (1999): 190–210. *EBSCO.* Web. 10 Mar. 2009.

Miller, Mitzi. "The First Time I Realized My Self-Worth." *Cosmo Girl!* 1 Jun. 2008: 142. *Lexis-Nexis.* Web. 26 Feb. 2009.

Moller, Michael. "Exploiting Patterns: A Critique of Hegemonic Masculinity." *Journal of Gender Studies.* 16.3 (2007): 263–276. *EBSCO.* Web. 10 Mar. 2009.

Peirce, Kate. "Socialization of Teenage Girls through Teen-Magazine Fiction: The Making of a New Woman or an Old Lady?" *Sex Roles.* 23 (1990): 491–500. *EBSCO.* Web. 10 Mar. 2009.

"Prom Q&A." *Cosmo Girl!* 1 Jan. 2009: 1. *Lexis-Nexis.* Web. 26 Feb. 2009.

Prusank, Diane T. "Masculinities in Teen Magazines: The Good, the Bad, and the Ugly." *The Journal of Men's Studies.* 15.2 (2007): 160–177. *EBSCO.* Web. 10 Mar. 2009.

Rich, Adrienne. "Compulsory Heterosexuality and Lesbian Existence." *Signs: Journal of Women in Culture and Society.* 5 (1980): 631–660. *EBSCO.* Web. 10 Mar. 2009.

Rodman, Gilbert B. "Race . . . and Other Four Letter Words: Eminem and the Cultural Politics of Authenticity." *Popular Communication.* 4.2 (2006): 95–121. *EBSCO.* Web. 10 Mar. 2009.

Sardis, Kristen. "Love Advice from . . . Jessie McCartney." *Cosmo Girl!* 1 Sep. 2006: 66. *Lexis-Nexis.* Web. 26 Feb. 2009.

Seal, David Wyatt and Anke A. Ehrhardt. "Masculinity and Urban Men: Perceived Scripts for Courtship, Romantic and Sexual Interactions with Women." *Culture, Health & Sexuality.* 5.4 (2003): 295–319. *EBSCO.* Web. 10 Mar. 2009.

Seidell, Streeter. "5 Things Guys Want in a Girlfriend." *Cosmo Girl!* 1 Mar. 2007: 87. *Lexis-Nexis.* Web. 26 Feb. 2009.

Steiner, Linda. "Would the Real Women's Magazine Please Stand Up . . . For Women." *Women and the Media: Content, Careers, and Criticism.* Ed. Cynthia M. Lont. Belmont, CA: Wadsworth, 1995. 99–110.

Tiefer, Leonore. *Sex is Not a Natural Act and Other Essays.* Boulder, CO: Westview, 1995.

Treise, Debbie and Alyse Gotthoffer. "Stuff You Couldn't Ask Your Parents: Teens Talking About Using Magazines for Sex Information." *Sexual Teens, Sexual Media: Investigating Media's Influence on Adolescent Sexuality.* Eds. Jane D. Brown, Jeanne R. Steele, and Kim Walsh-Childers. Mahwah, NJ: Lawrence Erlbaum, 2002. 173–189.

Vance, Carole S. (Ed). "More Danger, More Pleasure: A Decade after the Barnard Sexuality Conference." *Pleasure and Danger: Exploring Female Sexuality.* London: Pandora, 1992. xvi–xxxv.

Walkerdine, Valerie. "Some Day My Prince Will Come: Young Girls and the Preparation for Adolescent Sexuality." *Gender and Generation.* Eds. Angela McRobbie and Mica Nava. Basingstoke, UK: Macmillan, 1984. 162–184.

Walsh-Childers, Kim B., Gotthoffer, Alyse, and Lepre, Carolyn Ringer. "From 'Just the Facts' to 'Downright Salacious': Teens' and Women's Magazine Coverage of Sex and Sexual Health." *Sexual Teens, Sexual Media: Investigating Media's Influence on Adolescent Sexuality.* Eds. Jane D. Brown, Jeanne R. Steele, and Kim B. Walsh-Childers. Mahwah, NJ: Lawrence Erlbaum, 2002. 153–171.

Walton, Chris, Adrian Coyle, and Evanthia Lyons. "Death and Football: An Analysis of Men's Talk About Emotions." *British Journal of Social Psychology.* 43 (2004): 401–416. *EBSCO.* Web. 10 Mar. 2009.

Welch, Liz. "Tainted Love." *Cosmo Girl!* 1 Nov. 2005: 136. *Lexis-Nexis.* Web. 26 Feb. 2009.

Whitehead, Stephen. "Hegemonic Masculinity Revisited." *Gender, Work, and Organization.* 6.1 (1999): 58–62. *EBSCO.* Web. 10 Mar. 2009.

Williams, Raymond. *Marxism and Literature.* Oxford, UK: Oxford University Press, 1977.

Winship, Janice. "The Impossibility of *Best*: Enterprise Meets Domesticity in the Practical Women's Magazines of the 1980s." *Come on Down? Popular Media Culture in Post-war Britain.* Eds. Dominic Strinati and Stephen Wagg. London: Routledge, 1991. 82–115.

Wong, Y. Joel and Aaron B. Rochlen. "Demystifying Men's Emotional Behavior: New Directions and Implications for Counseling and Research." *Psychology of Men & Masculinity.* 6.1 (2005): 62–72. *EBSCO.* Web. 10 Mar. 2009.

Depicting Boyhood(s) in the Media

From "Booger Breath" to "The Guy": Juni Cortez Grows Up in Robert Rodriguez's *Spy Kids* Trilogy

Phillip Serrato

In the 1990s and into the 21st century, books such as *Real Boys* (1998) by William Pollack, *Raising Boys* (1998) by Steve Biddulph, and *Raising Cain* (1999) by Dan Kindlon and Michael Thompson exhorted parents and teachers to tend to the emotional and psychological welfare of boys. As suggested by subtitles such as "Rescuing Our Sons from the Myths of Boyhood," "Why Boys Are Different—And How to Help Them Become Happy and Well-Balanced Men," and "Protecting the Emotional Life of Boys," these texts dispute presumptions that boys are intrinsically resilient and tough individuals. In a distinctively alarmist manner, in fact, they depict contemporary boys as emotionally distressed and psychologically vulnerable due to experiences with, among other things, loneliness, bullying, and oppressive gender expectations.

Reflective of contemporaneous cultural concerns, Juni Cortez (Daryl Sabara) suffers through these same challenges in writer/director Robert Rodriguez's *Spy Kids* trilogy of films, *Spy Kids* (2001), *Spy Kids 2: Island of Lost Dreams* (2002), and *Spy Kids 3–D: Game Over* (2003). Initially besieged by feelings of inferiority, isolation, and abjection, the boy struggles over the course of the trilogy to arrive at a confident sense of self. For boy viewers working through the same sorts of issues that haunt Juni, his character could presumably provide a crucial point of identification. In Juni, a similarly conflicted boy could find validation of his own experiences, something which Pollack contends is essential for a boy to "[begin] to feel less ashamed of his own vulnerable feelings" (8). By the same token, the

eventual resolution of Juni's conflicts demonstrates for boy audiences the possibility of transcending the challenges of boyhood, actualizing, one might say, a fantasy of empowerment. However, inasmuch as the transformation of Juni might offer pleasure to boy viewers who identify with him, it simultaneously reinforces dominant associations of mature masculinity with self confidence, emotional invulnerability, and professional distinction, all of which are characteristics that Juni embodies by the conclusion of the third film. In effect, rather than expose and deconstruct the masculine ideals that continue to be imposed on boys, the *Spy Kids* films end up leaving these very ideals and their desirability intact.

Up from Abjection

The first *Spy Kids* installment introduces audiences to Gregorio and Ingrid Cortez (Antonio Banderas and Carla Gugino) and their children, Carmen (Alexa Vega) and Juni. According to a backstory provided in the form of a bedtime tale that Ingrid tells the children at the start of the film, Gregorio and Ingrid once worked for opposing spy agencies. When, by a twist of fate, each is assigned to assassinate the other, they end up falling in love. Of course they marry, and when they do they retire from spy work so they can raise their children. Amidst the relative doldrums of domesticity, the two accept a mission that requires them to venture to the castle of Fegan Floop (Alan Cumming), the host of the popular children's television program *Floop's Fooglies*. Floop, it turns out, is working on the side as a contractor for Mr. Lisp (Robert Patrick), a villain who has hired Floop to create a robot army that will help him take over the world. Apparently, a number of spies from the OSS spy agency have tried to foil Floop's work only to end up captured by Floop and transformed into one of his Fooglies, the bizarre characters who serve as Floop's sidekicks on his show. When Gregorio and Ingrid return to action to stop Floop and Lisp and rescue the captured agents, they too are caught and detained by Floop. It then befalls Juni and his big sister to travel to Floop's island and save their parents. While the circumstances within which Carmen and Juni find themselves set the stage for the possible maturation and empowerment of both characters, the film is primarily organized around Juni's development of courage and self reliance.

The empowerment that Juni exhibits by the end of the film constitutes a dramatic change from his condition at the start. In the film's opening sequence, viewers find him in the bathroom, a space intrinsically associated—especially in childhood—with shame and the abject. With a dejected expression that bespeaks a compromised self esteem, Juni stands before a mirror applying drops of medicine to the numerous warts that dot his fingers. Clearly, the eruptions on his fingers signify for him his abjection vis-à-vis his apparent aberration from normative, implicitly hygienic embodiment. That he is standing in front of a mirror

and contemplating his image while he tends to his fingers is a crucial detail; the crafting of the mise-en-scène clearly plays on psychoanalytic presumptions of the integral role of processes of mirroring in identity formation. Specifically, as Juni's eyes toggle between his fingers and his visage in the mirror, he is denied the narcissistic pleasure that Lacan describes in his discussion of the mirror stage. In Lacan's formulation (1977),

> The fact is that the total form of the body by which the subject anticipates in a mirage the maturation of his power is given to him only as *Gestalt*, that is to say, in an exteriority in which this form is certainly more constituent than constituted, but in which it appears to him above all in a contrasting size . . . that fixes it and in a symmetry that inverts it, in contrast with the turbulent movements that the subject feels are animating him. (2)

Whereas Lacan posits that the (child) subject's encounter with his/her specular image enables a coherent, and therefore pleasurable, sense of self by providing a refreshingly stable template for self recognition and constitution, the trouble for Juni is that the body that he sees in the mirror is not nicely bounded and coherent.

Consequently, instead of witnessing Juni's indulgence of narcissistic pleasure, we see illustrated Julia Kristeva's complication of narcissism:

> Even before being *like*, "I" am not but do *separate, reject, ab-ject*. Abjection, with a meaning broadened to take in subjective diachrony, *is a precondition of narcissism*. It is coexistent with it and causes it to be permanently brittle. The more or less beautiful image in which I behold or recognize myself rests upon an abjection that sunders it as soon as repression, the constant watchman, is relaxed. (13)

Most obviously, narcissism eludes Juni because the immediacy of his warts makes the repression of his own abjection impossible. Along these lines, Juni cannot perform the "separation, rejection, or ab-jection" that Kristeva mentions because he has no other over and against which to assert and define himself. Instead, he is mired in what Kristeva calls "the abjection of self" (5). According to Kristeva, the abject "is experienced at the peak of its strength when that subject, weary of fruitless attempts to identify with something on the outside, finds the impossible within; when it finds that the impossible constitutes its very *being*, that it *is* none other than abject. . . . There is nothing like the abjection of self to show that all abjection is in fact recognition of the want on which any being, meaning, language, or desire is founded" (5). In the case of Juni, the incompleteness and imperfection that he sees in the mirror produces an encounter—or reencounter—with "want," which ultimately underwrites his abjection.

The gendered implications of Juni's abjection certainly compound his shame and humiliation. Once again, the psychodynamics of abjection that Kristeva de-

lineates offer a means of theorizing the persistent "turbulence" that Juni experiences in the bathroom. In particular, her postulation that "The abject confronts us. . . with our earliest attempts to release the hold of the *maternal* entity" (13) enables the idea that his warts betoken the threat of a feminine subsumption of his emerging masculine self. As Kristeva notes, "The abject shatters the wall of repression and its judgments. It takes the ego back to its source on the abominable limits from which, in order to be, the ego has broken away" (15). On a much more conscious level, however, a correlation between nervousness, sweaty hands, and warts leads Juni to regret that his warts attest to an unacceptable emotional weakness on his part. To be sure, his understanding of the causes of warts is inaccurate, but the fact remains that in his mind warts signify a deficiency that situates him at a distance from proper masculinity. Symbolically, the pastel colors of the bandages that he wraps around his medicine-treated fingers underscore his alienated relationship to normative masculinity. Since these colors are stereotypically inconsistent with masculinity, his bandages effectively reflect and reinforce the imbrication of his abjection and his apparent gender failure. Interestingly, Juni's sensitivity to the gendered implications of his abjection reveals itself in the strategy he utilizes to surmount his condition. While contemplating his image in the mirror, he decides to imagine himself anew. To this end, he first removes his fingers from view, which allows for the momentary repression of his abjection. He then raises his chin, puffs out his chest, and warps his lips into a slight snarl in an effort to work himself into a more aggressive persona. Evidently, he wants—both in terms of desire and lack—"proper" masculinity.

The posturing that Juni tries on also constitutes an imaginary strategy for standing up to the various others who have instilled in him the inferiority that haunts him. First, his mother and sister emerge as his primary antagonists. In both relationships, Juni chafes against the females' authority over him as well as their potential to humiliate him. For example, when his mother reminds him in the opening sequence to brush his teeth before bed (and thus not be abject), the boy brusquely replies, "I am, I am," in a manner intended to neutralize her power over him (and perhaps keep at bay *"the constant risk of falling back under the sway of a power* as securing as it is *stifling"* [Kristeva, 1982, 13]). Shortly thereafter, when she asks to check his bandaged fingers, he refuses, tucking his hands behind his back to limit her ability to reinforce the shame that he already feels. Carmen, meanwhile, poses an even greater threat to the boy's self esteem due to the merciless disdain with which she treats him. By continuously hurling names at him such as "scaredy cat," "little twerp," and "butterfingers," she not only infantilizes and abjectifies him, but also contributes to his painful feelings of alienation from his own family.

Between the conflicts that arise with his mother and sister, a very conventional—and very problematic—stage seems to be set for Juni to recover his dignity

via an assertion of himself over and against the feminine. This of course would rehearse the all-too-familiar edict that a boy's assumption of normative masculinity depends on his repudiation and domination of the feminine. But soon enough viewers learn that females are not the only sources of distress for him. In a private conversation between Ingrid and Gregorio about problems that the children are having at school, Ingrid reveals to Gregorio, "And those school friends Juni talks about? No such beasts. It turns out the other kids pick on him. He has no friends." Accordingly, the only time we see Juni at school, a boy approaches him and taunts, "Hey, it's the mummy. Nice looking bandages, mummy." To no avail, Juni protests, "Just stop it, man." The bully forces himself on Juni, however, by proclaiming, "When I'm talking to you, you listen," which reduces Juni to a painfully belittled position. Once he finally makes his way into the school building, Juni sits alone, obviously disgraced, only to overhear Carmen pass by and complain to the several friends who flank her, "I even have to share a room with him because he's afraid of being alone." Unsurprisingly, Carmen's remark leaves Juni even more depressed and looking more and more like the kind of anguished and withdrawn boy that Kindlon and Thompson depict (142–143).

Given the loneliness and low self-esteem from which Juni suffers both at home and school, the appeal for him of *Floop's Fooglies* makes sense. Aesthetically reminiscent of recent children's fare such as *Teletubbies*, *Boobah*, and *Yo Gabba Gabba*, *Floop's Fooglies* is a hypercolorful program that features its host performing songs and delivering messages of encouragement to his young viewers. In one musical number, for instance, Floop promises,

> It's a cruel, cruel world
> All you little boys and girls
> And some mean nasty people
> Want to have you for their supper
> But if you follow me
> You can all be free!
> FREE!
> You can all be free!

With lyrics such as these and exhortations such as "Always remember, whatever you do, believe in yourself. Your dreams will come true," it is no wonder that watching the show brings a smile to Juni's face. As removed as he is, Floop constitutes the only source of inspiration, validation, and consolation available to Juni. Not to be overlooked, the presence of the Fooglies on the show reinforces for Juni the appeal of Floop. The Fooglies are the gibberish-speaking, rather monstrous-looking cast of sidekicks who participate in the program's onscreen shenanigans. Floop's apparent willingness to befriend these otherwise hideous creatures con-

vinces Juni that he is someone who takes in the abject. Consequently, when Juni overhears Carmen's rant about having to share a room with him, he says to the Floop action figure in his hand, "What's so special about being a Cortez? I wish I could go away to your world, Floop. You'd be my friend." As far as Juni is concerned, the presence of the Fooglies on Floop's show suggests that Floop might be inclined to befriend alienated and abject little boys, too.

The opportunity for Juni to transcend his abjection arises once Gregorio and Ingrid are captured on their spy mission and he and Carmen must rescue them. The first indication of a bolder, more empowered Juni appears when the children find their way to the workshop of their estranged uncle, Machete (Danny Trejo). Machete, the children discover, is a spy gadget designer who has not seen his brother Gregorio in years because of an unspecified falling out between the two. Due to his strained relationship with his brother, when Carmen and Juni track down Machete and ask for his help, he refuses. This puts the children in the position of having to take matters into their own hands. Subsequently, in the middle of the night, Carmen and Juni steal away in one of their uncle's mini-planes. Notably, when the hour arrives for them to make their escape, Carmen, with a glowstick in hand to light her way, approaches Juni's bed and asks, "Ready?" In response, the boy who had previously been an emblem of fear confidently states, "Let's go," at which point he unveils from beneath his pillow his own glowstick. In a rather blatant dramatization of Juni's emerging claim to normative (phallic) masculinity—and its corollaries of power, courage, and confidence—Juni's stick is markedly longer than Carmen's. Obviously, the visual suggestion is that Juni is indeed not just ready to meet the demands of their mission, but readier than Carmen. Unfortunately, among other things, this suggestion of a competition (which Juni wins) between Carmen and Juni over phallic mettle inaugurates a dynamic in which Juni's progression toward masculine integrity and distinction occurs alongside the disempowerment and subordination of his sister.

In a key moment during the flight, Juni definitively turns the tables of humiliation on his sister and turns a crucial corner in his *Entwicklungsroman*, or process of growth and maturation. As one would expect, neither of the children knows how to operate Machete's mini-plane. With Juni at the controls while she fumbles with the instructions, Carmen hurls a slew of insults at her brother, including "meat head," "warthog," and "booger breath." On this occasion, however, rather than internalize and capitulate to Carmen's verbal abuse, Juni repeatedly cautions her, "I'm warning you," and, "Stop it, or I'll call you names." Brimming with confidence, Carmen sharply asserts, "Go ahead. You got nothing on me." The boy does prove to have something on her, however; eventually he shuts her up (and thus down) by calling her "diaper lady." Immediately Carmen ceases and asks, "How long have you known?" which confirms to Juni and the audience that her little brother has managed to out-humiliate her and reduce her to an especially

infantile and abject condition. Importantly, the confirmation from Carmen that she is indeed the "diaper lady" overturns any presumption the audience might have carried that Juni wets the bed. When in captivity, Gregorio worries aloud about the ability of the children to fend for themselves, complaining, "They still wear diapers." In a cryptic manner, Ingrid insists, "Only one is in diapers and only at night. It's not that unusual, OK?" With Juni previously established as the more juvenile, more abject of the siblings, it is easy for the audience at this earlier point to jump to the conclusion that he is the bedwetter. Once it emerges during the plane ride that in fact Carmen, and not Juni, wets the bed, Juni begins recovering, at his sister's expense, some dignity and power for himself.

Juni's new potential to be more than just an abject little brother is realized once the siblings arrive on Floop's island and Juni finds himself left to his own devices. As the children snoop around Floop's castle in search of their parents, Carmen stumbles through a trap door. When she falls and cries out, "Find mom and dad," Juni assumes sole responsibility for completing the mission. In turn, the opportunity arises for him to find the courage, confidence, and self-reliance that he has hitherto lacked. Incidentally, the fact that this development coincides with the removal of Carmen from the narrative underscores her status as an obstacle to his development. Once she is removed, Juni proves himself capable of fending for himself and overcoming obstacles. He finds Floop, convinces him to reprogram the robot children he has made to be good, and frees both Carmen and his parents. In the process, he extricates himself from his initial condition of abjection.

Self-Differentiation, Self-Determination, and the Consolidation of Selfhood

Whereas the first *Spy Kids* film depicts Juni's negotiation of his inferiority complex, *Spy Kids 2* presents Juni as an emerging adolescent who increasingly asserts an autonomous sense of self via the self-conscious differentiation of himself from others. The film revolves around the efforts of Carmen and Juni—both of whom are now officially recognized Level 2 OSS agents—to recover the Transmooker device, a small, indescribably powerful apparatus that in the wrong hands could (somehow) mean the takeover—or even the end—of the world. Although the fate of the world hinges on the recovery of the Transmooker, the recovery of the device also becomes a means for Juni to restore his good name and professional integrity, both of which have been blemished by Gary Giggles (Matt O'Leary), a rival spy kid who early in the film unfairly blames Juni for the theft of the device. By the end of the film, Juni restores his good name and professional integrity by helping to save the world from domination by Donnagon Giggles (Mike Judge), Gary's father and the newly appointed director of the OSS. Donnagon, it turns out, or-

chestrated the Transmooker heist. By the end of the film, Donnagon is thwarted, but above all else, viewers see Juni embody masculine autonomy.

At the start of the second film Juni immediately displays his newfound maturity. It begins with Alexandra (Taylor Momsen), the daughter of the president of the United States, causing a stir at the Troublemaker theme park by climbing onto the ledge of the Juggler thrill ride. With the Transmooker device in her hand, she demands personal time with her absent father. Recognizing a need for the special talents of Carmen and Juni, Secret Service agents on the ground radio for the assistance of the siblings. Interestingly, when Carmen and Juni appear, they are wearing propeller hats and eating cotton candy. Evidently, they have been enjoying themselves at the amusement park. However, as soon as the realization that they need to work sets in, they toss aside the trappings of childhood fun and jump into action. That Juni springs into action without hesitation attests in particular to his courage and confidence. As Carmen attempts to shut down the ride from the control box, Juni climbs, with the aid of some Spiderman-like gloves, to the top of the ride where he exhibits an ability to listen carefully to Alexandra and explain, in a noticeably measured manner, why she should come down from the ledge. With a combination of wisdom and consolation, as well as the promise that as a Level 2 agent—which he proves by flashing his clearly marked badge—he has the power to force her father to meet with her, he talks her down and ends the crisis.

Certainly, Juni's possession of a Level 2 badge carries a host of implications. Foremost, it documents his entry into the prestigious echelons of the OSS. Given the usual standing of children as "marginalized mites in an outsized world of towering adults" (Griswold, 2006, 53), Juni wields a power that is not typically accorded to children. Such power is additionally in action at the banquet shortly after the theme park incident when Juni asks Alexandra to dance. When he approaches the girl, she says she cannot dance because of the horde of overprotective agents that encircles her. As soon as he flashes his Level 2 badge and instructs the towering men, "OK now, break it up," the agents part and he has his dance with the girl. With the work of Kaja Silverman in mind, we might go so far as to read Juni's Level 2 badge as a phallic signifier. Admittedly, discussions of the phallus and phallic symbols can quickly become overwrought and tiresome, but Silverman's work opens up some potentially insightful interpretative avenues for conceptualizing the privilege and prestige that Juni has accessed. Discussing the social stakes involved in the symbolic equation (or collapse) of the penis and phallus—chief among them the enablement and maintenance of patriarchal primacy—Silverman points out that biological maleness does not automatically guarantee patriarchal privilege or power. For some males, she notes, "Oppression experienced in relation to class, race, ethnicity, age, and other ideologically determined 'handicaps'. . . pose obstacles in the way of a phallic identification"

(47). In the first *Spy Kids*, various elements, including age as well as embodiment, work against Juni and preclude both ego integration and phallic identification (which according to the logic of Juni's portrayal are conterminous). As seen in the scene with the glowsticks, though, the film drives toward the resolution of the various handicaps that haunt him, including his alienation from normative, phallic masculinity. The Level 2 badge that he flashes at the start of *Spy Kids 2* symbolically confirms that he has indeed attained phallic masculinity and all of the honors and privileges appertaining thereto, which in Silverman's formulation include "power. . . and wholeness" (Silverman, 1992, 388).

While Juni thus seems, with Level 2 badge in hand, to have made significant progress in his advancement toward normative masculinity, the introduction of Gary Giggles in this sequel threatens to unravel everything he has attained. Gary functions as an ego ideal incarnate, and as such he threatens to induce anew inferiority and humiliation in Juni. Gary is tall, blond, slim, and overall well-groomed and good-looking, which stands in contrast to Juni's stout build. In fact, as registered by Carmen's interest in him, Gary has sex appeal. Moreover, Juni discovers at various points that Gary has superior spy gadgets. Bearing in mind Gary's mantra that "An agent is only as good as his gadgets," Juni finds himself wrestling with gadget-envy. Snide remarks by Gary about Juni's bulging "gut" and "big head" only reinforce the former's antagonistic role.

At the hands of Gary, Juni faces the evisceration of the distinction and integrity that he has accomplished. At the aforementioned OSS banquet, the waiters—who are actually Donnagon Giggles's henchmen—slip a sleeping potion into the champagne. When the adult OSS figures doze off in the middle of dinner, the waiters pilfer the Transmooker out of the president's coat pocket and attempt to make a getaway. Since the sleeping potion is slipped into the champagne, however, all of the spy kids—who are too young to drink champagne—remain awake and attempt to thwart the escape. In the course of the ensuing scuffle, Juni recovers the device, but motivated by a desire for glory, Gary struggles with Juni for possession of it. In the end of a tussle during which Gary derisively calls Juni "squirt" and "carrot top," the Transmooker flies out of both of their hands and into the grasp of a waiter, who along with the others manages to make an escape. When the adults reawaken, Gary unfairly fingers Juni as responsible for the loss of the device, at which point all eyes zero in on Juni. Significantly, as the scorned object of a critical gaze, he again occupies a condition of "otherness, subordination, and expulsion" (46), which Linda Kauffman (1998) succinctly describes as characteristic of abjection.

Blamed for what happens, Juni loses his job with the OSS, and with it, he loses his professional distinction as well as a measure of personal pride. Symbolically, the deposal of Juni culminates with the replacement of his Spy Kid of the Year photo by one of Gary. Gary also claims a superior phallic standing vis-à-vis

the conferral of a coveted Level 1 badge. Yet as the film proceeds, rather than let the apparent superiority of Gary hold sway over him and prompt in him an existential crisis, Juni disidentifies from his rival in a process that ultimately facilitates the consolidation—rather than the decimation—of selfhood. From the beginning of the film, it is clear that Juni resents Gary not only as an ego ideal that haunts him, but as a negative example of the person he wants to be. For this reason, when it is apparent that Carmen is developing a crush on Gary, Juni intervenes, "You like him and believe him? Gary's a bad guy, Carmen." When Carmen responds, "I know that. I think I can change him," Juni's mature perspective is reinforced (and the girl's status is further compromised as she is now figured as stereotypically obstinate and naïve).

Most explicitly, Juni's differentiation of himself from Gary comes into focus when he, Carmen, Gary, and Gary's sister Gerti (Emily Osment) discuss Donnagon's involvement in the theft of the Transmooker. Unwilling to be critical of his father, Gary simply proclaims, "He has his reasons. That's what being a good spy is all about. Trust no one." When Gary proceeds to quote from the *How to Be a Spy* handbook, "A good spy makes no binding commitments with family or friends," Juni forcefully interrupts, "Well I don't believe that, do you?" In this moment in which Gary uncritically promulgates the legitimacy of both his father and the spy handbook, Juni distinguishes himself as someone who thinks for himself.

By the end of the film, the restoration of Juni is accomplished when Donnagon is discovered and foiled. In acknowledgment of his efforts, Alexandra, acting on behalf of the president, offers Juni a Level 1 badge. He declines, however, telling her, "No, thanks. I'm leaving the OSS. I've seen what it takes to be a top spy, and I think I can be better use to the world by just being the best . . . me." Through this response, Juni effectively deconstructs what Kerry Mallan identifies as the phallic fantasy. As discussed by Mallan, the phallic fantasy is an ideal that "[privileges] the phallus and its relations of dominance and submission" (151). As such, its governing principle is that males should aspire toward social power and prestige. Importantly, Mallan notes that one of the implications of this fantasy is that it "closes off other possibilities for male and female ways of being" (151). An opportunity for "challenging dominant modes of patriarchal masculinity" (Mallan, 2002, 151) seems to appear, though, as Juni shuns hegemonic ideals. When Alexandra presses, "But what about all the cool gadgets?" which can simultaneously be read as an appeal to a juvenile fascination with toys as well as yet another offer of phallic masculinity, Juni assuredly removes an elastic band from his wrist and corrects her, "I got the best gadget right here. Use number one—a stylish bracelet," at which point he puts the band around her wrist in a mature gesture of friendship.

The Boy Becomes "The Guy"

Besides featuring one of Rodriguez's unclearer storylines, *Spy Kids 3–D* provides a fraught resolution for Juni's *Entwicklungsroman*. At the start of this installment, Juni narrates that he has cut ties with the OSS and is working as a private detective. He relates, "I'd been burned by the agency, the OSS. So I left. . . . I handle my own assignments now." Accordingly, we see him field phone calls from the OSS and insist, "Look, I'm no longer an agent. I can't help you. Whatever it is, it's your problem. Leave me alone." When he receives a call from Devlin (George Clooney), a former director of the OSS who is now president of the United States, Juni appears poised to issue yet another rejection. Devlin calls, however, to inform Juni that Carmen is trapped in *Game Over*, a virtual reality game that is actually a sinister ploy concocted by the Gamemaker (Sylvester Stallone) to take over the world. In an effort to stymie this new villain, the OSS sent Carmen into the game, but she has been caught and is being held inside. As soon as he finds out what has happened, Juni sets aside his bitterness and decides to cooperate with the agency this one time. Once inside the game, Juni encounters a group of beta testers who (mis)take him to be The Guy, a savior figure prophesied to be able to beat the game. In the role of The Guy, it befalls Juni to lead the beta testers through the game as well as find his sister.

The fact that Juni must navigate the unfamiliar landscape of the game and learn the rules that govern this realm reflects the ways that adolescence can be a potentially baffling and frustrating time in life when one struggles to figure out and accommodate oneself to the adult world. It can also be a time when one feels isolated and alienated. An especially important aspect of male adolescence is captured, however, when the beta testers assume that Juni is The Guy. Such a slippage results in a host of expectations for Juni that could be said to parallel the gender-specific expectations faced by adolescent boys making their way toward manhood. As The Guy, Juni is expected to be a courageous leader who knows how to win the game and thus claim the "untold riches, toys, and prizes beyond your wildest dreams" that allegedly await anyone who can defeat Level 5, the game's highest level. In its own way, such a narrative arrangement deftly points toward the fact that today's boys are expected to fearlessly, and without any guidance, negotiate adolescence and come out from the other side as winners who can lay claim to the material and social prizes that purportedly await them if they assume their proper gender role.

An important critique of such a predicament for adolescent boys is embedded in Juni's unpreparedness for the role of The Guy as well as his hesitancy to be thrust into it. Such a portrayal resonates with Pollack's contention that today's boys are expected to grow up "too abruptly, with too little preparation for what lies in store, too little emotional support, not enough opportunity to express their

feelings, and often with no option of going back or changing course" (xxii). Notably, Pollack's remark about boys having no option of going back or changing course is literalized in the fact that Juni must either win the game or face a Game Over (which carries a set of consequences that are never clearly specified but seem to be rather ominous). It is also seen during the Mega Race that Juni must complete to get through Level 2. According to the Gamemaker's instructions, "There are no rules at this game except win at all costs," which could just as well describe how adolescence works for boys in the real world of contemporary capitalism. When, to the terror of Juni, the Gamemaker announces, "The race will begin . . . now," and he rapidly counts down, "1–2–3, GO!" a compelling metaphor for the way that boys find themselves mercilessly tracked into normative masculinity takes shape.

All the while, we must note that Juni has been pushed into the role of The Guy simply because of his physical resemblance to the silhouette of the figure in a promotional billboard for the game. When Juni chances to step in front of this billboard, one of the beta testers notices the resemblance between him and the empty outline of The Guy and exclaims, "Hold onto your joysticks, boys. I think we got him." On one hand, that the only image that exists of The Guy is an empty silhouette critiques dominant formulations of masculinity by suggesting that they are fundamentally empty and constructed ideals. At the same time, the fact that the distinguishing feature of this figure known as "The Guy" is nothing more than a silhouette suggests that anyone with the "right" body could be The Guy or expected to be him. Such is precisely the reason Juni ends up pushed into the role, and it is also the manner by which contemporary boys end up feeling compelled to live up to the ideals of hegemonic masculinity. In this day and age, to be born with a boy's body results in the imposition of a demanding and specific set of expectations.

The gap between the role of The Guy and Juni's willingness and ability to fulfill the role encourages a consideration of the psychopathic, constructed nature of hegemonic masculinity. As Silverman notes, moments in which a male "fails" to embody normative masculinity always carry the potential to "expose masculinity as a masquerade" (47) as opposed to a natural condition or corollary of being male (or, more specifically, of having a male body). It is particularly interesting that the basis on which Juni fits the silhouette of The Guy is not even his real body but the suit of armor that he wears inside the game. This fact brings to mind Judith Halberstam's (1998) comment that masculinity in Hollywood action films, a popular venue for the codification and promotion of hegemonic masculine ideals, "is primarily prosthetic and [usually] has little if anything to do with biological maleness and signifies more often as a technical special effect" (3).

The exposure of hegemonic masculinity as a "technical special effect" continues through the unveiling of the true character of the different male characters

that Juni encounters inside the game. First, when Juni finds a set of shortcuts, which are a violation of the rules of *Game Over*, he finds himself face to face with the Programmerz, an intimidating pair of young men who threaten Juni with automatic termination. It is revealed, however, that beneath their tough exterior the Programmerz are nothing more than "computer nerds." Similarly, the savvy and smooth beta testers who initially rejected and challenged Juni are revealed at the end of the film to be rather unimpressive boys. In what is tantamount to a parade of shame, the three are escorted into the OSS lab where the now-reformed Donnagon Giggles is debriefing Juni and Carmen. At the sight of the three boys, a stunned Juni utters, "Hey, wait a second. What happened to Francis the Brain, and Arnold the Strong, and Mr. Cool?" Once the three acknowledge that they really are not as smart, strong, or cool as they pretended with the aid of the technical effects available to them in the world of the game, Juni exclaims, "Reality check!" The potent implication is that the legitimacy of the images and definitions that circulate in our technologically advanced media culture and serve as the touchstones for gender normativity must be reevaluated and recalibrated against the real nature of boys.

Ironically, however, alongside such a critically valuable implication, *Spy Kids 3–D* ends up reiterating some of the pillars of hegemonic masculinity. This occurs after the true identities of the three beta testers are exposed and Juni is asked, "So, who are you in the real world?" At this exact moment, Francesca Giggles—Donnagon's wife and the agent overseeing the *Game Over* operation—appears and addresses Juni, "Special Agent Cortez, we need you." While Juni plays down the scene by insisting, "I'm just Juni Cortez," he clearly remains endowed with a privilege, prestige, and power that distinguish him from the abject otherness of the three other boys. Indeed, we can say that Juni finally has abject others over and against which his normative, phallic masculinity can be asserted. All of this effectively rounds out not just the fantasy of the boy's extrication from abjection and humiliation, but the selfsame phallic fantasy that appeared to be subjected to deconstruction at the end of *Spy Kids 2*. The casting of Salma Hayek—an actress renowned for her sex appeal—for the role of Francesca Giggles only amplifies the fantasy element of the scene and its hegemonic implications. Through Francesca's apparent deferral to the professional status (and literal stature) of Juni, the petite woman finishes that to which the trilogy has been driving: the conferral on Juni of phallic masculinity.

Admittedly, ethnicity is an aspect of Juni which has not been addressed in this essay. Although the family is coded (very generically, it is worth noting) as Latino, Rodriguez really does not foreground ethnicity or culture as a significant factor in Juni's development. In effect, rather than present Juni as a Latino boy whose maturation is inflected in distinctive and meaningful ways by particular cultural conventions and pressures, Rodriguez ultimately presents him as just another boy

dealing with the same issues with which other boys (presumably) must deal. The casting of Sabara, who is not Latino, in the role of Juni further neutralizes the potential for the character to assume any racial or cultural specificity. To be sure, the fair complexion of Sabara offers to explode expectations that all Latino bodies are dark. But in the final analysis, the physiognomy of Sabara seems to aid in diffusing or sublimating the difference his character might otherwise embody. In all likelihood, Rodriguez departicularizes Juni to offer a text that can speak to a broader audience of boys. This causes a few problems, however. An indifference to race, class, sexuality, and other social and individual variables is precisely the limitation that Kenneth Kidd, Annette Wannamaker, and Kristin Anderson and Christina Accomando throw into relief in their discussions of recent boy-crisis books. For instance, in "'Real' Boys?: Manufacturing Masculinity and Erasing Privilege in Popular Books on Raising Boys," Anderson and Accomando (2002) assert, "[T]hese authors advance decontextualized arguments without meaningful discussion of power inequalities, class, race, sexuality, or other factors that necessarily form the basis of the social construction and intellectual analysis of gender" (492–493). With the understanding that the authors under discussion actually present "insidious and disguised forms of gender essentialism" (511), Anderson and Accomando conclude,

> [A] project that examines gender with a focus on boys . . . could help complicate notions of gender and critically inspect false universalities. Such analysis also could examine the ways in which boys and men both benefit from and are constrained by gender polarization and male privilege. The popular and influential books that we have examined here, however, represent a missed opportunity in this regard. . . . Contrary to their stated intentions, stereotypical notions of gender are reified through the authors' discussions of essentialized boys and parents. (511)

Notably, the departicularization of Juni plays into the universalizing and essentializing tendencies that Anderson and Accomando (and others) indict. As Juni thus comes to stand as a reiteration and emblem of hegemonic masculinity, it becomes clear that yet another opportunity to interrogate and deconstruct it has been missed.

Works Cited

Anderson, Kristin J. and Christina Accomando. "'Real' Boys?: Manufacturing Masculinity and Erasing Privilege in Popular Books on Raising Boys." *Feminism and Psychology*. 12.4 (2002): 491–516. Sage. Web. 28 May 2010.

Biddulph, Steve. *Raising Boys: Why Boys Are Different—And How to Help Them Become Happy and Well-Balanced Men*. Berkeley, CA: Celestial Arts, 1998.

Griswold, Jerry. *Feeling Like a Kid: Childhood and Children's Literature*. Baltimore, MD: Johns Hopkins UP, 2006.

Halberstam, Judith. *Female Masculinity*. Durham, NC: Duke UP, 1998.

Kauffman, Linda S. *Bad Girls and Sick Boys: Fantasies in Contemporary Art and Culture*. Berkeley, CA: U of California P, 1998.

Kidd, Kenneth B. *Making American Boys: Boyology and the Feral Tale*. Minneapolis, MN: U of Minnesota P, 2004.

Kindlon, Dan and Michael Thompson. *Raising Cain: Protecting the Emotional Life of Boys*. New York: Ballantine, 1999.

Kristeva, Julia. *Powers of Horror: An Essay on Abjection*. Trans. Leon S. Roudiez. New York: Columbia UP, 1982.

Lacan, Jacques. "The Mirror Stage as Formative of the Function of the I as Revealed in Psychoanalytic Experience." *Écrits: A Selection*. Trans. Alan Sheridan. New York: W.W. Norton, 1977. 1–7.

Mallan, Kerry. "Challenging the Phallic Fantasy in Young Adult Fiction." *Ways of Being Male: Representing Masculinities in Children's Literature and Film*. New York: Routledge, 2002. 150–163.

Pollack, William. *Real Boys: Rescuing Our Sons from the Myths of Boyhood*. New York: Random House, 1998.

Silverman, Kaja. *Male Subjectivity at the Margins*. New York: Routledge, 1992.

Spy Kids. Dir. Robert Rodriguez. Perf. Alexa Vega and Daryl Sabara. Dimension, 2001.

Spy Kids 2: Island of Lost Dreams. Dir. Robert Rodriguez. Perf. Alexa Vega and Daryl Sabara. Dimension, 2002.

Spy Kids 3–D: Game Over. Dir. Robert Rodriguez. Perf. Alexa Vega and Daryl Sabara. Dimension, 2003.

Wannamaker, Annette. *Boys in Children's Literature and Popular Culture: Masculinity, Abjection, and the Fictional Child*. New York: Routledge, 2008.

Adolescence Vérité: Shocking Glimpses of the Teen in Contemporary American Film

Kent Baxter

Although reviews have been mixed as to whether the 2008 feature-length documentary *American Teen* provides any new insight into today's youth, there is no doubt that the film has broken new ground in the use of cutting-edge marketing media. The film follows the lives of five teens during their senior year in a small town in Indiana. The extensive advertising campaign for the movie includes an elaborate Facebook page, which features the trailer, release dates, soundtrack, reviews, promotional events, pictures, *American Teen* buttons (of "profiles" that best represent fans of the film), and the *American Teen* "connections quiz," which allows viewers to categorize themselves amongst the five dominant categories of teens represented in the film (the rebel, heartthrob, jock, princess, and geek). Providing an even closer connection to the subjects of the film, the site also has links to individual pages and blogs for the cast members, who provide occasional updates on their lives since the premiere.

Even with this overload of information and seemingly unadulterated access to the cast, the film has been unable to escape the inevitable controversy as to whether what we see on screen, and read on the blogs, is really what happened. In his *New York Magazine* review, David Edelstein (2008) summed up most critics' inability to suspend disbelief by describing the film as one of "those animal shows where the crew nudges the gazelles in the direction of the lions with multiple cameras standing by." In a *Los Angeles Times* article titled "Lots of Drama over 'American Teen,'" director Nanette Burstein defended her film's veracity, arguing

that critics such as Edelstein are just unable to face the reality of teens finally being honest: "I think people have a hard time believing teenagers are willing to be that intimate on camera. So sometimes I feel I'm being criticized for what the film's achievements are" (Olsen 2008).

Where does the truth lie? It's up to the viewer, armed with his/her profile button and plugged into the blog of his/her favorite cast member, to find out.

Although the clues being uncovered and the new media tools being used to uncover them are new, this media-facilitated search for truth is far from unique. Indeed, a number of films and television shows over the last two decades have made similar claims about finally showing us the "real adolescent" and have inevitably become embroiled in debates about whether they really deliver on this promise. Films such as *Kids*, *Where the Day Takes You*, *Girls Town*, *Slackers*, *Thirteen*, *Hurricane Streets*, and *Voices from the High School*; and television shows such as *The Real World*, *My So Called Life*, *American High*, *Senior Year*, and *My Super Sweet 16*, have all made similar claims and have all given rise to seemingly endless conversation about whether what is on screen is real adolescence.

I would like to take a close look at two of these texts (Larry Clark's 1995 film *Kids* and Nanette Burstein's 2008 film *American Teen*), examining them not in terms of how accurately they portray teens or whether they are "real"—a thorny path traversed quite well by many others—but in terms of what their claim for realness can tell us about contemporary attitudes toward teens and how we understand these teens' relationship to media, in particular how these texts reflect and facilitate certain beliefs about teens and masculinity. What is at stake with this current fascination with the real? And, why has adolescence become the standard of realness? What can this quest for realness tell us about how we understand or talk about subjectivity and gendered identity?

The Trouble With Teens

Since the earliest full-length treatments of adolescence appeared at the beginning of the twentieth century, this developmental stage, with its connotations of unbridled sexual energy and raucous disregard for authority, has always had the ability to shock the American public.[1] In a general summary of the depictions of male adolescence that have appeared over the last century, Aaron Esman (1990) writes that "the normal adolescent [has been] conceived of as tempest-tossed, torn by unmanageable passions, impulsiveness, rebellious, and given to florid swings of mood. His relations with parents and the adult world in general were seen as antagonistic and conflict-ridden—a pattern later to be described as 'the generation gap'" (22). A quick gloss of the most well known theoretical approaches to this uniquely twentieth-century developmental stage support Esman's overview. In his 1904 work, *Adolescence*, G. Stanley Hall (1904)—commonly held as being

the "inventor" of the developmental stage—describes adolescence as a "stormy period of great agitation, when the very worst and best impulses in the human soul struggle against each other for its possession, and when there is peculiar proneness to be either very good or very bad" (407). Continuing with this "stormy" characterization, the two most widely read mid-century treatises on adolescence expound upon Hall's characterization. In her aptly titled 1966 essay, "Adolescence as a Developmental Disturbance," Anna Freud (1974) attempts to "place the adolescent reactions where [she] imagines them to belong, namely, at an intermediary point on the line between mental health and mental illness" (39). Similarly, in his popular 1959 book *The Vanishing Adolescent*, Edgar Friedenberg describes adolescence simply as "conflict—protracted conflict—between individual and society" (32). Such conflict has become synonymous with the adolescent's closest relative, the teen, a developmental category many critics argue came into being around the middle of the century. In his recent history of American childhood, Steven Mintz (2004) makes the point that the word "teenager" did not really enter the popular lexicon until it was used in a 1941 article in *Popular Science Monthly*; emerging from this decade, according to Mintz, was "the bored, restless, volatile teenager who combined a child's emotions with an adult's passions and was estranged from parents and other authority figures" (252).

Since its inception, the American film industry has exploited this largely negative characterization. As David Considine has noted in his history of teens on film, the impulsive, rebellious, and conflicted adolescent has been part of Hollywood fare, in one form or another, for many decades. In the section of his book dedicated to juvenile delinquency, he makes note of the conflicted and rebellious adolescents in classic films such as *Boys Town*, *Rebel Without a Cause*, *West Side Story*, and *The Outsiders*. In a section on adolescent sexuality, he discusses the common portrayal of adolescent impulsiveness in films such as *All Quiet on the Western Front*, *Splendor in the Grass*, *The Last Picture Show*, and *Saturday Night Fever*.

Considine's list of films that focus on "stormy" adolescence evidences the ways in which Hollywood in general has perpetuated the largely negative characteristics associated with this developmental stage. Whether such portrayals (and the theoretical texts upon which they are based) tell us anything about the reality of adolescence, however, is an entirely different question. Considine answers largely in the negative, concluding that "[i]n looking at this history one finds that, despite its obvious dependence on the young, the American film industry has been spectacularly unsuccessful in realistically depicting adolescence" (9). Considine's definition of "realism" here largely has to do with complexity. In regards to Hollywood's depiction of adolescent sexuality, for example, Considine makes the point that typically when sexual intercourse was explored in films such as *Blue Denim*, *A Summer Place*, and *Splendor in the Grass*, the "post-coital" situation was completely ignored, and the solution to the "problem" of adolescent sex was

simply to plunge the youth into a premature marriage or parenthood (217–234). Similarly, Considine points out that although juvenile delinquency has been a commonplace theme for Hollywood films—beginning in the 1950s with *East of Eden*, *Rebel Without a Cause*, and *The Young Stranger*, and continuing through the 1970s and 1980s with *Saturday Night Fever* and *The Outsiders*—these portrayals fall short of providing any in-depth exploration of the problem by simply blaming the parents and thus essentializing delinquency as a generational conflict (181–202). Considine also makes the excellent point that the realism of many of these films is tarnished by the age of the actors, who are typically ten to fifteen years older than the characters they are portraying.

I would add to Considine's analysis that the complex portrayal of the adolescent in these films is often compromised by the narrative structure of the film as well, which commonly concludes with the adolescent's movement into adult society. Even though these films shocked their audiences by featuring adolescent protagonists who were out of control, the narrative movement of the film was to tame the adolescent and bring him/her back into the fold. The focus of most of these early films is on adolescents who become (good, upstanding) adults.

Additionally, although Considine does not touch upon the issue of gender in his discussion of these films, a cursory analysis of the titles he mentions reveals some fairly pronounced trends. For one, juvenile delinquency is almost entirely depicted as a male phenomenon. Secondly, if there is any female rebellion it almost always takes the form of sexual permissiveness, as is evidenced by the films listed by Considine that deal, albeit in a limited way, with sexuality. Such a gendered distinction is not uncommon with depictions of juvenile delinquency in the west. In his history of juvenile delinquency in America, Joseph Hawes (1971) has noted that in the early decades of the twentieth century, while boys were cited for a wide variety of offenses, girls were most commonly arrested for crimes relating to sexuality. "The most common offenses for girls were 'incorrigibility,' 'immorality,' and 'disorderly conduct,'" he notes in his analysis of the cases heard before the early years of the juvenile court in Chicago (180). Arguably, such a gender barrier has persisted throughout the twentieth century. In his study of portrayals of youth in the media, Bill Osgerby (2004), has argued that the "moral panic" about juvenile delinquency in the latter half of the twentieth century, whether in the news or in fictionalized media, has adhered to very specific gender guidelines. He notes: "Alarm associated with the mods and rockers' lawlessness, the punks' outrageousness or the aggression of gangsta rap has largely (though not exclusively) focused on the behavior of young men. In contrast, girls have figured more visibly in moral panics related to sexual behavior and 'permissiveness'" (75). Although one could certainly find exceptions to this rule, the preponderance of this characterization of juvenile delinquency reveals a great deal about traditional beliefs about teens. Consistent with the depictions of adolescence cited earlier, misbehavior

amongst male teens has become as natural as puberty itself. While female teens occasionally partake of the same rebellion, particularly in terms of sexuality, it is often depicted as a mode of corruption rather than a natural instinct, thus vacating the female of any subjectivity and promoting an ideal of innate female purity.

In terms of their formal qualities, the sampling of recent films and television programs that I have dubbed "Adolescence Vérité" could be said to form a counter-movement to these traditional portrayals of adolescence in American cinema, by taking the portrayal one step further and showing the adolescent in his or her supposedly true form, uncompromised, unhindered. As the title of this chapter implies, these texts owe much to the Cinéma Vérité movement begun in France after World War II, which used hand-held cameras, civilian subjects, and rough editing techniques to capture life as it is lived, as opposed to the artificial constructions of Hollywood movies.[2] The "vérité-style" production qualities of these films and television programs, along with the shocking themes they often address, show a departure from, or direct reaction to, earlier, more traditional portrayals of adolescence. Additionally, speaking more directly to Considine's point about the failure of earlier attempts to provide a realistic view of adolescent delinquency and sexuality, the texts in my list are almost entirely devoid of parental figures, and thus, instead of essentializing the problems of adolescence as being part of a broader generational conflict, they provide an almost claustrophobic depiction of adolescent rebellion and sexuality that makes it appear almost innate and primal. Similarly, most of these more recent texts avoid a traditional "three-act" plot, where the ending features the coming of age of the protagonist as he/she moves into adult society. These are texts without easy answers and easy endings, and the adolescent conflict is made to appear to continue on without any solution. Regarding their depictions of gender, and in particular masculinity, however, these texts in many ways reiterate the same traditional myths about male and female adolescence that have been with us since the beginning of the twentieth century.

Kidding Around

In an interview with *The New York Times*, Larry Clark, director of the controversial 1995 film, *Kids,* claims that he had "always wanted to make the Great American Teen-Age Film," because, simply put, he "always thought teen-age movies were bull, made by guys who didn't understand the scene, and didn't know what was going on" (Gabriel 1995). Clark's attempt to capture "what was going on" led him to original extremes: the 52-year-old director learned to ride a skateboard and spent months carousing with teenagers on the streets of lower Manhattan. He commissioned eighteen-year-old Harmony Korine to write a screenplay about the lives of the teens he met on his journey and cast many of them in the film, which was shot in a six-week period in the summer of 1994.

The final product, released without a rating in 1995, inspired mixed reviews by the critics. Janet Maslin of *The New York Times* called it "bleak and legitimately shocking"; Amy Taubin of *The Village Voice* called it "a masterpiece"; Siskel and Ebert gave it two thumbs up. Although the critics have radically disagreed on whether Clark's vision of a day in the life of teens in lower Manhattan is trash or art, they all seem to agree that the central question one must ask when leaving the theater is whether Clark's vision is true or simply his own interpretation. Indeed, *New York Magazine* devoted a whole issue to this question, the cover of which reads, "The Kids Aren't Alright: The summer's most controversial movie is a disturbing picture of sex and dope and casual brutality among New York teenagers. Are they really this nasty?"

Why does Clark's film elicit such a response? On the most fundamental level, the desire to find out whether Clark's depiction is real or not is a result of his use of live documentary-style film techniques that distinguish this film from the more stylized Hollywood fare. Clark shot almost all of his footage with a handheld camera, which makes the film appear bumpy and unfocused and thus more "live" than most Hollywood films. As in documentaries, the actors in the film are almost entirely lit from the front, so there is no depth of shot, and no elaborate background such as that typically provided by backlighting on sound stages. Also, the editing is far from seamless; Clark moves from one shot to the next with little regard for continuity, producing "jump cuts" that make the movements of the actors appear sudden and irregular.

In addition to these technical aspects, Clark's choice of actors and actresses also adds a feeling of veracity to the film. Traditionally, directors have chosen professional actors in their twenties (or older) to play teenagers. Clark cast adolescents off the street, with little or no acting experience. Instead of fully developed actors giving polished performances, *Kids* features oddly developed adolescents giving awkward and often ill-timed performances. Whether it is Leo Fitzpatrick's—who plays Telly, the main character—slurred speech, or his oddly developed body, his performance, like the performances of the other actors in *Kids*, offers a striking contrast to the slick, professional look and delivery of most "adolescent" actors.

What all of these aspects do is to make the film feel more like a documentary than a fictional film. Thus the desire to know whether it is real or not arises from a fear that teenagers may really be like this, and, if they are, we better watch out. For part of what makes the film so controversial is that it moves far beyond the "storm and stress" traditionally associated with adolescence and shows violent, often pathological behavior. The film documents a day in the life of Telly, an adolescent boy who lives in lower Manhattan. But in contrast to the more traditional portrayals of adolescence, which may feature Telly conflicted as to where he fits in the adult world or Telly rebelling against his parents, in *Kids* we see Telly having sex with two virgins, drinking excessive amounts of alcohol, pissing on the

sidewalk, stealing, sneaking on to the subway, beating another teen unconscious, and thoughtlessly destroying someone's home. The film forces the audience to question the boundary between what is storm and stress and what is pathology. Is Telly's obsession with deflowering virgins typical male adolescent behavior? What about his drinking? Or, his brutality?

Additionally, the film brings these questions closer to home by making us identify with the adolescents themselves. The various production qualities that make the film seem real also make it adolescent-like. The film itself becomes an adolescent-like viewing moment for the audience. This is accomplished by the use of adolescent actors, but also the adolescent awkwardness of the actors is compounded by the awkwardness of many of the shot angles and the rough editing. The shaky hand-held camera and jump cuts make this portrayal of adolescence look and feel disturbingly awkward and unstable—characteristics that, as we have seen, often have been associated with this developmental stage.

The adolescent-like viewing moment is enhanced by the film's narrative structure. Most of the films about adolescence, such as those mentioned by Considine, follow the traditional "three-act" structure that is the mainstay of commercial film. The narrative dilemma or "hook" is established early, along with the motivation for the actors, and then solved by the end of the film, bringing a sense of closure, which, as mentioned earlier, typically is accompanied by the adolescent's movement into adult society. If *Kids* could be said to have any narrative structure it would simply be that it moves forward by following the immediate and primal desires of its protagonist, Telly, and his friend Casper. Thus the film begins with Telly's desire to have sex with a young virgin in her bedroom. After this desire is fulfilled, it moves to Telly and Casper's desire to steal some beer and go to Paul's house. Then it moves to Telly's need to get money from his mother, his need to have sex with Darcy, then his need to go to the pool and the party at Steven's house. The narrative movement of the film is not oriented around a complex moral issue or human dilemma that needs to be solved; rather, it just moves from one immediate desire to the next. The only real "dilemma" we get in the film is Jenny's discovery that she has contracted HIV from Telly, but instead of this crisis turning into a confrontation between Jenny and Telly, the film hopelessly follows Jenny around Manhattan as she searches for Telly, apparently to tell him of her diagnosis. And even this narrative movement goes nowhere: in the end, Jenny is unable to communicate with Telly because he is busy having sex with another girl. All in all, the narrative movement of the film is immediate, visceral, associative, and almost primal in its spontaneity. It feels like adolescence and thus forces the audience to question whether it is the real thing.

This identification with the adolescent is compounded by the claustrophobic atmosphere of the film. The intense focus on Telly and Casper as they move from desire to desire means that the viewer is given very little context in the film. We

never learn anything about the past history of these characters or about their family lives. There is no context for them and thus no possible explanation for their behavior; they are examples of a pure rebellious spirit. Similarly, there is very little screen time devoted to spaces outside the immediate perspective of Telly and Casper. There are very few establishing shots in this film and almost no panorama. The viewer is made to feel that there is nothing outside of the immediate consciousness of the protagonist, and we are given no choice but to see through his eyes.

In his analysis of *Kids*, Henry Giroux (2002) has argued that this "severely decontextualized perspective . . . plays on dominant fears about the loss of moral authority" with contemporary youth (181). Concomitantly, I would add, such a perspective essentializes adolescent behavior as something primal, biological, and global. It's important to note also that such behavior, particularly sexual desire, is also gendered almost entirely male in this film. Although the female characters in the film are given a certain amount of screen time, such as Jenny's search, mentioned above, or a private discussion amongst the girls about boys (that almost entirely focuses on their "dicks"), it either facilitates male desire or, as in the case of Jenny, demonstrates the futility of blocking this desire. Telly is portrayed as a predator of sorts; male sexuality is equated with death; and the girls are depicted as innocent victims. As Sudhir Mahadevan (2005) has argued in his analysis of male desire in *Kids*, even though a number of critics have attempted to queer such a focus on boys, taking their cue from Clark's erotic photography, which often features young boys in erotic poses, it all is in the name of heteronormative, and borderline misogynist, desire: "[E]ven as the boys in Clark's films exist in homosocial worlds and are visually presented in homoerotic ways, their heterosexuality is only reinforced, not compromised" (109). Realism here is the threat of adolescent male desire, which is boiling beneath the surface, and made worse when youth join together in predatory packs.

Who Are You?

Just as *Kids* can perhaps best be described as a film that looks like a documentary, *American Teen* can best be described as a documentary that looks like a film. In scouting locations for the feature, Nanette Burstein—Academy Award nominee for her 1997 documentary *On the Ropes*—considered more than 100 different high schools for the project, before settling on Warsaw Community High School in a small town in Indiana, described as "a typical Midwestern town" in the opening montage of the film. During casting, more than 100 students from the school were interviewed. The teens selected for the film were followed with cameras for the ten months leading up to their graduation. Burstein then edited down the over 1,000 hours of footage into a 95–minute feature, which earned her a directing award at the 2008 Sundance Film Festival.

As Burstein has discussed in a number of interviews, the editing process was not an attempt to accurately summarize what happened to these teens as much as it was a search for some archetypal stories in their everyday lives. "[I]f you break down fiction films on teenagers, they fall into the same four stories that you see over and over and they all exist in real life," she explains in an interview with Slashfilm.com. "[I]t's the Romeo and Juliet story where there's love across class lines or clique lines or race lines; or it's the underdog looking for acceptance . . . or it's the *Mean Girls* . . . or it's the sports like triumph over adversity in some way" (Sciretta 2008). According to Burstein, her goal was to take these archetypal stories and make them "very real and complicated and three-dimensional."

As with *Kids*, such a search for complexity and three-dimensionality could be seen as a reaction to the teen movies of the previous generation of filmmakers. But the focus on archetypes puts *American Teen* more in line with the complex teen character studies of John Hughes than the stream-of-consciousness crisis films of directors like Larry Clark. Hughes is of course best known for the string of movies he directed in the 1980s—*Sixteen Candles, The Breakfast Club, Pretty in Pink, Weird Science*, and *Ferris Bueller's Day Off*—that stood in stark contrast to the teen comedies (such as *Porky's*) of the day and provided a more complex (albeit formulaic) glimpse of middle-class high school life. Indeed, the marketing poster for *American Teen* features a sly allusion to *The Breakfast Club*. As can be seen by the two posters, Burstein focuses the film on five types: a heartthrob (Mitch), a princess (Megan), a jock (Colin), a rebel (Hannah), and a geek (Jake). This is a slight departure from Hughes's focus on the brain, beauty, jock, rebel, and recluse—ironically subverting Burstein's assumptions about archetypal teen stories—but, much like *The Breakfast Club*, these stereotypes govern the narrative of the film. Such character types speak to certain familiar stories associated with teens, but, also, they become obstacles for the teen to overcome as he/she discovers who he/she truly is during the course of the film. In Hughes's film, the characters are forced to look beneath the surface of the stereotypes, "bare their souls," and find the "real" person underneath. This process is the narrative arc of the film; the realization is the climax. Ultimately, looking beneath the surface is a revelation, "changing their lives forever."

As revealed in the *American Teen* poster, Burstein's film follows largely the same paradigm: the "five strangers" "change in ways" that free them of the self-imposed stereotypes of their age. In the opening montage of the film, Hannah's voiceover sets up the "caste system," as she calls it, and the quest: "At the top is the most popular group of girls, led by queen bee Megan Krizmanich. . . . And then there are the jocks who at our school are the basketball players. Colin Clemens is the star of the team. . . . At the opposite end of the spectrum is Jake Tusing, your quintessential marching band nerd. Then there's my best friend Clark and me. I guess you could say we're the in-betweens. This is all we have known since we were

little kids and in nine months it will all be over. In the meantime, all we have to do is, you know, figure out who we really are, and where we are headed in life."

Much like *The Breakfast Club*, this documentary on teens has a fairly clear narrative structure and quest, set up from the first scene. But whereas the teens in Hughes's film dismantle the stereotypes and caste system that is constraining them, the subjects of *American Teen* seem to learn more about the dangers that arise when you buck the system and the sacrifices that must be made to keep the system in place. Mitch reaches across class lines in a relationship with Hannah, who he says allows him to be "stupid and kinda nerdy," but he can't escape the fact that they are in two social groups and breaks up with her via text message. Megan's innate sense of privilege, and her acceptance to Notre Dame, seems as if it is going to be challenged when she gets caught taking revenge on a rival by spray painting "fag" on his bedroom window, but her father simply substantiates her special status by telling her such harassment is stupid if "you can't do it and not get caught." Colin bends to breaking point under the pressure of his father who tells him that the only alternative to a college basketball scholarship is being a cook in the army, but bounces back after he realizes that he can please everyone, including the college scouts, by passing more on the court and thus being "a team player." In the end, *American Teen* is as conservative as the Midwestern town it portrays. The dose of reality we get here is that stereotypes and caste systems are bad, but are as central to American life as Coca-Cola and the Dairy Queen, and we can't always overcome them.

The film's portrayal of gender identity and sexuality is shaped by the larger quest to discover one's identity, and, as such, it both adheres to and slightly transgresses some of the most traditional stereotypes. Megan's behavior in some ways transgresses the traditional depiction of juvenile delinquency, but the fact that it is all done in the name of middle-class heteronormativity and her father becomes complicit in the act ultimately reifies traditional gendered expectations. Jake's self-professed search to find "someone who really accepts me for who I am" is counteracted by his obsession with role-playing fantasy games, in which the gallant knight saves the princess via hand-to-hand combat with his rival; his desire for a "true" connection is conflicted by one of the oldest stereotypes of male identity. By the end of the film, he has apparently found this "real" connection with his friend Leslie from California, who stays in his room—which she describes as "creepy"—on a visit, thus trespassing upon the most sacred of adolescent spaces and apparently dismantling his misguided fantasy of male prowess. Hannah grows beyond her reliance upon her boyfriend for her identity. She tells us in the beginning that the only one she has in her life is Joel, thus setting up the inevitable breakup and crisis of identity that ensues. This crisis, which is apparently incited by them having sex, shreds her self-esteem, but she is able to re-integrate and survive a second breakup with Mitch. By the end she has appeared to move outside

the "caste system" of Warsaw to San Francisco, defying her mother's warning that she will be "a target of a lot of nuts out there." Colin wallows in the shadow of his father, who was a basketball star at Warsaw many years before. In an almost surreal ritual of masculinity, his father, who is also an Elvis impersonator, tells him that he hopes someday his son will be able to fit in his outfit; the moment seems comically transgressive, but turns out to be quite sincere, as, by the end of the film, Colin takes his first steps into manhood by getting the college basketball scholarship his father was never able to achieve.

As a bonafide "documentary," *American Teen* shares some, but not all, of the stylistic qualities we saw in *Kids*. There are a number of sequences filmed with a hand-held camera that both imply a sense of reality and emphasize the instability of the teen's lives, but this style of camera work is often used for the dramatic scenes, such as the arguments or conflicts, whereas the stationary camera is used for the self-reflective or joyful moments. The stereotypical geek, Jake, has all of the "natural" awkwardness of Telly in *Kids*, but he also serves as a foil to Hannah, Megan, and Mitch, who look like they just walked out of a Abercrombie & Fitch advertisement. The adolescent-like viewing moment of this film is undercut by the animated fantasy sequences, which are posited as abstract glimpses into the psyches of the various subjects, but add a sense of fantasy that can only remind the viewer of the constructed nature of the medium. These sequences pretend to be intimate glimpses into the minds of the subjects of the film, but are, of course, the filmmaker's interpretation; their simple, cartoonlike quality equates them even more directly with fantasy and childhood, a wink from the adult director that these are indeed fictions, and that we as an audience will see how the fantasies and dreams will fare when the kids grow up.

As any film can be, *American Teens* is a real depiction of teens, but it is a depiction that attempts to make the point that "real teens" don't break archetypes but ultimately enact them. As A. O. Scott (2008) summed it up in his *New York Times* review of the film, "the members of the class of 2006 . . . are part of a generation whose media-saturated lives make Andy Warhol and Marshall McLuhan look positively naïve . . . These kids were toddlers when MTV first aired "The Real World," and being on camera, or online, is another way of being themselves." In this sense, *American Teen* is a much more disturbing text than *Kids* in that it implies that certain archetypal stories of teens have become so commonplace that teens actually enact them as part of the process of growing up.

Get Real

So, in general, apart from some stylistic similarities, it would appear that the main quality these two realistic portrayals of adolescents have in common is their quite emphatic claim that they are in fact real. Interestingly, the association between

realness and adolescence, which has become such a central tenet of contemporary film and television, is not entirely new. In one of the best-selling theoretical works on the developmental stage of adolescence, the 1959 book *The Vanishing Adolescent*, Edgar Friedenberg argues that adolescence as a developmental stage is disappearing because the preponderance of consumer culture in American society hinders our ability to express our individuality. Friedenberg points out that adolescence "may be frustrated and emptied of meaning in a society, which, like our own, is hostile to clarity and vividness. Our culture impedes the clear definition of any faithful self-image—indeed, of any clear image whatsoever." Because consumer culture has infected the developmental process and prevents "clear and stable self-identification," Friedenberg concludes, "real adolescents are vanishing" (1). Friedenberg's invocation of the word "real" here, and a number of times throughout his study, makes his work an almost shocking precursor of the contemporary fascination with the real adolescent. The fact that it was uttered fifty years ago, under quite different cultural/historical circumstances, demonstrates the persistence of this quest to find the real adolescent, possibly implying that such a quest is synonymous with this developmental stage itself.

Friedenberg contrasts the real adolescent with convention and the inability to be frank and truthful. In Friedenberg's mind, being real means being harshly critical of one another. This harsh criticism allows adolescents to distinguish who they are and where they stand on various issues. In a section where he describes the beneficial effect of this realness on the developing individual, Friedenberg states: "The juvenile era provides the solid earth of life; the security of having stood up for yourself in a tough and tricky situation; the comparative immunity of knowing for yourself just exactly how the actions that must not be mentioned feel . . . the calm gained from having survived among comrades, that makes one ready to have friends" (22). The crudity of adolescence (which, according to Friedenberg, is an enviable lack of knowledge of social taboos and decorum) leads to a kind of harsh criticism that lets the adolescent define who he or she is. Once again, referring to realness, Friedenberg states bluntly, "[the adolescents'] job is not to be nice to each other, but to be real to each other" (26).

In terms of gendered identity, watching teens "be real to each other" on screen might be symptomatic of a type of nostalgia for more stable and seemingly innate gendered roles and/or a way to substantiate certain convenient (largely misogynist and heteronormative) myths about teens. Of course, these mediated moments, where film, television, and the internet are used to enact the truth about what it is to be a male or female teen in our culture, are telling case studies of what Judith Butler (1990) has called the "performative" nature of gender. As Butler describes it,

acts, gestures, and desires produce the effect of an internal core or substance, but produce this on the surface of the body, through the play of signifying absences that suggest, but never reveal, the organizing principle of identity as a cause. Such acts, gestures, enactments, generally construed, are performative in the sense that the essence or identity that they otherwise purport to express are fabrications manufactured and sustained through corporeal signs and other discursive means. (136)

One of the main discursive means used here is the very promise of seeing the real adolescent, which proffers that there is an essential adolescence that can be documented and which also essentializes the gender of this "internal core" as biological truth.

However, it is important to note that the promise of the real adolescent made by the commercials or advertisements marketing the film or movie is never really fulfilled, but rather is deferred endlessly as the viewer asks the inevitable question: "Is this what adolescence is really like?" It is important to emphasize that this search for the real that is instilled by the text is an endless search, symptomatic of a desire that can never be fulfilled. There is no real adolescent, just the promise and the endless search. The very question, "Is this what adolescence is really like?" reflects a moment in culture where the distinction between fiction and reality has become blurred. We not only live media-saturated lives, as A. O. Scott put it, but our lives have become media. At the center of this search is a crisis of identity, but this crisis is not only inherent in the text but the manner in which this text is processed and negotiated by the viewer as well. In her recent study of popular literature and culture for boys, Annette Wannamaker (2008) has argued that much of the discourse that surrounds our discussions of boys' relationships to the texts they consume or how boys are influenced by the texts marketed to them is predicated upon two main assumptions about gender: "those who see gender as being socially constructed argue that boys can be taught and guided to perform their gender in less hegemonic ways, and those who see gender as biologically determined often argue that misguided parents and educators should just 'let boys be boys'" (5). According to Wannamaker, this nurture versus nature binary informs many of the current debates about what is appropriate literature for boys, either justifying the call for more appropriate models to shape their young minds or for more realistic venues for them to express their innate savagery. At the root of these approaches are fundamental yet often invisible beliefs about gendered subjectivity; letting "boys be boys," in this case, means letting them enact biologically determined gender qualities, whereas teaching them to perform their gender in less hegemonic ways posits that they are at the mercy of socially constructed codes.

The phenomenon I am calling "Adolescence Vérité" offers a third paradigm of gendered subjectivity. Although, without a doubt, the promise of reality given by such films has been used by some as evidence of the innate storm and stress

of adolescence, and some conservatives have warned of the influences such depictions could have on teens, by far the dominant reaction to these films has been a continuing and endless debate as to whether what they depict is true or not. Such debates not only incite moments of self-definition upon the viewer but also are predicated upon the notion that subjectivity is both more complex than can be captured in film and that individuals consume texts in ways that always involve reality testing. Such instability forces viewers (young or old) to define themselves in relation to the text. Perhaps these films are so controversial because they not only force viewers to experience the impulsive instability of adolescence, but also because they force viewers into their own adolescent-like moment of self-definition. The recurring question of whether the portrayal is real or not is part of a more personal question about how we make the distinction between adolescent storm and stress and pathology or between individuality and types. Our desire to know whether the film is real or not is a desire to differentiate ourselves from this moment. The tempestuous space of adolescence, with its disregard for authority, its lack of decorum, and most importantly, its sexual energy, is one of the few spaces truly on the margins of society. A space like adolescence, a radical space that interrogates traditional notions of what makes a legitimate adult can be empowering. These portrayals of the real adolescence are shocking and, at times, depressing, but, also, they provide us with a powerful truth: it is liberating to see what adolescence is really like, because it incites a moment of self-definition. These glimpses are ultimately glimpses of ourselves.

Notes

1. For a more detailed examination of the developmental stage of adolescence see Baxter, *The Modern Age: Turn-of-the-Century American Culture and the Invention of Adolescence* (2008).
2. For a more detailed examination of Cinéma Vérité see Issari, *Cinéma Vérité* (1971).

Works Cited

American Teen. Dir. Nanette Burstein. Paramount, 2008.

Baxter, Kent. *The Modern Age: Turn-of-the-Century American Culture and the Invention of Adolescence*. Tuscaloosa, AL: University of Alabama Press, 2008.

Butler, Judith. *Gender Trouble: Feminism and the Subversion of Identity*. New York: Routledge, 1990.

Considine, David M. *The Cinema of Adolescence*. London: McFarland, 1985.

Edelstein, David. "Review of American Teen." *New York Magazine*. 28 July 2008. Web. 11 April 2009.

Esman, Aaron H. *Adolescence and Culture*. New York: Columbia University Press, 1990.

Freud, Anna. "Adolescence as a Developmental Disturbance." *The Writings of Anna Freud, Volume 7*. New York: International Universities Press, 1974. 39–47.

Friedenberg, Edgar Z. *The Vanishing Adolescent*. Boston, MA: Beacon, 1959.

Gabriel, Trip. "Think You Had a Bad Adolescence?" *The New York Times*. 26 July 1995.

Giroux, Henry A. *Breaking in to the Movies: Film and the Culture of Politics*. Malden, MA: Blackwell, 2002.

Hall, G. Stanley. *Adolescence: Its Psychology and Its Relations to Physiology, Anthropology, Sociology, Sex, Crime, Religion and Education, Volume I*. New York: Appleton, 1904.

Hawes, Joseph. *Children in Urban Society: Juvenile Delinquency in Nineteenth-Century America*. New York: Oxford University Press, 1971.

Hirschberg, Lynn. "What's the Matter With Kids Today?" *New York Magazine*. 5 June 1995.

Issari, M. Ali. *Cinéma Vérité*. East Lansing, MI: Michigan State University Press, 1971.

Kids. Dir. Larry Clark. Miramax, 1995.

Mahadevan, Sudhir. "'Perfect Childhoods': Larry Clark Puts Boys Onscreen." *Where the Boys Are: Cinemas of Masculinity and Youth*. Ed. Murray Pomerance and Frances Gateward. Detroit, MI: Wayne State University Press, 2005.

Mintz, Steven. *Huck's Raft: A History of American Childhood*. Cambridge, MA: Belknap, 2004.

Olsen, Mark. "Lots of Drama Over 'American Teen.'" *Los Angeles Times*. 23 July 2008. Web. 9 April 2009.

Osgerby, Bill. *Youth Media*. New York: Routledge, 2004.

Sciretta, Peter. "Interview: American Teen Director Nanette Burstein." */film: Blogging the Real World*. 1 August 2008. Web. 9 April 2009. <http://www.slashfilm.com/2008/08/01/interview-american-teen-director-nanette-burstein/>.

Scott., A. O. "Lives of Real Adolescents, In Very Deep Close-Up Movies." *The New York Times* 25 July 2008. Web. 7 April 2009.

Wannamaker, Annette. *Boys in Children's Literature and Popular Culture: Masculinity, Abjection, and the Fictional Child*. New York: Routledge, 2008.

Beyond the Gloss of Youth: Turkish Cypriot Television's Mediation of Young Men in the Public Sphere

Bayard E. Lyons

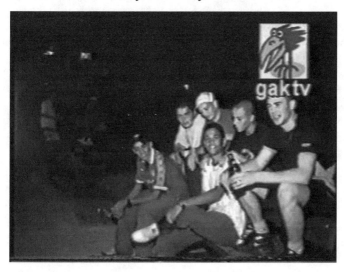

Figure 1: Turkish Cypriot youth hanging out in Lefkoşa (GakTV 2002)

"Public records most often reflect the concerns of those in power and only rarely contain evidence of the thoughts, action, or aspirations of teenagers and young adults unless those groups are seen as some kind of threat to people with power" (Lipsitz, 1994, 207).

Introduction

In the summer of 2002 a teenage girl in North Cyprus was struck and killed by a young male motorist driving without a license. Soon after, a protest was organized by community members with the assistance of a local nonprofit to raise awareness about the problem of unsafe roads in North Cyprus. A few days later, an evening television talk show program, GakTV, invited the bereaved family, as well as Turkish Cypriot experts on traffic safety, to discuss the problem of the unsafe roads.

A significant part of the discussion involved the role of young people in exacerbating or actually creating the unsafe roads in North Cyprus. As the program progressed there ensued an involved discussion about youths drinking and their appropriation of sidewalks along a main street in Lefkoşa/North Cyprus. In the course of the discussion the head of the Nonprofit for Traffic Safety, Dr. Mehmet Avcı, made the following comment:

> We gave a 17-year-old child a driver's license. He goes with his friend to the disco. That's also his right. He can buy alcohol. Okay so later he wants to return home by car. Now what have we done to prevent this? We have done nothing. In fact his mind is not fully mature. We are agreed upon that. As we know the child always comes in a car full [with friends/other youth]. His girlfriend is along. He is going to show off to her. With his male friends they all drink and provoke each other to drink more. We know they are all children. At least we could do is pass an alcohol law [that says], "Go to the disco but don't drink. If you drink alcohol you cannot return now by car." But we leave them free. We are making a mistake.

In North Cyprus there are varying definitions as to when and how children become validated/ratified members of a community. There is tension between the family-based cultural predilection to blur the line between youth and adulthood and the desire of institutional social actors like the government and local nonprofits to make this line distinct: to move the official transition between youth and adult to a later and later age.

In my year-long ethnographic study of youths in North Cyprus I found that parents, in keeping with cultural tradition, are eager to have their children, particularly their sons, prove themselves active and capable members of the community as soon as they reach puberty. Institutional social actors like the state and nonprofits, focused on modulating social stability and guided by findings in psychology and neurology, increasingly push this transition to adult status toward the late teens.

For example, in North Cyprus the definition of what constitutes an adult and a non-adult beverage remains one of the many ambiguous areas where cultural tradition and government regulation work in contradiction to define youth

participation in the public sphere. Traditionally, beer, mostly due to its reduced potency, has been perceived to be a suitable beverage as youth transition to drinking the more potent traditional beverages of brandy and raki in their adulthood. The state and other institutional actors in North Cyprus, on the other hand, particularly in their efforts to curb traffic accidents, have increasingly attempted to re-categorize beer as exclusively an adult beverage. Turkish Cypriot youths', especially boys', early introduction into alcohol consumption by their parents, seemingly an introduction into adulthood, contradicts the approach taken by the state, which perceives youth as equally unready for such adult experiences.[1]

Furthermore, while the traffic safety experts included in the GaKTV program and those I interviewed explicitly framed the discourse about youth, alcohol and consumption in gender-neutral terms, the implicit undercurrent of this discourse in fact employs the traditional gendered logic. Because there is a tendency for families to be more supportive of their sons to become public participants through driving and drinking, girls begin drinking and driving at a later age. Thus, because boys play a more prominent role in public earlier than girls, the traffic safety experts, as I will argue in the following, although talking about youth in general, tend to implicitly reference boys. Boys in this case become the standard bearers for both sexes in North Cyprus.

This paper focuses on the public and often gendered nature of official youth discourse. However, equally important here is the role that media has in the definition and redefinition of youth. Definition of the line between childhood and adulthood is significant because it determines how adults understand and relate to young people. Furthermore, it strongly shapes how youth understand themselves in relationship to the community. In the above the traffic safety experts use the forum of television to call for consistency in the definition of youth as non-adult. Television news programs like GakTV have been shown to play an important role in defining youth as the vulnerable and dangerous other, thereby emphasizing their non-adult status and their threat to adult social structures.

Media is a powerful tool by which youth involvement in the public sphere is shaped: how they are constructed and defined in public discourse. However, media can also play an important role in opening up the dialogue that, as Jurgen Habermas has argued, is fundamental to the ideal of a fully democratic public sphere.[2] Others, since Habermas, have argued, as I will argue here, that the media while frequently controlled by private interests to manipulate public voice, can still act as a key source for facilitating public discourse (Scannell, 1992; Silverstone, 1994, 17).[3]

Television news programs shape public perception of the place of youth in the public sphere by focusing the discussion on youth responsibility, giving far less attention to youth rights. Thus youth are defined by what they should be doing rather than by what they can do. In emphasizing youth responsibility, the

role that young people play in shaping public discourse is often overlooked and in turn neglects to invite youth to be active participants in the public forum. This is further exacerbated by the fact that research on youth roles in public has often looked at their isolation and rejection of adult norms, rather than at what happens when adults and youth are in dialogue.

In Turkish Cyprus many contradictory forces interact in the struggle to define youths' involvement in the public sphere. What follows is an attempt to illuminate the complex role that media plays in this conflict, examining one moment in Turkish Cypriot television. It is based on an analysis of transcripts from one episode of the talk show program GakTV recorded during my year-long ethnographic research project carried out in 2001 and 2002. The paper is part of a broader analysis I undertake elsewhere of intergenerational relations in North Cyprus (see Lyons, 2007).

In the media moment under scrutiny here, youths are invited by the GakTV host to explain their public role. I conclude that, while the GakTV program offers these Turkish Cypriot young men a unique opportunity to reshape their public image and actively engage the public sphere, their voices are overwhelmed by the narrow portrayal of youth offered by the adults on the program. I demonstrate that close attention to the dynamics of masculinity challenges the binary opposition of youth versus adult that is perpetuated in the gender-neutral language of this television program. Furthermore, being able to see beyond the youth/adult construct opens up opportunities for rethinking youths' active participation in the public sphere.

Turkish Cypriot Youth and the Public Sphere

Turkish Cypriot youth participation in the public sphere has been transformed by larger changes in Turkish Cypriot society. From the late 1800s to 1960 Cyprus, while under British colonial control, saw a rapid transformation. This transformation came about as a result of the pressures of modernization, urbanization and the strains of violent interethnic conflict that eventually led to the division of the island. Prior to the 1960s Turkish Cypriots lived intermixed with Greek Cypriots in communities throughout the island. Life during this time remained, especially in the rural areas, organized as it had been for centuries. For young people life was highly structured along lines of age and gender. However, the traditional hierarchies began to be challenged beginning in the 1950s with the entrenchment of modernity, rapid urbanization and the subsequent increase in access to formal education. The violent conflict between 1955 and 1974 first against the British colonial authority and later between Turkish and Greek Cypriots in which youth played a prominent role further transformed age and gender hierarchies.

After the division of the island in 1974 into the Greek Cypriot-controlled south and the Turkish Cypriot-controlled north the provision of formal school increased rapidly leading to increased opportunities for all Turkish Cypriot to attend high school in Cyprus and a large number to go to university primarily in Turkey but also other places in Europe. The universalization of formal education increasingly replaced traditional modes for mentoring young people. This resulted in extending the period of adolescence, ultimately leaving youths to be defined by their liminality (James, 1986). For girls and boys these transformations have different origins and different trajectories.

There is a long history of sex segregation of space in Cyprus.[4] Traditionally, Turkish Cypriot girls are not promised the same public role as boys. A young girl referred to as *kız* up until the time she is married, the only time it is socially acceptable for her to lose her virginity. In Turkish a woman who is married is referred to as "kadın." Thus, the traditional emphasis on a Turkish Cypriot woman's definition is on her chastity and responsibilities to the home more so than in terms of her public role.

While prepubescent Turkish Cypriot boys are referred to as "oğlan" once they reach puberty they have traditionally taken on a new moniker and new status: that of "delikanlı." Literally the term delikanlı translates as *crazy blooded* and refers to the unpredictable and rambunctious behavior of a male youth. However, the ideal delikanlı is also honorable, as demonstrated through his devotion to his male friends.[5] These expectations of honor parallel later expectations placed on adult Turkish men. Boys' development is defined by their transition from wild and promiscuous behavior to more consistent and predictable behavior and a refocusing of a sense of responsibility predominantly on their families and community.

While men are allowed a transitional phase after puberty and prior to marriage, during which they are granted a public place, there is no such phase for women during their youth. Ideally men mature into fully public citizens while women, according to the traditional scenario, mature into wives and mothers. These expectations are reflected in women's public mobility. Women are expected to be tied more closely to home than men, and when women are publicly mobile their movement is monitored by their fathers and husbands.

The infusion of a strong nationalist modernist drive in Anatolian Turkish culture, beginning with the Ottomans and coming to fruition in the 1920s under the leadership of Mustapha Kemal Atatürk, the father of modern Turkey, led to a challenge to this strict definition among Turks in Anatolia and Cyprus.[6] Atatürk's reforms, while retaining the division of child and adult in gendered terms, broadened the definition of *kadın*, inviting and encouraging adult women to be active members of the public sphere in addition to their roles as responsible mothers. Simultaneously, the term *bayan* or lady was introduced into Turkish (Lewis, 2002, 113) and came to be an official public term for referring to an unmarried as well

as married woman without indirectly commenting on her chastity and in turn her honor. More recently, Turkish women have begun to broaden the definition of young girls in terms of sexuality. Specifically, young women have appropriated the title of *delikanlı kız*, either as a self-reference or to another girl acting in many of the wild and erratic ways that young men do, without the shame that would have been traditionally placed on an unmarried woman acting in such a way. However, women are only to assume a public role without shame if they are able to remain chaste before marriage and able to fully fulfill their duties as wives and mothers after marriage.

Atatürk's reforms, enacted to bring women into the public sphere, influenced the way in which Turkish Cypriot young women envisioned their future roles as members of society. However, this did not lead to a transformation of the institutional structures and the subsequent social pressure on a young unmarried woman's sexuality.[7] While there has been a major transformation in parity between the sexes in the last fifty years, women in North Cyprus continue to find greater limitations on mobility and occupation of public space than do men.

The restrictions on women's mobility in North Cyprus are not as strict as those found in other communities along the Mediterranean. As a result of changes over the last fifty years Turkish Cypriot women have become university educated, drive cars and are employed in large numbers. Women have the freedom to dress as they choose. However, the expectations on female chastity remain, as well as a male concern of being cuckolded. Thus, an unmarried woman's movement is closely monitored by her father, and a married woman's movement is closely monitored by her husband. Gossip and the cell phone are important monitoring devices that also play roles in structuring women's movements in public space. The implicit violence involved, as I will discuss in further detail below, is a major constraint on women's mobility in public space.

Since the mid 1980s Turkish Cypriot young men and women have additionally had to confront the challenges of life under international embargo. The Turkish Cypriot community has been under international embargo since declaring itself a state in the mid-1980s. The embargo closed off all ports in North Cyprus from international commerce and travel. In order for the Turkish Cypriot community to survive as an entity distinct from the Greek Cypriot south they have had to rely on Turkey for all financial and political relations. Turkish Cypriot youth point to the embargo and those who are responsible for its continuation—the international community, the Greek Cypriots and particularly the past Turkish Cypriot administrations—for the high unemployment and Turkish Cypriot lack of political, economic and cultural self-determination.

The young men included in this study are in the midst of their education and the prospect of employment is a few years off. However, for Turkish Cypriot youth the embargo has been a dark cloud hanging over their future. Economic

and perceived social stagnation brought about by the embargo shapes youths' perception, especially when they compare their lives to their Greek Cypriot counterparts. Generally, Greek Cypriot youths are perceived to live more affluent lives, have better employment prospects and more vibrant social lives. Ultimately, this sets up a tension between young people who seek a vibrant economic and social life and older people in positions of power who are perceived to be intransigent keepers of the status quo. These tensions underlie youth-adult relations in North Cyprus and, as I will argue below especially gender relations.

In the following, I will explore one moment in the life of the Turkish Cypriot community of Lefkoşa, North Cyprus, where youth are invited into public discourse. Because it is the boys who take up the most prominent public presence granted to them by their greater freedom of mobility, it is not surprising that those interviewed in the following are all boys. However, there is little recognition of the fact that while the expert discussions are about youth in general, the actual discussants are all male. I conclude that generalizing tendencies of official youth discourse—without attention to the diversity of youth voice and the gender dynamics of intergenerational discourse—the media, even when it aims to open up a dialogue with young people, narrowly defines and misconstrues youth experience. The major obstacle to youth involvement in the public sphere is the lack of opportunities to engage in the public sphere as individuals rather than as a group categorized as youth.

Interviewing Youth in Public

The GakTV program began in 2001 with the intention of creating a public forum for discussion of issues important to Turkish Cypriots. Here I focus on one early episode on youths drinking and driving. In this episode, as is common to the format of the program, Harun Denizkan (Harun Bey), the host, offers video segments of his previously recorded interviews on the streets and in the homes of North Cyprus. In the midst of this discussion of youths drinking and driving, Harun Bey shares a videotape of recent interviews he carried out with Turkish Cypriot boys who were hanging out on sidewalks lining one of the major urban thoroughfares in North Cyprus. The phenomenon of youths hanging out and drinking along the busy thoroughfares of Lefkoşa is a more recent phenomenon, which my informants speculate began in the 1990s. While hanging out on the street corner is predominantly an activity of boys between the ages of 15 and 20, girls on occasion join in. In the following I offer partial transcripts from three interviews in order to better understand what happens when young people are invited to be active participants in the public forum.

Figure 2: Harun Bey's first interview—two youths hanging out in Lefkoşa (GakTV 2002)

Harun Bey: Good evening youths.

Youth 1A (Y1A): Good evening *ağabey* (honorific—older brother). How is it going?

Harun Bey: Hope it is a good sign that you are here like this at this hour?

Y1A: What can we do? I am sitting with my friend having a heart to heart talk.

Youth 2A (Y2A): We are hanging out within the limits of our budget.

Harun Bey: You are hanging out within the limits of your budget.

Y2A: Yes.

Harun Bey: What kind of budget are you on?

Y2A: We are at the cheapest place.

Harun Bey: You are buying your beer.

Y2A: We drink here every evening. [Sarcastically] The view is great. Where can you find a view like this? [View is of a deserted stretch of city street.]

Harun Bey: You do this every evening?

Y1A: Almost always when we have the money we are here, sitting on this manhole cover.

Y1A: Sitting on top of this manhole cover.

Y1A: Yes . . .

In this first exchange we see Harun Bey approach the two young men as an older brother; he starts out each interaction with the youths with "Hope it is a good sign that you are are here like this at this hour?" ("Hayırdır böyle buralarda

bu saatlerde?).*" Used in this way *hayırdır* is an expression of concern that acts in an indirect way to emphasize that the youth are engaging in behavior that is unusual and merits concern. It is an open-ended inquiry and not an accusational one. He quizzes them about their drinking and he advises them that, while it is not against the law to drink, it is to drink and drive. As the linguistic anthropologist Alessandro Duranti (1992) points out, this type of greeting is a means of social positioning that is mirrored in a physical hierarchical positioning (657).

Thus, what goes on here, if we look closely at the interaction, is a social positioning. In many respects the hierarchy between Harun Bey and the young people is established at the first statement. Rather than being a greeting lacking propositional content, it establishes important relations (Duranti, 1997, 220). The first exchange suggests the nature of the status hierarchies that will be played out in the remainder of the interaction. Harun Bey is older and a well-known journalist holding a microphone; he is accompanied by at least a cameraman and perhaps others. All of this contextualizes the interaction. It is interesting to note that the hierarchy is established through an expression of concern. This is demonstrative of the fundamental importance of empathy in interpersonal relations in North Cyprus and attempts to close the space that has been created by youth distancing themselves at remote locations late at night. This traditional greeting of concern is a reminder that older people are concerned and watching.

However, at the same time, this greeting is an open question and creates a horizontal rather than vertical hierarchical relationship between the speaker and the hearer. Through this greeting, Harun Bey sets the tone as an opportunity for these young men to explain themselves. His body language as well, positioning himself low and at eye level with the seated youth, further emphasizes Harun Bey's desire to appear on an equal footing with the youth. In this way Harun Bey positions himself as an intermediary between the young and the old, the experts on the program and the general public calling in.

These youths respond to the host with respect, identifying him as *ağabey,* "older brother." They present their activities as "hanging out" and having a "heart-to-heart talk." By pointing out that they do so on a limited budget, with a few beers in a place with a poor view of a deserted stretch of a city street, they are emphasizing that having no money places them in this pathetic situation. Their social activity is limited and modest. Their defense to accusations that they may be engaging in socially unacceptable behavior by doing something as weird as hanging out here at this hour is to construct themselves as impoverished victims of their social circumstance. In so doing these youth are implicitly referencing the economic and cultural stagnation brought on by the economic embargo and the intransigence of older people to find a solution to lifting the embargo. This is a common narrative among youth in North Cyprus.

When the host expresses concern for them being at this place at this time of night, their response is that it is not unusual for them. It is where they come frequently as unattractive as it may appear, to sit on this canalization cover and have heart-to-heart talks. This spot at this time of night provides a place that they consider their own, a place with personal meaning that they come back to whenever they have enough money to buy a few beers and some snack food. In this way the youths construct their hanging out as personally meaningful and normative behavior in contrast to the general public's perception that their late-night hanging out is erratic, irrational and abnormal. When compared with the second group Harun Bey interviews, there are some interesting consistencies in the interactions and story but some significant differences as well.

The following is a transcript from the interview with the second group of boys hanging out. This group is a larger group of seven to eight. They appear to be slightly younger than the previous group: high school students as opposed to university-age students. Furthermore, during the interview they are all on their feet and in motion. The atmosphere is much more jovial than the first interview with lots of joking and laughter.

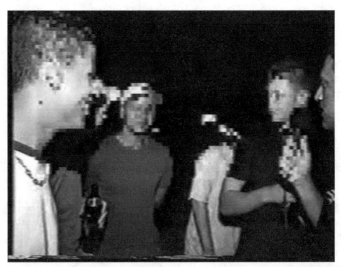

Figure 3: Harun Bey continues his interview with more youths (GakTV 2002)

Harun Bey: Yes young people, Hope it is not a bad sign that you are here like this at this hour?

Youth 1B (Y1B): What can we do? There is a thing to do [There is nothing to do.], there is nothing else.

Harun Bey: You are here every evening? Isn't it?

Y1B: More or less, more or less.

Harun Bey: Why do you prefer to do this? Are there no other entertainment spots?

Y1B: There are but there is nothing else. The Beer Garden is expensive. Everything is expensive! We meet with our friends here, every night. We drink and sit, chatting.

Harun Bey: Do you drink here every night?

Y1B: It is not every night. Every third or fourth night.

Harun Bey: As far as I can see you drink cheap beer. You are drinking Efes. You are drinking the cheapest beer.

(laughter)

Y1B: I told my friends (laughing) however yes we are drinking Efes.

Harun Bey: You are drinking Efes. Okay, in an evening how many beers do you drink for example when you come?

Y1B: Three, four, five, six. . . .

Harun Bey: Are you driving a vehicle?

Y1B: No. I can not drive, I am drunk.

Harun Bey: For example who among you is driving/drives a vehicle?

Y1B: He is lost (pointing)

Harun Bey: You drive.

Youth 2B (Y2B): I drive however, now I am not driving.

Harun Bey: For example, however this evening you drank?

Y2B: One.

Harun Bey: One is offense [To drink one beer and drive is an offense.]

Y2B: My house is right here in fact. I come here on foot.

Harun Bey: Generally you know traffic accidents always happen this way. Young people go to the discos and drink there. Of course it is not easy. Later an accident happens.

Y2B: When we get out on the roads we don't drink.

Harun Bey: For example when you go to the disco, for example when three youth go to a disco will all three of you drink?

Y2B: No. We tell the person who is driving that he shouldn't drink.

Harun Bey: You tell him directly.

Y2B: Yes, our family is against that. We say if you are driving that night you cannot drink.

Harun Bey: Of course we also [feel this way]. We are interested in you not drinking, we want you not to drink. Especially we don't want you to drink because you are going to drive a vehicle.

In the above exchange Harun Bey takes a further step away from moderator toward mentor. The young people are shy and embarrassed. They move around Harun Bey and the camera, destabilized by its presence, laughing and often ill

at ease. Harun Bey works his way step by step, drawing out first their habits of frequently congregating and drinking with the questions, "Are you here every evening?" "Do you drink every night?" "How much do you drink?" and finally, "Did you drive?"

The young people defend the suggestion that their behavior is abnormal by, as the above group does, pointing to the underlying economic restraints that confine their choices. "Everything is expensive." The young people resist the suggestion that they drink and drive; however Harun Bey constructs them as if they do. He states "Generally, you know traffic accidents always happen this way." He attempts to blur the line between all young people and these young people, a conflation that they resist. In the end Harun Bey is forced to construct a hypothetical situation and then insert the young people into it to elicit the connection. By responding that they have a designated driver and that they do so because their parents advise them is an attempt by *Youth 2B (Y2B)* to reestablish their credibility as young people who are sensitive to their own limits and social expectations.

This is in stark contrast to the final interview with one young man sitting on the back of a park bench. The youth appears to be university age. There is a striking difference in the tone of the interview which suggests a much more clearly equalized hierarchical status between the two. While Harun Bey is slightly more reserved in his questioning, the young person is more aggressive in his responses. The camera seems to cut to the interaction after the exchange of initial greetings and we jump right to Harun Bey's first question.

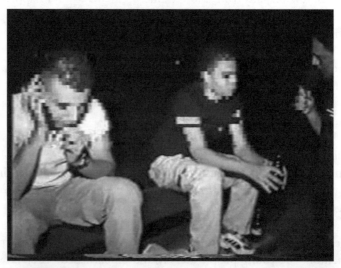

Figure 4: Harun Bey's third interview of youth hanging out (GakTV 2002)

Harun Bey: It struck me that generally young people are always here in the evening. Why is that?

Youth 1C (Y1C): How else can you spend time in Lefkoşa? At this hour? There is nowhere for the people to go. A place where you can go at 12:00 AM. Dereboyu closes. After 12–1 everyone comes to this area.

Harun Bey: It is 11:00 PM right now?

Y1C: It is a week night.

Harun Bey: It is because it is a week night.

Y1C: Of course. During the weekend everyone goes to Kyrenia etc. the discos. This is what it is like during the week. There is nothing to do.

Harun Bey: Do you come here every evening?

Y1C: No. Our friends get together everyone comes and meets here. There is nothing else to do.

Harun Bey: As far as I can see you are consuming alcohol.

Y1C: One or two beers.

Harun Bey: One or two beers.

Y1C: Yes. It passes the time.

Harun Bey: You know that one or two beers is an offense when driving a car.

Y1C: The person driving does not drink.

Harun Bey: For example this evening who is drink. . . who is driving?

Y1C: The one standing there is the driver.

Harun Bey: The driver is the one standing there.

Y1C: The one that is on the telephone.

Harun Bey: You will pay attention to this won't you youth (plural).

Y1C: Yes, it is very likely.

Harun Bey: You know that there are a lot of accidents in our country, and generally in 99% of these accidents alcohol is involved.

Y1C: In Lefkoşa nothing much can happen, just small accidents.

Harun Bey: Let's not say couldn't happen. An accident is an accident. Alcohol as you know does not stay as it does in the bottle and accidents happen. In the end deaths happen. What do you say about traffic accidents? What can you say about traffic accidents?

Y1C: Well

Harun Bey: Do you have a recommendation for young people?

Y1C: Those who cannot drive after drinking should not drive. But those who are able to drive after consuming alcohol should drive. What alcohol you drank—one or two beers?

Harun Bey: Is that not already beyond the line? Alcohol.

Y1C: Don't drink. People get together with their friends. They say come on let's drink a beer or two. Whoever wants to drinks one or two beers. There are some of course that drink too much. Their friends, if they are truly friends, are

not going to leave them. If they are their friend they would not leave them, but drive for them. Take them home. After he takes care of that he would go home.

Harun Bey: Among you in those situations is there a friend who will not drink? For example is there always one amongst you who does not drink that evening?

Y1C: Definitely there is. Definitely there is. When 10–15 people get together it is never that all 15 drink. The ones that want to drink take a beer and drink one or two beers. That definitely exists.

Harun Bey: Okay happy chatting.

Y1C: Thanks.

In this third interview the relationship between Harun Bey and the young person is dramatically different. The young people in the first group were restrained and polite and wished to convey that their behaviors were modest; the second group was open, ashamed and respectful. The youth in the third interview was much more confrontational. Sitting on the back of a bench the youth is spatially positioned higher than the other young people, creating a different dynamic. Harun Bey in his first question asks the young man to comment on youth behavior in general.

He invites the youth to explain why and when; the youth states that they come there after 12 PM. The oppositional tone of the conversation begins when Harun Bey draws attention to an inconsistency in the youth's statement about why people hang out. Harun Bey calls attention to the fact that it is currently only 11 PM. Harun Bey's attempts to guide and chastise the young person for drinking and driving are rebuffed. First, the youth emphasizes that they do so because there is nothing else to do. Here again this youth points to his limited choices. The young man downplays the suggestion that meeting here and drinking is something he and his friends do all the time. Then he dismisses the threat posed by drinking and driving during the week by arguing that within Lefkoşa there is not a big risk of accidents and, if accidents do occur, they are only minor ones. Then he argues that drinking one or two beers isn't a problem and won't lead to an accident. His advice to other young people is that those who are not able to drive should not; no one should drive drunk, and he reiterates that one or two beers is not enough to impair driving.

Analysis: Youth Constructed

Hanging out and drinking is one of a number of recent offenses inflicted by young people on the moral fabric of the urban areas of Northern Cyprus. Harun Bey sets out not only to better understand, but also in his interviews to reprimand

and guide youth on appropriate behavior. He is working to repair the breach created by the death of the young girl at the hands of a young driver.

Ultimately, the above discourse is one that involves the place of young people in the public sphere and the role of media in shaping that place. What are the rules that should be followed? What should the limitations be, for example, on alcohol consumption and driving? How should Turkish Cypriot young people be expected to act in public? How should youths' public participation be defined in North Cyprus? What are young peoples' duties and responsibilities to the public? What are youths' public entitlements? Should youths be allowed to claim ownership of public space? To what degree should public space be designed to meet the needs of youths? Finally, what is the role of the media in bringing youths into the public discussion?

Historically, youths have had limited access to, and little control over, traditional media. In a more recent phenomenon youths have acquired the ability to move into and occupy public space physically as we see above or virtually, through the consumption and use of new information technology. As youths occupy public space they become a curiosity, a potential market and/or an annoyance to adult direction and control of public space. To adults, youth in all these manifestations presents itself as a phenomenon that moves in a large coherent mass occupying and disrupting the social cohesion of public space.

In the above interactions, there is a tension between the stereotyping of *gençler* or youths and the effort of youths to contend with their inclusion in this generalization. In each case there were similarities in the responses given. They regularly hang out on street corners because they are bored and there is nothing else to do. They don't drink and drive and they use the designated driver system if they are out drinking in a group. Each rebuffs the suggestion by the journalist that if they are doing anything wrong by hanging out it is because of the lack of available alternatives. This consistent narrative of victimization redirects the blame (if there is any to be had) back on the larger society, reflecting their powerlessness in a community where they are limited by the social, economic, ideological and physical constraints of life under economic embargo. This discourse of youth-as-victim confronts adult discourses that characterize youths as lazy, irresponsible and destructive. Furthermore, it suggests that youths common interests may lie in challenging social stereotyping.

While there is a consistent attempt by Harun Bey to speak about youth in general and to characterize the young people he is interviewing as representative of youth, the diversity of responses the young men give denies this characterization. They defend themselves against the accusation that they are drinking and they soon may be driving a vehicle and therefore a threat in three different ways. We can see that the negotiation of status and hierarchy is complicated. While all of the young people interviewed could be classified as youths, they have different

orientations towards independence. While all seem to acknowledge authority and profess responsible behavior with regard to drinking and driving, each takes a different approach as to how their responsibility should be dictated to them.

Allison James has argued that the disjuncture between youths and adults resides in the non-specific status of youth in modern society. "Adolescents are very much people in the process of becoming and their lack of a structured place in society makes the restructuring of their own liminality the more critical for it is here that knowledge of the self is gained" (James, 1986, 158). Youths self-definition is often defined in reaction to the tendency of society to construct them as a homogenized whole. What is at stake in this contest over the definition of a common youth experience is the elaboration of terms by which youths should be accepted as participants in public space.

Gisa Weszkalnys's (2008) study of youth involvement in the renovation planning of the Alexanderplatz public square in Berlin is relevant here. Weszkalnys demonstrated that when young people who had an interest in the development of the square were invited into the discussion, and allowed to propose their own plan for the transformation of the public space, they offered a compelling defense of their right to have a say in the future shape of public space.

The youth workers in Weszkalnys's study conceived of public space in Habermasian terms. Weszkalnys argues that they are defining public space in terms of its *social robustness*; public space should be an all-inclusive and open forum. The Alexanderplatz youth workers argued that it is ultimately beneficial to society if youths are provided a space where they can become part of public life. Youths are seeking an invitation into public life that better meets their own needs. In the end, the focus on the social in the youth workers' definition of public space was at odds with the state's definition. The state perceived public space as needing to be robust in terms of technical, economic and aesthetic quality. Ultimately, the youths involved ended up endorsing the final plan for the Alexanderplatz Square, which seemed to integrate their concerns and in turn demonstrate a respect for youth's place in the public space (60).

In the above dialogue between Harun Bey and the Turkish Cypriot youths we see young people being invited into the public discussion. However, while on the one hand they are invited and given an opportunity to speak, they are forced to do so in a language that stereotypes them. While the youths consistently focus on their economic disenfranchisement, the adults focus on youth as a social problem. The above exchange demonstrates how an over-determined focus on youth as a category masks the complexity of youth experience. The interaction above, for example, pushes aside on the one hand the economic constraints and overshadows the significantly gendered nature of the above exchange. Here I explore what observing the interaction through a gender lens reveals. Given that all those participating in this public discourse appear to be male, the fact that gender is at

stake here is never acknowledged; rather the focus remains on youth. In the next section, I would like to explore the overlooked gender component of the above discourse.

Masculinity negotiated; gendered streets:

The following is a story told by Dr. Avcı on the same talk show. Dr. Avcı, immediately following his explication of youth drinking and driving previously quoted, describes his personal experience driving down Dereboyu, one of the main thoroughfares in North Cyprus and one of the preferred hangouts in Lefkoşa for Turkish Cypriot youth.

Dr. Avcı: We mentioned Dereboyu. I can tell you this, I will tell you this openly. Friday, Friday evening I was afraid to pass by there. At this age and this status/state underneath me I have a giant jeep. I was scared.

Harun Bey: On the streets on the street . . .

Dr. Avcı: Because someone parked their car on the street. . . . I called the Ministry of Security on the telephone and told them about it. A car was parked on the corner of the sidewalk. In the middle of the road next to the parked car was a young person with a beer bottle in his hand. He was chatting and they were right in the way where I was to pass. Either I am going to hit the gas and run over them, or I am going to pass on the right and strike the cars coming from the opposite direction. I stopped and blew my horn. I blew my horn as hard as I could. The child replied "Is there no place to pass?!" Now, if I am an annoyed/intolerant/easily angered person I would fight.

Harun Bey: Yes.

Dr. Avcı: Or, I am going to drive on top of him. Or, if I have been drinking, everyone drinks and drives anyway, I will do this. He is also drinking. He is going to try to fight me. Then you end up with a group fight. Alongside him there is another group drinking.

Harun Bey: Yes.

Dr. Avcı: And God forbid the stores there not to mention just the traffic problem . . . Consider in the midst of this two young women (iki tane genç bayan) trying to walk on the sidewalk. They cannot pass. Think of a young couple trying to walk on the sidewalk. They also can't pass because there are youth with beer in their hand drinking on the sidewalks. They also drink in the roads. And two separate groups also drink alcohol. If one night these groups get in a fight there will not be any unbroken shop windows left on Dereboyu and the police won't be able to make it in time.

During research in North Cyprus I heard several stories similar to the above about conflicts between Turkish Cypriot youth and their parents. Such conflicts

were bemoaned as the decline in Turkish Cypriot society. Turkish Cypriot youth are brought up in a culture that places heavy emphasis on respect for social hierarchies. While these have been eroded over the years through changes brought about by interethnic conflict and industrialization, parents hold high standards for their children's respect for social hierarchies and are greatly concerned when they are breached.

Dr. Avcı in his capacity as a traffic safety advocate has become a significant voice in constructing the moral panic about Turkish Cyprus' social decline and the particularly significant role of youth in this decline. Dr. Avcı explains above, "Friday, Friday evening I was afraid to pass by there. At this age and this status/state underneath me I have a giant jeep. I was scared." Close examination of the above media excerpt in the construction of youth-focused moral panic reveals that there is more to be learned about the nature of media's role in mediating youth voice in the public sphere. In Dr. Avcı's recounting of his confrontation with youth hanging out on the sidewalks in the summer evenings there are two striking elements at play. The first is that while the story of these confrontations is offered in the context of a discussion of *gençlerin* (youth's) drinking and driving, the tale takes a strongly gendered overtone, suggesting that the confrontation, instead of one between youth and adults, may be described as one between men. The second is the impending violence involved in the confrontation. Although Dr. Avcı claims to be talking about youth drinking and occupation of public space, it is clear from the above that he envisions the real threat to public stability to be young men and not young women.

Avcı asks us, "Consider in the midst of this two young women (iki genç bayan) trying to walk on the sidewalk. They cannot pass." While the focus of Avcı's concern is on the disruption of space by the youth hanging out, he implicitly refers to the challenges of movement in public for women in general.

The physical and social mobility that cars, schooling and urbanization have brought over the last fifty years has eroded the power of traditional authority. Even in a close knit community like North Cyprus the major thoroughfares, at their hours of abandonment when official business for the day ends, have become contested territories where young men stake out claims. As some of these young men become more courageous, controls over space can lead to confrontations with adults. As Avcı suggests the presence of these groups of youth in public space are perceived as threatening and Avcı's attempt (by honking his horn) to reassert a sense of order is met with brusque treatment by one of the youth hanging out, "Now, if I am an annoyed/intolerant/ easily angered person I would fight." As we understand the interaction there was no actual violence involved; rather it was the suggestion of violence that Dr. Avcı articulated. It speaks to the implicit violence involved in young men's occupation of public space in North Cyprus.

What appears striking in the above is the underlying threat of violence that pervades the interaction on the street. While the focus in the above is on youth seen through a gendered lens the interaction seems to be less about youth as an isolated and identifiable group and more about the negotiation of controls over use of public space of the street between older and younger men.

Turkish Cypriot public discourse suggests that there is a history of tension implicit in how older men define younger men's participation in the public sphere. On the one hand *gençler*, youth in Turkish Cypriot nationalist rhetoric, represents a social force that protects national ideas and exists to challenge all, including older men, who have strayed from these ideals. In a speech that appears at the beginning of textbooks in Turkey and North Cyprus Atatürk, the founding father of modern Turkey, calls on Turkish youth.

> Turkish Youth, Your first duty is to preserve and to defend Turkish independence and the Turkish Republic forever. This is the very foundation of your existence and your future. This foundation is your most precious treasure. In the future, too, there may be malevolent people at home and abroad, who will wish to deprive you of this treasure. If some day you are compelled to defend your independence and your Republic, you must not hesitate to weigh the possibilities and circumstances of the situation before doing your duty (Atatürk).

Atatürk, in line with the modernist nationalist orthodoxy of the time, perceives youth to be inherently well suited to transcend the hierarchies of the past to fuel a dynamic future. In this way youth becomes central to the vital essence of the nation and well poised to play a vital role in its protection.

On the other hand in Turkish the male adolescence is often referred to as the *delikanlı* years, the years of crazy bloodedness. These years are looked on with nostalgia by older men as days as the days of carefree bravado. *Delikanlı* in this way becomes an object of desire and young men must negotiate this objectified status.

Turkish men's nostalgia and emotional investment in youth is embedded in nationalist rhetoric and the cultural practice. Youth as constructed in Turkish culture is better understood not as a state of being but as a concept with indexical qualities, as Deborah Durham (2000) argues. Youth are conceptualized in Turkish discourse as a phenomenon by which older men narrate themselves and the nation. Older men are thus invested in the construction of youth in discourse and youth are in turn forced to confront the social definition laid before them. The emotional investment by older men in the cultural construction of young men is an important consideration when analyzing youth adult social interactions.

The story related by Dr. Avcı above suggests that the even the preceding interaction between Harun Bey and the youth is not just about the negotiation of an age hierarchy but a male hierarchy. Negotiations of masculinity remain the unacknowledged background to the focus on youth as seen above. Male youth

public incursions like the above are not rebellions in any collective sense, as implied by the media portrayal of youth against adults, but rather they are contests over power among men, at times tinged with violence, from which women are excluded.[8] As it is men who dominate the public space and the media the above is one among and implicitly about men. Rather than acknowledging that what is at stake is masculinity itself there remains a singular focus on youth. Employing a gendered lens draws into question the usefulness of the concept of youth if unarticulated by gender.

Conclusion:

Characterizing the above event as another moment in media generated moral panic does not capture the whole story, nor can it be classified as a triumph of youth resistance. When we look closely at the conversation between youth and the media as presented above we hear a conversation involving a diversity of voices. Harun Bey through his talk show GakTV creates a Habermasian 18th century English coffee house type forum for public discourse. With this program on drinking and driving he provides an opportunity for young people to confront accusations of blame for the high incidence of traffic problems in North Cyprus. Harun Bey mediates youth voice offering an opportunity to challenge the distinctness of the line dividing youth and adult behavior that others on the program consistently draw. [9]

However, in this program on traffic safety youth voice confronts major challenges. In this media moment a traffic safety advocate with significant social status who through highly emotionally charged accounts and several uncensored diatribes relays the threat of youth to the public order. Secondly, youth voice is overwhelmed by the insistence of the moderator on perceiving the young people interviewed as youth and not as individuals, thus significantly undermining opportunities for common ground to be found with those who share their concerns beyond their age group. Finally, the social interactions with young people that are relayed on the program as evidence of the youth problem demonstrate that there is a strong gender component to understanding youth's role in public space and what may be at play in the construction of youth by the media may be a byproduct of the negotiation of the hierarchies of masculinity.

Bringing a gendered lens to this moment of media-constructed moral panic reveals an important facet of youth experience in Turkish Cypriot media. The conversation above is as much about the definition and undefinition of youth as it is about the contest of masculinity. Considering the role of gender forces a reevaluation of the line dividing youth and adult, and suggests a commonality of experience across generations among men.

Strategies need to be developed which give greater parity to the commonalities of youth and adult experiences across the developmental trajectory. Media

has an important role to play here. The above discourse suggests that focusing on commonalities of gender might open the door to youths participation in the public sphere. A greater emphasis on inviting youths to speak and be heard as individuals might give deeper insight into how to transform the public sphere so that it sustains and promotes an atmosphere nurturing collective struggles for social improvement. This in turn may reduce the lamentable incidents that destroy lives and rend the social fabric.

Acknowledgments

This paper is the product of ethnographic study on Turkish Cypriot youth carried out between 2002 and 2003. I am grateful for the financial support received from Ford Foundation, the Woodrow Wilson Foundation and the Turkish Studies Association. I am also grateful to GakTV for allowing me to you use transcripts and images from their program on youth and alcohol aired in July of 2002.

Notes

1. A parallel tension is found in the starting date for driving. Parents traditionally expose young people to driving in fields and back roads in North Cyprus several years prior to the legally acceptable age.
2. See Nancy Fraser (1992) for an interesting discussion of the needed expansion of Habermas's conceptualization of the public sphere to be more sensitive to the women's access to the public forum.
3. The potential for new technologies for this kind of dialogue appears to be especially promising (see De Vreese, 2007).
4. This has been found to be true of other Mediterranean communities: see Peristiany (1965; 1976).
5. It is important to not confuse here Turkish cultural notions of honor involving duty and protection of one's family with the honorable behavior of a delikanlı. A young man demonstrates his maturity by protecting the reputation of his family but a delikanlı demonstrates his honor by helping another male friend in need.
6. Atatürk's reforms were immediately directed toward Turks living in Anatolia. However, his reforms garnered wide support from Turks living in Cyprus, which at the time was a British colony.
7. There remains implicit support for virginity exams on young women in Turkey (Parla, 2000).
8. See Leavitt and Herdt (1998) for a similar conclusion drawn from observations of Bumbita Arapesh youth of Papua New Guinea.
9. As the talk show moderator Harun Bey points out later in the course of discussion, adults also find themselves in parallel social situations drinking and driving. Harun Bey in the conversation references the tradition of the Turkish

Cypriot weekend family picnic in the mountains in which copious amounts of alcohol are consumed by adults who later get in their cars to drive home. In so doing Harun Bey suggests that the phenomenon of drinking and driving may be seen as a cultural phenomenon as well.

Works Cited

De Vreese, Claes H. "Digital Renaissance: Young Consumer and Citizen?" *The Annals of the American Academy of Political and Social Science* 611 (2007): 207–216.

Duranti, Alessandro. "Language and Bodies in Social Space: Samoan Ceremonial Greetings." *American Anthropologist* 94 (1992): 657–691.

———. *Linguistic Anthropology*. New York: Cambridge University Press, 1997.

Durham, Deborah. "Youth and the Social Imagination in Africa: Introduction to Parts 1 and 2." *Anthropological Quarterly* 73.3 (2000).

Fraser, Nancy. "Rethinking the Public Sphere: A Contribution to the Critique of Actually Existing Democracy." *Habermas and the Public Sphere*. Ed. Craig J. Calhoun. Cambridge, MA: MIT Press, 1992. 109–142.

Habermas, Jurgen. *The Structural Transformation of the Public Sphere: An Inquiry into a Category of Bourgeois Society*. Cambridge Massachusetts: The MIT Press, 1989.

James, Allison. "Learning to Belong: The Boundaries of Adolescence." *Symbolising Boundaries: Identity and Diversity in British Cultures*. Ed. Anthony Cohen. Manchester: Manchester University Press, 1986. 155–170.

Leavitt Stephen and Gilbert Herdt Eds. *Adolescence in Pacific Island Societies*. Pittsburgh, PA: University of Pittsburgh Press, 1998.

Lewis, Geoffrey. *The Turkish Language Reform: A Catastrophic Success*. New York: Oxford University Press, 2002.

Lipsitz, George. "Who'll Stop the Rain: Youth Culture, Rock 'n' Roll and Social Crisis." *The Sixties: From Memory to History*. Ed. David R. Farber. Chapel Hill, NC: University of North Carolina Press, 1994. 206–234.

Lyons, Bayard. *Narratives of Suffering, Dynamics of Space and the Practices of Intergenerational Memory in Turkish Cyprus*. Diss. University of California, Los Angeles, 2007.

Parla, Ayse. "The 'Honor' of the State: Virginity Examinations in Turkey." *PoLAR: Political and Legal Anthropology Review* 23.1 (2000): 185–186.

Peristiany, J.G., Ed. *Mediterranean Family Structures*. New York: Cambridge University Press, 1976.

Peristiany, J.G., Ed. *Honour and Shame: The Values of Mediterranean Society*. London: Weidenfeld & Nicolson, 1965.

Scannell, Paddy. "Public Service Broadcasting and Modern Public Life." *Culture and Power : A Media, Culture & Society Reader*. Eds. Paddy Scannell, Philip Schlesinger and Colin Sparks. London; Newbury Park, CA: Sage, 1992.

Silverstone, Roger. *Television and Everyday Life*. London; New York: Routledge, 1994.

Weszkalnys, Gisa. "A Robust Square: Planning, Youth Work, and Making of Public Space in Post-Unification Berlin." *City and Society* 20.2 (2008): 251–274.

Almost Paradise: Queer Utopias in Abeyance in David Levithan's *Wide Awake* and *Boy Meets Boy*

Jes Battis

In 2006, I taught an upper-division course on adolescent literature which included David Levithan's *Boy Meets Boy* (2003) on the syllabus. We looked at a variety of novels and programs featuring young characters, including Shyam Selvadurai's *Funny Boy*, Zoe Trope's *Please Don't Kill the Freshman*, and the popular teen drama *My So Called Life*. I include this bit of pedagogical context because, when we arrived at *Boy Meets Boy*, my students had a nearly unanimous reaction to the text: scepticism. Their comments ranged from "this town could never exist" to "it would be great to live there, but. . . ." There was always a *but*, which signalled doubt, and in some cases, outright mistrust. The consensus was that Nameless Town did not exist, could not exist, and had never existed. That left us asking if *Boy Meets Boy* was a fairy tale, a utopian text, or a hybrid of both. What surprised me was the level of critique that my students had for Levithan's book (they certainly didn't get as riled up about John Knowles's *A Separate Peace*), even as that critique was underscored by affection. They loved the novel, or at least really liked it, but somehow couldn't get on board with Levithan's premise.

Boy Meets Boy begins with an abduction. Tony's parents are non-specifically religious and do not approve of him visiting the city (we don't know which one, but it seems like New York). Paul, the novel's main character, arrives on a Saturday evening at 9 p.m. and is able to steal Tony away by convincing Tony's parents that their son is attending a hip young Bible-study group, when in actual fact they're going to see a DJ. "Our happiness is the closest we'll ever come to a generous

God" (1), Paul observes. Later that night, as Tony is reluctantly driven home, he remarks: "The Lord is my DJ. I shall not want" (7). This theological displacement or dispersion becomes an organizing principle within Levithan's novel, where two nameless cities—possibly New York and possibly Hoboken, NJ—become flashpoints for the articulation of queer utopic ideals. If "the Lord" is Tony's DJ, and happiness becomes a near-miss for the existence of a benevolent god, then part of Levithan's project seems to be the infusion of queer faith within a city where, by Paul's own admission, both the gay and straight scenes "got all mixed up a while back, which I think is for the best" (1). Tonally, this is quite the opposite of Levithan's 2006 book, *Wide Awake*, where the hope for a radically democratic and utopian America seems to rest solely on the shoulders of Abraham Stein, a gay Jewish president-elect.

Boy Meets Boy and *Wide Awake* are very different books, and the purpose of this chapter is not to construct a thematic comparison between them, but rather to explore the ways in which Levithan's teen characters participate in radical queer communities. Amy Pattee has already written on the establishment of a queer utopia within *Boy Meets Boy*,[1] and my discussion will focus instead on the impossibility of the utopian impulse within Levithan's work. Both *Wide Awake* and *Boy Meets Boy*, I want to argue, deploy partial utopias that function as vast unreachable spaces. Their contours grow hazier as both books progress, finally shimmering out (usually with one last spark) as the narratives each reach their tidy conclusion. What remains is an issue of clarity: Is a partial utopia better than the current reality, or ought young LGBT and straight readers be given a world-text that is more transparent?

Levithan's *Boy Meets Boy* ends with the description of a dance party in a pastoral clearing, with Paul's narration powering the dance machine:

> I see trees of green and dresses of white. I see Infinite Darlene whooping for joy as Amber attempts to dip her to the ground. . . . [I] see Kyle and Tony talking quietly together, sharing their words. I see Joni leading Chuck in a slow dance. I see candles in the darkness and a bird against the sky. I see Noah walking over to me, care in his eyes, a blessed smile on his lips. And I think to myself, *What a wonderful world.* (185)

Levithan's mapping of Christian iconography onto a queer secular event is striking here, if only for its deliberate vagueness. The "dresses of white," conveying both parochial and bridal suggestions, are juxtaposed against a natural backdrop, an almost druidic scene of revelry and ritual. Kyle and Tony are "talking quietly together," murmuring, while Joni "lead[s]" Chuck, her jock boyfriend, "in a slow dance." Noah, Paul's boyfriend, walks toward him with "a blessed smile on his lips," as if delivering a holy host. Given the novel's critique of Christianity, this has the tone of a mixed message.

In *The Heart Has Its Reasons*, Michael Cart and Christine Jenkins (2006) describe *Boy Meets Boy* as a story of both "gay assimilation" and "queer community" (150). Cart and Jenkins point to the novel's utopian elements, comparing it to Francesca Lia Block's *Weetzie Bat* novels, which are set in a postmodern Los Angeles. But it's difficult to locate precisely where this utopia exists in the novel, if a utopia—that is, a place that literally means "no place"—can be located anyplace at all. Certainly it is not Tony's hometown, located a few miles away from where Paul and Joni live. But if Paul's hometown is a utopia, then why does the book end with a pastoral scene set outside the town's limits? It is my contention that, rather than presenting a utopic model, Levithan's work produces a variety of adjacent and dependent utopias, overlapping, fragile, and different. If anything, both texts suggest the misfire of depicting a single queer utopia, since the notion of queered space may, in fact, be *outopic*: no space at all.

In a 2004 interview with James Murdock, Levithan declares (while talking about *Boy Meets Boy*): "I'm sick of reflecting reality. I wanted to create reality" (187). But this realist impulse clashes with his admission in the book's acknowledgments that "[*Boy Meets Boy*] started out as a story I wrote for my friends for Valentine's day," as well as the dedication: "For Tony: even if he only exists in a song."[2] Lyrically, Griffin's song is a memorial to "Tony," a gay teen whose suicide seems dramatically out of place within the world of Levithan's novel:

> Hey Tony, what's so good about dying
> He said I think I might do a little dying today
> He looked in the mirror and saw
> A little faggot starin' back at him
> Pulled out a gun and blew himself away. (Griffin 1998)

The Tony of *Boy Meets Boy* never has the chance to enact a completed suicide, since Paul, Joni, and the rest of his friends are always keeping him under a watchful eye. But even with the faint suggestion that he might pursue an eventual relationship with Kyle (also Paul's ex), Tony stands apart at the end of the novel. Earlier, he says to Paul that "you've *felt* lost, but you've never *been* lost" (151), and it's difficult to say whether Tony remains lost after the denouement. He isn't dancing, and he has no boyfriend with a "blessed smile" walking toward him. Like Infinite Darlene, the school's most popular drag queen/football jock, Tony seems to hover outside the central narrative.

Boy Meets Boy is driven romantically by the emerging relationship between Paul and Noah, but Tony remains a kind of cipher or supplement to this story, especially since the story itself is dedicated to him (or rather, dedicated to the boy in the song). Tony, in fact, becomes a mechanism for the success of this romantic plot, since Paul meets Noah while "rescuing" Tony from his religious parents,

and then enlists Noah in the group effort of escorting Tony to the high school's Dowager Dance. Tony is also an accomplice in Paul's plan to win Noah back after they've broken up, which involves delivering creative and romantic presents: "Tony starts it all off by calling Noah's cell phone and leaving a riddle" (165). I'm not suggesting that Tony fades to the status of plot-device at any point, since he does always cohere as a strong character within *Boy Meets Boy*. However, his complicated family life does take a backseat in order to foreground the love plot, and there is no point when readers might wonder if this is Tony's story rather than Paul's. Paul is the narrator, the focus-of-consciousness, and the only character in the novel that doesn't precisely learn anything new or change his ethical framework in a visible way. He cruises from a loving childhood to a seamless queer adulthood, and is mystified by the problems of his friends.

While *Boy Meets Boy* seems to suggest that a "better" or maybe queerer world is possible through the proper maintenance of filial and familial ties, *Wide Awake* declares that queer difference needs to be explicitly voted for. If there is a utopian impulse to Levithan's writing, *Wide Awake* shifts this impulse from teen collectivity and romance to the concrete register of the American electoral process. Throughout the book there is a radical conflation of sexuality and political participation, especially in scenes involving Duncan, the main character, and his boyfriend Jimmy:

> 'The personal is political,' Jimmy said to me one of the first nights I sneaked over to his house, 'and the political is personal. We vote every time we make a choice. We vote with our lives.' I pulled closer to him under the blanket, ran my hand down his bare chest. Voting.
> [. . .]
> '*Today is part of what America was meant to be*,' President-elect Stein said over our phones' open news channels. '*Justice. Equality. Democracy. We know what we have to do. . . and we will do it . . .* [*T*]*his is just the beginning*.' (21–22)

The characters in *Boy Meets Boy* certainly kiss and cuddle, but they do not vote. And, despite Paul's obvious infatuation for Noah, he pursues a relationship subtly and obliquely, like a courtly lover. There is nothing close to a sex scene within the novel, since sexuality becomes dispersed along a number of metaphorical pathways: song, photography, painting, dancing, and even paddle-boats. *Wide Awake* is a great deal more obvious in its depiction of queer teen sexuality, and presents multiple erotic scenes, both remembered and in real-time. This sexuality is always anchored by a principle of queer love which demands monogamy (another character is ruthlessly judged and punished later in the novel for her polyamory). Duncan and Jimmy emerge at the end of *Wide Awake* as an uncertain couple who, nonetheless, are united through their shared democratic politics.

In her review of *Wide Awake* in the *Lambda Book Report* (2007), Nancy Garden says of Duncan and Jimmy: "Their story includes the most tasteful, subtly graphic, and beautiful sex-scene I've read in YA literature" (26). She also provides a thematic critique of the novel that I agree with: "*Wide Awake* could certainly provide rich material for discussion in any social studies class whose teacher dares to introduce it, but as a unified work of fiction, it doesn't quite hang together" (27). The story takes place in the near future, after the Prada Riots and the Greater Depression, when Abraham Stein, openly gay and married to a man, is campaigning for the American presidency. He is on the verge of being sworn in when Kansas demands a recount, and all of his supporters—including Duncan and Jimmy—take a bus to Kansas in order to participate in a rally that never quite turns into a riot, but often teeters on the verge. Still, we never get the impression that any of the main characters are unsafe in any way. The animosity of the anti-Stein protesters is foiled when Stein is, in the end, declared president, and everyone gets back on the bus without so much as a stitch or a bruise.

One of the things that I find so compelling about this fusion of sexuality and politics is the equation that Levithan creates: voting = fucking. Jimmy insists that "we vote with our lives," and when Duncan touches Jimmy's "bare chest," he is also "Voting." Levithan is also careful to note that all of the teen characters in *Wide Awake* are too young to vote legally, and yet, Duncan and Jimmy propose a queer style of voting, an erotic electorate, which signals perverse and fantastic new forms of liberal parliamentary democracy. Unlike Paul and Noah, whose romantic focus is cathected around a number of high school commonplaces (the dance, a love-triangle), Duncan and Jimmy involve themselves actively in a political event that is unfolding before their eyes, and they both recognize that they are part of a human driving force behind this event. And yet, it's difficult to determine what two queer sixteen-year-olds could possibly be desiring while they campaign for Stein's presidency.

Just as *Boy Meets Boy* proceeds smoothly towards the conclusion of its primary issues, *Wide Awake* offers a seamless push into the safe politics of revolt for Duncan and Jimmy. People tell inspiring stories on the bus; one character is caught holding hands with someone who isn't her girlfriend; Duncan and Jimmy have a fight, which ends in cuddling. These are all things we might expect of a narration driven by young people attending their first political rally, but the chaos, confusion, and threat of incarceration that might loom over such events never really penetrates the experience of the characters. When Keisha and Mira break up, the level of shock is equal to the indignation felt over Stein's presidency being challenged. We remember that these characters are all still in high school, which is important. But, as Kathy Acker illustrates in *Blood and Guts in High School*, that period is not always so rosy. Duncan and Jimmy would probably not last

too long at the Gay Lesbian and Straight Education Network's current march on Washington.

April Spisak (2006) notes that personal relationships in *Wide Awake* are "certainly more colorful than the occasionally overlong speeches and political debates" (2), a point which I'll develop further in my own discussion of the novel's politics. But she also observes, a tad cryptically, that "readers who have been paying attention to the past six years of politics. . . will recognize contemporary overlays, and they will empathize with Duncan's (and Levithan's) passionate opposition to injustice and deceit in life or politics" (Ibid.). She may be referring to here to a geneaology of recent queer youth homicides, as well as the backlash created by the murder of Matthew Shephard in Laramie, Wyoming, in 1998, only three years prior to the period that she demarcates. This suggests that *Wide Awake* is a novel about retributive justice and public satisfaction, a celebration of revolt, when in fact the political events of the narrative unfold quietly, almost meekly. Stein's speeches are supposed to be rhetorical landmarks anchoring the plot, but instead, they serve as vague repetitions that only deflect us back into the mire of teen drama.

While *Boy Meets Boy* describes a particular style of utopia contained within a town (and further contained within a high school), *Wide Awake* begins "in the near future," narrating global changes that have occurred partly as a result of the events of 9/11. Levithan then goes on to complicate this political history, pointing to a number of subsequent fictional events and uprisings: The Greater Depression, the Prada Riots, the Reign of Fear, and the War To End All Wars (12). Aside from the "Prada Riots," which occurred in response to mass consumption, all of these are simply adaptations or recapitulations of modernist and premodern historical events. Levithan seems to suggest that, after 9/11, global history enters a period of endless repetition, which results in the conditions necessary for Stein's egalitarian presidency. Stein has a husband and children, which only further situates him within the arena of queer assimilation. He also has faith, which suggests a kind of queer oppositional consciousness—his faith is markedly, necessarily different from the Christian faith espoused by Presidents George Bush Sr., George Bush Jr., and Barack Obama. Stein's rhetorical proclamations produce a theological model closer to natural philosophy than evangelical Christianity, which is in perfect tonal agreement with the novel's utopian impulse.

However, *Wide Awake* and *Boy Meets Boy* are not literary utopias, especially if we define a utopia in Jamesonian terms as a collective that has been evacuated of some vitiating or negative political force. In *Archaeologies of the Future*, Frederick Jameson (2005) notes that "the Utopian calling. . . seems to have some kinship with that of the inventor in modern times, and to bring to bear some necessary combination of the identification of a problem to be solved and the inventive ingenuity with which a series of solutions are proposed and tested" (11). That is, literary and historical utopias are produced between the tension of wish-fulfillment

and material practice, between the impulse for a better world and the desire to lavishly appoint that world.

It is no coincidence that Jameson's example of this stylized world-building is Margaret Cavendish's science fiction text *The Blazing World*. Cavendish's world runs perfectly with the help of its demi-human populace, as well as its spiritual empress (who, really, is also Cavendish). Similarly, More's *Utopia* (1991) and Campanella's *City of the Sun* (1981), founded on principles of proto-communist exchange and scientific autocracy, are not waiting for a political event to propel them into a new age—as far as these worlds are concerned, they are living within the new age already. Levithan's utopias, however, are utopias in abeyance. They are both mobilized around two possible events: religious tolerance of queer sexuality, in the case of *Boy Meets Boy*, and political support of queer lives, in the case of *Wide Awake*.

The political space left for these stories can also be described as a generating utopia, something that is living, growing, and organically evolving, even if that evolution could eventually result in betrayal. What happens after the dance in the clearing? What happens after Abraham Stein becomes president of the United States? We don't know, and we aren't supposed to. In that sense, the act of reading itself becomes part of the utopian process, which can be short-circuited if/when the reader decides that these partial utopias, like psychoanalytic partial objects, could not, will not, or should not be realized. The reader gets to vote on this process, because if sex is voting, then reading certainly is as well. What remains a cipher in both of these narratives, like Tony's imprecise role, is the question of a faith-based queer community. What exactly do these characters believe in, if they believe in anything at all?

While religion is less of a battleground and more of a spectre in *Boy Meets Boy*, it is far more clearly realized in *Wide Awake*, with the ideological battle between two evangelical factions: the Decents and the Jesus Freaks. The Decents appear to be intolerant Christians, while the Jesus Freaks are young, sometimes queer evangelists, who have elevated Christian rock to a form of radical prayer. Levithan's own faith is either cloaked or absent within his writing. He mentions the Jewish holistic concept of תיקון עולם in *Nick and Norah's Infinite Playlist* (2008), which was recently adapted to the screen. תיקון עולם, broadly understood as "Repairing the World," is depoliticized within both the film and its source-text, ideologically unmoored from any suggestion of current Israeli/Palestinian conflict.

Like the Christian rock favored by Jesus Freaks Janna and Mandy, the ideal of global reparation becomes strangely transparent in *Wide Awake*, a gauzy and untraceable concept that seems to operate outside any realm of visible religious conflict. Like the hard science that sustains Campanella's utopian city, this ideal of reparation becomes both suspiciously natural and weirdly suspect. It remains unclear how the world is broken, how it is going to be fixed, and by whom. Stein's

political opponents from Kansas, in fact, propose their own negative version of
סילוע ןקית—protecting the world from indecency—which operates almost entirely
along the same structural and ethical principles (only with a different target).

The Decents are given only a universally intolerant voice within the novel,
while the Jesus Freaks, having ejected all of Christianity's historical baggage while
retaining some kind of holy kernel, are able to create for themselves a reputation of
moral superiority based on the friendly and welcoming dematerialization of that su-
periority which drives most forms of religious evangelism. Their church has a statue
of Jesus rather than a crucifix, a statue "peacefully watching over everyone who
wandered in" (38). Duncan even remarks, upon first seeing this idol, that "I was
Jewish, but I was still familiar enough with all the old paintings and the old ways
to be struck by this" (Ibid.). The Decents represent "the old ways," while the Jesus
Freaks are constructing a new theological paradigm based on tolerance. Duncan's
casual use of the past tense here—"I was Jewish" instead of "I am Jewish"—even
suggests that the Jesus statue's magnetic power is in the process of converting him.

Levithan's attempt to incorporate evangelical Christianity into the politics of
the queer movement here is fascinating and largely without precedent. Certainly,
Wide Awake has paved the way for other popular YA treatments of queerness
and religion, such as Alex Sanchez's *The God Box*. But this incorporation, like
the utopian impulse of the novels themselves, remains partial, incomplete, and
contradictory. *Wide Awake* seems to end with the suggestion that it doesn't mat-
ter what faith you/we have, as long as you/we have faith. This excludes the large
number of queer teens and adults who do not engage with faith-based politics, or
with faith at all, in any recognizable form. There don't appear to be any positive
depictions of young queer atheists in either *Wide Awake* or *Boy Meets Boy*, unless
we conclude that Tony's agnosticism has been pushed, by the novel's end, into a
form of chosen atheism. Both novels also detail the pleasures and pains of main-
taining faith, without touching upon the equal pleasures and pains—both erotic
and political—of being faithless, or of having faith in no faith.

Both novels present near-utopias that have a limited radius. It is difficult to
imagine antigay violence in Levithan's fictional town, since any suggestion of ho-
mophobia has been replaced by an almost relentless queer positivism. But Tony's
parents, his religious upbringing, his clear sadness, and his final aloneness at the
end of *Boy Meets Boy* all serve as reminders that a great many queer teens are not
as fortunate as Paul or Noah. It is for these teens explicitly that Levithan seems
to have written *Boy Meets Boy*, as both a fairy tale and kind of plea: *Wait. Things
are going to get better. It could/will be like this someday.* These politics of hope have
the tendency to be overshadowed by reality, such as in the case of Chris Colfer,
the out actor who plays the character Kurt Hummel in *Glee*. When asked by *The
Advocate* if he was out as a teenager, Colfer replies: "Oh no. People are killed in
my hometown for that" (Goldberg, 2009, 1).

Only time will tell if Kurt, like Duncan and Jimmy from *Wide Awake*, will get to enjoy a bit of on-screen action with any of the other Gleeks. Presumably, what made *Boy Meets Boy* more successful than *Wide Awake* was the fact that straight readers weren't threatened by the delicate metaphorics of the Paul/Noah courtly romance. Their love remains charming, and reminds us of how a simple kiss can be amplified by desire. When Duncan and Jimmy have sex for the first time in *Wide Awake*, their afterglow is narrated in precise terms:

> And still, what I loved most was the heartbeating. The heartbeating through the kisses. The heartbeating through the touch. The sharp, deep heartbeating when I came and the loose, lazy heartbeating of lying there after, drifting in that love-sewn quiet of lying next to him. (Levithan, *Wide Awake*, 66)

The "love-sewn" quiet has a textile feel to it, like the American flag displayed so prominently on the cover of *Wide Awake*, enfolding the entire book. The suggestion seems to be that "everyone is American," or that America itself is a visible text, a "love-sewn" piece of fabric. This cover was changed, in later editions, to a small heart-shaped version of the flag, making it all the more obvious that *Wide Awake* is a kind of love-letter to the United States. The rainbow flag is conspicuously absent.

Despite its tame sexuality and imprecise politics, however, *Boy Meets Boy* ends with a scene that leaves me breathless every time I read it. The dance occurs in an epilogue, but arguably the "real" ending happens in the last chapter, when Paul arrives to take Tony to the Dowager Dance. Tony's parents open their door to find a crowd of people waiting outside, including Paul, Noah, Joni, Chuck, Ted, Kyle, Infinite Darlene, and many others. When Tony's father asks Paul (rather reluctantly) if he is Tony's date, Joni answers: "We're all his date."

Aside from the fantasy of being taken to one's prom by a fierce army, this is also a moment of profound rebellion. Tony is not allowed to take a male date to the prom—not allowed to go to the prom period—so everyone he knows comes to rescue him. The logic is simple and dramatic: *you can't fight all of us*. So, Tony gets to go to the dance, not necessarily because his parents agree to it, but because they don't know how else to negotiate with the crowd of people gathered outside their door. Paul and Noah win because their team has the numerical advantage. It is both a sentimental and a potentially dangerous moment in the text. The possibility of queer revolt seems to stand on the edge of a knife, waiting for the other side's next move.

Notes

1. Pattee, Amy S. "Sexual Fantasy: The Queer Utopia of David Levithan's *Boy Meets Boy*." *Children's Literature Association Quarterly*, 2008: 157–71.
2. This refers to Patty Griffin's song "Tony," from her 1998 album *Flaming Red*.

Works Cited

Campanella. Tommaso. *The City of the Sun*. Berkeley, CA: University of California Press, 1981.

Cart, Michael and Christine Jenkins. *The Heart Has Its Reasons: Young Adult Literature with Gay/Lesbian/Queer Content, 1969–2004*. Lanham, MD: Scarecrow, 2006.

Garden, Nancy. "Wide Awake." *Lambda Book Report* (Winter 2007): 26–27.

Goldberg, Lesley. "Just One of the Guys: Interview with Chris Colfer." *The Advocate*, 6 October 2009.

Jameson, Fredric. *Archaeologies of the Future*. London: Verso, 2005.

Levithan, David. *Boy Meets Boy*. New York: Knopf, 2005.

———. *Wide Awake*. New York: Knopf, 2006.

———. *Nick and Norah's Infinite Playlist*. New York: Knopf, 2008.

More, Thomas. *Utopia*. New York: W.W. Norton, 1991.

Murphy, Ryan. *Glee*. Fox (2009).

Spisak, April. "Wide Awake." *Bulletin of the Center for Children's Books*, 60.3 (2006): 132–133.

"Word Up": Hip Hoppers' Smart Pose Outwits Masculine Scripts

Judy L. Isaksen

"'Rap' is as old as the African beating on a log . . . as old as the dictum that denied slaves drums because they were 'rapping' to each other after hours, drumming up rhythmic resistance. When the rappers say 'word,' it is old. Our speech carries our whole existence."
—Amiri Baraka (2001) "The Language of Defiance"

The face of the hip-hop nation has morphed multiple times over its 40–plus-year existence. From its sound and economics to its ever-broadening global reach, both time and circumstance have altered this cultural-musical movement. But one of the consistent aspects of hip hop is the resistive nature of its lyrical expression. Rappers and poets—who are primarily male—spit not only powerful words but also, more often than the commercial radio would lead us to believe, meaningful and deliberative words. As linguist-anthropologist H. Samy Alim (2006) puts it, "While some scholars and educators are quick to point to Hip Hop Culture's 'illiteracy,' Hip Hop Headz are even quicker to point to Hip Hop's ill literacy. ("Yo, that's *ill*, yo!")" (13–14). From the movement's earliest days, inner-city youths, primarily males of color, rhythmically call into question and resist the institutional structures—neglectful governments, police brutality, unequipped schools—that are largely responsible for the racial, social, and economic oppression that colors their lives. And despite the unfortunate commodification of hip hop by the entertainment and cultural industries, a sizable slice of hip hoppers are still operating from that deliberative, resistive, and socially conscious position.

The four creative elements that made up hip-hop culture—as it was taking shape in the South Bronx circa the 1970s—were MCing/rappin', DJing/spinnin', breaking/dancing, and graffiti art/writing. But respected leader, long-time activist, and "teacha" KRS-One (1999), who is still rockin' the mic, purposefully added more elements to move hip hop in the direction of consciousness as much as creativity, and he continually shares his views with wide-ranging audiences at colleges, universities, hip-hop conferences and summits ("9 Elements"). One of these newly added elements—street language—is the primary means by which hip hoppers can resist. KRS-One defines street language as the "correct pronunciation of one's native and national language as it pertains to life in the inner city," thereby flippin' the script on correctness and appropriateness and giving voice to an aesthetic that differs radically from mainstream culture (qtd. in Alim, 2006, 73–74).

Indeed language has arguably been *the* driving force of the resistive nature of hip hop. It's the vehicle through which the practices, performances, and productions of hip hop take place. Given that, it is useful to think about their discursive productions. What, specifically, are the frequently used stylistic techniques that surface repeatedly in rap music, and what is the history of these techniques? Equally interesting, what happens to hip-hop language once it is consumed by listeners and music fans? How does such language migrate and sustain and evolve among the young men who are a part of the hip-hop generation? And finally, what kinds of social and cultural knowledge as well as personal and collective identity formation are gained by the mediated hip-hop males who engage such public rhetorics? More specifically, how do they utilize these discourses to understand and alter their masculinity and socially constructed gendered roles?

In an attempt to probe these questions, by using a cultural studies methodology that includes both rhetorical analysis and gender performance theory, this chapter will track a host of rhetorical techniques within hip-hop language that traffic across time and place from the African and African-American oral traditions to contemporary hip-hop music to online Social Network Sites (SNSs). My SNS sample includes three sites—MySpace, BlackPlanet, and Facebook—with information gathered from male users, primarily of color, during the 2008 academic school year. Woven throughout these discussions is the argument that critically conscious hip hoppers—both performers and fans—use these traveling discourses as an intellectual means of resisting the stifling scripted roles of masculinity that reign in our culture, particularly the scripted roles of young urban males.

Gendered Scripts

Over the past few decades and since the "rhetorical turn" critical theorists have cogently posited that knowledges and identities are contingent, contested, historically situated, and political (Clifford, 1988; Grossberg, 1992; Hall, 1997) and

that discourse is a primary means for constructing, representing, and transmitting such knowledges and identities (Gee, 1996, 2005; Young, 2000; Hall, 1997; Bourdieu, 1990). Through discourse and practices, we are socialized to behave according to a vast host of ascribed manners, and gender reigns as one of the most potent features to not only organize our lives but also to determine our individual and collective identity. Gender—and construction starts with that first well-defined ultrasound—is so central to our lives and has become so normalized that we often don't recognize all that which is gendered; in other words, we have gendered scripts—scripts that reflect the workings of power in our culture—that we repeatedly, and often unconsciously, perform in our daily lives.

This notion of performance has been theorized by poststructuralist feminist Judith Butler (1993) who argues that we construct our gender identities through our expressions and performances. Gender is something we do rather than have: "*gender* is not a noun, but neither is it a set of free-floating attributes, for we have seen that the substantive effect of gender is performatively produced" (24). Moreover, our performances are never solo acts but collaborative productions because we also perform and express our identities in the context of social meaning, location, and time; each performance signals the individual actor as socially connected. We give voice to our gender identification through repetitive performances that have been normalized and ideologically scripted. Or as Butler puts it, "gender is the repeated stylization of the body, a set of repeated acts within a highly rigid regulatory frame that congeal over time to produce the appearance of substance, of a natural sort of being" (33).

As a culture, we internalize these gendered scripts—for men and women respectively—and are routinely rewarded when we behave appropriately and penalized when we don't; as a result, for the most part, we learn to perform what is socially expected of us.

The scripts of traditional masculinity within our culture are well researched, with identity formation traits including autonomy, competitiveness, mastery, supremacy, power, and toughness, all of which lead to the roles of provider and protector (Gilligan, 1993; Connell, 1993). These traits are firmly entrenched in our social norm, as Sallie Westwood (1990) explains: our society provides the "insistence of 'the male role' against which all men must be measured" (58).

But the traditional scripts of masculinity are somewhat different when applied to African-American males, particularly youth. Psychology scholar Shanette Harris (1995) cogently argues that "European American standards of manhood" are often beyond the grasp of African-American males due to "inequities in earning potential and employment and limited access to educational opportunities." She explains that this dilemma leads to even further problems: "To compensate for feelings of powerlessness, guilt, and shame that results from the inability to enact traditional masculine roles, some African American male youth have rede-

fined masculinity to emphasize sexual promiscuity, toughness, thrill seeking, and the use of violence" (279–280).

In a similar vein, Professor William Oliver (1988) has detailed the ways that African-American youth have been forced to find alternative ways to prove their masculinity by performing the role of the "tough guy" or the "player," both of which have detrimental consequences. While we know that almost all males attempt to be tough, we also know that such displays of masculinity by blacks are perceived as dangerous and threatening and nearly always lead to harsher sanctions in our society. For example, cultural critic Michael Eric Dyson (2007) articulates concern for the "near ubiquitous presence of prison in the social landscape of black male life," explaining that jail is a place where black men "shape a large part of their identity," and where their "manhood is tested and developed." Even sadder, the prison script that looms over black males indicates that they are "already in a kind of psychological and spiritual prison" (*Know What I Mean*, 14–15).

Equally problematic to the "tough guy" role is the "player" image that irresponsibly celebrates the African-American male who is surrounded by beautiful, adoring women; this is a common script that plays out continually within the popular culture playground, particularly within commercialized hip hop, thus socializing youth to believe that these are, in fact, traits of African-American masculinity. Majors and Billson (1992) even gave the performance of these problematic and demonizing masculine scripts a term: "cool pose" (2), but in actuality, there is nothing cool about this.

Given that the construction of gender is a continuous and active performance and that there is room for counter-hegemonic scripting, this chapter hopes to prove that alternative and much healthier scripts are being played out within the critically conscious sector of the hip-hop community, traits that constitute a wider range of what it means to be masculine. These are scripts that rely not on toughness or sexuality but on rhetorical brilliance, what we might think of as the "smart pose."

"Bringing Good into the World"—From Africa to America

Before detailing the specific rhetorical techniques that make up the smart pose so skillfully used by hip-hop lyricists and their fans, it is important to understand the power of—and regard for—language that lies behind these techniques, and this requires going back to Africa, ancient Africa. The peoples of Africa functioned purely by oral tradition; language was the glue that held their civilization together. More specifically, the people of the West African nations of Mali and Ghana put enormous emphasis on the uses, power, and keepers of language, which I flesh out below, and if hip-hop headz do not have specific knowledge of these ancient rhetorical concepts, they are, at the very least, affected by them tacitly.

Socioethical philosopher Maulana Karenga (2003) provides valuable historical information about the uses of language that conscious hip hoppers would find comforting and reaffirming. Karenga perceives ancient African communicative practices as a tradition concerned with "building community, reaffirming human dignity, and enhancing the life of the people" (5). He cites four African rhetorics that embody specific intents: First, a "*rhetoric of community*" consists of "communal deliberation, discourse, and action" with the intent of "bringing good into the community and the world" (5–6). Second, a "*rhetoric of resistance*," in which messages are "forged in the crucible of struggle" due to the "holocaust of enslavement" and systematic oppression (6). Third, a "*rhetoric of reaffirmation*" that purposefully reaffirms their "dignity and divinity" and their "right and responsibility to speak their own special cultural truth to the world" (6). And finally, a "*rhetoric of possibility*," which encourages an "ongoing quest for effective ways to solve human problems" and "elevate the human spirit" (6). These four ancient rhetorics, as a whole, operate as a voice of empowerment and transcendence, qualities conscious hip hoppers not only continually strive for but also use as a means to rewrite the script of masculinity that so often limits such positivity.

The second vital African concept is the ancient oral tradition of *nommo*, an inherent belief in the magical power of the word. Literary scholar Janheinz Jahn (1961) describes *nommo* as "the awareness that the word alone alters the world" (125). Like the basic necessities for growth, *nommo*, like sun and water, is a life force. Educator Ceola Baber (1987) explains that "*nommo* generates the energy needed to deal with life's twists and turns," lifts "spirits in the face of insurmountable odds," and turns "psychological suffering into external denouncements" (83). Today, *nommo* lives on in hip hop, as the movement literally builds itself with words. This generative power of language literally supports and sustains the smart pose that young males use to alter their reality.

The final ancient rhetorical concept that has influential effect on today's hip hoppers has to do with the keepers of language, the griots, who were the West African storytellers, historians, peacemakers, ambassadors, and musicians. Highly regarded by the villagers, these men were entrusted to preserve the tribal history as well as its genealogy, which they then shared through oral narratives and songs. They were so important to the community that an apocryphal quote about them lives on: "When a griot dies, a whole library burns to the ground." Considering the intent of the four ancient Africa rhetorics coupled with the power of *nommo*, it is not difficult to consider the role of rappers as the modern iteration of African griots. Michael Eric Dyson (1993) refers to rappers as "urban griots dispensing social and cultural critique" (*Reflecting Black*, 12). Indeed, today's hip-hop performers function as both current-day news reporters and historians about local, national and global happenings, but they are also articulating their own gender identity.

African-American studies scholar Ronald Jemal Stephens (1998) contends that through their words socially conscious rappers "seek to provoke and arouse the emotions and imaginations of their listeners and critics" as their words "communicate the hopes, dreams, values, fantasies, fears, frustrations, and sufferings of audiences" (31). Clearly this is a stunning description of rappers engaging in the *rhetorics of community, resistance, reaffirmation,* and *possibility* fueled by the power of *nommo* and taking on the role of the gifted griot.

By looking at rappers through the historical lens of these ancient African rhetorical concepts, one might think that hip hoppers are trapped by these traditions; in other words, they cannot—using such ancient rhetorical traditions—rearticulate current gender scripts to healthier, smarter scripts. But, in fact, the crossover indeed takes place. As Alim puts it: "hip-hop discursive practices are most certainly tradition-linked, they are not tradition-bound" (101).

Linguist Geneva Smitherman (2000), who has considerable influence upon African-American rhetorical scholarship, perhaps best summarizes the relationship between African and African-American discourse:

> The structural underpinnings of the oral tradition remain basically intact even as each new generation makes verbal adaptations within the tradition. Indeed the core strength of this tradition lies in its capacity to accommodate new situations and changing realities. (*Talkin that Talk*, 199)

Online Social Network Sites: Will You Be My Friend?

When Smitherman wrote of "new situations and changing realities" in 2000, it's doubtful that online Social Network Sites were on her mind, not to mention that they were in their infancy (a few SNSs did launch as early as 1997, but MySpace, BlackPlanet, and Facebook didn't blow up until 2003, 2005, and 2006 respectively); and clearly, ancient African rhetoricians nor even the early pioneers of hip hop could have predicted this networked public sphere. At first blush these three worlds—African and African-American oral traditions, hip-hop discourse, and SNSs—have seemingly no connection, but indeed a powerful connection does exist, for SNSs are a key location where the discourse of hip hop thrives, evolves, and travels; in other words, for better or worse, the latest adaptation of the oral tradition has now been digitized.

SNSs, arguably teens' and young adults' most popular—and daily—online destination, allow individual users to construct a personal, though public, profile; establish a visible bank of networked friends; and then as if traveling in a web-like fashion, publically navigate within the system to socialize with their friends and their friends' friends, an act that is also on public display; as an added measure, while users are logged on to SNSs, their presence is publically noted to enhance their ability to socialize. Participants either enjoy and maintain already-existing

friendships or engage with strangers because of similar interests. Discourse on SNSs—or what I think of as SNSology—can take shape in a variety of forms, including mini wall tweets—"John is soooo gonna enjoy Spring Break"—and lengthier expressions in chat rooms, forums, discussion threads, and blogs.

Hundreds of SNSs catering to different audiences exist; three, however, reign supreme. MySpace has become "a lifestyle, with more than 80 million registered users" (Bryne, 2008, 20), and it's the most music-friendly, attracting a huge proliferation of bands—both indie and mainstream—who network with fans. Black-Planet, a SNS attracting primarily people of color, has over 15 million users, ranging from 16 to 24 years old (Bryne, 2008, 16). (Wonder if this SNS's title is a nod to Public Enemy's 1990 *Fear of a Black Planet*?) And the fastest growing SNS, according to their website, is Facebook, boasting over 400 million active users as of Spring 2010.

Social scientist Nigel Thrift (2005) describes SNSs as places to "capture the 'everydayness' of the 'knowledge economy'" (3), but they are also unique sites for youth to discursively wrestle with normative gender scripts. The cultural practices that arise on SNSs are in many ways shaped by the very structures of SNSs, but such practices are also shaped by the subjectivities of each individual user, who acts independently and with agency. As such, SNSs are often a vehicle for hip-hop users to perform and reconstruct their gender identities.

Smart Pose: The Traveling Discourses of Hip Hop

Having explored the value of language in the hip-hop movement, having looked at the power of gendered scripts within our culture, having unpacked three major rhetorical concepts from Africa—the four rhetorics, *nommo*, and the griot—that have influenced the African-American oral tradition, including its hip-hop version, and having explored SNSs, a public sphere of discourse exchange and performance where the construction of personal and collective identities takes shape, it is now time to connect these realms. What follows is a three-part interconnected exploration of selected rhetorical techniques, which have traveled from ancient days to today. First is their resurfacing in the African-American oral tradition; next is the way in which hip hoppers, who are primarily African American males, draw upon these techniques and artistically and discursively re-articulate them; and finally, the ways in which these same rhetorical techniques, now in the form of hip-hop discourse, surface yet again in the expressions and performances of male SNSs users.

And in every reiteration of this discourse, from the ancients to the digital, there is a measure of identity building, resistance, and counter-hegemonic performance that underpins this creative use of language. In each realm, conscious hip hoppers engage in discursive performances—the "smart pose"—rather than the

"cool pose" as a possible means of outwitting our culture's scripts of masculinity. Conscious hip hoppers have created a cultural stage in order to discursively construct different performances of masculinity, ones that strive to break away from the rigid scripts of society and instead embody possibility, community, creativity, and agency.

Flippin' the Script

While linguists call this act "semantic inversion" and most people call it "slang," hip-hop headz call it "flippin' the script"—that is, using artistic space to take ordinary words and concepts and giving them entirely new meanings or creating entirely new words, and every creation is flava-filled.

Thinking back to the concept of *nommo*, the power of words, and revisiting this chapter's title and opening epigram, consider Smitherman's (1994) connection between that ancient concept and a vital expression that hip hoppers have created and use regularly:

> The African concept of *Nommo*, the Word, is believed to be the force of life. To speak is to make something come into being. Once something is given the force of speech, it is binding—hence the familiar . . . Hip-hop expressions WORD, WORD UP . . . stem from the value placed on speech. (*Black Talk*, 7–8)

Being knowledgeable of the ancient concept of *nommo* gives today's expression, WORD, a wholly different force and considerably more depth. *Nommo* resides in every new discursive invention; and entire dictionaries, which are ever-growing and changing, are filled with hip-hop language.

Notwithstanding the roots of *nommo*, some expressions used today do have a history that precedes the hip-hop movement. For example, the expression *dead presidents* means money in hip hop-ese, a concept the hip-hop group who calls themselves Dead Prez subversively toys with. Similarly, Puffy's "It's All about the Benjamins" refers to money by way of the image of Ben Franklin on $100 bills. While such expressions were dropped in the late 1990s, Alim notes that the black American community has been using these monetary terms since the 1930s (74). Alim notes that frequently artists will include glossaries of their newly constructed expressions in the CD/album liner notes, a tradition that stems back to jazz and bebop artists of the 1940s (74–75).

Countless hip-hop expressions have become part of our everyday lexicon, and it is likely that most members of youth culture, particularly males, are not only familiar with but also employ the following expressions in their day-to-day speech: frontin' = faking; dope = cool; down = up for something; drop = publish or release; spittin' = writing; biting = plagiarizing; dogged = treated poorly; sick and ill = awesome; my bad = sorry; give props = address and praise; big ups = lots

of love; wack = bad; phat = excellent; and, of course, word = I agree, I hear you, well said, yes.

And then there are words that have multiple meanings. The word *rock*, for example, can be a noun as in a diamond (that one's from back in the day) or crack cocaine, but it can also be a verb as in rockin' the party, to enliven it, or rockin' that hair, to carry off a stylish look. *Pimp* is another word that has been flipped to mean more than soliciting prostitution; it now carries a variety of connotations that stem from the action of making something flashy for the sake of improvement. The discursive effect of hip hop on this expression was so powerful that MTV titled a show *Pimp My Ride* in which they custom designed cars.

The effect of hip hop didn't stop at MTV. Advertisements for the company Pimp My Profile abound on SNSs, offering services for flashy layout, backgrounds, and glitter to enhance users' homepages. And, of course, an endless array of hip-hop expressions fills SNSs' walls, blogs, chat rooms, and forums of youth. Michael wrote, "Stay fly! Holla Soon."[1] on a friend's wall, which means stay well and keep in touch; his friend, Gene (2006), replied, "B E Z"—be easy or take care. In a thread on a BlackPlanet Forum discussing which artists would make a hip-hop supergroup, JayHigh617 (2007) writes the following; notice his playful spelling and his verb choice: "Diplomats and BraveHearts in 1 group would be outrageous w/ Lil' Kim as the leader. . . dropping rhymes like Biggie Smalls and Pac at the same time . . . w/ a touch of Pharrel instrumentals in the background echo'N thru every song on the album . . . thatz wazzup. :)." And when someone adds KRS-ONE, he responds with a "BIG UP." All of these examples, and countless more exist, are indicative of the ways in which hip-hop discourse is sustaining and traveling on SNSs. Calvin (2008, 2009), however, not only uses hip-hop discourse, but he is also quite aware of his identity construction as he self-reflexively performs on his Facebook wall: "Calvin is on facebook on a friday night. yea im ballin," which means Calvin has a pathetic social life.

Throughout each of these acts of flippin' the script, the males are engaging in the reconstruction of masculinity, but on their own performative terms. Males, particularly young urban males, have not been constructed to engage in peer-to-peer dialogue that includes expressions such as "stay well" or "take care," but "stay fly" and "B E Z" is a discursive terrain that permits a connectivity while simultaneously maintaining their sense of gendered power. Moreover, agency is gained when creating and employing new lexicons, for oral performance rituals are often sites for constructing gendered subjectivity, particularly within African-American culture.

Flippin' the script can also lead to the actual birthing of identity, the taking on of alternate public personas. For example, rapper Puffy has gone through multiple name changes, repeatedly flipping the script from Sean Combs to Puffy to P. Diddy to Diddy. Purposefully taking on a name and inhabiting an alter

ego or fictional character is a typical act within the world of hip hop. Rarely do hip hoppers use their given name on stage, and Saddik offers a cogent explanation for this "empowering gesture" of making a name for one's self: "rappers call for a reappropriation of the self"; they create "names for themselves in order to consciously resist the identities imposed on them by white mainstream culture" (117). In these various ways, flippin' the script serves young males as they reconstitute gender roles, but with their own sense of creativity and agency.

Metaphors

Folk study this figure of speech in English literature classes, but African Americans and hip-hop headz have been rockin' them for a minute (long time!). The imaginative use of gutsy metaphors has a long history within the black oral tradition, and this frequently used stylistic technique is a favorite among MCs. Sounding much like the ancients who spoke of the *rhetoric of possibility*, hip-hop scholar Imani Perry (2004) positions the metaphor "at the heart of artistry in hip hop," because it allows a "space of possibility" and movement outside of the "boundaries of their communities," and "limitations of human fallibility" (64–65). Metaphors abound for hip hop itself; for example, Perry cites boxing as a metaphor for the skill and grace but also the competitive nature of hip hop (58–59), and Chuck D when talking to journalists likened rap to a news station that reports for and about the voiceless, which led to the oft-repeated sound bite that rap is Black America's version of CNN.

In his eloquent song "Hip hop" from *Black on Both Sides*, Mos Def (1999) explores his relationship with language in perfect metaphorical style by opening up with a powerful slam of a discursive hammer that is his tool for managing his world. Mos Def brilliantly bangs out his identity by positioning himself as an agent who uses language for social transformation. And while most MCs use both metaphor and similes interchangeably, conscious hip-hop artist Common (1999) points out their distinction in "One-Nine-Nine-Nine," correcting those who say he is talented with metaphors when, in fact, he is actually using similes when he expresses a lifetime of memories as he rocks the mic. Common is not only a self-reflexive hip hopper but a rhetorically accurate one too.

Similarly, Lauryn Hill in The Fugees' "How Many Mics" (1996) feels as rhythmically off balance as an incomplete drum set when she's not rockin the mic, and Talib Kweli (2007) boasts to speak out to his audience with the skills of then-presidential candidate Barack Obama. These are examples of typical comparative wordplay that MCs spit, wordplay that positions them as active participants, managing themselves—via discursive performances—within the restraints of the world.

While most English teachers would delight if their students were writing metaphors outside of the classroom, this is exactly what the hip-hop movement has fostered. Metaphors, likewise, abound on SNSs. They show up regularly on Facebook wall hits and often serve as a means to express one's personal identity: "Jon (2008) is strapped like bookbags"; "Nelson (2007) is gotm more game than da parker brothers." And Calvin, once again, is self-reflexively sizing himself up: "Calvin is coming out the cacoon this year. been clark kent too long."

And in a BlackPlanet Forum discussion on hip-hop talent, OleClirt (2005) wrote this: "Tupac was an ill MC. I'd say top 50. I stepped away from this forum for a while because I could talk around the subject of who is or wasa the greatest, but I could never pick one; I've seen cats on here talk about STYLE, some talk about METAPHORS, some talk about IMPROVISATION, some LONGEV-ITY, but still I could never pick one."

Metaphors matter to the hip-hop generation; hip hoppers regularly use them because they understand that metaphors are a means to structure self-identity. Peter Murphy's (2001) work on metaphors and masculinity explains that meta-phors often "reveal the shared assumptions" that we reflect about masculinity and restrict the ways in which we can imagine ourselves as gendered beings (4). But like Perry, Mos Def, and Talib Kweli, Murphy too sees the metaphor as a "space of possibility." A dialectical relationship between language and behavior exists, and since masculinity is largely a social and cultural construction, then new and different verbal descriptions can alter those constructions (13). Hip hop itself is, indeed, a metaphor for possibility.

Narrative Storytelling

This is a picturesque discursive practice that stems back to the African griots, and the art of storytelling is just as revered today as it was in ancient West Africa. Sto-rytelling is the primary reason that rappers are often referred to as urban griots. But in addition to its connection to the motherland, hip hop's use of storytelling is also a direct descendant of Black oral traditions in America. Perry describes the narrative in hip hop as a stylized version of early African-American folktales, with the "MC replacing Dolemite or Brer Rabbit" (78). And when rappers use the verb *flow*, they are describing one's ability to spit ill rhymes to a beat. Alim posits that flow relates "directly to narrative sequencing because it impacts the telling of the story" (95); it's the "temporal relationship between the beats and the rhymes" (15).

While any number of hip-hop songs could serve as an example of narrative storytelling, "The Message" by Grandmaster Flash and Furious Five (1982), with Melle Mel MCing prevails because when it was dropped back in 1982 it revolu-tionized the genre; "The Message," aptly titled, was the first hip-hop song to move away from pure party beats and give voice to the South Bronx's grim reality. Mel

lyrically paints a vivid picture reporting the poverty, urban decay, and blight that is smothering him. As Mel flows to seductively syncopated beats, his story depicts a sordid inner-city life: a crazy lady eating out of a garbage can, stolen TVs, bill collectors, reefer-smokin' kids, panhandlers, pickpockets, and peddlers. Woven in between each stanza is the chorus by the narrator who is admittedly hanging on by a thread, and there is a clear sense that he's representin' for the underclass of America.

In peeling back the veil and exposing their material reality, in engaging in a performance that "ruptures the boundaries between representation and the real" (Saddik, 2003, 116), "The Message" is a sterling descendant of the *rhetoric of resistance* and *community* that the ancient Africans engaged, and it laid the groundwork for an entire movement of socially conscious hip-hop music.

Does the art of storytelling à la hip hop cross over to the digitized world of SNSs? The answer is a resounding yes. Some of the most interesting stories and narratives come from hip hoppers' first cousins, spoken word poets, who are hugely prolific on SNSs. Facebook has over 500 groups dedicated to spoken word. BlackPlanet has 62 spoken word poetry groups with healthy participation. The Underground Poetry Slam group has over 1300 active members, and the Lyrical Liquor group, "Where the Written Word Comes Alive," has over 55,000 members, and a remarkable number of these members are young males. MySpace, however, is the most saturated with spoken word. A simple search of "Spoken Word" renders 382,000 hits; "Spoken Word Poetry" brings up 11,600 hits. MySpace also has a Def Poetry page, the principal connection between hip hop and spoken word, which undoubtedly attracts many writers.

It doesn't take long to sense that many spoken word poets have a deep connection to the ancient griots; on MySpace, 174 spoken word poets use "Urban Griot" in their username as they performatively re-appropriate their identity.

On occasion, poets honor griots directly in their pieces, and the four ancient *rhetorics of resistance, community, reaffirmation* and *possibility* constitute the very spirit of this genre. Here is an excerpt from a narrative that gives homage to the ancients as well as their rhetorics, Gagnez's (2008) "The Beginning":

> . . . Cradle of the civilization Africa/the first world power of recorded history/ were governed by people who looked just like me//and days of old when our people were kings/gold and diamonds were common things/even now our people still bling/thousands of years ago African women bought gold nose rings// sense of justice back then was king/griots existed/our libraries living/written records in oral tradition. . .

With such words, the ancient oral tradition is connecting with a contemporary oral tradition based in hip hop; a quick stroll through his home page reveals that Gagnez is a youth deeply connected with and influenced by hip hop. All of his poetry is spoken over beats and he specifically identifies his work as a "brand of

Spoken Word Poetry and Progressive Hip hop." But he is clear to identify his performance, of both his gender and his world view, as socially conscious as he rhetorically resists the seedier sides of hip hop through this pronouncement: "I created a CD of Spoken Word Poetry and Hip hop—called 'The Beginning.' I didn't use one B*tch, H*e, C*nt, Sl*t or any other degrading term primarily aimed at women. Nor did I shoot and kill every known black male in every hood known to man. And my CD is still TIGHT!!!"

Gagnez's narrative storytelling is indeed counter-hegemonic, and he is, with pointed convinction, positioning himself affirmatively within the masculine world of hip hop; he fully recognizes the performative gender scripts that are firmly in place, but he's choosing to act outside of those limitations, choosing smart over cool.

Playing the Dozens and Signifyin'

This is one of the richest rhetorical practices to carry over from the African-American oral tradition to hip hop. Drawing, once again, on *nommo*, words are the centerpiece of this ceremonial game where two players verbally volley insults—often called snaps—back and forth. Hip hoppers call this dissin' but many Blacks know this ritual as playing the dozens. Smitherman describes it as a game of "one-upmanship" between two players, with an audience of onlookers playing a significant role of egging the players on with their interjecting responses. "The audience, with its laughter, high fives, and other responses, pushes the verbal duel to greater and greater heights of oratorical fantasy." The insults in the dozens typically consist of "yo mamma" jokes, which are overt and blunt. But some snaps rise to the next level of slyness to what's referred to as signifyin'; these insults are more subtle and indirect, more suggestive and clever than the dozens, and they are aimed not at the opposing player's mamma, but at the opposing player (*Talkin that Talk*, 223–224). Linguist-anthropologist Claudia Mitchell-Kernan (1981) defines signifyin' as "complimentary remarks" that are "delivered in a left-hand fashion" (314).

At first blush, this gaming ritual may sound peculiar, even misogynist, but, in fact, it is a rite of maturation from boyhood to manhood. Smitherman sees it as a "form of release for the suppressed rage and frustration" caused by racial oppression. It also teaches "discipline and self-control; it was a lesson in how to survive by verbal wit and cunning rhetoric, rather than physical violence" (*Talkin that Talk*, 225).

As we have seen, most aspects of the African-American oral tradition can be traced back to Africa, and evidence exists that such a ritual game was, indeed, played in Nigeria and Ghana, though it went by the name *Ikocha Nkocha*, which means "making disparaging remarks." African and African-American

studies scholar Amuzie Chimezie (1976) describes a game that took place under the African moonlight in the presence of family members and villagers in which youngsters exchanged insults, with the audience having, once again, a role of urging on the participants (403–404). This description clearly calls up all the qualities of the ancient African *rhetoric of community*. Chimezie theorizes that the game made its way to America with the slaves who "played in the isolated slave quarters" (414–415). Evidence of the game being a part of our cultural fabric shows up in American literature as early as 1933 in Erskine Caldwell's *God's Little Acre*, a novel set in the impoverished south where a character says, "If you want to play the dozens, you're at the right homestead." Zora Neale Hurston also references it in 1942 and Langston Hughes in 1948.

Considering the history of the dozens, including its signifyin' variety, along with its privileging of vernacular discourse, it's no surprise that hip-hop artists embrace it. Smitherman lists four qualities for havin' game in playing the dozens, all of which are applicable to hip hoppers: One, you can't hold back; it's all about high energy—a given. Two, you must use figures of speech like similes and metaphors—we've already seen that hip hoppers are down with that. Three, timing is everything, and the delivery has to be spontaneous and immediate—perfect description of freestyling. And finally, only the masters of the dozens meet the fourth criteria: rhyming (*Talkin that Talk*, 227).

Signifyin' and playing the dozens are ubiquitous in hip-hop lyrics; a most mentionable example, solely because they were signifyin' about the very spirit of hip hop itself, is the volleyed disses between Common and Ice Cube back in the 1990s. In *Resurrection*, Common (1994), a poetic, socially conscious rapper, articulated the downfall of hip-hop music in "I Used to Love H.E.R." in which he tenderly personifies hip hop as a beautiful woman whom he connected to and loves, but she left for the West Coast only to spiral downward into the world of glocks, rocks, and hardcore. Common, drawing upon the ancient *rhetoric of possibility*, is filled with hope and love for her and wants to bring her back home for nurturance. This, of course, is allegorical for the brewing discontent between the conscious rappers who express—through words and actions—their concern *for* society and the thugs who also through words and actions act out *against* society. Ice Cube, former member of N.W.A. (N*gg*z with Attitude) and the poster boy for gangsta rap, quickly dissed back on "Westside Slaughterhouse," a brutal piece in which he positions himself as the ultimate gangsta. He spews degradating labels at Common's allegorical woman, claiming she lacks common sense, attacking both conscious hip hop and the artist Common. Even more outrageous is Ice Cube's claim that hip hop was born on the West Coast, which is ridiculously untrue. Common (1996) volleys back one last time with "The B*itch in Yoo," a cogent diss that opens with a direct address to Ice Cube. And despite the powerful impact of his words, Common's delivery, as always, is soft-spoken and sincere. He

calls Ice Cube out for frontin like a gangsta when he's really educated and well off. He also calls Ice Cube a has-been whose latest works are wack. Most importantly, Common expresses his annoyance at Ice Cube for setting up an antagonistic East Coast/West Coast dichotomy of geography within hip hop, and Common points out that he is not even from the East but from Chicago.

This recorded call-and-response battle that stretched from 1994–1996 was filled with male-laden braggadocio not only on the part of Common and Ice Cube but also the fans. Hip-hop headz were totally aware of this battle and just like the friends in the game of the dozens and the villagers in the game of *Ikocha Nkocha*, they fully participated with an array of opinions; imagine how that battle would have unfolded had the blogosphere been in existence. While it's impossible to declare a definitive winner, Ice Cube's silence could indicate that Common's reliance on the ancient *rhetoric of resistance* and *possibility* prevailed. Whatever one's opinion, signifyin' went down.

And sometimes signifyin' will occur during live performances. Alim recalls The Roots signifyin' on an audience at Stanford University for not being "as culturally responsive" as they would have liked them to be. So they stopped their music and began snapping their fingers and singing television theme songs like "Diff'rent Strokes" and "Facts of Life" in a "corny (not cool) way." To The Roots' dismay, the "largely White, middle-class audience of college students sang along and snapped their fingers—apparently oblivious to the insult" (Alim, 2006, 84).

Not surprisingly, youths are digitizing this aspect of the oral tradition on SNSs; they are going back to their roots by actually playing the dozens. Multiple BlackPlanet (2009) forums have threads that go by names like "dozens" or "yo mama"; they continue for thousands of posts and include hundreds of quick snaps between dueling players and interjecting lurkers. Enjoy:

A-Deuce: Yo mama ain't got no ears . . . I heard she wanna sign with Def Jam records.

Benson: Yo mama so stank, they won't let her swim in the ocean cause they won't be able to get the smell off the fish.

A-Deuce: Yo mama sucks more than a dirt devil vacuum cleaner.

Benson: Ay, tell yo mama, Jesus wants his high school letterman jacket back.

A-Deuce: Yo mama so old she got more wrinkles than a pair of courdoroys.

Benson: Ay, man, white folks upset cause they can't see Big Foot no more. Tell yo moms to get her *ss back to work.

A-Deuce: Tell me why yo mama so dumb she thought T-Pain was a medical condition.

Benson: OK. That shyt was funny.

I saw they're auditioning for a new film. Tell yo moms to get down there before they sign somebody else to play Biggie.

A-Deuce: I seen you stupid mama at Burger King tryna order a Biggie Smalls.

Benson: I saw yo moms in KFC. Hungry Heffa tried to order the bucket on the roof.

A-Deuce: Thanks Homes!

 I heard yo mama called a plumber to fix a crack pipe.

Benson: Busted Dog. I saw you use that one on the other forum. DO-OVER.

A-Deuce: Dang! Good eye man. OK.

Yo daddy got forearms like popeye cuz he jack off so much.

And on they go. The participants are delighting in word play and wit; they appreciate the art form so much that they compliment outstanding snaps and call each other out for cheating. And the references to hip hop are typical. Here's one more:

BlaqI: Yo mama so black, she leaves finger prints on charcoal.

Miles: Yo moms' under arm stink so bad . . . rightguard was wrong . . . lol.

BlaqI: Yo mama's so fat, I asked her for her weight, she gave me her phone number.

Carlyle: Yo mama is sooooo fat . . . she's just fat.

 I've never been good at this. *hands in black card*

Notice how Carlyle tries his hand at the game but knows his limitation and quits. Also notice his use of the adjective *never*, implying the history he—and many others—has with the game.

And this is a game, playful and hyperbolic, but it's also an extremely useful game. Without knowledge of their rhetorical and cultural roots, these snaps can strike an outsider as misogynistic, offensive, and valueless, but such interactions are, indeed, serious performances of masculinity, serving the valuable role of releasing racial rage—via words rather than weapons—that has been long suppressed. In "Performance Practice as a Site of Opposition" bell hooks (1995) considers the value of such performances:

> Throughout African-American history, performance has been crucial in the struggle for liberation, precisely because it has not required the material resources demanded by other art forms. The voice as instrument could be used by anyone, in any location. (211)

It's a (W)rap

Performance, as articulated by male hip hoppers, regardless if the performance is live on stage, recorded, or within the digital world, is indeed both individually and socially meaningful. The highly recognizable gender scripts that the hip-hop generation has bought into are firmly in place. How each individual hip hopper

chooses to work within these gendered confines is the heart of the matter. Far too many hip hoppers have sadly adopted the "cool pose" of the gangsta, working within the scripts of masculinity through abrasive physicality and pimp sensibilities, but some hip hoppers, both producers and their fans, who are more critically conscious have chosen to work against the scripts of masculinity through *nommo*—that is, the power of words. The world of the black male is a tenuous one, scripted with danger and traps, but as we have seen, many hip hoppers—more than we're apt to give credit to—brilliantly use rhetorical techniques as defense mechanisms to survive and re-articulate masculinity. Their attention to these rhetorical techniques indicates their keen awareness that masculinity—of all races— is, indeed, a performance, and they are rewriting the script.

Hip hoppers engage metaphors because hip-hop culture itself is metaphorical, for history, for economic, racial and, yes, gendered inequalities, for gaining a voice. While it is a musical movement that serves to create entertainment, ultimately, it attempts to shine a light on the disempowered. Hip hoppers have to signify because such performances sustain them in the face of oppression; this technique has been used by males within the African and African-American tradition for generations. Laughing to keep from crying is a necessary means to side step the constraints of masculinity. The same can be said for braggadocio, a sensibility of bragging and proclaiming greatness that runs through hip-hop masculinity. When a hip hopper expresses himself as all-knowing or a hero of sorts, we are witnessing a form of self-empowerment that symbolizes triumph against the odds. All of these techniques comprise a trickster mentality that allows them to use rhetorical wit as a powerful means of resisting the masculine scripts that attempt to define them.

Tracing these traveling rhetorics as they migrate, overlap, and converge, as well as resurface, influence and transform, we find that despite socially constructed gendered scripts, the *rhetorics of resistance, community, reaffirmation,* and *possibility* have astonishing power, and the spirit of the word, centuries old, continues to have effect regardless if the community is under an African moon or on a digital public network. Whether the discourse is happening through snaps, raps, or chats, performances are taking place, identities are being re-constructed, and agency is being obtained as critically conscious hip hoppers attempt to re-write deeply entrenched masculine scripts.

Note

1. MLA does not provide guidelines for citing Social Network Sites, but I cite within the spirit of MLA online guidelines, providing user name, thread or Home Page name (if the writing isn't part of a thread), date posted, date retrieved, and URL. I use first names and/or anonymous user names for youth I

don't know, and I change the names of youth I do know to protect identities. I have not interacted with nor requested permission to quote directly from all of the samples; according to the practices of online research scholars, such practices are fairly common, given that all the information is publicly available.

Works Cited

Alim, H. Samy. *Roc the Mic Right: The Language of Hip Hop Culture.* New York: Routledge, 2006.

Baber, Ceola. "The Artistry and Artifice of Black Communication." *Expressively Black: The Cultural Basis of Ethnic Identity.* Ed. Geneva Gay and Willie L. Baber. New York: Praeger, 1987. 75–108.

Baraka, Amiri. "The Language of Defiance." *Black Issues Book Review.* Sept.–Oct. 2001: 28.

BlackPlanet. "Yo Mama." Forum. 25 Feb. 2009. Web. 26 May 2010.

Bourdieu, Pierre. *The Logic of Practice.* Stanford, CA: Stanford University Press, 1990.

Bryne, Dara N. "The Future of (the) 'Race': Identity, Discourse and the Rise of Computer-Mediated Public Spheres." *Learning Race and Ethnicity: Youth and Digital Media.* Ed. Anna Everett. Cambridge: The MIT Press, 2008. 15–38.

Butler, Judith. *Gender Trouble: Feminism and the Subversion of Identity.* New York: Routledge, 1993.

Calvin. Home Page. *Facebook.* 25 Aug. 2008. Web. 16 Feb. 2009.

———. Home Page. *Facebook.* 24 Jan. 2009. Web. 2 Mar. 2009.

Chimezie, Amuzie. "The Dozens: An African-Heritage Theory." *Journal of Black Studies.* 6 (1976): 401–420.

Clifford, James. *The Predicament of Culture: Twentieth Century Enthnography, Literature, and Art.* Cambridge, MA: Harvard University Press, 1988.

Common. "The B*itch in Yoo." *YouTube,* 1996. Web. 13 Feb. 2010.

———. "I Used to Love H.E.R." *YouTube,* 1994. Web. 13 Feb. 2010.

———. "One-Nine-Nine-Nine." *YouTube,* 1999. Web. 13 Feb. 2010.

Connell, R.W. "Disruptions: Improper Masculinities." *Beyond Silenced Voices.* Ed. Lois Weis and Michelle Fine. Albany, NY: State University of New York Press, 1993. 191–208.

Dyson, Michael Eric. *Know What I Mean?: Reflections on Hip Hop.* New York: Basic, 2007.

———. *Reflecting Black: African-American Cultural Criticism.* Minneapolis, MN: University of Minnesota Press, 1993.

Facebook. Press Release. n.d. Web. 9 Mar. 2010.

Fugees. "How Many Mics." *YouTube,* 1996. Web. 13 Feb. 2010.

Gagnez. Def Poetry. *MySpace.* 11 Nov. 2008. Web. 10 Mar. 2009.

Gee, James Paul. *An Introduction to Discourse Analysis: Theory and Method.* 2nd ed. New York: Routledge, 2005.

———. *Social Linguistics and Literacies: Ideology in Discourses.* 2nd ed. London: Taylor & Francis, 1996.

Gene. Home Page. *Facebook.* 9 Sept. 2006. Web. 29 Nov. 2008.

Gilligan, Carol. *In a Different Voice: Psychological Theory and Women's Development.* Cambridge: Harvard University Press, 1993.

Grandmaster Flash and the Furious Five. "The Message." *YouTube*, 1982. Web. 13 Feb. 2010.

Grossberg, Lawrence. *We Gotta Get Out of This Place: Popular Conservatism and Postmodern Culture.* New York: Routledge, 1992.

———. "Who Needs 'Identity'?" *Questions of Cultural Identity.* Ed. Stuart Hall and Paul du Gay. London: Sage, 1996. 1–17.

Hall, Stuart. *Representation: Cultural Representations and Signifying Practices.* London: Sage, 1997.

Harris, Shanette Marie. "Psychosocial Development and Black Male Masculinity: Implications for Counseling Economically Disadvantaged African American Male Adolescents." *Journal of Counseling and Development.* 73 (1995): 279–287.

hooks, bell. "Performance Practice as a Site of Opposition." *Let's Get It On: The Politics of Black Performance.* Ed. Catherine Ugwu. Seattle, WA: Bay, 1995. 210–221.

Ice Cube with Mack 10. "Westside Slaughterhouse." *YouTube*, 1995. Web. 13 Feb. 2010.

Jahn, Janheinz. *Muntu: The Outline of Neo-African Culture.* Trans. Marjorie Grene. London: Faber & Faber, 1961.

JayHigh617. Hip Hop Supergroup. Forum. *BlackPlanet.* 2 Feb. 2007. Web. 28 Feb. 2009.

Jon. Home Page. *Facebook.* 9 Nov. 2008. Web. 29 Jan. 2009.

Karenga, Maulana. "Nommo, Kawaida, and Communicative Practice: Bringing Good into the World." *Understanding African American Rhetoric: Classical Origins to Contemporary Innovations.* Ed. Ronald L. Jackson and Elaine B. Richardson. New York: Routledge, 2003. 3–22.

KRS-One. "KRS-One Gives 9 Elements of Hip Hop at Harvard." The Next Level Conference. Harvard University. *YouTube*, 1999. Web. 13 Feb. 2010.

Majors, Richard and Janet Mancini Billson. *Cool Pose: The Dilemmas of Black Manhood in America.* New York: Lexington, 1992.

Michael. Home Page. *Facebook.* 9 Sept. 2006. Web. 29 Nov. 2008.

Mitchell-Kernan, Claudia. "Signifying." *Mother Wit from the Laughing Barrel: Readings in the Interpretation of Afro-American Folklore.* Ed. Alan Dundas. New York: Garland, 1981. 310–328.

Mos Def. "Hip Hop." *YouTube*, 1999. Web. 13 Feb. 2010.

Murphy, Peter F. *Studs, Tools, and the Family Jewels: Metaphors Men Live By.* Madison, WI: University of Wisconsin Press, 2001.

Nelson. Home Page. *Facebook.* 21 Nov. 2007. Web. 29 Jan. 2009.

OleClirt. Hip-Hop Talent. Forum. *BlackPlanet*. 26 Oct. 2005. Web. 29 Jan. 2009.

Oliver, William. "Black Males and Social Problems: Prevention Through Afrocentric Socialization." *Journal of Black Studies*. 24 (1988): 379–390.

Perry, Imani. *Prophets of the Hood: Politics and Poetics in Hip Hop*. Durham, NC: Duke University Press, 2004.

Saddik, Annette J. "Rap's Unruly Body: The Postmodern Performance of Black Male Identity on the American Stage." *The Drama Review*. 47.4 (2003): 110–127.

Smitherman, Geneva. *Black Talk: Words and Phrases from the Hood to the Amen Corner*. Boston, MA: Houghton Mifflin, 1994.

———. *Talkin that Talk: Language, Culture and Education in African America*. New York: Routledge, 2000.

Stephens, Ronald Jemal. "Rappin' and Stylin' Out in the USA: Images of Rap Artists as Contemporary Tricksters and Griots." *Challenge: A Journal of Research on African American Men*. 9.2 (1998): 25–56.

Talib Kweli. "Say Something." *YouTube*, 2007. Web. 13. Feb. 2010.

Thrift, Nigel. *Knowing Capitalism*. London: Sage, 2005.

Westwood, Sallie. "Racism, Black Masculinity and the Politics of Space." *Men, Masculinities and Social Theory*. Ed. Jeff Hearn and David Morgan. Cambridge, MA: Unwin Hyman, 1990. 55–71.

Young, Josephine Peyton. "Boy Talk: Critical Literacy and Masculinities." *Reading Research Quarterly*. 35.3 (2000): 312–337.

The Lost Boys of Sudan: Race, Ethnicity, and Perpetual Boyhood in Documentary Film and Television News

Rebecca B. Watts

How Young, Southern Sudanese Refugees Became the Lost Boys of Sudan

Lost Boys. Our first thought on hearing this phrase may return us to memories of hearing in our childhood the story of Peter Pan's orphaned friends. J. M. Barrie's Lost Boys became lost after falling out of their strollers when their nurses were "looking the other way," were "not claimed in seven days," and thus were "sent far away to Neverland to defray expenses" (Barrie). But more recently, the phrase Lost Boys has been used widely in the popular media to describe young men from Southern Sudan who, in the mid to late 1980s, became orphaned refugees in the wake of Sudan's ongoing civil war. Forced to flee their peaceful rural existence in the face of violence, these young boys walked many miles under the harshest conditions, crossing borders from Sudan into Ethiopia back into Sudan and finally into refugee camps in Kenya. When their plight came to the attention of U.S. State Department officials in 1998, some of these Lost Boys were considered for resettlement in the United States. Finally, in 2000 and 2001, approximately 3,800 of these formerly Lost Boys found homes in cities throughout the United States. With the help of local refugee support agencies, these young men were connected with apartments, entry-level jobs, and in some cases educational opportunities, but were then left largely on their own to navigate the complexities of contemporary American life (Bixler, 2005).

Methodology: Ideological Rhetorical Criticism

The Lost Boys' story has been told and retold in the American media. Something about these orphaned refugees from the other side of the world resonates with the American imagination, perhaps because their story is portrayed as a sometimes gut-wrenching, sometimes heartwarming rendition of the American dream. In television, film, radio, newspapers, books, and web sites, the Lost Boys' story is often reported as the classic tale of opportunity and hard work. These young Sudanese men are portrayed as fetching something good out of the evil circumstances (Bormann, 2001: 44) that wrenched these boys away from their families in the midst of childhood, leaving them floating through the fast-paced American lifestyle in a seemingly perpetual state of naïve, innocent boyhood. The Lost Boys' compelling life stories have been so widely featured in print and electronic media that it would be impossible to do justice to these many portrayals in this chapter. Thus, I have chosen to limit the focus of this analysis to the major film and broadcast news portrayals of their story through the documentary films *God Grew Tired of Us* (2006) and *Lost Boys of Sudan* (2003) and an in-depth report featured on *Dateline NBC* (2001). These texts will be the focus here because of 1) the more pervasive influence of these media and 2) the ability of film and television to allow audience members to see the faces and hear the voices of the young Sudanese refugees in addition to the narrative of the journalists covering their stories.

The methodological perspective I apply to these texts is rhetorical criticism, which is the analysis of how people seek to persuade others to share their points of view through strategic use of verbal, symbolic, and visual elements. Specifically, the type of rhetorical criticism employed here is ideological criticism, which is based on the assumption that "multiple ideologies . . . exist in any culture and have the potential to be manifest in rhetorical artifacts" (Foss, 2009, 210). Ideological critics often draw on the precepts of cultural studies, "an interdisciplinary project focused around the idea that relations of power within a society are embedded in and reproduced through cultural creation" (Foss, 2009, 212). In cultural studies, "artifacts of popular culture," such as the film and television texts under consideration here, are seen as "legitimate data for critical analysis because they are places where struggles take place over which meanings and ideologies will dominate" (Foss, 2009, 213). The basic steps a rhetorical critic conducting an ideological criticism follows to conduct such an analysis are to 1) identify an artifact or set of artifacts; 2) analyze the artifacts by isolating their persuasive elements; 3) determine what ideology those elements are used to support; and 4) consider what purposes that ideology furthers (214). In this study, I first identified the many print, television, and film artifacts that feature the Lost Boys of Sudan and their stories. After reading through and viewing these many texts, I discerned themes or elements common to all. Then, I narrowed the texts to those which seemed

to have the widest possible audience yet could communicate the most details in their depictions of the Lost Boys of Sudan: feature-length documentary films and in-depth television news specials. Next, I looked for specific examples of the three common themes (playfulness, naïveté, and dependence) I identified amongst the texts. Finally, I explicated these examples so as to reveal how the filmmakers and television producers who created these texts were seeking to persuade the U.S. film and television viewing public to understand these young Southern Sudanese men as existing in a state of perpetual boyhood.

As Foss notes, "the primary goal of ideological critics is to discover and make visible the ideology embedded in an artifact. As a result of an ideological analysis, a critic seeks to explicate the role of communication in creating and sustaining an ideology and to discover whose interests are represented in that ideology" (213). I argue that the documentary filmmakers and television news producers behind these mediated portrayals of the Lost Boys of Sudan made rhetorical choices that situate these young Sudanese as playful, naïve, and dependent yet adult men trapped in a perpetual state of boyhood. Such depictions reinforce many U.S. Americans' views of themselves as more mature, focused, hardworking, knowledgeable, and independent than those portrayed as the Other, as black men and those from "less developed" countries are often figured in the mainstream of U.S. culture.

The Lost Boys: Living at the Intersection of African and African-American Life

In *Mistaking Africa: Curiosities and Inventions of the American Mind*, historian and political scientist Curtis Keim critiques the ways in which African people, places, and cultures are presented in mainstream American media such as *National Geographic* magazine and cable documentaries as well as in popular culture through theme parks and advertising that evoke stereotypical African themes. Keim argues that most portrayals of Africa in U.S. media oversimplify Africa as an exotic place besought with troubles. While Keim admits that based on "sheer numbers of programs, Africa is actually better represented on television than many other areas of the world," he observes that "the shows do not provide a very accurate view of Africa." The Africa portrayed on television nature documentaries shows viewers "a place filled with wild animals, park rangers, and naturalists who battle against poachers and encroaching agriculture," playing up "carnivores . . . to emphasize 'survival of the fittest' motifs." Meanwhile, the Africa featured in television news reporting is "bleaker," focusing on "war, coup, drought, famine, flood, epidemic, or accident." While he points to positive aspects in CNN's coverage of stories from the African continent such as their featuring of African reporters, overall Keim is disappointed that "news programs border on entertainment," playing to

an audience who wants their "emotions aroused, but not so much that we actually might feel compelled to think deeply or take some kind of action." He also observes the great expenses incurred by U.S. media covering African news, which serve to limit their coverage. Overall, he argues that the skewed picture of Africa that American audiences get through extremely limited coverage of mainly the exotic and problematic aspects of African existence may be reinforced by the fact that "we learn what we want to learn and that we like our picture of Africans the way it is now" (Keim, 2009, 16–18).

While Keim does not address the Lost Boys of Sudan or media coverage of their stories, it is interesting to juxtapose their ubiquity in U.S. media with Keim's observations of how Africa and Africans are understood by Americans through the lenses of our media. The Lost Boys came to the United States—making it much easier logistically and less costly financially for filmmakers and journalists to document their experiences. And, while the biographies of each of these young Sudanese men are portrayed as being filled with experiences of exotic, adverse conditions in Sudan, Ethiopia, and Kenya, ultimately the media portrayals feature the life-affirming aspect of how these boys overcame adversity through their noble characteristics of perseverance, faith, loyalty, and unselfishness. Consequently, the "picture of Africans" conveyed through media portrayals of the Lost Boys of Sudan emphasizes a positive, if childlike, view of the refugees. It is this characterization of the young men in a state of perpetual boyhood that Keim might find troubling, in that it places them in the role of children in relation to the older, wiser American "parents" who "saved" them.

In addition to the colonialist implications of infantilizing the Lost Boys, the characterization of adult refugees as "boys" is doubly problematic in an American context, where black men have been called "boys" in order to demean them. Riché Richardson explores portrayals of black men in the United States, specifically in the South, through literature, film, and music in *Black Masculinity in the U.S. South: From Uncle Tom to Gangsta*. She emphasizes the role of sexualizing or desexualizing black men in establishing the hierarchies of race and gender that continue to influence relationships, personal and political, in the South and in the nation at large. Richardson explores how the "asexual and docile" and thus "apolitical and counterinsurgent" Uncle Tom (15) and the hypersexualized, "pathological and bestial" black rapist (5) are caricatures that have functioned to limit the ways black men are portrayed by media and perceived in daily life. In U.S. documentary films and television news reports, the Lost Boys of Sudan are characterized as "safe" black men akin to the Uncle Tom figure in the American imagination; they are framed as polite, hard-working, naïve, and overall in a state of perpetual, nonthreatening boyhood.

As will become clear through the examples featured in this analysis, these young Sudanese men are described in ways very much in contrast to the ways in

which young African-American men are described in contemporary television and film, which is often much closer to the "black rapist" archetype. For example, Richardson notes the "inherently pathological" bent of "the news media's generalized portrayals of black male youth as rampaging rapists, looters, and criminals in the city of New Orleans after Hurricane Katrina in 2005," arguing that "the idea of the 'bad Negro' shapes public and popular responses to black men, who are imagined to be inherently bad" (Richardson, 2007, 234). And while, on one level, the appellation "Lost Boy" is meant to evoke J.M. Barrie's orphan characters in need of Peter Pan and Wendy's shepherding, calling any black man "boy" can, on another level, be problematic considering the word's "abusive uses in southern history to infantilize and emasculate black men" (Richardson, 2007, 229). By framing the Lost Boys as asexual, docile, and apolitical, filmmakers and journalists produce the vision of a black "boy" who feels safer to the sensibilities of mainstream, white America than other dark-skinned immigrants or citizens.

Living in Perpetual Boyhood:
The Lost Boys as Playful, Naïve and Dependent

Common to the film and television depictions of the Lost Boys of Sudan are depictions of these young men as living in perpetual boyhood. As Tom Brokaw pointed out in a 2001 *Dateline NBC* profile of Lost Boys resettled in Seattle, these young men are literally ageless due to "the fact that they don't have birth certificates. They really don't know how old they are. In the camp, aid workers simply estimated their ages" (Brokaw, 2001). The fact that many of these young men do not have a documented age worked to the advantage of some Lost Boys, who were able to get documentation (sent from Sudan) of an age young enough to allow them to enroll in American high schools rather than adult education programs. This situation is shown in the documentary *Lost Boys of Sudan* when Peter, a refugee resettled to Houston, moves to a suburb of Kansas City. One of the Lost Boys he knows there tells him, on his arrival, "They should adjust your age, so you can go to high school. Because in Southern Sudan most people aren't born in hospitals, our ages are just a guess." Peter is indeed able to gain admission to a public high school there, as he tells his friend Santino back in Houston, "I just got a new birth certificate from Sudan. . . . It's possible to make a complaint to say that I'm younger than my age" (*Lost Boys of Sudan*). It is significant that the young men are shown claiming younger ages that will aid them in being placed in high school, the archetypal capstone experience of American childhood. But, perhaps more importantly, the Lost Boys strategically staking a claim to continued boyhood also frames them as taking on some agency as they seek to use this status to their own benefit.

While the Lost Boys are sometimes depicted as ageless due to their lack of birth certificates, more common are depictions of them as living in perpetual boyhood based on their playful lifestyle and naïve outlook in contrast with Americans, and their positioning as dependent children in need of protection and nurturing. In the media depictions under consideration here, scenes from the Lost Boys' daily life, both in the Kakuma refugee camp in Kenya and after their resettlement in various locales around the United States, repeatedly portray these young men as playful, naïve, and dependent—especially in contrast with more experienced, more adult-like Americans. These young men are often shown at play by participating in or learning sports or as having a playful, joking manner when interacting socially with fellow Lost Boys. Likewise, the Lost Boys are also depicted regularly as naïve; they are amazed by things Americans take for granted such as the plenty in our grocery stores and the conveniences of electrical appliances. Because these young men are viewed as playful and naïve like children, they are also framed as dependent. While most of these young men were in the their late teens to early and mid 20s when they resettled in the United States, they are often portrayed in film and television as needing the wise shepherding of parent-like figures. Nurturing, mothering Wendy figures (to continue the Peter Pan analogy), in the form of social workers and volunteers, guide orphaned Lost Boys in need of direction through the confusing, complex Neverland of contemporary American life.

Playful Lost Boys

One way in which the Lost Boys are portrayed as being in a perpetual state of boyhood is that they are often featured at play. For instance, in the film *God Grew Tired of Us*, in footage of their life at the Kakuma refugee camp in Kenya, the young Sudanese men are shown laughing, dancing, and playing games together. Another feature-length documentary, *Lost Boys of Sudan* (shown on PBS' POV documentary series), depicts Santino and other refugees playing soccer in the camp prior to Santino's departure for the United States. Likewise, in a short profile of Lost Boys on CNN International in 2000, reporter Catherine Bond begins her voiceover by highlighting "An evening game of basketball for the lost boys of Sudan," portraying the young men as playful at the very outset of her report. While the living conditions in the Kakuma camp are portrayed as very basic with the refugees living in huts with dirt floors and cooking over open fires, nonetheless these young men without parents are shown consistently in a state of play. This may have to do with Western constructions of childhood as a carefree time of play. Media producers want to convince us that these Lost Boys are still children even after they have experienced trauma.

Once they are resettled in the United States, *God Grew Tired of Us* shows the young men swinging on a playground, playing guitar, and playing soccer at the park with one another (*God Grew Tired of Us*). Later in the film, after shown resettling in Syracuse, New York, some of the Lost Boys are shown at an ice rink, asking a child if it is difficult to skate and then shown falling as they try to skate for the first time, as a small child would. Another winter scene shows the young men riding their bicycles in the snow, again evoking boyishness. But, these scenes of wintertime play are juxtaposed with the next scene in which one of the young men is shown getting up at 5 a.m. to shine this shoes, pack his lunch, and prepare for his early commute to work (he is driven to work by volunteers), where he must wait for two hours before the factory opens (*God Grew Tired of Us*).

In the *Lost Boys of Sudan* documentary, two young men are profiled. In the beginning, the two friends, Peter and Santino, resettle together with other Lost Boys to a working-class apartment complex in Houston. But fairly early into their resettlement, Peter decides to relocate to Kansas City to pursue his education in the more open school system he has heard about from other refugees there. While Peter's lifestyle as a student with an afterschool job and Santino's lifestyle working the nightshift at a plastics factory are often contrasted in the film, the filmmakers emphasize the element of play and playfulness in both their lives.

In Houston, early on while Peter still resides there, he is shown playing basketball at a local outdoor court with African-American young men his age. They are heard calling each other and him "boy" as they aggressively compete for control of the ball. Later, back at the apartment, Peter and other Lost Boys converse about the differences they perceive between themselves and African-American young men: "In this country, the black people don't play smart, they play rough." Some of the Lost Boys then argue about their relative similarity or dissimilarity to African-American young men, one opining that African-Americans will steal from you while playing basketball, while another believes they are more similar than different. But as Peter concludes, "Even if someone does something wrong to you, you still play peacefully with them. Don't get aggressive. . . . But we will play them again."

A common setting for the play of the Lost Boys in Houston is in their apartment complex parking lot, their answer to the outdoor common area they shared in Kakuma. In the parking lot, the Lost Boys meet to dance, play chess, circle around on their bicycles, play ball, and generally joke around, converse, and spend time relaxing with one another. Their parking lot play is contrasted at one point in *Lost Boys of Sudan* with a Hispanic father concentrating on washing his car, other middle-aged Hispanic men in a serious discussion, African-American young men walking along comporting themselves with noticeable coolness, and an African-American woman sweeping her porch. This scene serves to frame the young Sudanese men as boyishly playful in contrast with their adult neighbors.

When Peter is in Kansas City, he is shown bouncing on a trampoline in a backyard with American teenagers he has met through school, hanging out at the local basketball court at night with local teenagers, and trying out (albeit unsuccessfully) for the school basketball team. In his downtime at his apartment, he is shown on his couch watching MTV spring break coverage, as his American high school peers might do. One scene that captures poignantly Peter's boyish playfulness is when he is shown hopping around a field near his apartment at dusk; when he returns to his apartment, viewers learn he was out in the field trying to catch small birds as a gift for a girl whom he met when she was interviewing him for the school newspaper. She visits him that evening and he proudly presents her with a large stuffed bear and a cage with two birds he caught himself. This scene depicts Peter as innocent and playful in his quest to capture the birds to present to the object of his boyish affections. The placement of this endearing scene complicates the portrayal of Peter, however, as it comes immediately after a scene in which he reads his college entrance essay to his school guidance counselor, an essay in which Peter reveals the many hardships of his life thus far. Again, boyish play is juxtaposed with the maturing trials that made Peter and the other Lost Boys become adults in childhood. For Peter and the Lost Boys, as they are depicted in these media portrayals, it seems as if the typical development from boy to man has been reversed; as boys they were forced through trials to become men, but as young men they have, in some respects, been given an opportunity to (re)experience their boyhood.

In Brokaw's profile on *Dateline NBC*, the Lost Boys' playful, upbeat attitude and approach to life come through as they ride together in a van with their social worker Cindy Koser on a field trip to the Boeing factory. As Brokaw narrates,

> They haven't had a childhood like we've ever known. And so some of those—some of that childhood comes out in real giddy little ways that is just incredibly—it's charming [boys singing in van]. The Lost Boys grew up fast, but they've kept a sense of wonder as Cindy discovered when she took her group sightseeing to a Boeing plant in Everett, Washington. (Brokaw, 2001)

Similarly, in *Lost Boys of Sudan*, many Lost Boys are shown reuniting for a Lost Boys Retreat at YMCA Camp Letts just outside Washington, D.C. At the camp the young men are shown canoeing on the lake, swimming in a pool, dancing, and enjoying one another's company as they tell jokes and stories. One moment of significance comes while in the pool some of the Lost Boys recall the crocodiles and the thousands of Sudanese who died in the Gilo River, which they had to cross when fleeing their country. But, as one Lost Boy points out, this is a pool and not a river. Nonetheless, even in these moments of seemingly carefree, boyish fun, memories can quickly and perhaps unexpectedly come back to remind

the Lost Boys of their difficult past. Both Brokaw's description and *Lost Boys of Sudan*'s depiction of the summer camp characterize the young Sudanese refugees as experiencing childhood wonder, charm, and giddiness even though they have been through very maturing experiences fleeing Sudan and resettling in the United States. This juxtaposition of childhood wonder and joy with adult knowingness and sorrows within the lives and attitudes of the Lost Boys may help to explain the fascination they hold to American media-makers and their audiences.

Naïve Lost Boys

From the very outset of their journey to the United States, the Lost Boys are framed as naïve. The life these young men knew in their early childhood in Southern Sudan was a life of rural, subsistence farming, while the life they knew in the Kakuma refugee camp was, while safe, a very basic existence in dirt-floor huts with open-fire cooking. As Tom Brokaw described them on *Dateline NBC*, "They're used to living in mud houses without indoor plumbing and electricity. They eat one meal a day that they cook over an open fire. For them, America might as well be a distant planet."

Beginning with their first plane trips from Kakuma to Nairobi within Kenya, and then on from Nairobi to connections in Europe that would take them on to the United States, these Lost Boys encountered modes of transportation, varieties of food and drink, and a plethora of "modern conveniences" to which they had heretofore had little to no exposure, let alone daily use. As Cindy Koser, a Seattle social worker interviewed by Brokaw, stated, "They have come from a time that I don't know" (Brokaw, 2001). Thus are the Lost Boys depicted as primitive, not only from another place but also from another time where they lived sheltered from the "more developed" ways of the West.

The Lost Boys' journey to the United States is depicted in both *God Grew Tired of Us* and *Lost Boys of Sudan*. On the first leg of their trip, from Kakuma to Nairobi, one Lost Boy says, "It shakes up my stomach!" (*Lost Boys of Sudan*). Both documentaries include scenes of the airline flight from Nairobi, in which the Lost Boys are depicted as fascinated and confused with every aspect from the remote controls to the in-flight cuisine. They are depicted as confused about what to do with butter, salad dressing, and condiments. Of the salad dressing, one Lost Boy asks, "Is it soap, meat, milk? I cannot tell." He declares that the airplane food is "not as good as what we're used to eating" (*God Grew Tired of Us*). While making a connection in the Brussels, Belgium, airport, the Lost Boys are shown experiencing some confusion and difficulty with the moving sidewalk and elevator as well as in the airport restroom with the water faucets and hand dryers. People-watching in the New York airport, they seem amazed at the diversity of people they observe (*God Grew Tired of Us*). On landing in Houston, Peter and Santino

have a dialogue about what they see outside on the tarmac: "Is this the airport? It looks like an airport. We will have to get home by foot. It looks like there are no cars" (*Lost Boys of Sudan*). Not only was the means of travel totally new to them, but what waited for them on the ground would also cause them to react with wonder, fascination, and confusion.

When a YMCA caseworker drives Peter, Santino, and other Lost Boys to their working-class apartment complex in Houston, they see architecture unlike the structures in which they have lived previously. One young man observes of the two-story, brick-facade apartments, "These houses look like they could fall on me," to which his friend responds with a laugh, "Yeah? You just came from mud huts" (*Lost Boys of Sudan*). Later, after settling in to their new homes, the Lost Boys gather in one of the apartments to compare notes on their experiences and reactions thus far. One shared, "Living upstairs scares me. I am afraid we will fall through the floor. At night when I hear footsteps, I get scared—boom, boom, boom" (*Lost Boys of Sudan*). Not only are the structures unfamiliar, so too is the scope of the nation's fourth largest city, Houston. Gathered on the floor of their apartment around a folded out map of Houston, one young man asked, "Is all of this our village?" As they trace their route from the airport and locate their apartment complex on the map, the Lost Boys smile and chuckle in amazement at just how big their new village is (*Lost Boys of Sudan*).

Another common element of mediated depictions of the Lost Boys is the inclusion of the orientations the young men received to everything from the conveniences of their apartments to navigating the local grocery store. The Lost Boys being resettled in Pittsburgh are shown their apartment by a resettlement social worker who explains (albeit briefly) about subjects as varied as using keys, turning lights on and off with a switch, running hot and cold water, eating potato chips and pretzels, using the trash can, dish soap, shower head, and toilet, not sharing beds, and above all setting up your alarm clock-radio. As the social worker is sure to point out, "One of the most important things in America: Time is money" (*God Grew Tired of Us*). Similarly, the YMCA liaison in Houston showed the young men how to safely use the stove and oven controls and the garbage disposal (*Lost Boys of Sudan*). Likewise, the Lost Boys in Seattle, according to Brokaw, "will need God's help and more in the coming months if they try to go from the simple surroundings back home to the complexities of modern life. In the camp, almost everything was done by hand, including washing and drying their few items of clothing. A machine to do that for them is a source of wonder" (Brokaw, 2001). In Seattle, the young men's reaction to all of the complexities of an American kitchen "overwhelmed them, so they skipped breakfast" (Brokaw, 2001). Meanwhile, a Lost Boy resettled in another location is shown mashing Ritz crackers with a hammer handle and then mixing them with milk to create a food similar to what they were used to eating in Kakuma (*God Grew Tired of Us*). From outright

avoidance to making the unfamiliar familiar, the Lost Boys are shown as coping with their confusion in a variety of ways as they adjust to their new American lifestyle.

Another aspect of the Lost Boys' acculturation process that is commonly included in mediated portrayals is the grocery store orientation. In the setting of urban America, it is unclear walking through a store from where the bounty of food and goods have come. Brokaw notes that, "It could not have been more different than their camp in Africa. The variety and the sheer volume of food was overwhelming." One Lost Boy is shown asking, "All these things come from where? All these things?" As social worker Cindy Koser observed, "Walking through the supermarket, they will mention, 'I see meat everywhere and I have not once seen a cow'" (Brokaw, 2001). Especially for the Lost Boys of the Dinka cultural group of Southern Sudan, in which the cow is prized as the source of much of what sustains the Dinkas, this must have been a significant concern and not just a point of idle curiosity (Bixler, 2005, 37). The Lost Boys in Pittsburgh also are shown being given a grocery store tour. They are shown in the produce section, examining with great fascination helium-inflated Mylar balloons and a resin garden squirrel, learning what hoagie buns and doughnuts with sprinkles are in the bakery—all the while being stared at by onlookers (*God Grew Tired of Us*). Meanwhile, the YMCA case worker assigned to show the Houston Lost Boys around the supermarket used it as an opportunity to give a lesson in personal hygiene: "If you smell bad, anyone cannot approach you. It's very important to be clean, so you will need to use this one [holding up a deodorant stick]. . . you will stop your perspiration" (*Lost Boys of Sudan*). These orientations to American conveniences and habits not only depict the many differences between the American and Sudanese cultures, but they serve to characterize the Lost Boys as literally lost when it comes to navigating these differences. Aspects of the culture that Americans take for granted—electricity, indoor plumbing, appliances, separate beds and bedrooms, grocery stores, and personal hygiene products and practices—are foreign to these young men, thus are they framed as naïve to much of what characterizes life in the materialistic and convenience-driven mainstream of American life. In addition, such portrayals serve to frame these young men as primitive, feral-like boys in need of a mother—or, in place of a mother, of being civilized through feminizing social norms.

Another aspect of the Lost Boys being portrayed as naïve is their lack of familiarity with American processes and customs. Being immigrants to a new nation unaccompanied by parents or other elders, and with no family members already present in the United States to help them settle, the Lost Boys had to trust that guidebooks and case workers would apprise them of everything they needed to know. But some lessons were left for them to learn on their own. In America, one of the main rites of passage from childhood and its dependence to adulthood and

its independence is the process of learning to drive a car. For most, this process occurs in one's teen years, taught by a combination of parents, older siblings, and high school drivers' education instructors. Living in a society in which the importance of having one's own vehicle is quickly imparted to immigrants as a cultural value, many Lost Boys' first major purchase was a used car to make navigating a big city easier. Santino, a Lost Boy in Houston, is shown driving without his license. When he learns he needs a license, he is shown taking his driving test, failing, and then driving away in his car—still without a license. Later, Santino is shown on his way to court, having received several tickets for driving without a license or auto insurance. When he is called before a middle-aged, African-American woman judge, she comes across as a patient yet frustrated mother figure, carefully explaining to Santino that it does not matter if one is in the process of applying for a license and insurance—that he must wait until he has both until he may drive again legally (*Lost Boys of Sudan*). Similarly, when Santino paid his rent with a money order but lost his stub or receipt, he could not prove that he had paid that month's rent. Here he appeals to a kindly, middle-aged white mother figure, hoping she will take pity on his situation. The apartment complex manager is depicted as patiently explaining the process to Santino so that he will understand in the future what his responsibilities are in the rent-paying process. Everything from how to approach a young woman in whom you have a romantic interest to what would be best to order at a fast-food restaurant (*Lost Boys of Sudan*) are portrayed as situations in which the Lost Boys lack sufficient cultural knowledge and thus come across as naïve to the customs of the nation into which they are attempting to acculturate. However, their lack of knowledge is offset by their great curiosity and desire to learn, as evidenced by the fact that, as Brokaw observed of the Seattle Lost Boys, "They were full of questions. . . . They wondered whether the waters of Lake Ontario were as dangerous as lakes in Africa" (Brokaw, 2001).

Dependent Lost Boys

An element of the Lost Boys' cultural identity that sets them apart from Americans is their perspective on the relationship of the individual to the community. The Southern Sudanese cultures in which the Lost Boys were raised are, as are many other non-Western cultures, collectivistic in nature. This means that individuals place the good of the group over their own personal good. In daily life, this translates to people taking the time to help one another, of putting the family's or other group's reputation ahead of individual concerns or preferences, being more apt to take the time for social interactions, and to welcome friends and strangers alike into their homes so as to build community. The Lost Boys are used not only to helping others, but also being able to count on others, especially their Lost Boy brothers, to help them—which may be interpreted as childlike dependence by

individualistic Americans. In some collectivistic cultures, individualism is seen as immaturity, while becoming a contributing member of the community is seen as maturity. Thus, the more individualistic culture of the United States is depicted as complicating the Lost Boys' cultural transition. As Brokaw notes, "Not surprisingly, they still have anxieties. They will be alone in their new home, and America's quiet streets are unsettling to them. They wonder, who would be around to help them if they were attacked or robbed?" (Brokaw, 2001). The documentary *God Grew Tired of Us* depicts an incident in which merchants in the Lost Boys' neighborhood called police because they felt intimidated by the large groups of tall young black men coming in to the store together. A meeting was called to advise the boys not to travel in large groups (*God Grew Tired of Us*). The Lost Boys are not used to being alone; they are used to living in closer community with others who may be relied upon as sources of help.

The Lost Boys often are heard in media depictions as longing for more connections with fellow Lost Boys, missing family members, and the Americans they encounter in their everyday lives. One Lost Boy recalled how in the Kakuma refugee camp they were used to being in a group, but with "only four of us here, it's difficult." As Nicole Kidman narrated, the boys were "faced with an increasing sense of loneliness," causing them to turn to agencies such as the Red Cross to help them locate their parents (*God Grew Tired of Us*). Being immigrants without families accompanying them or awaiting them to help ease the transition through a network of social support magnified the Lost Boys' desires to make friends. As Peter shares a fast-food lunch in a park with two of his co-workers, he tells them, "But there in Africa, there is no 'time is money.' But I came here, everyone is busy. I say, how am I going to find friend now. . . . I say, this place, there is no friends here. And all the time, you cannot stay without talking to anyone" (*Lost Boys of Sudan*). At a Fourth of July parade, one Lost Boy commented, "We see people walking around with girlfriends, parents. We can't. There's nothing we can do." The lack of community and connectedness takes its toll on these very collectivistic young men: "People feel hopeless. They want to kill themselves" (*God Grew Tired of Us*).

At a Lost Boys Reunion held in Grand Rapids, Michigan, one Lost Boy observed, "It's like being in Kakuma. We chat. We talk on issues. . . about the betterment of our future. Being a Dinka man requires you to help. . . . But I'm worried about the young guys. What if they forsake the culture?" He went on to discuss the importance of the "way you dress, do your hair," your way of "conducting yourself." This is an example of how these young men, orphaned or separated from their families, have a concern for how will they ensure their traditions and values continue on to the next generation—but without the previous generations there to reinforce these cultural practices. Juxtaposed with footage of the refugee camp, another Lost Boy recalls the social structure the refugees formed with one another there. Their desire to live in community with one another is "why I

started Parliament—to give each other a chance to talk, say what we want to say, forget about war, come together like a family." He talks about people back home and comments that "I believe people have talents—in community. God didn't create me alone. I was born to do something" (*God Grew Tired of Us*).

Another Lost Boy, John Bul Dau, is shown reading a letter from someone back home: "My dad and my mom, my three brothers and sisters are living in Uganda." The letter revealed that they were "suffering from disease in a refugee camp in Uganda" and that other relatives had been killed. John acknowledged that "Right now I am feeling a weight. It is my time to help them. I am strong enough to do that." Though John was planning to go to school, "The discovery of my family changed my plans. . . I had to work two jobs and even three jobs, so I decided not to go to school until I change their situation" by bringing them to the United States so he can "know they are well and secure." In addition, John sends money to friends who remain in the refugee camp in Kenya. He explains that he went to America thinking of helping people back home, but he and his fellow Lost Boys have been overwhelmed with requests for help; one day they received 28 messages on their answering machine. When asked for help, despite their unselfish ideals, they must often reply "No, I don't have the money" and lament that "We shall end up with nothing. I thought we shall go further than this" (*God Grew Tired of Us*).

Peter and Santino and their counterparts in Houston are depicted as encountering similar pressure to send the money they are earning back to friends and even long-lost relatives. They compare notes as to how much each has sent to Africa, one having sent $1,250 and the other $600 so far, and joke about needing to tell people who call them for money that they are not there so that they can save some money for their own needs. Later, after Peter relocated to Kansas City, he is shown talking with his sister on the telephone. Peter's sister chides him that, "Even if you go to America, you still have to take care of things at home." Peter responds that, "It's hard for me to be responsible for myself, my school, and the conditions back home" and, after further arguing with his sister, details his daily schedule hour by hour to prove that he has no time to work another job or to call her more often (*Lost Boys of Sudan*). All three of these Lost Boys find themselves vacillating between being carefree young men who want to be able to buy their first car yet feel keenly their responsibilities to others back home. In such instances, the Lost Boys are depicted as occupying a conflicted space between boyhood and manhood as well as between African priorities and American priorities. These moments of indecision over whether to privilege being a successful individual or supporting one's family and community serve to frame these young men as Lost Boys in a confusing Neverland of cultural influences and life stages.

Just as the Lost Boys are framed as valuing life in community with others and realizing their responsibilities to others, so too are they characterized as depending

on others as children depend upon their parents. For instance, in *God Grew Tired of Us*, one young man without his own vehicle must depend on volunteers to drive him to work before daylight (even though he must then wait two hours until his workplace opens). Another Lost Boy notes that, "We have many questions to ask, but no one to ask" (*God Grew Tired of Us*). In *Lost Boys of Sudan*, Peter discussed how difficult it was to try out for the school basketball team without support from parents who could teach him the fundamentals and give him the lifestyle that would afford him practice time: "I am actually like somebody who is among the children of the rich people. . . I'm a poor person without parents. What can he do amongst the children with parents who are rich?" (*Lost Boys of Sudan*).

The Lost Boys' identity as both orphans and refugees places them in a position of weakness that makes them appealing "charity cases" for people looking for someone to guide and nurture. Journalist Mark Bixler, in his book profiling four Lost Boys who resettled in Atlanta, notes that the volunteers most drawn to the Lost Boys tended to be middle- to upper-class, middle-aged women with no children of their own; he theorizes that these women were attracted (even if subconsciously) to helping the Lost Boys because it provided an outlet for their maternal instincts (Bixler, 2005, 103). Being alone in a new country with little money and limited cultural knowledge places the Lost Boys in a position of dependence on those who would help them. Brokaw notes that what the Lost Boys, as refugees in Africa, needed more than food or drink or a bed in which to sleep, "was safety, a feeling of reassurance that we will take you to a safe place where your life is not in danger." Now that they have resettled in the United States, the Lost Boys are framed as still in need of safety and reassurance in the form of people to help them, like social worker Cindy Koser, whom Brokaw portrays as "their surrogate mother . . . seeing life through new eyes" as she tries to answer their constant questions. Like a good parent, "Every day, Cindy teaches them the fundamentals of modern life" (Brokaw, 2001). This is no doubt a favorable depiction of the help so generously offered by caseworkers and volunteers. However, being framed as the children of that "surrogate mother" places the Lost Boys in the role of being less knowledgeable and less capable than other young people their age, thereby furthering their image as young men caught in a state of perpetual boyhood.

Finding the Lost Boys' Significance in Mediated American Culture

Why has the story of the Lost Boys of Sudan so captured the American imagination? What is it about these young male Southern Sudanese refugees that makes their story so appealing to American journalists and filmmakers and consequently their audiences? One explanation may reside in the fact that these young black Sudanese men and their life stories may seem incongruous with the way young black American men are often portrayed in American journalism and film. Though

both groups are young black men with similarities of physical appearance, age, and in some cases socioeconomic status, they end up being portrayed in media accounts as more dissimilar than similar. Young African-American men are often depicted as street-smart, uneducated, ignorant, and out for themselves—an embodiment of the "American nightmare." Conversely, these young Sudanese men are depicted innocent in their playful, naïve, and dependent behaviors yet hardworking and out to give back to their communities rather than advance only their own interests—an embodiment of the purity of the "American dream."

Even the Lost Boys themselves are shown in the film documentaries commenting on their identities in the context of how Americans see African-American men, at times confusing the Lost Boys for being American black men rather than Sudanese black men. Media-makers' insistence on framing the Lost Boys as living in perpetual boyhood serves to make them, as both young black men and as immigrants, a "safer" version of the Other for American sensibilities. The consistency with which the Lost Boys of Sudan are portrayed as embodying the characteristics of perpetual boyhood, in the three media texts considered here and in a multitude of other media accounts, is indicative of the deep-seated nature of Americans' need to make these Lost Boys safe to interact with through the mainstream of American mediated culture.

Works Cited

Bixler, Mark. *The Lost Boys of Sudan: An American Story of the Refugee Experience.* Athens, GA: University of Georgia Press, 2005.

Bond, Catherine. "Sudanese Lost Boys Begin Again in United States." *World News.* CNN International. 19 November 2000. Lexis-Nexis. Web. 22 January 2009.

Bormann, Ernest G. *The Force of Fantasy: Restoring the American Dream.* Carbondale, IL: Southern Illinois University Press, 2001.

Brokaw, Tom. "The Lost Boys: Sudanese Boys Who Have Struggled to Survive in Their War-torn Homeland Get New Start in America." *Dateline NBC.* NBC. 9 September 2001. Lexis-Nexis. Web. 22 January 2009.

Foss, Sonja K. *Rhetorical Criticism: Exploration and Practice.* 4th edition. Long Grove, IL: Waveland, 2009.

God Grew Tired of Us. Dir. Christopher Quinn and Tommy Walker. Newmarket Films/National Geographic Films, 2006.

Keim, Curtis. *Mistaking Africa: Curiosities and Inventions of the American Mind.* 2nd edition. Boulder, CO: Westview, 2009.

Lost Boys of Sudan. Dir. Megan Mylan and Jon Shenk. Actual Films/Principe Productions, 2003.

Richardson, Riché. *Black Masculinity in the U.S. South: From Uncle Tom to Gangsta.* Athens, GA: University of Georgia Press, 2007.

Boys and Young Men Consuming and Creating Media

Consuming the WWE: Professional Wrestling as a Surrogate Initiation Ritual among Somali Bantu Teenagers

Sandra Grady

The television commands a central place in the living rooms of most Somali Bantu apartments in the United States, and is often—depending on the means of the family—ensconced in an entertainment center with multiple items of entertainment technology: stereo consoles and speakers, DVD players, video cassette recorders, other televisions, and an assortment of music CD's, videotapes, and DVD's. This seeming wealth of media commodities is in sharp contrast to the traditional African décor in the rest of their living spaces and the corresponding sense of resistance to the external American environment. The contrast between American media and African surroundings is made even clearer when the television (or multiple televisions) remains switched on continuously, broadcasting the sounds of U.S. programs over family gatherings in the otherwise African space. As it is for many American families, the entertainment center is an important source of family recreation for Somali Bantu refugees, for whom this access to media is an important new element of family life in resettlement. It is also representative of wider forces affecting diverse culture groups across the globe at the early part of the 21st century. Arjun Appadurai argues that two defining characteristics of the postmodern world are the increased scale of human migration across the globe and the abundance of electronic media options available to consumers. These two forces are particularly important because they influence the imagination and, consequently, shape identity (3–4). In other words, the variety of media options available has democratized the work of the social imagination, and

serves to further disrupt previously central practices of identity formation. Among young refugees, Appadurai continues, the consumption of media is particularly significant because it offers the young a multiplicity of alternatives to the models of adulthood provided by parents or elders in traditional practices of cultural reproduction (43–45).

In order to explore Appadurai's argument, this essay examines the media practices of a group of East African refugees resettled to the urban United States. Among Somali Bantu boys, both viewing practices and media content indicate that the media provides important models of gendered behavior which both reinforce traditional gender roles while, at the same time, connecting them to important values within American life and to consumer practices which extend the social imaginary of professional wrestling into their daily lives.

The Somali Bantu Community

The Somali Bantu are a population of agriculturalists from the Jubba Valley, members of a variety of ethnically distinct communities who share a common general history and an emerging cultural identity. The designation of *Somali Bantu* is a recent one, created within the international refugee administrative systems following the displacement of many self-contained rural communities during the political upheavals in Somalia in the early 1990s. Historically, the Somali Bantu arrived in Somalia during the 19th century slave trade from a variety of culture groups originating in present-day Tanzania and Mozambique, settled in agricultural communities in Somalia, integrated into the Somali clan system, accepted Islam, adopted a local dialect of Somali, all while they perpetuated various non-Somali cultural practices from their pre-slavery past. In the century or more that followed slavery, they co-existed as social inferiors to the ethnic Somali pastoralists, and remained on the margins of colonial and post-colonial Somali society as second-class citizens; consequently, they have appeared only briefly in scholarly literature, often only glimpsed in larger studies about Somali pastoralists (see Besteman, 1995, "The Invention of Gosha: Slavery, Colonialism, and Stigma in Somali History" and Besteman, 1999, *Unraveling Somalia: Race, Violence, and the Legacy of Slavery*; Cassanelli, 1988; Menkhaus, 1989). With the collapse of the state in the early 1990's, a large portion of the Somali Bantu population fled to refugee camps in northern Kenya, where they have remained for over a decade. In 2003, the U.S. State Department began resettling approximately 15,000 Somali Bantu to 52 sites in the United States (Van Lehman and Omar, 2002).

The research for this essay was conducted from 2007 to 2009 in a large midwestern city, where approximately 1,000 Somali Bantu have resettled.[1] As part of a larger project on the construction of adolescence within this population, I conducted ethnographic fieldwork with approximately 30 Somali Bantu teenag-

ers, first establishing myself as a participant observer in their school, and then later at their homes. As I gained greater familiarity with these young people, I conducted informal interviews with them and with members of their extended kinship network, which included parents, surrogate parents, siblings, cousins, and other relations that had co-located in this city. Because my research subjects were minors, I have changed their names in this essay, but all other elements remain as I observed them.

The refugee experience has been paradoxical for the Somali Bantu. As the adults move to cement their emerging identity by documenting their own history and language and forming associations with other groups of Somali Bantu across the U.S., relocation has forced them to adapt their cultural practices significantly in order to accommodate the demands of American life. One of the greatest adaptations has involved their youngest members, the school-age refugees. Resettlement in the U.S. has fundamentally altered the Somali Bantu life cycle by displacing their traditional practices of initiation into adulthood and introducing the experience of adolescence within the structure of the American educational system. Their new roles as students in school and non-child/non-adult at home have radically extended the period of transition to adulthood and usurped the educational aspects of the traditional life cycle event, which was previously characterized by ritualized genital cutting and an extensive period of seclusion and recovery that allowed for instruction in their new roles as adults within the community. After the recovery period, the initiates would re-emerge into the community as adult members of it. This pattern of separation from childhood, a discreet period of transition (or liminality) guided by community elders, and subsequent incorporation into the community as an adult has been well documented by scholars of initiation ritual (Turner, 1966; Van Gennep, 1960). In the case of the Somali Bantu, the disruption of these traditional rites of passage by flight and resettlement into a very different cultural context forces young refugees to seek models of identity within their new environment. One place where these models can be found is through media consumption generally, and for the boys, through professional wrestling in particular.

Television Practices

Within the Somali Bantu home, the living room is a space dominated by women and is a site of much of their labor and entertainment. Consequently, women have considerable authority about the media choices made in that space, and are its primary consumers. While the television plays, women, teen girls, and young children move about the room often simultaneously preparing food and caring for the gathered children. Meanwhile, Somali Bantu men and teen boys move in and out of the room, engaging briefly in the ongoing television entertainment,

often moving on to other activities. For many of the boys, this activity often includes backstage media consumption with their male peers, watching and playing videogames in the bedrooms of their age mates, or the front rooms of those houses where women and children are not present to dominate the living space. In this highly gendered and restricted environment, World Wrestling Entertainment (WWE) programming is one of the most popular sources of media consumption.

In keeping with this removed practice, my initial exposure to the WWE came not from watching it in the home, but in a discussion with Hassan, a teenage male. Not only was this conversation an introduction to an important practice in his peer group, but it also highlighted the significant elements of WWE programming and how many boys absorb them as part of their ongoing effort to incorporate into adulthood. At that time, Hassan's household included his mother and two sisters, one of whom was blind. The responsibility of caring for her disabled daughter prevented Hassan's mother from supporting the family financially, and left Hassan with concerns about money, and his future potential to provide for himself and his family. Because he had begun to demonstrate seriousness of purpose in his studies, Hassan had been enrolled in an afterschool trade program at a local community college where he was gaining skills as an electrician. In nearly all of our tutoring sessions, Hassan would ask me for career advice, whether to continue in high school and attempt to get his diploma or dedicate himself full-time to his trade course instead. He also had a number of questions about how he might earn an even larger income, whether he should continue progressing higher in electrical certification or finish high school and try to go to college. Every now and then, as he explored these pragmatic options with me, Hassan would ask me about more fantastic ways to be successful in America. One idea Hassan had, for example, was to go on *American Idol* and, by winning it, become a successful pop star. Although I thought his options to do this were limited by his lack of English language skills and inexperience in performing music of any kind, Hassan seemed confident that he could win the competition if he could find somebody to support him with some musical training and help auditioning for the show.

Later, in a similar discussion, Hassan asked me a series of questions about the WWE. He had been watching wrestling with his cousin Mohamed and the two had begun debating whether what they saw on television wrestling was real or staged. Hassan insisted it was a performance, while Mohamed thought it was a contest of strength. It is important to note that the relationship between Hassan and Mohamed was complicated and symbiotic, particularly in their approaches to integrating into U.S. life. While Hassan lived in a household of women and felt considerable pressure as its sole male to support the family, Mohamed had lost his mother and lived a bachelor existence in a second family apartment away from the home of his father's current wife and their children. Neither boy had daily access to an adult Somali Bantu male as a role model, and both were picking pieces

from the variety of models around them in their progress toward manhood. After a period of wild behavior and disrespect for school authority, Hassan had begun working hard at his education, and sought out additional support from teachers to improve his chances at success. Mohamed, on the other hand, barely participated in school. Most efforts to teach him were met with blank stares or laughter. At the housing project where they lived, Mohamed was securing a reputation as a troublemaker because his unique living situation offered him considerable freedom, though it simultaneously failed to meet many of his needs. Both Hassan and Mohamed wanted to establish themselves as successful men in American life, but were pursuing very different paths. At the point when Hassan asked me about the WWE, he saw a route to the future through hard work at school and the development of an employable skill, while Mohamed was inclined toward petty thieving and found role models in his considerable media consumption. According to Hassan, the two argued not only over whether the fights on the WWE were staged, but also over Mohamed's plan to become a WWE wrestler when he reached an employable age. Of course, the lure of such models was attractive to Hassan as well, and his question to me also indicated that he too would consider a career as a wrestler if I thought it was a feasible way forward.

Teenage engagement with WWE

As my fieldwork moved from the school and into individual homes, it became increasingly clear that the WWE was an important part of entertainment among most Somali Bantu teenage boys, not just these two, and I soon learned that this avid viewing interest also had an impact on their internet consumption and participation in other competitive activities. Most Somali Bantu teenagers avidly followed one or both of two weekly programs, *Raw* and *Smackdown*. Both of these programs are owned by the WWE, the largest professional wrestling promotion in the world. Professional wrestling, as demonstrated on both programs, is a combination of three elements: sport spectacle, complex narrative drama, and repeated promotion of other WWE products. In my experience of WWE consumption among Somali Bantu, there are observable gendered practices in the way teenagers engage with these three separate elements of WWE programming.

To illustrate these three elements, I will describe my experience of viewing an episode of *Raw* in the company of two Somali Bantu teenagers, Ahmed and Abdikadir. In this particular instance, we began watching the program on a television in the almost empty living room of Abdikadir's house. At my arrival, female members of Abdikadir's family appeared from other apartments to be introduced to me as a visitor. I want to note that, while many teenage and adult Somali Bantu females claim that they follow the sport, this front-room consumption of it with multiple genders and generations of family members was not common. When

the program began, we were joined by Abdikadir's father, two adult women, and Abdikadir's younger sister, Hawo. The adult women left soon after the program began, and while Abdikadir's father stayed, he largely ignored the onscreen activities. Hawo, like the boys, watched eagerly, and sometimes ventured an opinion about one or another character. It was the boys, however, who dominated the discussion of the events on television.

As a spectacle of athleticism, Somali Bantu boys demonstrate a keen appreciation for the physical elements of wrestling as sport. In my conversations about the WWE with the teenage boys, many indicated that they liked to watch a particular wrestler for his characteristic move, not simply because of his role in a particular narrative arc. In fact, the physical display is the part of the genre that renders the discussion over whether the sport is real or fake insignificant within this group. Like Hassan, most of the boys indicated at some point that they knew or at least suspected that the matches were staged; likewise, most ultimately indicated that the issue was irrelevant because the wrestlers still must perform the physicality of their roles successfully within the staging. The boys' appreciation for this was clear from the opening of this particular episode. As the program began, a retired "legend," Ric Flair, was using a microphone to call out Chris Jericho, a younger wrestler with whom he had an established rivalry, which had recently spilled over into Flair's retirement. Soon, Jericho interrupted Flair's challenge from a microphone in the backstage area of the stadium, and eventually appeared in the stadium and approached Flair in the ring. Both men were dressed in gray suits and ties, seemingly unprepared to wrestle, while fans shouted for them to fight. Soon the scripted argument turned into a physical confrontation between the older and younger man, and the narration was taken up by the unseen sports commentators who explained the background of the conflict to uninitiated television viewers. As Jericho punched Flair in the face, pushed him to the ground, and threw him, bleeding, into the stands, the commentators registered their disapproval, noting that Flair is a hall of famer, and Jericho was simply humiliating him. Soon blood poured from Flair, and Jericho continued to beat him outside the ring. Eventually, Jericho grabbed a camera off one of the production staff and attacked Flair with it, who then collapsed, seemingly unconscious. The crowd roared and chanted, and Jericho stripped Flair of his gold watch and stomped it into the ground as the commentators called out for him to stop. The camera closed in on Flair lying in blood before the program went to commercial.

The question of authenticity came up immediately with Abdikadir and Ahmed, when I indicated discomfort in watching a young man, Jericho, attack and bloody an older one, Flair. As I expressed dismay that a respected elder would be beaten in such a violent way, both young men sought to alleviate my concern. Abdikadir helpfully pointed out to me that Flair is stronger than any of us, and therefore not to be pitied, and if he arrived in the apartment while we were view-

ing the fight, he could beat us all up. He cautioned me not to feel any concern about him. When I asked about the bleeding, Ahmed underscored the irrelevance of the violence onscreen and, to some extent, the central point of WWE drama by noting, "they get a lot of pay whether it's real or fake." While the seeming violence of the sport was deemed largely irrelevant by the boys, the performance of combat was a matter of considerable interest. The boys repeatedly noted that, regardless of whether the action is real, the wrestlers are all in top physical condition, and they engage in highly athletic moves, such as flips and throws. As these particular matches played out on screen, Ahmed repeatedly pointed out to me the characteristic moves of each wrestler and expressed admiration for his performance. Likewise, Abdikadir, who has begun a performance dance troupe for male Somali Bantu teenagers, was also interested in the choreography demonstrated in the ring. In his writing on professional wrestling as melodrama, Henry Jenkins (1997) notes that sporting melodrama allows for the display of physical prowess within a narrative event. In the case of the WWE, that display becomes a spectacle characterized by ongoing cycles of physical vulnerability and restored potency (53). In her analysis of the sport, Sharon Mazer (1998) ties this spectacle specifically to the performance of masculinity, noting that "professional wrestling explicitly and implicitly makes visible cultural and countercultural ideas of masculinity and sexuality. Wrestling's apparently conservative masculine ideal is constantly undermined through the parodic, carnivalesque presentation of its opposite" (4).

Beyond the flamboyant costumes of certain characters, this carnivalesque presentation is also apparent in the performance of violence as well. One of the most complicated storylines of the series, an ongoing feud between Randy Orton and Triple H, involved violence spilling over into the private lives of both fighters, which nevertheless had been caught by WWE cameras and could be aired for the program. In this story, there was a series of increasingly outrageous violent inversions over the course of multiple episodes. What began with Orton harming members of Triple H's family, moved next to an attack by Triple H on Orton's home and girlfriend, which then moved inside the arena as H imprisoned one of Orton's tag team partners alone in the ring and attacked him with a sledgehammer. In this episode, Orton avenged his partner by handcuffing Triple H to the ring ropes and demanding that H's wife come and beg for his life as Orton wielded his own sledgehammer. The episode ended with H's wife prostrate and unconscious on the mat, H unable to reach her from his cuffed position on the side, and Orton stroking his sledgehammer as he moved between the two weighing his options.

This model of masculinity reinforces the use of physical prowess and usually violence to achieve one's ends. At the same time, the violence is clearly performed, not real. Like a serial television program, *Raw* cuts to commercial at critical points of violence in the drama, suspending any kind of consequence to the violence. A

bleeding Ric Flair is not removed by an ambulance, and Orton does not deliver the fatal blow to either H or his wife. The strongest man wins for the moment, until the next round of violence, in which his antagonist will have gained in strength and power. It is perhaps not surprising that such a performance of masculinity is highly compelling to a group of young men whose lives so far have included flight from the security of home, a decade or more in massive Kenyan refugee camps where violence (and particularly sexual violence) was a constant threat (Musse, 2004; Nowrojee, 1993), and resettlement to a new country where their economic opportunities are limited by their English language skills and lack of previous education.

Mazur notes that, in professional wrestling, "victory always equals masculinity" (5). For Hassan, Mohamed, Abdikadir, Ahmed and their male peer group, the restored potency through physical prowess offered in all WWE narratives, and its corresponding potential for providing wealth, makes not only for compelling viewing but also for a compelling vision of how to be a man. When they discuss their experience of the refugee camps, most teen boys describe primarily the sense of physical danger they felt there from other groups, and many find the surrounding African-American community in their housing project likewise threatening. Furthermore, these boys know that their future ability to support themselves and, eventually, a family depends on their ability to perform physical labor, as the educational system has already proved difficult, and their only hopes for higher education depend on athletic skill, another type of physical labor. Consequently, the ongoing WWE narrative, in which the strongest man always wins, validates their own hopes for a secure and prosperous future for themselves.

The second element of WWE programming, the narrative drama, is the element that is equally attractive to both teen boys and girls. The separate, complex, and largely incredible story lines acted out by the wrestlers were well known among teenagers. While I watched this episode of *Raw*, for example, all of the teenagers present provided me with deeper background on the individual rivalries than what was offered from the commentators. In this particular episode, one of the more involved story lines was a romantic triangle that had developed between Paul "The Big Show" Wight, Adam "Edge" Copeland, and Vickie Guerrero. Guerrero has a long history in the WWE, appearing in fights with her late husband, and in subsequent feuds following his death. On this particular episode, rival wrestler John Cena provided narrative background to the viewer by reading a Get Well card to Guerrero, which allowed *Raw* producers to include footage of the previous fight between Edge and The Big Show, and which had seemingly resulted in injury to Guerrero who had appeared with the two rivals. The live audience roared as Cena mocked Guerrero's looks and boasted about his impending win against both fighters at *Wrestlemania*.

As part of the experience of watching the program with the teenagers, I learned more about Vickie Guerrero and her history on the program, and how the feud between Orton and Triple H began, as well as the level of violence that had already been visited on their individual families than what was provided by the commentators. Likewise, in instances when I had discussed the WWE with the teenagers away from an instance of viewing, they often named favorite wrestling characters and described their current intrigues within the WWE narrative. Drama scholars point out that the open-ended, cyclical and melodramatic model of narrative structure featured on the WWE, and often demonstrated in other televised sports, is one shared by daytime soap operas. Initially, this type of drama was framed as a feminine model, but as mediated sporting events have increasingly adopted it, analysis has turned away from its gendered aspects and towards its overarching popularity. Melodramas, like soaps and wrestling, allow the narrative to continue past individual media encounters, remaining only temporarily resolved. Further, they allow viewers to move into an emotional register, ultimately collapsing the boundary between television screen and sporting event. The (often male) spectator becomes part of the action, calling plays and arguing with officials (Rose and Friedman, 1997, 4, 9). This collapsing of the boundary between spectator and participant is particularly true of the Somali Bantu males, and will be further considered in the discussion on consumer practices below.

In his analysis of professional wrestling specifically, Jenkins considers wrestling as popular theater staged to insure the maximum emotional impact while directing viewers towards a specific vision of the social and moral order. Put simply, professional wrestling championships are staged as battles of higher justice where victories are granted to the virtuous (54–55). The reinforcement of a particular moral economy happening in WWE stories was underscored in my experience with Somali Bantu teens. In this viewing experience, for example, the boys typically explained the complexities of the story line in an effort to explain which fighter should win the match. They demonstrated that, like the commentators, they expected the outcome of the match to reflect some kind of narrative justice. Hawo, on the other hand, simply summarized past feuds and offered opinions based on issues of personal attractiveness. This gender difference was repeated outside this particular viewing instance among both teen girls and boys throughout my research. Most Somali Bantu girls could name their favorite fighters, but demonstrated little expectation that a particular match would reflect a satisfying narrative outcome. The boys typically summarized the plots that involved their favorite wrestlers in an effort to demonstrate why their picks should ultimately win. In this instance, for example, both Abdikadir and Ahmed wanted Triple H to win his *Wrestlemania* match-up with Randy Orton, not because H was the better wrestler—he is actually considerably older than Orton—but because Orton had victimized H's family in beginning the rivalry, so he must correspondingly

be punished. Jenkins points out that this linkage between moral authority and possession of physical strength is particularly appealing to members of the working class, because it puts power in the hands of those who render physical labor (55). Michael Ball (1990) takes that analysis a bit further, noting that the values that are reinforced are traditional working-class values, but they are sustained and reinforced through elite interpretation, which reinforces stereotypes and feeds corporate profit (141, 57).

The feeding of corporate profit is the third element of the WWE that has proved compelling to Somali Bantu youths, who consume not just the television programming, but also multiple strains of WWE product. In addition to *Raw* and *Smackdown*, teenagers also engage with the WWE on the internet and through the purchase of consumer products. These interactions often push the world of the WWE into the unmediated lives of the boys, connecting them tangibly to the larger social imaginary that they encounter on television. To an extent, this consumer activity is ostensive, in that it allows the teenagers to enact a role within the WWE rather than simply retell a story from outside their personal experience. Ostensive patterns among adolescents have been well documented, particularly in the phenomena of legend-tripping, where teens find a way to insert themselves into local legends—particularly those involving death and violence—by visiting the sites of these legends and interacting with the story in some way, a practice which often subsequently evolves into a localized rite of passage (Ellis, 1996).

In the case of these refugee boys, the purchase of WWE goods allows them to extend the television spectacle and narrative, as well as its valorization of physical prowess, into their ordinary lives. For example, early in my fieldwork, Ahmed acquired an imitation WWE championship belt. Because he lives in his grandparents' apartment at a large urban housing project near other extended family, Ahmed's home is frequently filled with a large number of very young cousins and older siblings who typically display very little respect for individual personal property. The belt, however, was always treated with considerable care and respect whenever it made its way into the common space. In my visits to the home, the belt was routinely kept away from the small children, who consequently bypassed seemingly more interesting children's toys to find it for play. Even the older siblings prioritized the preservation of this particular item. In short, the family treated the belt as if Ahmed had obtained it through some kind of personal achievement, rather than simply purchasing it as a consumer good. The belt, which does indeed represent achievement for fighters in the WWE, also came to represent accomplishment in Ahmed's home.

This representational pattern also extended into school. On the last day before winter break, as the High School Welcome Center held its annual celebration for the students to celebrate their diverse cultural backgrounds, there was an arm-wrestling tournament for the male students. It moved through multiple rounds of

play, and eventually ended as a contest between Abdikadir and one of his West African classmates. Although there was a diversity of activities available to students, as the championship match began, most of the African male and female students gathered around to see the final outcome. Before a crush of fellow students, Abdikadir soundly defeated his counterpart. As the Somali Bantu students celebrated this victory, Ahmed—who had been eliminated in an earlier round—brandished his WWE belt as he escorted Abdikadir away from the site of the match and the clutch of fellow student spectators. The belt was a useful emblem of both Abdikadir's individual and the Somali Bantu students' collective athletic achievement.

Conclusion

In his discussion on cultural reproduction in an era of dislocation, Appadurai (1996) remarks that the "pains of cultural reproduction in a disjunctive global world are, of course, not eased by the effects of mechanical art (or mass media)" because the media provides to young people "counternodes of identity," contrary to parental desires in which new gender politics and violence are included. The difficult task of reproducing "the family-as-microcosm of culture" is often drowned out by the loud background soundtrack playing out the fantasies of the new ethnoscape (45). In fact, the media consumption of these Somali Bantu teens indicates a highly complex relationship between the fantasies of the WWE and the reproduction of traditional culture. By stressing the resolution of complex dramas of justice and the defense of the home through contests of physical strength, the genre reproduces traditional male roles. Likewise, the repeated, ongoing performance of violence in professional wrestling provides a new, largely gender-segregated, and backstage ritual event for these young refugees, not unlike the traditional rites of passage. As Hamid Naficy (1999) noted of Iranian refugee television viewing, the watching of the event becomes its own ritual genre, a repetitive action that moves them from the liminal space of exile to reincorporation within the larger society (538–539). In the Iranian case, reincorporation happens through the high volume of advertisement that moves the exiles into a consumerist lifestyle emphasizing the individual over the collective, thereby incorporating them into U.S. society not through the linear process of traditional rites of passage, but through "a conflictual and dialectical process involving resistances, differences, reversals, and leaps forward during which features of both liminality and incorporation may coexist for quite some time" (563). It is too soon to know if, for Somali Bantu teen boys, the purchase of WWE consumer product is part of that same long-term dialectical process of incorporation into U.S. culture, or if it provides them with tools to incorporate U.S. culture into their own improvised rites of passage.

Note

1. This chapter, as well as a corresponding one in its companion book, *Mediated Girlhoods*, appears as part of an integrated chapter on the role of media in modeling gender for Somali Bantu refugees in my dissertation, *Improvised Adolescence: A Study of Identity Formation among Somali Bantu Teenage Refugees*.

Works Cited

Appadurai, Arjun. *Modernity at Large: Cultural Dimensions of Globalization*. Minneapolis, MN: University of Minnesota Press, 1996.

Ball, Michael R. *Professional Wrestling as Ritual Drama in American Popular Culture*. Mellen Studies in Sociology. Vol. 8. Lewiston, NY: Edwin Mellen, 1990.

Besteman, Catherine Lowe. "The Invention of Gosha: Slavery, Colonialism, and Stigma in Somali History." *The Invention of Somalia*. Ed. Ali Jimale Ahmed. Lawrenceville, NJ: Red Sea, 1995. 43–62.

———. *Unraveling Somalia: Race, Violence, and the Legacy of Slavery*. Philadelphia, PA: University of Pennsylvania Press, 1999.

Cassanelli, Lee V. "The End of Slavery and The 'Problem' of Farm Labor in Colonial Somalia." *Proceedings of the Third International Congress of Somali Studies*. Ed. Annarita Puglielli. Rome 1. ed. Pensiero Scientifico Editore, 1988. 269–282.

Ellis, Bill. "Legend-Trips and Satanism: Adolescents' Ostensive Traditions As 'Cult' Activity." *Contemporary Legend: A Reader*. Ed. Gillian and Paul Smith Bennett. New York: Garland, 1996 [1991]. 167–186.

Jenkins, Henry. "'Never Trust a Snake': Wwf Wrestling as Masculine Melodrama." *Out of Bounds: Sports, Media, and the Politics of Identity*. Ed. Aaron and Todd Boyd Baker. Bloomington, IN: Indiana University Press, 1997. 48–78.

Mazer, Sharon. *Professional Wrestling: Sport and Spectacle*. Jackson, MI: University Press of Mississippi, 1998.

Menkhaus, Kenneth. "Rural Transformation and the Roots of Underdevelopment in Somalia's Lower Jubba Valley." PhD Dissertation. University of South Carolina, 1989.

Musse, Fowzia. "War Crimes against Women and Girls." *Somalia—the Untold Story: The War through the Eyes of Somali Women*. Eds. Judith Gardner and Judy El-Bushra. London: Ciir, 2004. 69–96.

Naficy, Hamid. "The Making of Exile Cultures: Iranian Television in Los Angeles." *The Cultural Studies Reader*. Ed. Simon During. 2nd ed. London; New York: Routledge, 1999. 537–563.

Nowrojee, Binaifer and Dorothy Q. Thomas. *Seeking Refuge, Finding Terror*. New York: Human Rights Watch, Africa Watch and Women's Rights Project, 1993.

Rose, Ava and James Friedman. "Television Sports as Mas(s)culine Cult of Distraction." *Out of Bounds: Sports, Media, and the Politics of Identity*. Ed. Aaron

and Todd Boyd Baker. Bloomington, IN: Indiana University Press, 1997. 1–15.

Turner, Victor Witter. *The Ritual Process, Structure and Anti-Structure.* Lewis Henry Morgan Lectures, 1966. Chicago: Aldine, 1969.

Van Gennep, Arnold. *Rites of Passage.* Trans. Monika B. and Gabrielle L. Caffee Vizedom. Chicago, IL: University of Chicago Press, 1960 [1909].

Van Lehman, Dan and Omar Eno. "Somali Bantu: Their History and Culture." 2002. *The Cultural Orientation Project.* website. Center for Applied Linguistics, The Cultural Orientation Resource Center. Web. 12 May 2009.

The Shrines to What They Love: Exploring Boys' Uses and Gratifications of Media in Their Personal Spaces

Stacey J. T. Hust

Although much research in recent years has focused on adolescents' access to the media, most of it has neglected to enter the domain central to the investigation. For the most part, scholars who have investigated teens' media access in their bedrooms have done so from afar. For example, many mass communication scholars have sent surveys to thousands of teens in hopes of getting a more complete story of what is going on in teens' bedrooms (e.g., Livingstone & Bovill, 2001; Roberts & Foehr, 2004). Overall, these surveys suggest teens are exposed to a significant amount of media, and their bedrooms are becoming "little media centers" (e.g., Roberts & Foehr, 2004).

Increased access to the media in the bedroom has been positively associated with more frequent media use (Roberts & Foehr, 2004). It has also been argued that if teens have access to the media in their bedrooms they are more likely to see violent or sexually explicit material without parental monitoring (Jackson, Brown & Pardun, 2008). Further, teens who attend to the media more frequently may be at risk for poorer health (i.e., obesity, poor sexual health decisions, and smoking and alcohol use) (Brown & Witherspoon, 2001). Yet, very few investigators have actually gone into the world of interest—the teens' bedrooms. The little research that has included visiting American teens in their bedrooms has focused primarily on young white women (Brown, Dykers, Steele & White, 1994), with one exception being Steele and Brown's (1995) work that included tours of a few boys' bedrooms.

The current project expands existing research by visiting with young men (ages 13 to 15 years old) in their bedrooms to better understand how they talk about using the media in their private spaces. This study stems from the larger *Teen Media* study that investigates the connection between teens' media use and sexual health through large-scale longitudinal quantitative surveys (for a description of the project, see L'Engle, Brown & Pardun, 2004). Teens involved in this study completed a media use survey for *Teen Media,* but were not chosen to participate in the Teen Media panel and, thus, were eligible to participate in this room tour project. Thirteen young men participated in this project (see Table 1).[1] This largely ethnographic project involved multiple points of data collection: focus groups, Who Am I? collage construction, room tours and in-depth interviews. In this chapter, I will discuss findings primarily from the room tours and the in-depth interviews, although the other points of data collection are referred to when needed.

The coding approach described by Strauss and Corbin (1998) was used to analyze the multiple forms of evidence collected for this project. Open coding, or in-vivo coding, first was conducted to remain as true to the teens' voices as possible. Open codes were then organized by concepts and dimensions in axial coding. The axial codes were then grouped and central categories were developed. Throughout the analysis, members of the research team wrote memos about the findings that were shared and discussed with others who study adolescents and the media. The coding was done in Atlas.ti, a computer software program.

In this chapter, I identify the purpose of the boys' rooms and why they are of such importance. Then I focus on three interconnected aspects of male adolescents' media use: the presence of media tools in their bedrooms, the frequency of media use, and the boys' motivations for use of the media tools.

Male Adolescents' Bedrooms

"My own private spot. . . where I can't be bothered"

The bedroom may provide teens with a space in which to work on personal issues and cope with the stresses of adolescence. Larson (1997) wrote that solitude "appeared to be a more voluntary domain of daily life with entry into adolescence, and it came to have a positive relation with short-term and global well-being" (89). Teens' rooms also serve as a social area where they can interact with their friends. Livingstone & Bovill (2001) conducted in-depth interviews and bedroom tours with teens in Europe. They found that "The bedroom provides a flexible social space in which young people can experience their growing independence from family life, becoming either a haven of privacy or a social area in which to entertain friends" (198).

Some of the mystery surrounding teens' bedrooms may stem from adults' discomfort with the physical and mental changes that occur during adolescence.

Parents who are accustomed to dealing with a young child who talks with them freely and who feels no need to be alone may be uncomfortable when faced with a teenager who is secretive, contemplative, and struggling to be independent (Larson, 1997). As Larson suggested, "Parents suddenly encounter a child who keeps the bathroom and bedroom doors closed and insists that others knock before entering" (540). Privacy becomes important as teens form more concrete self-concepts and strengthen ideas about gender roles.

All of the adolescents involved in the study had their own bedroom. The majority of the boys reported spending a lot of time in their rooms with most spending between three to four hours each day there, not including the time they spend sleeping. They spent the majority of their non-sleeping time in the bedrooms attending to the media, relaxing, or studying. The boys all liked their rooms because it was "my space." For many, especially those with no other places in the house to call their own (such as family or recreation rooms), their bedroom was their sanctuary. Eugene, an articulate and self-confident actor, had spent hours decorating his room so that it reflected his personal style. When he opened the door to his bedroom, he said, "This is my shrine to everything I love." Like Eugene, many of the boys were proud of their rooms and the space they had purposefully "created" for themselves.

Most of the boys said they valued their room because of the solitude and privacy it gave them. One said, "It's just my own private spot, so I can go where I can't be bothered." Although previous studies have found that having a larger family was not associated with a greater need for solitude (Larson, 1997), my findings suggest that boys from large or non-traditional families especially valued their privacy. For example, Samuel, an academic achiever and athlete, lived with a younger sister who he wanted to keep some things from. When asked how important his room was, he said: "It's very important, that's where I keep a lot of my stuff away from the family." In part, Samuel felt that in other parts of the house he could not keep things away from his sister. In his bedroom, however, he could "hide" things that his sister could not find. Other boys also talked about hiding things, such as lists of girls' telephone numbers and private notes from girlfriends, in their rooms. A gregarious and friendly boy named Sean, for instance, kept a flyer for an activity at his high school on his bedroom wall. To most visitors, it just looked like he wanted to remember the event. However, Sean showed the interviewer that on the back of the flyer he kept a list of girls' phone numbers. He said no one would look on the back of the flyer to find his "lady list."

Although previously scholars have noted that teens' bedrooms are their private spaces, I was amazed at how independently some of these young men lived—even within their parents' homes. Chuck, a working-class white boy, directed me to "his wing" of his family's one-and-one-half-story home. The family has lived for Chuck's entire life in this same small three-bedroom house in a rural community

outside of Willowsprings. His bedroom and the children's entertainment room (also called a "bonus room") were on the upper one-half story of the house while the other family members' rooms were on the main floor of the house. Chuck said that he rarely interacted with the rest of his family, because he spent all of his time in either his bedroom or the "bonus" room. Another boy from a melded family, James, had a food locker and a couch in his room. He said that he liked to keep snacks, like Poptarts, crackers and soda pop, in his bedroom so that he did not have to go to the kitchen to get a snack.

Male Adolescents' Media Environment

Although privacy was the most valued attribute of the boys' bedrooms, the majority of boys also reported that the access to media in their rooms was very important. In 2002–03 when these interviews were conducted, the standard home in the United States was well equipped with a variety of media. Almost all U.S. households had more than one TV set, most of which were hooked up to cable or satellite TV that could access more than 100 channels. In most homes, music could be listened to on portable CD players, elaborate sound systems or radios in every room. In recent years, most adolescents' bedrooms have included a variety of media delivery systems or what we might call "media tools" (Austin, Hust, & Kistler, 2009).

In the early 1990s, Sherman (1996) found that about one-third of households with children under 12 and about one-half with teens had television sets in their child's bedroom. By 1999, more than half of children and adolescents between the ages of 8 and 18 had a television in their bedroom (Roberts & Foehr, 2004). Thus, children's and adolescents' bedrooms were quickly becoming "little media centers." In more recent years, most teens had stereos, bookshelves stuffed with books and magazines, and 45 percent of older youth also had a video game player. A growing number also had a computer in their bedroom (Roberts & Foehr, 2004).

The room tours revealed that the boys' rooms were in many ways "little media centers" as Roberts and Foehr (2004) suggested. In fact, no boy in this study had a room that was wholly bare of media tools. All of the boys had at least a stereo or "boombox" in their bedrooms, four also had a television, and three had computers. It should be noted, however, that all but four of the boys had access to a children's entertainment or bonus room that also had a television and a computer.

An Added "Bonus": The Children's Entertainment Room

Four boys said that they spent little or no time in their bedrooms, but all of these boys said they spent a lot of time in what they called the "entertainment" or "bonus" room. This room was a separate room that typically housed a television,

VCR or DVD, stereo, and computer. Many of these rooms also housed video game consoles. Unlike the media in teens' bedrooms, the media tools in bonus rooms were usually new and cutting edge technology. Some of the bonus rooms I toured had flat screen television sets, DVD players, and state-of-the-art surround sound stereo systems.

Bonus rooms typically were shared by the children of the household, but not with the parents. Thus, in families with multiple children the bonus room provided parents the opportunity to give all of the children access to television and other media without having to purchase or pass down multiple sets. This trend was most evident in a conversation with Michael, a young boy interested in video games who had just moved to a new house. In his old house he and his brother had a television in the bedroom they shared. When the family moved into the new house, the boys had their own rooms and the television was placed in the bonus room.

Michael, Eric, and Samuel had access to bonus rooms but said they still spent a lot of time in their bedrooms. All three boys had obstacles that prevented their access to the bonus room. Michael and Eric shared the bonus room with older or more dominant brothers who they said controlled the media there. Samuel said that he had to spend the majority of his time studying because he had to maintain high grades in school.

The importance the boys gave the bonus room was directly linked to the presence of media. While conducting a tour of his room, James, whose interests revolved around media, said, "My favorite place is downstairs in the video-room, yeah, the computer and the TV's down there and, yeah, the video games." Further, the boys with bonus rooms liked their bedrooms, primarily because they offered access to different media tools and not for the privacy it afforded them. For instance, Rueben said he spent the majority of his time in the bonus room, except when he wanted to use the computer in his room. When given the option, however, the boys said they would prefer to have media tools in their bedrooms. Bedroom access to all types of media would mean that they did not have to spend as much time out of their rooms, they said.

The boys did not have privacy in their bonus rooms. It was not a space that they could dominate, although many tried to. Jason, for instance, tried to keep his younger brother, Eric, out of the bonus room because he thought of it as his own room. In comparing the control over his own room with the control he had of the bonus room, Jason said:

Yeah, I can kick my brother out of it [his bedroom]. So yeah, it's my room. And the computer room, I can't really kick him out. 'Cause it's really not my room. It's practically is my room, 'cause that's where I spend a lot of time on the Internet and on the phone.

Jason did not stop using the bonus room, even though he could not *"kick his brother out."* Instead, he did his best to control access to the room and sacrificed the solitude and potential privacy that likely would be more available in his bedroom. Other boys in the study also gave up the privacy of their own rooms to spend time with the "better" media in the children's entertainment rooms. Therefore, although the boys reported that privacy was the most important aspect of their bedroom, access to the media was worth the sacrifice of privacy.

Class Differences in Media Tool Ownership

Large-scale surveys have shown that teens from lower socio-economic families are more likely to have bedroom access to televisions, VCRs, and video game consoles (Christakis, Ebel, Rivara & Zimmerman, 2004; Roberts & Foehr, 2004). In contrast, teens of higher socio-economic status are more likely to have computers and music media in their bedrooms (Roberts & Foehr, 2004). Research has shed little light on what these differences mean, however. Typically, studies have suggested that more educated parents are more concerned with parental monitoring of the media and thus are less likely to condone bedroom media (e.g., Christakis et al., 2004). In fact, authors recently suggested that interventions geared toward preventing the presence of televisions in adolescents' bedrooms should target lower class parents (Christakis et al., 2004). Findings from the current project provided some context for these recommendations.

Most of the boys from families of high socio-economic status that I interviewed had access to screen media (televisions and DVD players) in a bonus room. These media tools were not in the teens' bedrooms, because the parents had another alternative—one that was not available in the lower class households. Parents could purchase pricier media tools and provide multiple teens access to them. Yet, more personal and relatively inexpensive media, such as music items, were still located in the boys' bedrooms.

Since previous surveys have not asked teens about the media they have access to in a bonus room environment, it is possible that they underrepresent the number of personal media tools higher socio-economic teens have access to. When counting the bonus room, the boys in this study all had televisions and most had either a VCR or a DVD player. Most had access to a computer that was primarily for their personal use. When considering the boys' access to all of the media tools that were in both the bonus room and the bedroom there appeared to be no class differences. Furthermore, many of the boys, such as Jason, reported that the bonus room media were essentially their own. Some reported that they spent almost all of their time at home there. Very few reported sharing these media tools with their parents.

Hand-me-Down Media Tools

When Roberts and Foehr (2004) called teens' bedrooms "little media centers" they suggested that teens' bedrooms are high-tech havens decked out with the latest in media technology. Yet, their survey did not gather data on the age or functionality of media in teens' bedrooms. Thus, media coverage of these studies has suggested to the general public that teens' bedrooms are filled with the latest in media technology. Yet, this image is far from the reality of the boys' bedrooms I toured. Most of the screen media tools in these teens' rooms were "hand-me-downs" that previously belonged to the family or parents and were moved to the children's rooms when others were upgraded.

Since they were second-hand media tools, they were most often not the latest in technology. Some of the boys' television sets were not very big and lacked accessories. For example, Tony received his mother's old television set when he moved in with his grandmother. Tony said, "I need to have a remote because this is my mother's old TV, so we got it, it never had a remote, so I just turn it." He said he will soon get a newer television so that he can hook up his video game console to it, since video game consoles do not work well on older televisions.

Many of the boys complained that they could not use their video game consoles with their existing television sets. Eugene said he has to play his Playstation 2 downstairs on the family's television, because the television in his bedroom is too old. In fact, most of the boys' video game consoles are housed in the bonus room. Reports of teens' media access also posit that the presence of computers in teens' bedrooms is highly associated with both higher educated parents and higher socio-economic status. Previous studies have suggested that lower socio-economic families cannot afford pricier media tools, such as computers. Two of the boys, who had computers in their rooms, came from higher educated families, but lived in modest homes in middle-class neighborhoods. Both boys, however, received their computer only after their parents had purchased a new one for the family. In fact, both of these hand-me-down computers were given to the boys because of the amount of time they had spent on the family's older computer—the boys said their parents wanted more time on the computer themselves.

Frequency of Media Use

According to the data collected from the media use survey in summer 2004, the boys watched an average of seven and a half hours of television per day. Sports programming was the only type of television program watched by a clear majority (8 of the 13) of the boys. There were no race differences between those who reported watching sports, but only black boys reported watching television programs that featured primarily black characters.

The majority of the boys said they were most often alone or sometimes with friends when they attended to the media. Attending to the media with their parents or other family members was a last resort and usually was done only when there was no other opportunity available. A number of the boys only watched movies with their parents when a new movie had been rented or when their family went to a movie theater. In these cases, the advantages of watching a new movie outweighed the perceived disadvantage of spending time with their parents. Even so, some boys tried to avoid ever going to the movie theater with their parents.

The boys also said they rarely watched television with their parents, and were far more likely to watch television either alone or with their friends. Although previous research concluded television is a family activity (Arnett, 1995), the proliferation of televisions in teens' private spaces may significantly increase their opportunities for solitary participation even with television. Similarly, music listening was almost always talked about as a solitary activity, except for the rare occasion when the boys listened to music with their friends. Most of the boys did not talk about listening to music with their parents, in part, because they had such divergent music interests. Solitary media viewing, however, limits the potential for parental monitoring of both frequency of use and content. Scholars have been concerned that unmonitored viewing of the media may lead some teens toward more risky behavior.

The Media Nest: A Multi-tasking Environment

Although these male adolescents spent a significant amount of time with the media, these findings suggest they often used media tools simultaneously. They would have their music on while reading magazines or while corresponding with friends on IM. They scanned through the latest music magazine while their favorite television program aired in the background. They listened to their favorite music videos while they played computer games. This study was conducted before social networking sites became so popular, so it is quite possible that now adolescents are listening to and posting about their favorite music while chatting with their friends—all from the same networking site. Thus the amount of time they were exposed to the media may be significantly lower than when the media are considered independently. This has been identified as "media multi-tasking" by authors of a recent national study that found one-quarter of all teens (both males and females) reported attending to two or more media at the same time (Roberts, Foehr & Rideout, 2005). My findings also suggest that the boys' media multi-tasking is enhanced by computers, a media multi-tasking tool, and by creating "media nests," which allowed them to conveniently access multiple tools at once.

A number of the boys had configured the other media tools in their rooms in a way that allowed simultaneous use. Although Roberts and his colleagues' de-

scription of teens' rooms as "little media centers" is an apt description, visually a more appropriate description might be "media nest." Many of the boys had areas of their rooms where their media tools were concentrated. Televisions, video game consoles, boom boxes, and computers were all set upon and near one another so that a boy could access the various tools with just a turn of his chair.

The size and depth of the "media nest" depended on the type and number of media tools a boy had in his room. For instance, although few of the boys had a video game console in their room, those who did kept it next to the television and a chair or sitting area faced the main screen. Boys who had multiple video game consoles, like Eric, had the consoles situated around the television. Eric sat nested in a bean bag facing the television screen, surrounded by his media tools, and was able to switch between watching television and playing various games on a multitude of consoles. Boys with computers in their rooms usually had their computer surrounded by accessories, compact disks, and computer game boxes. Their stereos and televisions were usually close to the computer, as well, which enhanced their ability to media multi-task.

Male Adolescents' Motivations for Media Use

Uses and gratifications theory first arose in the early 1940s as scholars were identifying the functions of specific types of media and their programming (for a review of this research see Katz, Blumler & Gurevitch, 1973). Research in the 1970s built on the lists of functions identified in earlier research to conceptualize a formal theory of the uses and gratifications of the media (Katz et al., 1973). This theory identified what motivates individuals to choose media and media content. Uses and gratifications differs from other media effects theories because it conceptualizes the individual as an "active user" who purposefully (at least most often) chooses the media to fulfill needs. It also recognizes that the media compete for attention with other leisure and information-based activities, such as talking with friends or playing sports. Throughout its history, the theory has been used at the introduction of each new media tool. Uses and gratifications concepts have recently been applied to the personal computer and the Internet (Lee & Perry, 2004; Papacharissi & Rubin, 2000; Song, LaRose, Eastin & Lin, 2004; Stafford, Stafford & Schkade, 2004).

The majority of uses and gratifications studies still examine only one type of medium at a time. Although these studies try to compare the functions of the medium under investigation with previously identified functions of other media, few focus on multiple media tools or multiple types of content. In this way the existing studies are removed from how people actually use the media in their daily lives. These studies, however, have identified standard uses and gratifications for the mass media, such as surveillance, emotional regulation, and socialization. My

findings suggest these boys used the media for: surveillance for self-socialization, emotional self-regulation, social interaction, securing independence and environment creation. Although certain media tools lend themselves to certain uses, some of these needs were fulfilled by multiple kinds of media.

Surveillance of Popular Culture and Self-Socialization

Adolescents use the mass media for self-socialization (Arnett, 1995). Previous studies have found individuals survey the media for information that is important to their daily lives. Although scholars have previously identified surveillance as a main function of political news media, this study indicates that for these adolescent boys popular culture, especially about music and sports, was most important in their daily lives. Further, these findings support other research that indicated teens turn to the media to "learn" how to interact with their peer groups. In combining both surveillance and self-socialization motivations for media use, the teens scanned the mass media for cultural and social cues to help them fit in with their peer groups and others.

Even though both the black and white boys talked about rap music and sports programming, they attended to these media genres differently for purposes of surveillance or self-socialization. The black boys I interviewed typically followed the rap industry and its key celebrities. They stayed abreast of the newest rap artists and knew of the latest record deals. In contrast, many of the white boys I interviewed followed sports more often than music. The white boys knew who the latest draft pick was, and who was in the running for the Most Valuable Player awards. Boys, regardless of race, used video games to learn sports jargon and science fiction content that allowed them to interact with their peers more easily.

The boys talked about using video games for socialization as well. The games were a topic of conversation among other boys, and winning the games was a sign of skill and achievement. Samuel said he often talked with friends about video games:

> Just talk about what they like about a game; they might have played it before me, they might have it before me, and they might just tell me about it, or they may come over to the house and play it with me, and that may just influence me to get it, or just discussing it at school, talking about it, like they recommend the stuff.

Other boys also indicated that "winning a game" was an achievement. For instance, James had played *NCAA* so often that he had successfully completed the game numerous times. "I try to play NCAA with my brother," he said, "'cause I've beaten the game so many times I just need somebody to play against."

All of the boys talked about media stars as role models and turned to them to make decisions regarding their personal appearance and behavior. When asked directly, the boys denied personally using the media in this way but often said others would mimic media figures. Thus, it was easier for them to admit that others, or teens in general, use the media to fit in. Teens who cannot resist the media were considered to be lacking in intellect. As Samuel put it, the media "influences the not-so-smart people." Yet, when they were more comfortable or asked indirectly, they would say they, too, tried to mimic media figures. This supports previous research that has found a third-person effect in regard to mass media effects. The theory of third-person effects posits that individuals find it easier to identify that the media affects others than it is to identify that it affects them (e.g., Salwen & Dupagne, 1999).

The boys argued that they were active users of media content they attended to. They said that adults who think they cannot resist media messages were naïve, and most of the boys were insulted by this lack of confidence in their abilities. For instance, Lance used to have a television in his room, but his father was concerned about how it was affecting him, so when it broke it was removed. Lance sarcastically said, "'Cause you know, everyone's point is you'll get too absorbed in watching TV." He then said that he rarely used the television and was able to attend to it without getting "absorbed." Although Lance seemed to respect his father's opinion, he believed that his father was overreacting. Most of the boys said their parents' and others' concerns about the media were exaggerated, and they often argued that they could pick and choose what they took from the media.

Even so, many of the boys spoke about using media for self-socialization in ways that revealed that they do not resist all of what they see and hear. Although the boys argued that they were not affected by the mass media and that they were smart enough to resist its messages, they had a difficult time distinguishing between whether they used the media to support their ideas or if their ideas originated in the media. This suggests that the boys' active use of the media was perhaps a cyclical process—one in which they purposefully selected the media and were then influenced by that media to make similar or different media selections.

Emotional Self-Regulation

Previous research on emotional self-regulation suggested that people often use a form of media, either a song, movie, or television program, to help regulate their emotional states (e.g., Kubey & Csikszentmihalyi, 1990; Larson, 1995; Thompson & Larson, 1995). Television viewing has been found to have a numbing effect on adults' stressful states (Kubey & Csikszentmihalyi, 1990). Scholars have suggested that teens may also turn to television and other media to relax after their stressful school days (Larson, 1997; Thompson & Larson, 1995).

According to Reed Larson, adolescence is a period when the "responsibility for emotional self-regulation is being transferred, albeit sometimes precariously, from parent to child" (3). Thus, adolescence may be a period when teens begin to learn how to use the media for emotional self-regulation. Much of the existing research on adult emotional self-regulation has focused on television, yet my findings support research that suggests adolescents are less likely than preadolescents to become emotionally involved with television (Larson, Kubey & Colletti, 1989). The only boy to mention using television for emotional regulation was Eric, who was the youngest participant at the age of 13. He said he watched a basketball program that encouraged him to try harder in life and give 100 percent. Instead of television, the boys in this study used music and video games to regulate and control emotions. Boys used music to combat sadness, loneliness and anger, and they used video games to vent aggression. There were no race or class differences in the use of the media for these purposes.

Music for Emotional Self-Regulation

The adolescent males in this study said they listened to music as a way to disengage from their troubles. Many explained that when they came home from school, they would go to their bedrooms and loudly play their music—especially before their parents returned home from work. Samuel played music in his bedroom as soon as he came home from football practice until he went to bed, which was about four or five hours. He said it helped him to relax. Listening to music also allowed the boys to disengage from the world around them and reflect on what occurred during the day. The boys talked about using music to help them relax and go to sleep. James, who like Samuel played his music whenever he was in his bedroom, said that he "just listens to his music and goes to sleep." Other research has found teens experience more arousal and psychological investment when listening to music in their bedrooms (Thompson & Larson, 1995).

A few of the boys reported that they listened to music specifically when they were either sad or angry. The music allowed them to calm down and regulate their emotions. For instance, Samuel said that he often listened to rap music to calm himself down, especially if he was mad at something. When he was happy, Samuel would "probably like just like just a dance type song, like I don't know, maybe like ARC, if you're happy." Similarly, Todd included a picture on his collage of two men fighting and a picture of his favorite rap artist. He wrote: "I put a dude getting kicked in the face because I would love to do that to a lot of people. I finally put Kanye West on there representing rap, 'cause rap chills me out." Thus Todd recognized that he was angry, he also knew that listening to rap music helped calm his anger. In contrast, Michael did not like rap music because he was not angry: "Because now it's like they're [rappers are] just making up these songs,

because they're angry at somebody, so you know, why would I listen to this, I'm not angry at anybody." Thus, the boys in this study used music to regulate their emotions, and a few even avoided certain types of music because it did not match their emotional states.

Boys can, and often did, carry their favorite songs on portable CD players, ipods or MP3 players. Two boys in the study reported listening to music "all of the time," even taking their portable CD players with them to school and listening to music any time they were not in class. Although these two boys did not talk about using music specifically for emotional self-regulation, their behavior suggested that they used the songs as personal mantras to help them cope with day-to-day stresses. In an investigation of teens' uses of the media, Larson (1995) found one young boy he interviewed kept the lyrics of a favorite song in his head throughout the entire day. He suggested the boy used the song to "keep the provisional self he had built around this song intact" (545). James, a participant in this study who struggled with school and family life, listened to music all day long. He said, "I like to keep a song in my head." He said he continued to replay, both in his head and on his CD player, a song that caught his attention while he was listening to music on the bus.

In contrast, Sean sang his favorite song out loud even during the focus group. He was animated and cheerful as he continuously repeated the same chorus: "She looks like a movie star, like a chocolate candy bar." A few times Rueben sang a few lines of the song, and neither he nor Lance was annoyed by Sean's constant singing. Sean sang almost subconsciously. When he was asked during the in-depth interview about his singing, he said that he did not know he had been doing it.

Most of the boys were consciously aware that they used music to deal with their emotions. I asked them what their lives would be like if they listened to a different type of music. I expected the boys to talk about differences in personal appearance and peer group affiliation between listeners of different types of music. Surprisingly, however, the boys responded in terms of differences in emotions and emotional behavior. The boys said country music listeners were "happy," but "tired and old." James, who listened to rap music "all day long" said that if he listened to country music, he would be "tired all of the time." In contrast, those who listened to heavy metal music were perceived by the boys to be "wild," "aggressive," and "crazy." Teens who listened to rap music were "excited," but "angry." Michael, who listened to rock and pop music, said that his twin brother listened to rap music because he is "often angry." To these boys, music genres have emotional styles.

Video Games for Emotional Self-Regulation.

Many of the boys said they played video games to reduce tension and work through their anger. A few boys engaged in ritualized play, every day after school,

as a means to "debrief" after a long day. These boys, like James, played video games every day for one or two hours. Others played video games to virtually act out their aggressions when they were angry. For example, Samuel said, "Sometimes I just be in the mood, like if I'm mad I might come to a video game, like play football just to hit somebody, you know, branching out." To Samuel, "branching out" was when he released his anger. Samuel suggested that hitting someone in the video game potentially produced the same anger relief that hitting someone in real life would without the real-life consequences.

Although the majority of boys reported using video games to relieve stress or anger, some of the boys talked about video games in a manner that suggested they mentally transport into the world of the game. Green and Brock (2000), conceptualize transportation "as a distinct mental process, an integrative melding of attention, imagery, and feelings" (5). They argue that individuals fully integrate or are "transported" into the narrative and leave their reality behind, like being lost in the book (Green, Brock & Kaufman, 2004). Depending on the degree of transportation, measured by the extent of integration into the narrative, an individual's personal thoughts and behaviors may be changed by what is experienced in the narrative. Green and her colleagues (2004) identify video games as participatory narratives that lend themselves to transportation:

> by providing individuals with the option to place themselves (or, more specifically, a virtual representation of themselves) into a narrative context, allows them to transcend their typical role as audience members or consumers of media and, to varying degrees, shape and control the flow of events in the virtual world. (322)

My findings suggest that the ability to shape and control the "flow of events" is what attracted the boys to video games. They used the video game to disassociate from the real world.

One of the many indicators that a boy was transporting into the video game world was the use of the first person in descriptions of the game play. For example, when Eric described the game he was playing, he said, "I have to go stop the robbers from doing that." It should be noted, however, that some video games lend themselves more easily to first-person narratives. For example, boys who played first-person shooters and role-playing games were more likely than those who played sports video games to use first person descriptions. Eric played video games more frequently than the other boys involved in this study. During his in-depth interview, Eric rarely talked about other media, and said he played video games the majority of the time. Not surprisingly, then, Eric's description of transporting into the video game world went beyond a first person account:

> Well, they're just cool 'cause they're like basically, it's just cool to play, because it's like you're the person that's making all this stuff happen, and I guess it's just

fun to see you achieve something, you know, like watching yourself do it. It's just fun.

Although Eric was not the main character in the game, he transferred his identity to the character to such a degree that he said he was watching himself complete the quests.

Social Interaction

Previous studies of adult uses and gratifications of the Internet have found that in addition to surfing for information, adults often used it to interact with virtual communities or to maintain existing relationships. A person was identified as using the Internet for a virtual community if he was forming new relationships that differ from those he maintained in real life (Song et al., 2004). The creation and maintenance of relationships have previously been identified as social interaction by scholars who have analyzed the uses and gratifications of new media (LaFerle, Edwards & Lee, 2000; Lee & Perry, 2004; Papacharissi & Rubin, 2000; Stafford et al., 2004; Stern, 2007). Social interaction was the only type of use that has predicted increased Internet usage (Papacharissi & Rubin, 2000).

Interestingly, the boys used the Internet primarily for social interaction, with much of this focused on maintaining their existing friendships and forming new ones. Most of the boys said they used IM, a way of sending messages over the Internet in "real time," but a few said they used other messaging platforms or e-mail. Although boys with Internet access in their bedrooms used IM the most frequently, even boys who did not have computers in their rooms used Instant Messaging whenever they were on-line. In an ethnography of girls' IM use, Shayla Thiel Stern (2007) found that the girls she interviewed used IM for social planning. Social planning was also a prominent purpose for IM among these boys. The boys mainly used IM to ask classmates and friends about homework and to plan outings, but they also often talked to each other about sports, games, and movies. Scholars who have studied the uses and gratifications of IM have been surprised that young adults and teens are using it as a "primary human communication medium" (Lee & Perry, 2004; LaFerle et al., 2000).

In many ways it appeared the teenage boys in this study used Instant Messaging in much the same way their predecessors used the telephone. However, the boys said that they used IM and the phone differently. For example, Jason, who carried a cell phone on his belt at all times and used IM many hours per day, said that he would "chat" on-line about "the outside world." On the phone, however, ". . . it's just like anything that comes up, goes, really. I talk about anything." Although this implies that Jason monitored and guarded his on-line communication, his other comments suggested that he felt more freedom when talking with someone on-line:

> Like, if you talk to the same person online and you're talking to them on the phone, it seems like the conversation just changes. 'Cause you can talk about anything online, really. I mean, it's not like you're talking to them on the phone. I mean, it's just different, there's something about it.

Here, Jason admitted that he talked about anything while on-line and the monitoring he suggested earlier was disregarded. Further, he suggested that sometimes after two individuals have spoken on-line, their more personal interactions may be awkward or at the very least "different." That the boys admitted that the telephone was more personal than on-line chatting may signify a willingness to talk about things on the Internet without considering how it may affect their real-life relationship.

In contrast to the phone, one of the benefits of IM for teenage boys was the "ever readiness" it allowed for their daily lives. If they wanted to go to a movie at night, they could post a message to a number of friends and ask who wanted to join them, while remaining under their parents' radar. It also allowed for their communication with peers to be far less purposeful than talking on the telephone. Many boys reported that they "chatted" with whoever was on-line, signifying that they did not always talk to their closest friends but rather with anyone who was available. This ritualized element of IM communication has been identified by others and has been linked to a way young people "fill free time they have due to reduced face-to-face contact" (Papacharissi & Rubin, 2000, 191).

The boys were not just talking to their classmates and friends from school, though. Some of the boys reported that they used IM to talk with other teens they had met during summer camps and others said that they used it to meet new teens, primarily those associated with their real-life friends, such as their best friend's cousin. Although some boys, like Eugene and Chuck, talked about talking to strangers online, the majority of them recognized that the anonymity could potentially be misleading (i.e., a man says he is a young girl). Therefore, the majority of them avoided talking to strangers online.

Another concern about IM is that the "freedom" teenage boys and girls feel when talking on-line will lead them to talk more openly about sex or other taboo topics than if they were talking in person. Stern (2007) found that the young women she interviewed talked openly about sex and romantic relationships via IM. In fact, many of the IM conversations she studied contained "flirtatious conversations" (Stern, 2007, 68). Although these boys mentioned that they talked with girls over IM, none of them specifically said they "flirted" on it before they were asked. Once asked, however, they said that they and other teens do flirt online. Many of the boys reported that flirting was most often initiated by girls. When they received "flirty" IMs, the boys said they either ignored them or moved the conversation to the telephone. In part, this was because many of the boys

were cautious of who they were speaking with online, but also because they believed they could better connect over the phone or in person. One boy, Michael, mentioned that IM was an aspect of relationships when they were younger (i.e., sixth grade) but that their more mature relationships now required more person-to-person contact. The movement away from Instant Messaging as components of romantic relationships once they have matured is supported by other studies of IM use. Scholars have identified that individuals who are uncomfortable and avoid face-to-face interaction likely choose the Internet as a "functional alternative channel to fulfill interpersonal needs" (Papacharissi & Rubin, 2000, 191). Thus, we would expect that as adolescents become more comfortable with face-to-face contact as they progress through adolescence, they may depend less on IM for romantic relationship interactions.

Securing Independence

As part of the process of adolescent development, at least in Western cultures, young people begin to distance themselves from their parents, as they seek increased independence. Previous studies, however, suggested that attending to television prevented teens from breaking away from their parents. Larson (1997) suggested television viewing is an activity that bonds a teen to his family. "In terms of the Western developmental process of individuation, these heavy viewing teenagers might be described as developmentally behind: TV viewing reflects, or may be deliberately used, to maintain close emotional bonds to the family," according to Larson (542). Yet, today, when many teens have televisions in their bedrooms, television viewing may actually serve to separate male adolescents from their parents. Because teens own their own televisions and often have an opportunity to choose among more than one hundred television channels, they may be less likely to watch television with their families.

The boys in this study did not watch television with their families. Instead, they used television and other media to help identify how they are different from the family unit. It allowed them to disassociate from their parents and in many cases from their siblings as well. For instance, some of the boys said they had televisions in their rooms because their parents were tired of fighting with them about what to watch on television. Having a television in the teens' bedroom also allowed some parents and guardians space to enjoy their own television viewing, according to the teens. For instance, Tony watched television in his room so that he was not underfoot in the living room: "I don't watch TV in the front because of it's [the living room is] real nice, so I just watch it right here [my bedroom]."

None of the boys who had access to a bonus room shared the room with their parents. Boys who had recently received televisions in their rooms often acknowledged the freedom it provided them to spend time away from other family mem-

bers. Even boys who had access to bonus rooms said that if they had a television in their bedroom they would not have to leave their room much and could avoid interacting with their family. For instance, Chuck said if he had a television in his bedroom he "wouldn't come out of his room much."

The boys also used the media even when their parents asked them not to. Thus, the media tool becomes a physical object of independence. Samuel said that even though his parents did not allow him to listen to unedited CDs, he listened to some of these CDs, like those of *50 Cent,* at his friend's house. Other boys, like Chuck and Todd, said they sometimes visited pornography on the Internet.

Although some of the boys listened to the music their parents forbade and visited websites that were off limits, the majority of them attended to the same types of content they normally would, but did it when they were asked not to. Thus the parental rules that were violated were not about content but about the amount of time spent with the media. For example, Eric, who sometimes argued with his mother about the amount of time he spent playing video games, used an electric portable game console to play late at night so that she would be unaware that he was playing it under the covers of his bed.

Environmental Uses

Few existing studies detail adolescents' use of the media in their environment, but my observations in teens' bedrooms suggest these male teens often used media products as secondary objects. For example, most of the boys had pasted cut out magazine advertisements and editorial graphics on their bedroom walls as decorations. Some boys used the pictures to create a quasi-sophisticated décor in which the pictures looked like framed pieces of art. In these rooms, the boys put up only one or two photographs or advertisements and placed them prominently. For example, Samuel showcased two-page spreads from *Sports Illustrated for Kids* of his favorite football players making incredible plays. In contrast, other boys used multiple (more than 20) different advertisements and photographs pasted in a collage fashion to literally "cover" the walls of their room. Eugene, for instance, used pictures from his favorite magazines, such as *XXL, Ebony* and *Jet,* to celebrate and honor celebrities he admired. Eugene's room was a virtual collage-in-process as the old tape from his previous favorite pictures still clung to the walls. Lance had showcased his love for science fiction movies, the *Alien* trilogy, on his walls. When I toured his room, he was in the process of drawing a mural of the Alien monsters on the main wall of his room.

The boys also used the mass media to create a background environment within their bedrooms. Most of them said their music was playing whenever they were in their rooms, regardless of other activities. Those boys who had televisions in their rooms also reported using them to produce background noise. Thus the

media were being used as a kind of white noise to break the silence during times of solitude.

Conclusion

These findings shed light on adolescent boys' bedroom media use. Almost all of the boys in this study had a stereo, and many had a television, DVD player, and/or video game console in their bedrooms. That so many boys have access to additional media tools in bonus rooms provides an explanation for previous studies that have found that teens from higher socio-economic families have fewer media tools in their bedrooms. This study suggests that these findings may be underestimating media access because the media tools are in another highly accessible room. These boys also reported using multiple-media tools simultaneously in their "media nests." Although other research has identified that teens often media multi-task, my findings provide a picture of how boys accomplish this in their bedrooms. These finding also expand existing knowledge of boys' motivations for media use. The boys in this study used the media for surveillance of popular culture and self-socialization; emotional regulation; social interaction; to secure independence, and to enhance their environments.

Table 1: Description of the Participants

		Name	Age	Lives With?	SES	Resident of
Boys	White	Lance	14	Biological parents	Middle	Sheraton-Dentonville
		Todd	14	Mother	Low	Willowsprings
		Michael	14	Mother and Stepfather	Middle	Willowsprings
		Jason	14	Mother; Father and Stepmother	Middle	Willowsprings
		Eric	13	Mother; Father and Stepmother	Middle	Willowsprings
		Chuck	14	Mother	Low	Willowsprings
		Luke	15	Biological parents	High	Willowsprings
	Black	Sean	14	Aunt	Low	Sheraton-Dentonville
		Rueben	14	Father	Low	Sheraton-Dentonville
		James	14	Father and Stepmother	Middle	Willowsprings
		Samuel	14	Biological parents	High	Willowsprings
		Tony	15	Grandmother	Low	Willowsprings
		Eugene	14	Biological parents	Middle	Willowsprings

Note: Socio-economic status was identified via data collected from the participants and observations of the participants' homes and neighborhoods.

Notes

1. The current project included participants from the Sheraton-Dentonville and Willowsprings areas in the Southeastern United States (names of specific locations have been altered to protect the privacy of the participants). Sheraton (population 16,782) is adjacent to Dentonville (population 48,715; U.S. Census Bureau, 2000). The two cities have a joint school district, and a large, nationally renowned university is located in Dentonville. Willowsprings (population 187,035), 20 miles to the north of Dentonville, is a large metropolitan area that has a separate school district. About 75% of the people in Sheraton and Dentonville are white. Willowsprings is more ethnically diverse, with a majority non-white. For the purpose of this project, Sheraton and Dentonville will be considered one geographic area. In comparison to Willowsprings, Sheraton-Dentonville has a much higher standard of living.

 The Sheraton-Dentonville school district ranks among the top 37 school districts in the entire country, and is often touted as the top performing district in the Southeastern United States, according to its website. Students from this school district do well on standardized tests and the majority of them attend college. It should be noted, however, that black families often criticize the school district for not meeting the needs of their children. Willowsprings also enjoys a high proportion of students pursuing higher education. Many Willowsprings students attend two-year colleges, while the majority of Sheraton-Dentonville students go to four-year universities.

Works Cited

Arnett, J.J. "Adolescents' uses of media for self-socialization." *Journal of Youth and Adolescence*. 24.5 (1995): 519–533.

Austin, E.W., Hust, S.J.T., & Kistler, M. (in press). "Powerful media tools: Arming parents with strategies to affect children's interactions with commercial interests." *Parents and Children Communicating with Society: Managing Relationships Outside of Home*. Eds. T.J. Socha and G.H. Stamp. New York: Routledge, 2009.

Brown, J.D., Dykers, C.R., Steele, J.R., & White, A.B. "Teenage room culture: Where media and identities intersect." *Communication Research*. 21.6 (1994): 813–827.

Brown, J.D. & Witherspoon, E.M. "The mass media and the health of adolescents in the United States." *Media, Sex, Violence and Drugs in the Global Village*. Eds. Y.R. Kamalipour and K.R. Rampal. Lanham, MD: Rowman & Littlefield, 2001.

Christakis, D.A., Ebel, B.E., Rivara, F.P., & Zimmerman, F.J. "Television, video and computer game usage in children under 11 years of age." *The Journal of Pediatrics*. 145 (2004): 652–656.

Green, M.C. & Brock, T.C. "The role of transportation in the persuasiveness of public narratives." *Journal of Personality and Social Psychology.* 79.5 (2000): 701–721.

Green, M.C., Brock, T.C., & Kaufman, G.F. "Understanding media enjoyment: The role of transportation into narrative worlds." *Communication Theory.* 14.4 (2004): 311–327.

Jackson, C., Brown, J.D., & Pardun, C.J. "A TV in the bedroom: Implications for viewing habits and risk behaviors during early adolescence." *Journal of Broadcasting and Electronic Media.* 52.3 (2008): 349–367.

Katz, E., Blumler, J.G., & Gurevitch, M. "Uses and gratifications research." *The Public Opinion Quarterly.* 37.4 (1973): 509–523.

Kubey, R. & Csikszentmihalyi, M. *Television and the quality of life: How viewing shapes everyday experiences.* Hillsdale, NJ: Lawrence Erlbaum, 1990.

LaFerle, C., Edwards, S.M, & Lee, W. "Teens' use of traditional media and the internet." *Journal of Advertising Research.* 40.3 (2000): 55–65.

———. "Secrets in the bedroom: Adolescents' private use of media." *Journal of Youth and Adolescence.* 24.5 (1995): 535–551.

Larson, R.W. "The emergence of solitude as a constructive domain of experience in early adolescence." *Child Development.* 68.1 (1997): 80–93.

Larson, R., Kubey, R., & Colletti, J. "Changing channels: Early adolescent media choices and shifting investments in family and friends." *Journal of Youth Adolescence.* 18.6 (1989): 583–599.

Lee, K.C. & Perry, S.D. "Student instant message use in a ubiquitous computing environment: Effects of deficient self-regulation." *Journal of Broadcasting & Electronic Media.* 48.3 (2004): 399–420.

L'Engle, K., Brown, J.D., & Pardun, C.J. "Accessing adolescents: A school-recruited, home-based approach to conducting media and health research." *The Journal of Early Adolescence.* 24.2 (2004): 144–158.

Livingstone, S. & Bovill, M. (Eds.). *Children and their changing media environment: A European comparative study.* Hillsdale, NJ: Lawrence Erlbaum, 2001.

Papacharissi, Z. & Rubin, A.M. "Predictors of Internet use." *Journal of Broadcasting and Electronic Media.* 44.2 (2000): 175–196.

Roberts, D.F. & Foehr, U.G. *Kids and media in America.* New York: Cambridge UP, 2004.

Roberts, D.F., Foehr, U.G., & Rideout, V. "*Generation M: Media in the lives of 8–18 year olds.*" Menlo Park, CA: Kaiser Family Foundation, 2005.

Salwen, M.B. & Dupagne, M. "The third-person effect: Perceptions of the media's influence and immoral consequences." *Communication Research.* 26.5 (1999): 523–549.

Sherman, S. "A set of one's own: TV sets in children's bedrooms." *Journal of Advertising Research.* 36.6 (1996): RC9–RC12.

Song, I., LaRose, R., Eastin, M.S., & Lin, C.A. "Internet gratifications and Internet addiction: On the uses and abuses of new media." *CyperPsychology & Behavior.* 7.4 (2004): 384–394.

Stafford, T.F., Stafford, M.R., & Schkade, L.L. "Determining uses and gratifications for the Internet." *Decision Sciences.* 35.2 (2004): 259–289.

Steele, J.R. & Brown, J.D. "Adolescent room culture: Studying media in the context of everyday life." *Journal of Youth and Adolescence.* 24.5 (1995): 551–576.

Stern, S.T. *Instant identity: Adolescent girls and the world of instant messaging.* New York: Peter Lang, 2007.

Strauss, A. & Corbin, J. *Basics of qualitative research: Techniques and procedures for developing grounded theory.* Thousand Oaks, CA: Sage, 1998.

Thompson, R.L. & Larson, R. "Social context and the subjective experience of different types of rock music." *Journal of Youth and Adolescence.* 24.6 (1995): 731–744.

Love Song: Queer Video Use of One Pop Tune by Homosocial Boys and Young Men

Keith Dorwick

(Accompanying website: queertube.info/lovesong)[1]

Introduction

There are many (hundreds, easily) of videos from across the world using the soundtrack of Haddaway's ubiquitous pop song "What is Love?" (clip 1 on accompanying website). There are, in fact, so many that one could write a book, however specialized or unpublishable it might be, on the various tributes to and parodies of this song that have been posted on the WWW. This essay is a reading of five video adaptations of "What is Love?" made by various (sometimes queer) young men and boys. Although these boys may or may not understand or accept how they are implicated in the homosocial, a careful reading of these videos, all created by boys and young men, demonstrates the significant ways homosociality can impact and influence youth culture and its self-portrayal on the web.

Haddaway's commercial music video "What is Love?" (1998) presented an interracial story alluding to the connections between vampire legends and an overheated, irresistible, yet diseased sexuality. The original video featured Haddaway singing while being pursued by three scantily clad women. However, the song soon began to receive much more play in various same-sex appropriations, perhaps because the original video was already marked in some ways as queer. The most important of the U.S. variants of Haddaway's "What is Love?" was incredibly visible and public, at least to audiences in the United States. His tune became

the soundtrack for an ongoing *Saturday Night Live* (*SNL*) (2009) skit that often featured various hosts including Jim Carrey and Sylvester Stallone accompanying the two Butabi brothers, kings of the un-cool, played by Chris Kattan and Will Ferrell. In the skits, the Butabi brothers and friends would go to dance clubs and stand together bobbing their heads to "What is Love?" as a series of women turned them down or ran away. As the primary soundtrack for the skits, "What is Love" became necessarily central to the soundtrack of a full-length movie, *A Night at the Roxbury* released in October of 1998.

Following its use in *A Night at the Roxbury*, the audio track of "What is Love?" became a big hit in lip-syncing videos found all over YouTube and MySpace including versions by Latino men, three young Asian men, and many others. These videos became more homosocial/queer in each incarnation as young men created remixes and mash-ups of earlier tributes and parodies. The song—and its context and meaning—was transformed as it made its way across the internet. For example, Jake Walmsley created a YouTube video that was a sophisticated and sensual remake of Haddaway's "What is Love?" Walmsley, who would later become a member of the very queer (though not necessarily homosexual/gay) Syncsta collective, produced and performed this tribute to the song with his girlfriend Samantha ("Sammie") Lowe in approximately 2006. A few years later, a young gay man from France, Yoan, used Walmsley's pre-Syncsta version of "What is Love?" to create an homage, not to Haddaway's original tune, but to Walmsley's version, which then became an expression of Yoan's own sexuality.

What interests me more than the ways in which these boys and young men might represent themselves in real life are the images and the associated audio of the videos, and what these two sets of data (visual and auditory) say about sexuality and gender. The videos I am examining in this essay demonstrate the rich friendships boys and young men have and find important. Because of the developmental concerns of young people, these friendships are implicated necessarily in gender and sexuality concerns. One thing is very clear: the younger the filmmakers, the harder it is to draw hard and fast lines between mere play or horsing around and identity politics, especially in the context of what can be actually seen and what is outside the frame of the screen:

> [. . .] while the Web may enable digital youth to encounter multiple cultures and various social relationships, they often experience those interactions through the window and frame of their PC [sic], and in this technological context, all encounters with others become visually boxed into the confines of the screen: here, the frame of the screen serves as a mental container for Otherness. (Samuels, 2008, 232)

Though these limitations exist, it is also true that many youth can find the small space of the video frame in YouTube liberating. For example, I have docu-

mented in other critical work the ways in which some female to male transgen-
dered boys noted that YouTube was the only space they had to be open about their
gender identity (Dorwick, 2009). It may be that the makers of videos document-
ing "Otherness" have a very different relationship to cultural difference than do
the viewers of the videos they post.

Methodology I: Webrot

As many internet researchers have noted, the problem of web rot or link rot is
paramount. Web or link rot is what happens when the material cited by an es-
say's author suddenly disappears and therefore no longer is available to the essay's
readers: Links found in the works cited pages suddenly lead to a dead end or to a
notice that the linked material is now offline. This is particularly true in the case
of the materials I am working with for this essay. The video makers may choose
to take down their work as they move to different understandings of their own
sexuality and gender, or they may change their names, thus necessitating a change
in the citations found in this chapter. Sometimes this is simple self-protection fol-
lowing too open an internet presence:

> The Net Generation is opening up to a degree that astounds their parents. Many
> [social networking] enthusiasts post any scrap of information they have about
> themselves and others online, for all their friends to see—from digital displays
> of affection to revealing pictures. Most are not motivated by malice; they sim-
> ply want to share what they consider to be happy or fun events with others.
> Net Geners clearly don't understand why privacy is important. (Tapscott, 2009,
> 65–66)

Perhaps not, as young netizens often react badly to suggestions from older net us-
ers that discretion may be a virtue, or even that there ought to be a clearly defined
line between private and public. That is, privacy may not be an issue for them
until they get too much public criticism of their public selves from their peers. A
first response is simply to delete the offending webpage or video, but by that time
the damage may be done and electronic copies of the material flung far over the
wide range of the internet.

Other materials may be forcibly removed by site owners such as YouTube
following user complaints. In addition, adaptations of music videos and lipsync
videos may have the audio track removed following a complaint by the copyright
holder. Indeed, as I write this, my works cited page already references several
works that are only available on the website associated with this chapter. If copy-
right violation was the cause for removal, it's unfortunate: these young video mak-
ers are well within American law (in spite of YouTube's easy willingness to remove
audio at the request of any record company's say so). As the authors of "Code of

Best Practices in Fair Use for Online Video," the Code for Best Practices Committee (2008) noted that

> video makers often create new works entirely out of existing ones, just as in the
> past artists have made collages and pastiches. Sometimes there is a critical pur-
> pose, sometimes a celebratory one, sometimes a humorous or other motive, in
> which new makers may easily see their uses as fair [. . . .] Sometimes, however,
> juxtaposition creates new meaning in other ways. Mashups (the combining of
> different materials to compose a new work), remixes (the re-editing of an exist-
> ing work), and music videos all use this technique of recombining existing mate-
> rial. Other makers achieve similar effects by adding their own new expression
> (subtitles, images, dialog, sound effects or animation, for example) to existing
> works. [. . .] This kind of activity is covered by fair use to the extent that the reuse
> of copyrighted works creates new meaning by juxtaposition. (8–9)

Two boys lipsyncing their hearts out in a suburban bedroom may not create
enough of a "new meaning by juxtaposition" to warrant copyright protection,
though that's arguable. However, the more sophisticated videos I am studying
certainly do.

In order to preserve these works, the website http://queertube.info/lovesong
archives excerpts from the videos discussed, comprising enough of the clip to
make my argument clear. Throughout this chapter, I am using internal references
to these archived excerpts from the videos I am citing. These are noted as clip 1,
clip 2, and so forth and match the notation on the website. I can't guarantee that
the full versions noted in the works cited information that is part of this essay will
always be available, but the video links found on my site will be stable.

Methodology II: Defining Queer Use of Online Spaces

There are a great number of demographic sub-communities on the web, commu-
nities of creators and viewers who share common identities or affinities. Notably,
one can find any number of videos that represent the concerns of lesbian, gay, and
bisexual youth. Like online users of any age or other demographic, overtly queer
youth use YouTube, Vimeo, and MySpace to post videos they create in order to
comment on society and to both display and defend their life choices, especially
those that concern gender and sexuality. These youth implicitly or explicitly ques-
tion their own gender and sexuality and are very vocal/embodied about address-
ing their concerns in these online spaces. (I use "embodied" as the visual equiva-
lent to "vocal," as when two boys kiss, then stare into the camera, using visual
representations of their bodies to confront their viewers.)

However, digital youth of all sexualities and genders often eschew particular
labels: Straight or gay, butch or fem, male or female, the old line categories of
sexual politics simply don't matter to these youth, except perhaps as an issue that

is available for discussion and critique. As queer critic Jonathan Alexander (2006) has noted,

> [. . .] generational issues may be at play in such discussions and representations, and I sense that many queer digital youth are defining and articulating their senses of self via the Web in contradistinction to perceived "older" gay understandings of sexuality and sexual orientation identity. The frequent use of the word queer, for instance, might signal a configuring of sexuality that appreciates, if not fluidity, then at least *variety*, as opposed to the binary oppositionality of gay and straight. (274, italics in original)

Distinctions between the homosocial, the homoerotic, the homosexual and, for that matter, the heterosexual often overlap. For the purposes of this chapter, the presence of the homosocial, Eve Kosofsky Sedgwick's category for discussing the intertwining of male lives so deeply that the men (or boys) involved are emotionally involved with each other, is often enough to queer a video that is otherwise merely straight, even to its makers. This is emphatically true even if no sex has ever taken place, or will. It is this that distinguishes the homosocial from the homoerotic, in which the possibility of sex itself is much more present. It is also this that distinguishes the heterosexual from the homosocial: men and boys can be happily heterosexual and deeply implicated in the homosocial. The homosexual is just one category in which same-sex affection is explicitly linked to the genital, just as heterosexuality is but one way of linking the genital to opposite-sex affection. Bisexuality, for instance, can complicate these overlapped distinctions even more, especially in the case of some of these young video makers.

Though "'homosocial' is a word occasionally used in history and the social sciences, where it describes social bonds between persons of the same sex [and] is a neologism, obviously formed by analogy with 'homosexual,' just as obviously meant to be distinguished from 'homosexual'" (Culbertson, 1998, n.p.), the distinctions between the homosocial, the homoerotic and the homosexual overlap. As Sedgwick argued, homosocial relationships are often so intense that the possibilities of sex are always potentially present at the same time they are also always absent (3). Queer theorists Guy Hocquenghem and Sedgwick further describe the ways in which male-male desire can be played out, in Sedgwick's famous phrase, "between men":

> [. . .] Hocquenghem's theories on homosexual desire and [. . .] Sedgwick's later theories on male homosocial desire that follow his logic reveal how the patriarchal system is based on male homosocial bonds that retain masculine power and dominance, excluding women and openly gay men. Because of the necessarily close relationships between men, male homosocial bonds have a (disavowed) homoerotic component or undercurrent. (Synder, 2007, 254)

It is important to note that while this "homoerotic [. . .] undercurrent" is indeed "disavowed," it is also and always present in the homosocial. Thus, the most seemingly homophobic displays by young men in videos on YouTube and MySpace can simultaneously be read as homoerotic because they create a space for the expression of behaviors that could, if expressed honestly and openly, lead to social isolation, danger, injury or even death from gay bashing. This means that "queer," a more universal term, can be used to include a wide variety of behaviors and identities, including not only the homoerotic, homosocial and homosexual but also other non-normative heterosexual practices of varying kinds.

My reading of these videos is also a separate queer act that cuts against the perceived grain of these primary materials in order to challenge current mainstream ideas of sexual and gender hegemony. I am not much concerned with the self-identification of the makers of these videos. Though most are, in fact, straight or refuse to let site software publicly out them, the video artifacts they produce count as queer to the extent that the homosocial is itself queer.

Even in throw-away pieces such as a cell phone video recording of a soccer team on a bus belting out a hit tune a cappella (clip 4) or three boys joyfully acting out a scene from a movie that originally depicted two men and a woman dancing (clip 3), the line between homosocial and homoerotic is blurred and some gender transgression is created. Thus, this chapter's subjects have one thing in common: regardless of their sexuality, their videos present their images in ways that, at the very least, are implicated in Eve Sedgwick's homosocial, a category that moves beyond and complicates the gay/straight binary.

Methodology III: Data Collection and Replication

The boys and young men posting videos on the WWW have differing production skill sets and a varying number of rhetorical purposes. As a result, therefore, they produce a wide variety of genres of digital video. In some cases, these videos are in your face "talking heads," in which the poster faces the camera and begins talking directly to an imagined audience. In other videos posters have appropriated pre-existing materials from popular culture, such as music videos, and remade them. Some of these appropriations exist to parody popular culture, while others are deliberately artistic attempts to recreate and remix the source from which they came. Other genres abound, such as humorous sketches, videos in which their makers dance to popular songs, and very personal, almost confessional narratives.

The quality of video and audio production varies widely as well. Some videos are made with a low-end smart phone and no editing evident (often with apologies for the video's length). Others evidence great care taken post-production using software such as Final Cut Pro, Windows MovieMaker, or their equivalents which allow for superimposition, multichannel single frame images, changing the

playback speed of the film, and the mixing of multiple audio tracks. It's clear that, especially in the case of the more polished and crafted videos, "attention must be paid" (*Death of a Salesman* 1.5) when reading and analyzing these texts.

As is also clear, however, the ubiquity of material on the web leads many researchers such as Jonathan Alexander (2006, 274) to note the inability to research "the Internet" as a hegemonic whole. Rather, one can only attempt a deep description of one portion of it or one type of material that may or may not have implications on a wider scale. So it is with this project; the sheer volume of material on YouTube and MySpace is enough to give one pause. There is simply so much. Therefore, I began this project with a certain sense of obsession. Its earliest versions focused on a lipsyncing duo of English teens known as Syncsta. I soon became fascinated with their gender play in such YouTube covers as "The Gay Barbie Song." As I continued to work through their repertoire, I found a link in the YouTube sidebar to Jake Walmsley's cover of "What is Love?" (clips 6 a and b). I became intrigued with the possibilities of webcam art and its associated ability to question our ideas of gender and sexuality. His "What is Love?" is a lovely artifact shot in a grayscale register and raises interesting issues of the connections between viewer and viewed, as I discuss below in greater detail. I began to wonder about its source and thus began working through the huge number of webcam videos associated with and derived from the original "What is Love?" The song spawned so many covers and adaptations that I became interested in it, and began tracking its use. As I did so, I found that, for whatever reasons, Haddaway's tune created a space for lots of homosocial youth to create videos that were, in many ways, more interesting than the original itself.

The Strange, Not Seemingly, but Really Queer Case of "What is Love?"

For a number of reasons, "What is Love?" has spread all over the world, usually in videos made by youth that are implicated in the homosocial. The history of this series of appropriations begins with a tune by the single-named black musician called Haddaway. "What is Love?" is, at least in terms of YouTube and MySpace, by far his greatest hit: on YouTube it has today almost 50 million hits, roughly double that of his "I Miss You" (28 million hits). His third place entry on YouTube, 1994's "Rock My Heart," clocks in with a mere 75 thousand hits (clip 1, website), less than a mere drop in the ocean of the MySpace and YouTube worlds. The original video consists of a largely incomprehensible series of moody shots of Haddaway running through a mansion while being chased by three women, some of whom run backwards and make Haddaway crawl backwards. One of these women is clearly a vampire complete with a vinyl g-string, big vinyl pasties, long silk cape and fangs. Apparently, this situation is enough to confuse him so

that he must sing, over and over again, the title phrase of the song until he allows himself to succumb to the vampire's bite (whatever the failings of the video, there's no doubt the tune is really quite catchy, a major fact, I would think, in its viral replication online). The other two women featured in the video are apparently not vampires—they are, however, clearly femme fatales who put Haddaway through his paces. While the presence of the other two women in the video may best be explained by the misogyny all too often present in U.S. music videos, a female vampire adds a layer of allure, an oft present trope in modern vampire legend. Their world is both diseased and desirable, and humans are both lovers and food.

From the queer/gender standpoint from which I write, Haddaway's video is more interesting than it might appear on the surface, which may explain its fascination for young queers in particular. Christopher McGunnigle (2005) has argued that the vampire phenomenon is a primarily homoerotic one:

> The vampire embodies the repressed and un-desirable sexuality of the hero (and his society). Dracula's figure is evil and perverse, the dichotomy of Harker's Victorian image of purity. According to Christopher Bentley, Dracula represents a 'perversion of normal heterosexuality', an incarnation of the society-styled pervert in Harker (and all of us). While Bentley suggests that Dracula is purely heterosexual, the circumstances of his un-living arrangements suggest otherwise. Not only does the dreaded Count reside in a secluded castle with a harem of three women, he does not engage in any intercourse with them, instead importing businessmen from abroad to serve as his sexual toys. Dracula's indulgence in these homosexual practices flies in the face of Victoria's waning masculinity. However, to even more of an extreme, the vampire figure is a representation of confused gender identity. (174)

While the story is more complex than McGunnigle makes it out to be (his analysis ignores Lucy's role in Stoker's novel), the mansion in "What is Love?" is the site of an inverted version of the Dracula myth. It is home to three women who are dangerous to men, similar to the residents of Dracula's castle, but the gender confusion here is not Dracula's. It is Haddaway's. By eliminating the male Dracula figure and replacing it/him with a female vampire, Haddaway casts himself in the role of Lucy, who is entirely seduced and consumed by vampiric love in the same way that Haddaway is, though this is only clear in the visual language of the genre of the music video. He is first dressed in a blue suit with a white shirt, but, upon being bitten by a white female vampire, he is converted to a boy toy with seeming supernatural powers. Now dressed in tight pants and an open vest that shows off his smooth and surprisingly chiseled chest, he easily leaps onto the fireplace mantel where he begins dancing, then flies down in a smooth leap that demonstrates his new vampiric power. It is Haddaway's portrayal of his own representation that is the androgynous tension of the vampire story.

Perhaps such a reading was already available to queer watchers of Haddaway's video everywhere, but another more likely, and still queer reading, was that of a very strange moment in American TV: the use of "What is Love?" as the soundtrack of a long running joke on *SNL,* in which we follow the adventures of the two Butabi brothers, Doug and Steve. In these comedy sketches, Will Ferrell and Chris Kattan go out clubbing with their heads bobbing to the beat of "What is Love?" (clip 2, website). Only in America could a series of short skits from a comedy show become a full length movie—but it did: *A Night at the Roxbury* (1998).

The movie became a place in which the homosocial (though not the homoerotic) was explicitly played out between the brothers (image 1, website). At the climax of the movie, we find Steve preparing to wed following a rupture in the relationship with his brother. Just before the vows are uttered, Doug comes out of his room, holding high a boom box playing their signature tune "What is Love?," thus breaking off a marriage the movie pictures as impossible: there's no way Steve is going to be happy with his fiancé, who reacts to the breakup during the ceremony by proposing to and marrying the best man just a few moments later. As she points out, there is already a clergy person present.

The next scene is of the brothers' tender reconciliation. This scene takes place on a bridge over a river with lots of flowers, the traditional romantic imagery of springtime.

> Doug: I said a lot of bad things before [but] we're brothers . . . When we're together, I just . . . You don't drag me down, I drag me down. You . . . you complete me.
> Steve: Shut up, just shut up. You had me at "hello." [They hug]

In the second to last scene, the use of the soundtrack to the "What is Love?" video is explicitly referenced. As it plays, we hear:

> Cambi (Elisa Donovan): I love this song!
> Doug: Actually, I'm getting kind of tired of it.

It is at this point, the moment they reject their signature tune, that the brothers find true heterosexual happiness: they manage to successfully pick up women and dance with them for the first time ever in either the skits or the full length movie. Nonetheless, the homosocial is never explicitly rejected; indeed, it is implicitly retained. It is only as the brothers cruise together that they succeed together. Their successful homosocial relationship is exactly what fuels their success with the two women, who are themselves friends.

Clip 3 (website) is a prime example of a video clearly modeled on the *SNL* sketches; as it begins, two (later three) young Asian men face the camera waiting

for the music to begin. As soon as it does, they begin acting out the scene from the sketches, complete with head bobbing and the actual dialogue seen in the excerpt featuring Jim Carrey (clip 2). Their film demonstrates their friendship with each other and—very clearly—their great high spirits. The boys are having the time of their lives making this one-minute video, despite the casting difficulties they face. In the original sketch, three men dance with one woman so obnoxiously that they push her off the dance floor. However, in this YouTube appropriation, a boy plays the role of the female character. When the first two boys, unfazed by the movement out of frame of their buddy, continue dancing, this is an innovation and rewriting of their source that makes their version explicitly homosocial. I'm not suggesting that these three young men are sexually involved (though I don't rule it out), but the playful spirited rendition of "What is Love?" does give all three boys a space to both roughhouse and to dance together.

That they have posted this remake of "What is Love?" on the web raises two possibilities. If they have thought through the fact that a world wide audience can see them, the act of posting this video is a public statement and their rough-housing simultaneously affirms both heteronormativity and the homosocial. Even though the third boy is pushed out of the frame of the webcam and onto the floor, not without a certain amount of violence and youthful energy, the dance continues without him and continues (as of this writing) to exist on the web. While the posting of this video could be seen as a private act that does not concern any outside viewers, spaces like MySpace and YouTube are part of a very public discourse, one in which the possibilities of reading video texts as both/and are both exciting and transgressive.

Another homage to the *SNL* sketches, Clip 4 (website) is more interesting than it might seem at first glimpse, given its total lack of production values. It was most likely filmed on a cell phone by a soccer team traveling on a bus, and the low-end video and audio quality makes it difficult to do visual analysis. This version of "What is Love?" undercuts its source and the music entirely by being shouted in chorus, rather than sung. At least some of the soccer players are aware of the *SNL* sketches—two or three of them are engaged in the head-bobbing that is such a part of the *SNL* visuals.

Still, it's the music that's the main draw here as the video continues to play. Some of the boys are primarily engaged in and with Haddaway's lyrics as they begin to sing, not only the tune, but also his wordless accompaniment; they imitate keyboards, some bass, and some percussion, thus indicating that the boys are thinking of the soundtrack as a musical piece first and foremost as they spontaneously divide themselves into parts. One young black man takes the role of Haddaway himself by singing lead but in a falsetto that the others try to ignore, an impossibility as the tune itself rises in pitch forcing the singer yet higher and higher. As he does, the appreciative crowd begins laughing uproariously, and the

impromptu rendition of "What is Love?" falls apart. As with other videos, this is a record of a group of boys having a great time playing, but there is also a potential edge here: The higher the lead's voice, the more raucous the boys and the more the falsetto voice becomes itself a gender transgression, though admittedly one that the boys seem to enjoy very much.

If the soccer team's rendition of "What is Love?" is a mix of *SNL* and the original Haddaway source, Clip 5 (website) is a pure Haddaway variant that features two of the Kings of Lipsync (KLS) (2007). Mostly comprised of young Latino men from Phoenix, KLS is clearly harking back to the song rather than to the *SNL* sketches. In clip 5, two of the KLS members appropriate Haddaway's version of "What is Love?" in ways that make clear they focus on the musicality of "What is Love?" They ignore the visual aspects of their source entirely and concentrate—as the name of their group, the KLS, indicates—on faithfully recreating the music through lip-sync.

By doing so, these two members of KLS (Juiceman to the viewer's left; Boneman/Bonie to the viewer's right) treat the song as a replacement for the musical skills and instruments that they do not appear to have. This is evidenced by the use of Juiceman's "vocals" and Bonie's "keyboards"—mimed by use of his hands. As the video progresses, a wordless female solo is a prominent part of the music, and Bonie, feminizing himself, takes that role on as well as keyboards. As he does so, especially on the second rendition, Juiceman begins to pay attention to Bonie. Mostly, before this, Juiceman has been facing straight into the camera and singing to the viewers, not to Bonie. He raises his fists close to his face in a way that reads as defensive. Once again, the gender play, while still a source of great fun and high spirits, is also transgressive behavior that allows for homosocial play and homoerotic possibilities, but just as firmly inscribes them as other and separate. They perhaps don't consciously realize their gender performance, but they are following Judith Butler's (1990) idea of performativity:

> gender identity might be reconceived as a personal/cultural history of received meanings subject to a set of imitative practices which refer laterally to other imitations and which, jointly, construct the illusion of a primary and interior gendered self or parody the mechanism of that construction [. . .] The loss of the sense of "the normal," however, can be its own occasion for laughter, especially when "the normal," "the original" is revealed to be a copy, and an inevitably failed one, an ideal that no one can embody. In this sense, laughter emerges in the realization that all along the original was derived. (188–189)

The failure of gender boundaries may be fraught for these boys (KLS members were in high school at the time they made these videos) but they are also and apparently hilariously funny in just the way that Butler suggests they should be.

Another performer who is engaged with the music as music and who attempts to reproduce it, more or less seriously, is YouTube viral hit Jake Walmsley. First off, there is no doubt in the mind of any viewer (or so I'd imagine, at least) that when Walmsley appropriates the soundtrack of Haddaway's "What is Love?" it is a doubly straight artifact. Walmsley's version is very heterosexual, except insofar as his physical appearance does not map onto traditional images of male beauty—he was then, quite simply, too pretty to be read as traditionally masculine.

Once part of a collective called Syncsta, Walmsley has made one of the loveliest versions of Haddaway's hit tune (clip 6, website). His version is very far removed from the kitsch of the original video. Shot in black and white, it is visually quite moving, presenting without any other narration than the lyrics the story of a breakup between a young man (Walmsley was 17 at the time) and his girlfriend. This breakup is first seen in a photograph tossed away in despair (clip 6a), and then in an embrace (clip 6b) that we somehow know signals not the end, but the continuation of what is clearly a problematic and challenging relationship that confuses the "singer" of this lip-sync production: "What is right? What is wrong? Give me a sign." This focus on what ought to be private and isn't, and on what the exact relationship between "real" life and cinematic depiction ought to be, follows what postmodernist critic Roland Barthes argued about the content of Proust's autobiographical work:

> Proust himself, despite the apparently psychological character of what are called his analyses, was visibly concerned with the task of inexorably blurring, by an extreme subtilization, the relation between the writer and his characters [. . .] By a radical reversal, instead of putting his life into his novel, as is so often maintained, he made of his very life a work for which his own book was the model. (144)

By making himself the object of the first half of his version of "What is Love?" Walmsley, whether he intended or not, created a seemingly straight piece that is also simultaneously queer, because of its (self) adoration of Walmsley's physicality; he is his own object of his gaze as both performer and actor in this piece. The camera focuses lovingly on his face and body in ways that echo the cinematic conventions of the forties, complete with a scene of him smoking, a mainstream film cliché of the lover in pain. This echo of the past may be the reason Walmsley's video is shot in black and white though color webcams were certainly available in 2006.

From the point of view of this essay, the narcissistic position of Walmsley's self-referential gaze is accentuated by his initial shot of himself as he sings "What is Love?" into a small framed mirror. This is, of course, a cinematic illusion: while it appears he is singing to us or to himself, he is in fact gazing into the reflection of the webcam. The camera as the stand-in for the auteur ("director") is

complicated by the fact that this film is self-directed. As the camera continues to linger on Walmsley's image, he looks directly into the camera and at us. Halfway through the video, the stance changes a bit as the narrative grows more complex. The sexual/emotional tension between the lovers is made evident by the presence of Sammie Lowe, who is credited at the end of "What is Love?" as its producer. She appears first in a photograph that signals her unavailability, but then later in the flesh as she kisses Walmsley (clip 6b): it is a long lingering kiss in which the illusion that Walmsley is the singer is discarded—he gives up lip-syncing for this portion of the video. By doing so, he has moved from the position of maker of art to that of lover, and the soundtrack moves from direct interrogation of the nature of love to commentary on that love. As the embrace between the lovers continues with Sammie's back to the camera and the viewer, we are placed in an entirely voyeuristic position, with Walmsley looking towards, then away, then back again to the camera. He glances sidewise in brief, almost guilty, glimpses at the camera which becomes, with us, an intruder, as we stare at this intimate moment.

He knows, it seems, that we are looking at him through the camera; he knows that the Sammie of the video world of "What is Love?" does not. That supposed double knowledge is a violation of her onscreen autonomy in which both he and we are complicit. Walmsley's version of "What is Love" is a complex reappropriation of pop music, an early and suppressed "straight" piece, a sophisticated and sensual remake of Haddaway's "What is Love?" It may not seem sensible that YouTube videos are worthy of any serious critical attention, but in fact they can be serious attempts at art. John Palfrey and Urs Gasser (2008) would argue for the possibilities of digital art produced by youth by noting the following:

> There are few, if any, examples where Digital Natives have used digital technologies to generate something that is certainly of such creativity and beauty that it represents work for the ages, like a Shakespearean drama. But when photography was first introduced, it was dismissed as inartistic by comparison to painting, on the grounds that photography was merely documentary and couldn't improve upon nature. No credible source would say that today when looking at images by Weegee, Robert Mapplethorpe, Man Ray or Richard Avedon. (127)

Nor is mash up and use of derivative works a problem for these critics: "[the critique of use of derivative sources] ignores the extent to which creators of all sorts inevitably build on the shoulders of others" (127). Therefore, if works such as Walmsley's "What is Love?" don't last for the ages, it will much more likely be for lack of proper archiving as much as it might be for any issues of artistic quality. The clip excerpted on the website accompanying this chapter is a bootleg copy, a form of remembering a lost digital past. Unlike the rest of Syncsta Productions' previously well-archived videos, many of which have complicated homosocial tensions between Green and Walmsley, this undoubtedly heterosexual work has

been taken off both the Syncsta site YouTube channel and from jakewalmsley. com. Indeed, at this point in time, all of Synscta's videos are offline due to a fight between Chris Green and Jake Walmsley that seems to be due to a parting of artistic ways ("Explanation").

Even though it has been removed from the web, this significant pre-Syncsta piece has had its own adapters. For example, images from Walmsley's version of "What is Love?" are used in the visual field of a video named "Rupture" (clip 7, website). Yoan, a twenty-two-year-old French gay video maker, chose Roberta Flack's "Killing Me Softly" for his soundtrack, a musical selection that pointedly inverts the narrative from "his" point of view to "hers" by switching the sex of the singer from male to female, a seeming mistake in this most queer video. Yoan begins his overtly homosexual discourse with the inclusion of images of two men, possibly Yoan and his boyfriend, kissing in the snow interwoven, beautifully, with images mashed from Walmsley's version of "What is Love?" The lyrics are carefully chosen: the implication is that Yoan is in agreement with Walmsley (and through him, with Haddaway) about the central problem of love, the very real fact that opening oneself to the emotional life of another is a risk: "Baby, don't hurt me."

The images float back and forth between the new portions of the video and the appropriated images from Walmsley's work. It gives Yoan a space to both explore and display his own sexuality in ways that are quite explicitly artistic, including his use of multichannel video (images overlaid on top of other images). It is this ability to make one's one mark on the internet by appropriating and remixing other materials so attractive: "Authors possess more control over the impressions they give [of their own selves] than they do in offline spaces, since they make all the decisions about what to reveal, omit, embellish or underplay, although they are, of course, limited by their design skills and the software itself" (Stern, 2008, 106). Yoan is clearly manipulating the visual field available to him in ways that explore not only sexuality but also the visual image itself.

This allows him to create a gay meditation on the difficulties of love, though it's clear that Yoan finds Walmsley's straight version of "What is Love?" emotionally resonant. On first reading, an absent Walmsley is in fact the one "strumming my [Yoan's] pain with his fingers," and Walmsley's video is the equivalent of the singer pictured by Roberta Flack as playing the guitar and singing a song composed out of her pain. If one assumes that this fascination with another human is shared by people of any gender identity, then the sex of the singer of "Killing Me Softly" is immaterial. Why not replace Haddaway with Roberta Flack?

At first, this use of a new tune might seem to be an almost random choice. Not so. As the video progresses, a third figure is introduced. This is a young woman who looks at the two men cavorting in the snow with a look of loss; she is pictured in isolation. It is her pain, one feels, the pain of desiring an unavailable

man from the outside and in the cold. If this is the correct reading, then the use of a song by a female singer is not immaterial but key to this remaking of Walmsley's version of "What is Love?" Yoan and his friend may feel the pain that Walmsley sings of in Haddaway's voice, but it is this unidentified woman whose pain we feel. It is for this reason, I would assume, that Yoan changed soundtracks: to create a surrogate voice for the voiceless woman of the visual field. Indeed, the tension between Yoan, his boyfriend and this unnamed woman may well be the source of the very rupture denoted by the title of this video.

Clearly, many of the variants of "What is Love?" that exist on the web are throwaway efforts, created, perhaps, during a boring afternoon at home or a long ride home from a soccer meet. Nonetheless, even these minor efforts also serve as cultural documents in which attitudes and beliefs about gender and sexuality manifest themselves, whether or not such was the intent of their authors. With the Kings of Lipsync, the matter rapidly becomes more complex. The very fact that they have a collective name and have archived their MySpace videos as the work of that collective indicates that their videos, far from being something improvised without thought, are instead part of a deliberate aesthetic. Like the best lipsyncing on the web, care is taken to see that the lip movements create the illusion that the performers are the singers as well as the auteurs of their videos.

This is deliberate simulation: "It is the fantasy of seizing reality live that continues—ever since Narcissus bent over his spring. We dream of passing through ourselves and of finding ourselves in the beyond: the day when your holographic double will be there in space [. . .] Of course, [when it happens,] it will no longer be a dream, so its charm will be lost" (Baudrillard, 1997, 105). Thus the Kings of Lipsync create their videos in order to recreate a moment in popular musical history, thus paying homage to it in a playful way.

It is Walmsley and Yoan, however, who push the simulation of lipsyncing beyond mere homage. Walmsley, who went viral by remaking music videos as part of Syncsta Productions, begins by lipsyncing Haddaway's tune but soon abandons his attempt to recreate his source. By not pretending to sing, Walmsley makes a video that stands beyond and above its source material with his own rich visuals. Yoan, in turn, avoids lipsyncing entirely by dubbing over Walmsley's "What is Love?" with a whole new soundtrack. By driving webcam technology to its limits, and by creating rich visuals for the love song they are referencing, they do indeed ask "What is Love?"

Global Implications

One classification system for versions of "What is Love?" that seems useful for analysis is to note that there are two major varieties or adaptations of the song. One of these varieties directly follows Haddaway's original music video and is the

source for music videos made for and by European pop stars. Another category includes those videos that are entirely or partially based on a long-running series of *SNL* sketches. Those sketches used the audio portion of Haddaway's hit as the basis for a running joke.

Using this classification, something striking seems apparent. Those videos that follow Haddaway's version focus on the music, entirely to the exclusion of the visuals. It is as if the adaptors of "What is Love?" that worked from the source material itself had never seen the video, but instead were working from the audio alone. With a great deal of research, I have been unable to find a single version of Haddaway's tune that referenced the vampire motif, which is such a strong and marked presence in the original video.

Second, those videos that reference *SNL* indicate the sheer cultural weight these skits carried during the eighties and nineties (where I grew up in the suburbs of Chicago, *everyone* I knew seemed to watch, or at least to talk about the skits at school or work the next week). It is the head-bobbing of the Butabis that attracts some young men and boys who try to replicate it, however unsuccessfully in some cases. At their purest, these types of video use the soundtrack in the same way as the sketches—a musical background that is little more than noise. These types of videos also often replicate dialogue or action from the sketches and the movie.

This clear difference (one that is increasingly striking as one looks at the huge corpus of "What is Love?" variants) is one that is partially associated with the geographic location of the viewer and creator of the videos. Though there are exceptions, for the most part, those videos based on Haddaway's original version hail from outside the United States. They did not feature the head-bobbing so characteristic of the *SNL* variants, which were, for the most part, decidely U.S. in origin. As important as *SNL* was to American culture, it clearly did not extend very far beyond the Atlantic or Pacific.

In both cases, however, and in very different ways, these queer and homosocial boys have used the possibilities of the webcam to create work that is an engagement with a collective homosocial and queer memory. By doing so, they have entered what Russian formalist critic Mikhail Mikhailovich Bakhtin (1981/2001) has noted as the space of the novel in another generation, the place where public life is discussed and weighed:

> On the other hand public life—any event that has any social significance—tends toward making itself public (naturally), necessarily presuming an observer, a judge, an evaluator; and a place is always created for such a person in the event; he is in fact an indispensable and obligatory participant in the event. The public man always lives and acts in the world, and each moment of his life, in principle and in essence, will avail itself to being made public. Public life and public man are by their very essence open, visible and audible. Public life adopts the most

varied means for making itself public and accounting for itself (as does its litera-
ture). (122–123)

It is that concern with and involvement with the public that is the source of my
fascination with these videos. After all, they are, as Barthes (1977) has noted, part
of the world of narrative and story-telling that makes us human:

> The narratives of the world are numberless. Narrative is first and foremost a
> prodigious variety of genres, themselves distributed amongst different sub-
> stances—as though any material were fit to receive man's stories. Able to be
> carried by articulated language, spoken or written, fixed or moving images,
> gestures, and the ordered mixture of all these substances; narrative is present in
> myth, legend, fable, tale, novella, epic, history, tragedy, drama, comedy, mime,
> painting (think of Carpaccio's Saint Ursula), stained glass windows, cinema,
> comics, news item, conversation. Moreover, under this almost infinite diversity
> of forms, narrative is present in every age, in every place, in every society; it
> begins with the very history of mankind and there nowhere is nor has been a
> people without narrative. All classes, all human groups, have their narratives,
> enjoyment of which is very often shared by men with different, even opposing,
> cultural backgrounds. Caring nothing for the division between good and bad
> literature, narrative is international, transhistorical, transcultural: it is simply
> there, like life itself. (79)

These narratives, then, are "life itself" for the young men who have made them.
They are, in fact, the stories of their lives, and even in the most light-weight and
silly of these works high stakes are involved. They force us, the viewer, to see the
reality of the lives of queer boys and young men in ways that perhaps we might
not have done before. And they will, along with the blogs, other websites, books,
poems and stories they write, change their world, and ours.

Note

1. The works cited list preserves the names of the original titles and authors of
 online works as they are self-styled, in spite of inconsistencies of grammar,
 punctuation, capitalization and other surface conventions. Also, references to
 archived videos found here in the print version of this paper are to my person-
 al website at http://queertube.info/lovesong (see "Methodology I") in order
 to provide the greatest stability and ease of reference for readers. Individual
 web pages on that site will include the best citation available at the time of
 publication; however, these materials, as I've noted above, are very fluid and
 even in the case of materials available online at the time of writing, not even
 authors' names are necessarily stable. Finally, the URL queertube.info should
 not be confused with queertube.com which sells porn and is entirely separate
 from my site.

Works Cited

Alexander, Jonathan. *Digital Youth: Emerging Literacies on the World Wide Web. New Dimensions in Computers and Composition.* Eds. Gail E. Hawisher and Cynthia Selfe. Cresskill, NJ: Hampton, 2006.

Bakhtin, Mikhail Mikhailovich. *The Dialogic Imagination.* University of Texas Press. Slavic Series: no. I. Translation of *Voprosy literatury i estetiki* by J. Michael Holquist. Austin, TX: University of Texas, 1981, 2001.

Barthes, Roland. *Image, Music, Text.* Essays selected and translated by Stephen Heath. New York: Hill and Wang, 1977.

Baudrillard, Jean. *Simulacra and Simulation.* Trans. by Sheila Faria Glaser. Ann Arbor, MI: University of Michigan Press, 1997.

Butler, Judith. *Gender Trouble: Feminism and the Subversion of Identity.* New York and London: Routledge, 1990.

cewdk. "Lily Allen and Friends Show with Syncsta." YouTube, 29 Feb. 2008. Web. 1 March 2010.

Code for Best Practices Committee. "Code of Best Practices in Fair Use for Online Video." *centerforsocialmedia.org.* Center for Social Media Website, Jun. 2008. PDF. 3 Mar. 2010.

Corse, Yoan. "Rupture." *queertube.info/lovesong.* Love Song, 26 Jun. 2009. Web. 26 Jun. 2009.

Culbertson, Philip. "Designing Men: Reading the Male Body as Text." *The Journal of Textual Reason*, Vol. 7, 1998. Web. 19 Jun. 2009.

Dorwick, Keith. "Brave New Bodies: The Video Presence of Female to Male Transgendered Men in YouTube and MySpace." *Louisiana Association of College Composition.* The University of Louisiana at Monroe. 14 Nov. 2009.

Haddaway. "I Miss You." YouTube, 14 Nov. 2007. Web. 3 Mar. 2009.

_____. "Rock My Heart." YouTube, 15 Feb. 2007. Web. 3 Mar. 2009.

_____. "What is Love?" YouTube, 1 Apr. 2006. Web. 3 Mar. 2009.

_____. "What is Love?" *queertube.info/lovesong.* Love Song, 26 Jun. 2009. Web. 26 Jun. 2009.

The Kings of Lipsync. "What is love—Haddaway." *queertube.info/lovesong.* Love Song, 14 Mar. 2007. Web. 22 Jun. 2009.

McGunnigle, Christopher. "My Own Vampire: The Metamorphosis of the Queer Monster," in Francis Ford Coppola's *Bram Stoker's Dracula. Gothic Studies*, Vol. 7, Issue 2, pp. 172–184. Nov. 2005.

Miller, Arthur. *Death of a Salesman.* New York: Penguin, 1996.

A Night at the Roxbury. Dir. John Fortenberry. Paramount Pictures, 2 Oct. 1998. 22 Jun. 2009.

only john of course. "What is Love." *queertube.info/lovesong.* Love Song, 26 Jun. 2009. Web. 26 Jun. 2009.

Palfrey, John and Urs Gasser. *Born Digital: Understanding the First Generation of Digital Natives.* New York: Basic, 2008.

Samuels, Robert. "Auto-Modernity after Postmodernism: Autonomy and Automation in Culture, Technology, and Education." *Digital Youth, Innovation, and the Unexpected*. Ed. Tara McPherson. *The John D. and Catherine T. McArthur Foundation Series on Digital Media and Learning*. Cambridge, MA: MIT Press, 2008.

SNL. "What is Love?" *queertube.info/lovesong*. Love Song, 26 Jun. 2009. Web. 26 Jun. 2009.

skategirly94. "Syncsta—The Gay Barbie Song." YouTube, 2 Oct. 2009. Web. 2 Mar. 2010.

Snyder, Michael. "Crises of Masculinity: Homosocial Desire and Homosexual Panic in the Critical Cold War Narratives of Mailer and Coover." *Critique*, Vol. 48, Issue 3, pp. 250–277, Spring 2007.

Stern, Susannah. "Producing Sites, Exploring Identities: Youth Online Authorship." Youth, Identity and Digital Media. Ed. David Buckingham. *The John D. and Catherine T. McArthur Foundation Series on Digital Media and Learning*. Cambridge, MA: The MIT Press, 2008.

Syncsta Productions. "Syncsta Productions." YouTube, n.d. Web. 27 June 2009.

Tapscott, Don. *Grown Up Digital: How the Net Generation is Changing Your World*. New York: McGraw-Hill, 2009.

Walmsley, Jake. "Jake Walmsley—Explanation." YouTube, 30 Sept. 2009. Web. 2 Mar. 2010.

Walmsley, Jake and Sammie Lowe. "What is Love?" *queertube.info/lovesong*. Love Song, 26 Jun. 2009. Web. 26 Jun. 2009.

william. "What is love." *queertube.info/lovesong*. Love Song, 26 Jun. 2009. Web. 26 Jun. 2009.

Growing Up Multimodal: Young Men Talk Media

Margaret Mackey

The stereotyped gamer is a familiar character: young, male, obsessed, possessed of diminishing humanity and negligible cultural interest as a result of his passion for wreaking digital havoc. "High levels of violent video game exposure have been linked to delinquency, fighting at school and during free play periods, and violent criminal behavior," says Craig Anderson (2003). "[V]ideo game 'addiction' is a problem among adolescents, particularly among males, and . . . addiction is associated with adjustment problems such as school performance and aggressive attitudes and behaviors," say M. R. Hauge and D. A. Gentile (2003). And, Julie Steenhuysen (2007), reporting a study from the Archives of Pediatrics and Adolescent Medicine, claims that "Boys who play video games on school days spend 30 percent less time reading."

Such familiar comments imply a degenerate sub-culture of masculinity raging completely out of control. Contemporary boys and their pleasures are demonized, rendered simultaneously mindless and threatening. There is no sense of the contradictions built into these assertions; for example, those boys playing video games on school days may well be reading *inside* the world of their game. Additionally, these doomsayers ignore the actual content of the materials they decry. As Thomas Newkirk (2002) reminds us,

> One final problem with traditional research on media violence needs to be noted. Few shows that contain violence are about *only* violence; most action movies also stress teamwork, loyalty, perseverance, ingenuity, problem solving, stoicism,

athletic fitness, courage, and frequently patriotism. The action hero typically has to overcome adversity, failure, and sometimes discouragement at having to face a superior force. . . . Why should one message—that of the acceptability of violence—be the sole effect of these shows when even cartoons are about so much more than that? The alarmist claims about the effects of media violence rest on research that reduces complex narratives with multiple messages to simple "stimuli" that work automatically, like a carcinogen, at an unconscious level. Not only is the media narrative reduced; the young viewers too are reduced, to being unconscious reactors with no interpretive resources. (102–103)

My interest lies in that question of interpretive resources. To look to the kind of button-mashing, havoc-wreaking automaton described in the quotes that open this chapter for subtle insights about growing up surrounded by multimodal opportunities would seem to be a silly waste of time. Boys who spend their time creating mayhem cannot reasonably be expected to be articulate even about the games that eat their hours in such anti-social ways, let alone about nuances in the contrasting and overlapping pleasures of reading or viewing or gaming.

But young male gamers are as varied and perceptive as the rest of humanity. On the basis that some of the most interesting observations about contemporary boyhood might come from those who have most recently left it behind, I gave nine young men the opportunity to speak at length about the differences between experiencing a fiction in book, film and game form. These young men were at the upper end of adolescence and they represent a generation that has grown up with games as a natural and unquestioned component of their media universe. In their discussions with me, they were eloquent in their individuality and very thoughtful in their reflections on the affordances of different media. Their descriptions of their own interpretive resources belie the relentlessness of the image of young male gamers as locked in mindlessness. They provide eloquent answers to the charges outlined in my introductory paragraph.

A Changing Context

Before we move to the comments of these young men, it is worth briefly exploring the sophisticated demands of the context in which they have matured as interpreters of a variety of text forms. Contemporary young people have grown up in what Henry Jenkins (2008) calls a "convergence culture." Discussing the most contemporary and revolutionary end of the interpretive spectrum, Jenkins talks about "transmedia storytelling," which

> refers to a new aesthetic that has emerged in response to media convergence—one that places new demands on consumers and depends on the active participation of knowledge communities. Transmedia storytelling is the art of world making. To fully experience any fictional world, consumers must assume the role

of hunters and gatherers, chasing down bits of the story across media channels, comparing notes with each other via online discussion groups, and collaborating to ensure that everyone who invests time and effort will come away with a richer entertainment experience. (20–21)

Using a different term to describe some of the same transmedia phenomena as they explicitly affect print books, Eliza Dresang (1999) talks of "radical change." Burnett and Dresang (1999) discuss "the manifestations of this aesthetic that reflect the interactivity, connectivity, and access of the digital world as changing forms and formats, changing perspectives, and changing focus in literature for youth" (425). Synergy, nonlinear and nonsequential organization and format, multiple layers of meaning, and interactive formats mark these new literatures, even when they appear in print on paper. Victoria Carrington and Jackie Marsh (2009), writing a decade later about new forms of literacy, invoke other patterns: "ubiquity, convergence, mobilization, and personalization" ("Forms of Literacy").

In short, contemporary Western young people must move adroitly among a plethora of enticing options. Does growing up in a digital world cause boys and young men to turn their backs on older and more established media formats such as print? Has sustained reading fallen by the wayside in the face of fleeting multimodal attractions? Is concentration the casualty of the new sophistication? In this chapter, nine ordinary young men provide some provocative answers to such questions.

The Framework of the Study

I met these young men when they volunteered to take part in an extended research project that involved them in reading a novel, watching a movie, and playing a PlayStation game, from beginning to end in each case. The project explored the question of whether books, films, and games would elicit comparable narrative interpretive strategies among participants familiar with all three media. Twelve undergraduates signed up for this project and tackled the three stories, working in small groups of three. All their responses were video- and audio-recorded, transcribed, and analyzed.

The conversations reported here, however, represent the one point in each session where I stepped back from immersing my participants in the three story worlds and asked them to articulate their own experiences of reading, watching, and playing. In effect, I am reporting on group interviews. Each of these conversations took place in the third session of the sequence; by this stage, participants had viewed the film (*Run Lola Run*, directed by Tom Tykwer, 1998), finished reading the novel (*Monster* by Walter Dean Myers, 1999), and played a relatively short session of the game (*Shadow of the Colossus*, a game designed by Fumito Ueda for

PlayStation 2, 2005). In other words, they had some common local experience in three different media to draw on when I asked them to consider the differences between the personal experience of watching, viewing and playing a fiction.

The fictions I chose for their consideration all include some cross-media elements. *Monster* is a novel told by means of private journal entries and a screenplay, formatted in various typefaces and illustrated with photographs and a court drawing. *Run Lola Run* imitates a videogame in its structure: Lola runs to her boyfriend's rescue three different times, and on each occasion small differences in the course of events lead to widely variant outcomes. *Shadow of the Colossus* is a quest game with many violent scenes that nevertheless offers considerable potential for the introverted reflections normally associated with print literature.

At the same time as I invoked some transmedia elements *within* the texts, I made a deliberate effort to select three freestanding stories that, at the time of the study, existed only within the confines of a single text. I did so in order to reduce "noise" of possible knowledge introduced into the project by participant awareness of other versions of the particular story world under investigation. The three narratives they investigated with me had no transmedia cousins at the time of our project (though there have been hints since then of an upcoming movie of *Shadow of the Colossus*).

The young men who speak here are listed alphabetically below, along with their university major and their age, where known (all of them were approximately 20, plus or minus a year), at the time of these conversations:

Adam	English/drama	age not known
Dan	general science	age 20
Jacob	general arts/business	age 20
Jarret	education (English/history)	age 20
Keith	chemical engineering	age 20
Lewis	genetics	age 21
Martin	English	age not known
Neil	microbiology	age 21
Sebastian	engineering	age 20

It is worth noting that fully two-thirds of this group is studying science, engineering or business. This is not a pool selected to represent an artificial bias toward the pleasures of reading.

These undergraduates were recruited via an advertisement in the student newspaper, inviting students aged 18–21 with some minimal competency in gaming to

volunteer for a study involving reading, viewing and playing. I did not want my sessions to flounder because participants were fumbling with the game controls, but I made no stipulation regarding competence in or enjoyment of reading. The group named here were selected from a slightly larger pool of applicants because it was possible to combine their timetables to set up four groups of three for a sequence of two-hour sessions; the larger pool also skewed heavily male. Not all participants in this study were white but they provided no information about racial or ethnic background. Each group participated in one session viewing and discussing the movie, two sessions reading and discussing the book (some reading was done at home), and as many sessions as it took for each trio to complete the game. Ethical approval for this study was obtained from the Research Ethics Board of the Faculties of Education, Extension and Augustana at the University of Alberta.

Comparative Lives

As these interviews testify, all of these young men were utterly at home with comparative thinking. They do not remember a "starter" time when they knew only one medium. As a result they were highly articulate about the advantages and disadvantages of different media forms. In this chapter, I provide extended transcripts of their discussion, in part to challenge the stereotype that the capacity for sustained thinking is one more casualty of gaming life.

Here is a sample of conversation among Dan, Neil and Keith. All three would probably fit the gamer stereotype at a casual glance (Dan, for example, mentioned one 14–hour stint playing *World of Warcraft*), but their discussion of format differences is subtle and sophisticated. I asked them if a game is experienced differently from a book or a film.

> Dan: Well one thing I noticed with games always is that if you're in a part of a game, or something you're into in a game, I think you often sometimes notice your adrenaline is pumping, you're into it and I think it's almost because the effect has a direct outcome on you. Like, it's strange to say but in a book you're very aware that it's separated from you. I think in a game that line is blurred and you're almost more involved in the story yourself, so I think there's a lot more investment in the story when you're actually the one acting it out.
> Margaret: So you're a participant, not a spectator.
> Dan: Mm.
> Neil: Yeah, yep. A book is a lot more passive, but on the other hand, emotionally it's a little bit more manipulative.
> Margaret: Which is, the game or the book?
> Neil: The book. The book can feed you emotions or ideas or ways to look at a situation and a game really can't do that.
> Margaret: Yet, or absolutely, do you think?
> Neil: Pardon?
> Margaret: Do you think that it's a game can't do that *yet* or it *never* will?

Dan: Yeah, I've had a game do that, definitely, but it's not your average game. I think it's the exception rather than the rule. For the most part I think games are an entertainment tool and they're meant to catch you up and entertain, but they're not necessarily meant to give emotional responses to the person who's experiencing it. It's just like a movie—if you go between a drama and an action—I mean there's an obvious disparity between this one wants you to feel something and this one just wants you to watch the action, so that's kind of what it's like for a book and a game. A game is definitely the action movie and the book is much more versatile; it can be anything it wants. And even within the same work it can switch between them.

Keith: I think having to do something in the game kind of almost distances you from like, feeling. Like I can see—yeah you get into the game but you're more concerned about what you're doing rather than what you're feeling sometimes.

Neil: I agree.

Dan: Yeah. I think for me like, what I meant by the adrenaline thing is more like the task is under your control and you want to complete it and say there's a clock counting down or you're about to be stomped on by a Colossus, obviously there's more of a response that's going to be physical, associated with that, rather than if you're just watching. "He watched as"—you know, in a book, so I think it's a very hard thing to describe, really.

Neil: I think it's easier to lose oneself in a book. A lot easier to lose oneself in a book because if you're good at reading and you can do it subconsciously enough then you're experiencing the story that's been created for you and you're in it and you're just experiencing it. Whereas with a game you've got objectives and you've got to accomplish something.

Margaret: So you have more of a to-do list.

Neil: You're more intensely aware of that. I mean—well I mean, so in *Halo 2* or something, I'm running around and I'm trying to figure out what I'm supposed to be doing and all that, so it's more *me* than it is them. I guess that's how I describe that. There's a lot more me there than—and I think a game will always have that.

Dan: Yeah.

Neil: That's the nature of it.

Dan: Yeah I think it's like you brought up the first time. It's all about control and in both situations you're still a victim of the story to some extent, but in a game you definitely have control over the outcome whereas in a book you're most definitely aware that the outcome is not under your control and all you can do is either hypothesize or let it take you and let the story play out. So I think that's the thing with the physical or maybe emotional razzle of the game is that at least to some extent you could alter the story. And when the story's under your control, even to some extent, that just adds a different type of investment. Maybe it's not as deep as you get reading a book but it's still significant.

Dan was eloquent on the appeal of the game:

Being able to have an influence on an environment or at least just, I think, a deep-set human need to influence your environment. I think that's something you can have in a game and you can't have in a book. I don't know, it's strange, but in the book occasionally you feel, umh—*futile*. You can't do anything even though you might want to. Whereas in a game, I mean, there's definitely some joy in being able to influence the outcome and have an effect and that's definitely something that's enjoyable about the game and I think that's *why* it's so popular.

And yet it was clear that Dan also appreciated the power of reading:

I think in the movie you're under the impression and you expect that the characters are going to be flat and when I'm reading at least, just like Neil, I don't even realize I've turned a page or that I'm reading; it's effortless and it's all about the story. And I think the whole point is, when you get to that type of reading, the joy of a book over a movie is that the book's not so shallow and everything has more depth and it has a lot more to it and I think that what makes it so enjoyable. A game is, I would say, in a sense even shallower than a movie characterwise, because it's hard to develop a character in a game, but they each kind of take an aspect of a book and each has something a book does. And the movie I think, has the intense visual component that a book can't have and a game has the interaction and effect on the environment that a book can't have, but the book really has the experience and the emotional investment that—or even, I should say, the knowledge of the characters and the character development that both of those can't achieve.

Discussion

These three young men clearly understand the pleasures of reading as well as of gaming and watching movies. Yet it is striking in their conversations that they are not inclined *a priori* to consider that a book is automatically the experience with the most cultural capital; a book has to earn its credit. A book is sometimes manipulative in the way it feeds you emotions, says Neil; a reader sometimes feels futile, says Dan, because he is so powerless to affect events in a novel. It would be easy to read these words as pejorative, but my sense is that they are actually neutral attempts to pin down what distinguishes one medium from another. It is clear that they understand and appreciate the power of reading.

Those who wish to communicate the delights of reading, such as teachers, librarians and parents, would be well advised to acknowledge the power of these comments. Simply asserting that reading is better is not necessarily the most helpful response to such language.

In fact, what is noticeable about these observations is that reading does not have to plead a special case to these young men. These three gamers, all science majors, are happy to be analytical about the differences between media, but they are also clear about the positive experience of reading. Reading offers a form of

imaginative investment that they all appear to regard as deeper than other forms of media engagement (Neil talks about being lost in the book, Keith says a book is less distancing than a game, Dan describes the knowledge of character development that is best accomplished by a book and speaks explicitly of "emotional investment").

Considering these responses, would the defenders of reading make a better case by being less defensive? Many advocates of reading run the risk of coming across as shrill and strident; their numbers include some teachers and librarians, as well as the National Endowment for the Humanities in the United States, whose 2004 report on reading in America dismissed games and ignored many kinds of reading in their famous jeremiad on the decline of the literary reader. These young men in their detached evaluation of the pleasures of different media make a strong case for reading as simply one kind of fictional experience, in contrast, for example, with the ill-informed rant of Dana Gioia, Chairman of the NEA, in his introduction to the 2004 report:

> Reading a book requires a degree of active attention and engagement. Indeed, reading itself is a progressive skill that depends on years of education and practice. By contrast, most electronic media such as television, recordings, and radio make fewer demands on their audiences, and indeed often require no more than passive participation. Even interactive electronic media, such as video games and the Internet, foster shorter attention spans and accelerated gratification. (vii)

In contradiction, these young men, comparing print to game, refer to *reading* as the more passive activity (and not necessarily in any pejorative way). A reader is "just experiencing" the story, says Neil. Dan talks about being a "victim" of the story and says when reading, there are only two choices: to hypothesize or to "let it take you and let the story play out." Even the act of turning the page fades from attention in the rush of the story. The reader is carried along in a way that they all seem to regard as highly pleasurable and distinctive of reading.

There is a real tactical question about whether the defenders of print literature should continue to bolster reading by means of dismissing other forms of fictional engagement as worthless—or whether relaxing enough to acknowledge (and genuinely accept) that different media offer different virtues and pleasures would actually make for a more persuasive case for reading. Certainly it is hard to picture Dan's 14–hour foray into the game of *World of Warcraft* as a case of "shorter attention spans and accelerated gratification," and it is clear when he talks about reading the novels of Robert Jordan that it is exactly the same potential for extended immersion that appeals to him. In this case, Dan's argument is subtler and more helpful than Dana's argument! Dan is actually at home with a variety of media, old and new, and speaks of all of them with comfort and ease. Gioia is aggressive and negative about every textual pleasure except reading, and wants his

reading to look like work. It is not difficult to choose the discourse more likely to persuade young people that reading is an activity worth exploring.

Analogous Experiences

Asked to describe their mental experiences while reading, some participants described multi-sensory experiences. The novel *Monster* is a story about a boy charged with murder, told in two formats (with a few added images and annotations). The two main formats in this book are a private journal and an imaginary screenplay, created by the accused boy as a way to help him survive the court case.

Here is a sample passage from the journal, at the very beginning of the book, as Steve is coming to terms with his new life in prison:

> The best time to cry is at night, when the lights are out and someone is being beaten up and screaming for help. That way even if you sniffle a little they won't hear you. If anybody knows that you are crying, they'll start talking about it and soon it'll be your turn to get beat up when the lights go out. (Myers, 1)

Steve decides his psychological survival depends on finding a way to detach himself from the experience and determines to create a screenplay of his time in court, just as he learned to do in his film class at school. Here is a brief excerpt from that screenplay.

> STENOGRAPHER
> I hope this case lasts two weeks. I can sure use the money.
> GUARD 1
> Six days—maybe seven. It's a motion case. They go through the motions; then they lock them up.
> (Turns and looks off camera toward STEVE.)
> Ain't that right, bright eyes?
> CUT TO: STEVE, who is seated on a low bench. He is handcuffed to a U-bolt put in the bench for that purpose. STEVE looks away from the GUARD. (Myers, 14)

Adam and I had an extended conversation about his approach to reading, based on these and other passages from *Monster*. He responds intensely to this combination of storytelling techniques, and develops a very specific realization of characters and story as he reads. Here is part of our discussion, in which he describes his reading experience.

> Margaret: I want to ask you a little bit about how you read. And this is an area where there are truly no right, no wrong answers because readers are so different. You mentioned the close-ups and medium shots and that sort of stuff that's just kind of directing you to see it in your mind's eye, but not all readers visualize

when they read. So I'd just like to ask you whether you—well, first of all, did you visualize this book as you read it? Did you follow the instructions for "this is a close-up shot" and "now the camera is backing away" and that sort of thing? Or did you see it more seamlessly than that without the cuts in it, or did you not see it at all? Just this book specifically to start with?

Adam: Ah, in this case I definitely was paying attention to that.

Margaret: So you were seeing the cuts?

Adam: Yeah. Ah, partially because I was reading it as a screenplay and again, the background is playing into that whole thing, because I read plays and I need to pay attention to that because I need to know how it's going to be staged and everything like that. The entire time I was actually considering about what would this be like if it was a movie and would it be following this—these things, anything like that. There were times every now and then where I'd say, "Oh I don't think a close-up would work here;" "I don't think a long shot would work here." But—

Margaret: And did you have a definite image of the characters and the court scenes and that sort of thing?

Adam: Oh yeah.

Margaret: So you had faces in your mind?

Adam: Yeah.

Margaret: And is that how you always read?

Adam: Yeah.

Adam's visual images appear to be very specific but his reading is not just visual; audio also plays an important role:

Adam: I definitely give each character a different voice.

Margaret: And you hear the voices?

Adam: Well I need to actually, or else I can't keep them straight in my head. So they need to have these separate identities, these separate voices that argue and even when the—especially during the courtroom scenes where the lawyers are getting angry at each other and they're shouting out "Objection!" I imagine their voices getting higher and angrier.

Margaret: So you hear in detail.

Adam: Definitely!

Margaret: What about—in this—there's not much of it in this book, but what about the narrative voice? Do you hear that?

Adam: Steve's voice?

Margaret: No, in a book that's narrated by the author's—in you know—the description.

Adam: Almost like the actor describing a close-up kind of stuff?

Margaret: Yeah or a book that has lots of description and character, you know, setting and character description and atmosphere description and that sort of thing.

Adam: In a regular book, that's generally just my voice, and then in this one as well it was my voice reading the stage directions.

Margaret: But there is an audio component to it?

Adam: There is, yeah. I find it really hard to separate a word, because a word on paper doesn't really mean anything until it's spoken, so I need to give it that.

Margaret: Right. So you're really taking things off the page and turning them into visuals and audio?

Adam: Well, yeah it's even—even when, umh, when looking at certain sentences I need to do that because I need to decide where the inflection is. And decide where the person is putting the emphasis because it will completely change the way it's taken.

Margaret: And do you think that slows you down, to be doing all that?

Adam: Ah—not as far as I've noticed. If it does slow me down it's negligible.

Adam adds voices in other media as well:

Adam: Actually, just to bring this also to video games. When I play a video game I even give the characters voices.

Margaret: Even when they don't have them?

Adam: If they don't have them.

The entire effect is clearly very absorbing to Adam, as he makes clear in a multisensory account of his reading experience:

When a character is describing what physical space they're inside, ah—and they're describing how that makes them feel. I can definitely see that. There's actually sections in some books that I—I find difficult to read because I get too invested in them and it just—it raises a mild claustrophobia in me sometimes regardless of where I'm reading.

Given his background in drama, it might be reasonable to expect Adam to prefer film and television to books, but he says flatly,

A book is always better. . . . To sort of go along with the whole directorial thing, it's—when you're reading a book you can direct it yourself and you know what you like. So I like the book a lot more because I am always making the decisions. I am always saying, okay go to a long shot for this, focus in on that whenever this happens, go there. Whereas with a movie—and you can see this especially with books that turn into movies—you sit there and you go, "No, that is not the right choice! There is no way you should have done that!" It's just that a book you can do anything, because you have the imagination to do so, where with a movie it has to have some aspect of realism. And even the computer generation stuff we're going into now, you can make it look fantastic, but you can't make it look as fantastic as somebody already has in there. So I'm going to have to go with the book.

Adam's account of his reading practices made strong use of the comparison to a play director, raising an interesting contrast with Dan's pleasure in the idea of the reader as "futile." Lewis and Sebastian are readers who draw on analogies from other media to describe their reading. Here is Lewis:

> I am a visual reader the whole time. I played it as a movie going through my head while I read it. Different things, you know, would pop into my head. What music would go well here, stuff like that. I know at the end, one part where it cuts to different things in the courtroom, it was building up tension and I thought that was really cool, but definitely I am a visual reader, especially for this book, but in general too as well.

Sebastian draws on a different comparison to describe his relationship to the printed words:

> I usually think a bit more in the third person view, where almost like in a video game, where you're just hovering behind the character and you can see them and you can see what they see, but you're not necessarily looking through their eyes or even among them.

And Adam refers to yet another format, a graphic novel, to make a point clear. Asked if he reacts emotionally to the story of Steve, he says no:

> Because there weren't thought bubbles. There wasn't really any inner monologue. Every now and then I get it when Steve was doing this little jotting down, but not really. If there was, it was me assigning something to it and it didn't feel as real.

Discussion

A couple of centuries ago, which of these analogies would have illuminated a description of private reading? The explicit metaphors of radio or film or game—or even comic-book frame—would obviously have been impossible, but have we always (or at least since the dawn of silent reading, a very different time-scale indeed) had readers who specifically focus on the visual or the aural or the kinaesthetic aspects of processing print? It is impossible now to resurrect the responses of these bygone readers. What is very clear is that the participants in this study inhabit a convergence culture and move easily among a variety of media metaphors to help them articulate their responses to reading print.

Words are abstract marks on a piece of paper or some other surface. The three letters of the word "sun" have no intrinsic content of heat or light or comfort or optimism, or any of the myriad other associations a reader of English brings to this arrangement of these letters. People have different ways of bringing these associations to life in their minds. Perhaps a majority visualize—but not everybody sees images when they read (I almost never do myself, for example). Perhaps more people visualize today because of the vast range of visual options we take for granted. Perhaps two hundred years ago, in an era of reading aloud, more people brought words to life in their minds by hearing them, as Adam does. We simply

do not know if media experience provides a *lens* for mental processing of words or simply a *metaphor* for articulating a complex process—and we do not have enough data about the mental processes of reading to establish how they may or may not shift from one era to another.

What is clear is that these young readers have many metaphors at their disposal with which to articulate the internal processes of realizing a fictional world, and that their capacity to describe the creation of that mental world is enlarged by their ability to refer to other kinds of fiction. The range of available metaphors also makes it possible for them to convey with great vividness the invisible truth that readers' mental processes are not identical. Not only is the monolith of the male non-reader challenged by these lively accounts, so too is the idea of the monolithic reader *per se*—*the* reader who responds reliably and uniformly to print and who features too heavily in many curriculum documents. These young men move easily among different media, old and new, and are able to draw on the contrasts to express individual and personal accounts of their experiences.

Freedom to Imagine and Limits on Imagining

Adam and Lewis had an intense discussion of the differences between reading a book and watching a film. Lewis observed that there is "definitely more freedom with a book," but went on to say that he thought a film of *Monster* would adhere more closely to the original simply because of the fact that the original was itself a screenplay. Adam wasn't so sure.

> Lewis: And I've already. . . I don't think much would change between what was in my head and what is on the screen, but that's for this book. For a different book I would say that—definitely you know, like, come on director, what are you doing? If he changes what you—it's your personal story—it's your—it's what you create, so I would have to go with the book for personal experience.
>
> Adam: At the same time, like thinking about that if it was made into a movie. I would actually have difficulty—like even more difficulty with the end because there is a certain way that she [the lawyer who, at the end of the story, refuses to look at Steve] looks at him in my head when she turns away that if the director didn't get, I would—I would hate it. I would absolutely detest it.
>
> Lewis: What was the look in your head?
>
> Adam: I can't describe it.
>
> Lewis: Really?
>
> Adam: It's one of those things. Like I'm sure that my look is different than your look.
>
> Lewis: Oh for sure.
>
> Adam: Your look—
>
> Lewis: I was just curious.
>
> Adam: It's almost not even a look; it's almost a look you just attribute sort of.

Margaret: So it's too subtle to describe.
Adam: Yeah.
Lewis: But it's important.
Adam: But it's there.
Lewis: It's important.

Adam is very clear about the enormous importance of the privacy of the reading experience. Paradoxically, he values how the words of the novel can elicit a reader's mental interpretation that is too subtle to be expressed in other words.

We briefly discussed the difference between a movie, which is relatively short, and a television series that has some of the extended space of the novel. Adam again made the case for reading.

Adam: I think that would really depend on the series and it really depends on the storyline and the direction of that series because there are some fantastic stories out there that are told phenomenally well. Umh—but again, if there were books, the book would trump them.
Margaret: Even if it was brilliantly done in the format of the television series, you think a book of it would be better?
Adam: I think so, just because you can change things again.
Margaret: Right.
Adam: In your head.

Adam is clearly reading very subtle nuances into that movement of the lawyer's head at the end of *Monster*. Other readers, however, found that the author of this novel did not really give them enough to go on in terms of truly subtle empathy. Here are Jarret and Jacob, also talking about *Monster*. I asked them about how easy they found it to feel for Steve in his terror, and they made some interesting observations about the role of the text in the reader's experience.

Margaret: There are bits in it where he's saying "this is awful, I really hate this, this is—I'm frightened, I don't know what to do next." Did you get the—I'm not saying did you feel with him, but did you feel his feelings as it were when you were reading, if that's clear enough?
Jarret: See, this is the problem I had with the book in that, like, I understood why he was so scared because of what *could* happen, but in terms of what actually happened, he never had any of those *really* horrible things happen to him that was in the book. Like, he was never sexually molested by any of the other prisoners, never really physically abused and so it was actually almost harder to try to relate to him in that fashion.
Margaret: Right.
Jarret: I can understand his *fear*, but the other emotions were difficult to connect with.
Jacob: I found—I was really sad when he was talking to his dad and of course it's that—I really felt for him then and that was really emotional, but

yeah, when Jarret was saying he was in the jail and he was afraid then I—I can understand him being afraid but I didn't really share the feeling. . . . I really empathized with the fear he felt about going to prison and losing his freedom and his youth, pretty much and just losing a big chunk of his life. I do really feel that and one part that really stuck out for me, the part where he was thinking about how he got here, he's like, "what was I thinking? What was I thinking on doing this?" I understood that as well.

Discussion

Jarret and Jacob stand as an interesting corrective to Adam's enthusiasm for reading, in terms of reminding us that the author is also a responsible partner in the reading experience and that we may reasonably expect him to give us enough to latch on to. In their case, they found that the story was too simplified in some ways, possibly with more telling than showing, and they were interested rather than moved. Scholars such as Booth (1988) and Nussbaum (1997) consider empathy to be one of the returns on reading narrative fiction, but not all novels press their readers into emotional identification with the heroes. Newkirk, for instance, suggests that boys may often prefer stories of adventure rather than character. *Monster*, however, is a book of reflection on action and most of these readers were happy to explore the ambiguities of such reflection.

Popular culture texts, however, often emphasize identification with characters. The three stories on offer in this project are relatively stylized, and more than one interpreter commented on his lack of commitment to a story that doesn't operate on the basis of inviting a state of overwhelming empathy. Here is Dan on the subject of the lack of flow in *Run Lola Run*:

Umh, I'd say the ending was of course satisfying because it resolved itself, but at the same time it's kind of aggravating for me to watch because usually when you like, I guess watch, there's a flow to it you know, it's got an ending and a beginning whereas this kept restarting and we were seeing what happened. It was interesting but that's something that I wouldn't generally watch.

Neil spoke of the lack of satisfying character development in the movie:

They didn't get into a lot of—especially the character building except for the ultimate timelines [of the three run-throughs of the storyline]. They each were somewhat different in each of the timelines, so since you don't really know the characters before the timelines it doesn't really especially matter what happens after the timelines.

In terms of analyzing the different effects of style and substance, these interpreters made a number of subtle observations. Although they could appreciate the stylistic flourishes of *Monster* and *Run Lola Run*, they were clear that they thought

surface interest was achieved at the expense of more thorough imaginative realization of setting, character, and complex action. In addition to distinguishing among the possibilities of different media, these interpreters provide complex analysis of the interactions between form and content.

Intertextuality

Movies and games supply images; in books, readers are given the option of creating their own mental images, more or less constrained by the words. Some of these readers, however, testify to a mental imaging process that actually draws on other media texts for information. Calling up a different text can serve a variety of functions. In many of the game examples, the purpose is to make an instruction more explicit. At one point, Sebastian advised Jacob as he manned the controls of *Shadow of the Colossus*: "Shimmy! It's like *Zelda* except different," and somehow this reference, which should have obscured things, was actually helpful.

Other interpreters called on imagery from different media. Martin, for example, talked about reading the two different text styles in *Monster*.

> I found that the movie parts [of the book], I *saw* it. In the movie I saw it easily, and then his diary, they were words. In his diary—his diary was descriptive and I was basically picturing him in this like you know, dark, shadowy *Shawshank Redemption* sort of cell. So yeah, I guess there was usually an image in my mind.

Asked what he was picturing, Martin drew on a television analogy this time:

> Martin: Oh . . . like, for instance with the umh, the trial with they're interviewing or they're examining Briggs or Henry and then they're doing Bobo and then they're doing you know, these people I guess. Bobo had a pretty long conversation. I was just picturing these sleazebags; I was picturing watching like, *Law and Order* except it was this book, so it's like Bobo is like this bald guy with a smirk and would probably have a toothpick in his mouth and then like, Sal—
> Margaret: Very specifically visual.
> Martin: Well, like, because everything in here is put in there for a reason. Like, Sal Zinzi, what does that sound like. That sounds like this slippery sneaky guy with like slicked back hair and shifty eyes. Everybody was like that.

Yet for all his easy use of movie and television stereotypes, Martin was paying careful *readerly* attention to the way the text was put together, with the internal perspective of the journal and the external point of view of the screenplay.

> And never once are you in a place of neutrality. Never once are you unbiased about what you're reading. . . . It seemed like through Steve's perspective and just through the ambiguousness of the book, like of the two perspectives of being inside and out. It separates me from the concepts of what the book was

about. Like, the whole time I was thinking about justice and the whole time I was thinking about who was right and who was wrong and who deserved to go to jail and who was lying because somebody was. Umh, and yet there was never a place for me where I could actually evaluate those things as a reader based on a description, a narrative. Like there wasn't anything in there. Everything was too contradictory for me to have any sort of opinion on those things and so instead of having an opinion, I was constantly shifting between these biased perspectives.

For all the apparent glibness of his resort to stereotypes such as the "slippery sneaky guy with, like, slicked back hair and shifty eyes," Martin here articulates a sophisticated moral assessment of his reading experience.

Discussion

We understand far too little about the automatic mental processes by which readers bring print to life in their heads—through visual, audio, kinaesthetic or emotional means. Images (of any kind) are often swift and fleeting, sometimes wrong, sometimes abandoned when they prove unworthy, sometimes obstinately adhering to the words and phrases even when their utility is suspect (Mackey, 1997). Ideas often move swiftly through our heads to be sustained or abandoned without much conscious attention; Would Martin be as likely to produce such a careful articulation of his assessment of justice in this story without some external stimulus, without some requirement to account to other readers (teachers, book group members, etc.)? Martin, of course, was accounting to me and the research project, and when pressed to express processes that often fly by unaccounted, he actually had a great deal to say.

As Martin demonstrates, we often draw on images from other stories to vivify our understanding of the printed word. Such intertextual flashes are often swift and seem involuntary in their sudden appearance. We may even need to increase conscious attention and deliberately slow down the fleeting moment to be able to attach a pedigree to these images at all. Often there is no reason to take that trouble. Yet Martin's capacity to articulate the rich movement of images between different experiences of fiction demonstrates that it is a mistake to dismiss the fictions of other media even if we intend to focus exclusively on the reading experience. Fictions cross-pollinate in interpreters' minds, and we will better understand any one form of fictional experience by taking others into account.

Conclusions

Fiction has been multimodal for many decades now—and in terms of its roots in storytelling, has always transcended simple words on paper. These young men have grown up in a world where they can tap into a fictional universe through

many different portals. Their own two decades of such experience enable them to explore many aspects of the role of reading, viewing, and playing, and to reflect on the affordances and pleasures of different media in thoughtful ways.

Instead of fearing or simply dismissing the attractions of the videogame and exaggerating its deleterious effects on contemporary males, it makes more sense to talk with them about what they are actually enjoying and actually learning. At first sight, the group portrayed here does not come across as a likely pool of ardent readers. All were committed gamers. A two-to-one majority of the participants came from disciplinary backgrounds such as science or business, which are often perceived as being antithetical to the appeal of recreational print narratives. Yet, even though the numbers are small, this project offers its own testimonial to the survival of reading for pleasure among a demographic group that has sometimes been carelessly categorized as non-reading, even anti-reading. The ease with which these young men draw on a variety of fictional experiences to articulate the delights of reading is itself a powerful testimonial to the rich cognitive possibilities of a mind furnished with many forms of engagement with invented worlds.

The nonchalance with which these young men discussed the pleasures of gaming, viewing, *and* reading is reflected in some of the figures in a new survey of American young people aged 8–18. Like many such studies, the Kaiser Family Foundation study of January 2010 did not explore online reading in any depth. It noted a slight decline in magazine and newspaper reading between 1999 and 2009 but time spent reading books actually increased slightly (Rideout, Foehr & Roberts, 2010, 30). Given the observation that "[p]rint media are among the least multitasked of all the various media," that "when young people do sit down to read print materials, they are less likely to also be keeping an eye on the TV or listening to music than they are when they use most other types of media" (Rideout, Foehr & Roberts, 2010, 31), and that unknown amounts of online reading need to be added to the average of 25 minutes a day spent reading books, the picture is more complex than the prophets of doom acknowledge.

Instead of crying vainly for young people to abandon their shallow pleasures of television, film, and games, and to return in an "either/or" kind of way to the austere rewards of reading, it makes much more obvious sense to explore the virtues of a world of "both/and." Moral panics do not illuminate our understanding of the complex and sophisticated media world we all inhabit. Talking with our young men about what they are learning is a much more productive route to improving our own awareness. They have much to tell us.

Works Cited

Anderson, Craig A. "Violent Video Games: Myths, Facts, and Unanswered Questions." *Psychological Science Agenda*. 16.5 (Oct. 2003). Web. 3 Aug. 2009.

Booth, Wayne C. *The Company We Keep: An Ethics of Fiction*. Berkeley, CA: University of California Press, 1988.

Burnett, Kathleen and Eliza T. Dresang. "Rhizomorphic Reading: The Emergence of a New Aesthetic in Literature for Youth." *Library Quarterly*. 69.4 (Oct. 1999): 421–445.

Carrington, Victoria and Jackie Marsh. "Forms of Literacy." *Beyond Current Horizons*. 2009. Web. 14 July 2009.

Dresang, Eliza T. *Radical Change: Books for Youth in a Digital Age*. New York: H.W. Wilson, 1999.

Gioia, Dana. Preface. *Reading at Risk: A Survey of Literary Reading in America*. Research Division Report #46. Washington, DC: National Endowment for the Arts, 2004.

Hauge, Marny R. and Douglas A. Gentile. "Video Game Addiction among Adolescents: Associations with Academic Performance and Aggression." Presentation at Society for Research in Child Development Conference, Tampa, FL, Apr. 2003. Web. 3 Aug. 2009.

Jenkins, Henry. *Convergence Culture: Where Old and New Media Collide*. Updated ed. New York: New York University Press, 2008.

Mackey, Margaret. "Good-Enough Reading: Momentum and Accuracy in the Reading of Complex Fiction." *Research in the Teaching of English*. 31.4 (Dec. 1997): 428–458.

Myers, Walter Dean. *Monster*. New York: HarperTempest/Amistad, 1999.

Newkirk, Thomas. *Misreading Masculinity: Boys, Literacy, and Popular Culture*. Portsmouth, NH: Heinemann, 2002.

Nussbaum, Martha. *Poetic Justice: The Literary Imagination and Public Life*. Boston, MA: Beacon, 1997.

Rideout, Victoria J., Ulla G. Foehr, and Donald F. Roberts. *Generation M2: Media in the Lives of 8– to 18-year-olds*. Menlo Park, CA: Kaiser Family Foundation, Jan. 2010. Web. 1 Feb. 2010.

Run Lola Run. Dir. Tom. Twkyer. X-Filme Creative Pool. Sony Picture Classics, 1998.

Shadow of the Colossus. PlayStation 2. Sony Computer Entertainment, 2005.

Steenhuysen, Julie. "Video Games Rob Reading, Homework Time: U.S. Study." Reuters, 2 July 2007. Web. 2 Aug. 2009.

Contributors

Michelle Ann Abate is Associate Professor of English at Hollins University. She is the author of *Tomboys: A Literary and Cultural History* (Temple UP, 2008) and, most recently, *Raising Your Kids Right: Children's Literature and American Political Conservatism* (Rutgers UP, 2010).

Jes Battis is Assistant Professor of English at the University of Regina. He teaches classes in children's fantasy fiction and literature of the eighteenth century. He is the editor of *Homofiles: Theory, Sexuality, and Graduate Studies* (Lexington, 2010).

Kent Baxter is Associate Professor of English at California State University Northridge, where he teaches young adult/children's literature and age studies. He is the author of *The Modern Age: Turn-of-the-Century American Culture and the Invention of Adolescence* (The University of Alabama Press, 2008).

Keith Dorwick has published a number of articles on popular queer culture. He is Associate Professor of English at the University of Louisiana at Lafayette and co-editor of the journal *Technoculture*. His chapter is part of a larger work in development, titled *QueerTube: Online Use of Video and Audio as Social Commentary by LGBTQ Youth* (http://queertube.info).

Suzanne Enck-Wanzer (Ph.D., Indiana University-Bloomington) is Assistant Professor in the Department of Communication Studies and Women's Studies Program at the University of North Texas. She is a scholar/activist, advocating for survivors of domestic violence and sexual assault. She also works to empower and educate women in prison.

Sandra Grady recently completed her Ph.D. in Folklore & Folklife at the University of Pennsylvania. Her dissertation is an ethnographic study of the practice of adolescence among the Somali Bantu, an ethnic minority population from East Africa whose life cycle rituals have been disrupted by flight from southern Somalia, displacement in refugee camps for over a decade, and subsequent resettlement to the United States. She currently teaches in northwest Ohio.

Stacey J. T. Hust (Ph.D., 2005, University of North Carolina at Chapel Hill) is Assistant Professor of Communication at Washington State University. Her research explores how the mass media can be used for health promotion through strategies such as entertainment education and media advocacy. Her research has been published in refereed journals such as *Mass Communication & Society, Journal of Health Communication*, and *Health Communication*. She is also a core faculty member of the Murrow Center for Media and Health Promotion.

Judy L. Isaksen is Associate Professor of Media and Popular Culture Studies at the Nido Qubein School of Communication at High Point University in North Carolina where she teaches courses in communication, media theory, cultural studies and pop culture, visual rhetoric, women and gender studies, race studies, rhetorical theory, hip-hop culture, and African-American literature. Her research and publications have examined audio rhetoric, gendered hip-hop, Zora Neale Hurston, whiteness studies, and racial discourse.

Bayard Lyons is an anthropologist based in Portland, Oregon. He holds a Ph.D. in Cultural Anthropology from the University of California, Los Angeles and a Masters in Gender and Women's Studies from the Middle East Technical University in Turkey. He is the author of several articles on the role of media in shaping trans-generational relations. He is currently working on a book on the struggles of unemployed young teachers in Portland.

Margaret Mackey is Professor in the School of Library and Information Studies at the University of Alberta. Her newest book is forthcoming with Palgrave Macmillan's new series, Critical Approaches in Children's Literature, and is provisionally titled *Narrative Pleasures in Young Adult Novel, Film, and Video Game*. She has published widely on the topic of multimodal literacies.

Scott A. Murray is an independent scholar residing at Indiana University Bloomington. His research and writing, which explores the intersection of sex, gender, and public policy through a libertarian socialist lens, has appeared in periodicals such as *Z Magazine* and *The Body as a Site of Discrimination*.

Matthew Prickett is a Ph.D. candidate in the Childhood Studies Department at Rutgers University at Camden. He has published on Pete Hautman, Francesca Lia Block, and L. M. Montgomery, and been featured on NPR's *With Good Reason*.

Phillip Serrato is Assistant Professor of English and Comparative Literature at San Diego State University, where he is on the faculty of the National Center for the Study of Children's Literature. He is presently at work on a book about masculinity in Chicano/a literature, film, and performance.

Annette Wannamaker is the author of *Boys in Children's Literature and Popular Culture: Masculinity, Abjection, and the Fictional Child* (Routledge, 2008). She is Associate Professor in the Department of English, Language and Literature at Eastern Michigan University, where she serves as Coordinator of Children's Literature Studies at EMU.

Rebecca Bridges Watts is the author of *Contemporary Southern Identity: Community through Controversy* (University Press of Mississippi, 2008). She is Assistant Professor of Communication Studies in the College of Arts and Sciences at Stetson University in Florida, where she teaches courses in gender and communication, intercultural communication, Africana studies, and rhetorical theory and criticism.

Index

mediated youth

Sharon R. Mazzarella
General Editor

Grounded in cultural studies, books in this series will study the cultures, artifacts, and media of children, tweens, teens, and college-aged youth. Whether studying television, popular music, fashion, sports, toys, the Internet, self-publishing, leisure, clubs, school, cultures/activities, film, dance, language, tie-in merchandising, concerts, subcultures, or other forms of popular culture, books in this series go beyond the dominant paradigm of traditional scholarship on the effects of media/culture on youth. Instead, authors endeavor to understand the complex relationship between youth and popular culture. Relevant studies would include, but are not limited to studies of how youth negotiate their way through the maze of corporately-produced mass culture; how they themselves have become cultural producers; how youth create "safe spaces" for themselves within the broader culture; the political economy of youth culture industries; the representational politics inherent in mediated coverage and portrayals of youth; and so on. Books that provide a forum for the "voices" of the young are particularly encouraged. The source of such voices can range from in-depth interviews and other ethnographic studies to textual analyses of cultural artifacts created by youth.

For further information about the series and submitting manuscripts, please contact:

> SHARON R. MAZZARELLA
> Communication Studies Department
> Clemson University
> Clemson, SC 29634

To order other books in this series, please contact our Customer Service Department at:

> (800) 770-LANG (within the U.S.)
> (212) 647-7706 (outside the U.S.)
> (212) 647-7707 FAX

Or browse online by series at WWW.PETERLANG.COM